DEAR NEW YORK

BRANDON STANTON

ST. MARTIN'S PRESS ❀ NEW YORK

At 2:19 A.M. on the morning of July 11, 2024, a child was born on the streets of New York City. A baby boy. If the birth certificate is honest, the place of birth should be marked as a small stretch of sidewalk on Twenty-Third Street, just west of Tenth Avenue. There was no welcome party to greet the arrival of this newest New Yorker, no ticker tape parade. In fact, less than a minute after being born the child was abandoned by his mother, set down directly onto the pavement beneath an old, elevated railway track: no blanket, covered in mucus, umbilical cord still attached. From this spot on the sidewalk there was very little the child could know about this city, except that it was the opposite of where he came. His skin, which had never known the touch of air, now rested against concrete. His eyes, which had known nothing but darkness, now stared into a white fluorescent light hanging from the bottom of the railway track. And his ears, which until moments ago had known nothing but the most muffled noises, were now, every few minutes, assaulted by the scream of a siren. It's a horrible sound by design, the siren. Engineered to sink into your nerves. But reverberating off the steel beams of an elevated railway track, it is haunting.

The child's mother would later be arrested while checking herself into a nearby hospital. Thirty-seven years old, her last known address a homeless shelter. What long, dark road could have possibly led her to make that decision in that moment? What battles, what monsters, had she faced? Only she can know. But for sure, there were battles. And then, the baby boy. For forty full minutes he lay there: in that hard, loud, bright place. Every need unmet. Too weak to cry. His blood slowly draining from the umbilical cord and pooling next to him on the sidewalk. What fear must he have felt during those forty minutes? What loneliness? Could there be a deeper loneliness? To not know, even, if there is anyone else in the world. And for this child—no claim to crime, no claim to sin—to experience all of this. It is an event so devoid of poetry, so devoid of justice that it calls into question the benevolence of nature, the existence of God. The next day a reporter would ask the super of a nearby apartment building for comment: "How could something like this happen?" The super replied with those same four words that every citizen of this city holds in reserve, to explain the unexplainable: "This is New York."

It was summer when I first saw the city, fifteen years ago. I arrived on the late-afternoon Megabus from Philadelphia. I must admit, I was selfish. Twenty-six years old, full of ambition, backward hat plastered permanently to my head. I was looking for what part New York could play in *my* story. I was traveling around the country on a mission to become a street photographer. The path forward was a hazy one: Instagram did not yet exist. I was looking for a lane, experimenting with every type of subject matter: graffiti, urban decay, and most recently—people. I'd begun stopping strangers on the street and asking permission to take their portrait. As the bus pulled out of the Lincoln Tunnel, my face was plastered against the window. But I wasn't looking up at the skyscrapers. I was looking down, at the sidewalks. New York to me was what I needed. And what I needed, was people. *This is going to work*, I thought. But there was no time for photos that first night. It was getting dark, and I had to get to Brooklyn where I'd arranged to sleep on a friend's couch. "Just take the subway," he'd told me. So I descended into the Thirty-Fourth Street Station.

The rush hour subway station is a fitting lobby for New York. There is an edge of desperation in the air. The benches along the wall collect the unhoused, the mentally ill, the people with nowhere else to go. Things aren't any better down on the tracks, where rats with chewed-off tails wage war over a crust of dollar pizza. And then, there is the subway itself. The pace is relentless: a train passing every three or four minutes. There is a momentum, an urgency: the loud, violent urgency of the city. The train will not wait for anyone. At each stop a friendly automated voice reminds you of this: "Please, stand clear of the closing doors." If the request is not obeyed, the conductor will sometimes get on the intercom to repeat the command, with a subtle threat of force: "Stand clear of the closing doors!" But more often, they will go straight to force. The doors will close on you. Even if you are infirm, even if you are shepherding small children, the doors will close on you. They will leave streaks of grease on your face. A temporary tattoo, a small souvenir. A reminder of the fundamental inhumanity of this city. It stops for no one. Everything bends, everything bows to the needs of the city.

But if you do manage to get on the train, you will be struck by that equal and opposite side of New York: the humanity. New York is the most diverse city in the world. Other cities have tried to claim this crown with cherry-picked statistics, with every gauge of measurement except for the eyes and ears. Fine cities, all of them. But whatever diversity they might claim, they have not the density to exhibit it fully. Nowhere are there more types of people packed into a smaller place than New York City. And whatever thin walls separate New Yorkers aboveground, dissolve underneath. In the subway every type of person is pressed together, in every arrangement, like jigsaw pieces: back-to-back, chest-to-chest, and sometimes, yes, sometimes, not by choice, but by the demand, the decree, of this city, ass-to-face. In *The Little Mermaid* there is a scene where the sea witch Ursula offers Ariel a trade: "If you give up your voice, you can be where the people are." It's a trade every New Yorker will recognize. Only instead of your voice, you must trade personal space, peace of mind, all your money, and sunlight.

But in return, you get to be where the people are. Just as one might dive among coral reefs to marvel at nature, one can come to New York City to marvel at humanity.

And marvel we will. But before we marvel, let us stare the beast in the eye: all of these people is not, entirely, a good thing. In New York the critics of humanity will find all the evidence they need to secure a conviction: every foul odor, every unspeakable secretion of the human body. Every excess, every pettiness, every crime. But if you can wade through all this and maintain any sort of curiosity toward our species—a spectacle awaits. I spent that first night studying the subway map, running my finger along the lines. I looked at all the stations, all the dots, and tried to guess what they held by their names: Jamaica, Crown Heights, Astoria, Coney Island. What wonders, what treasures, what people did these dots hold? And all of them connected, all held together, by these subway lines. Could it be? That all of it is here? The world in miniature? And all of it could be yours for only $89 a month—the price of an unlimited MetroCard. The density of the city creates a tantalizing prospect for an artist—especially a broke artist, without a car, who recently decided to make his name and living by photographing random people on the street—that you could somehow cover it all. With your paintbrush, your pencil, your camera: you could draw a circle around it. Put the city in a single frame, sign your name, and say: "This is New York."

I have tried—and I mean really tried—on three different occasions. The first attempt began that very first morning. The idea was this: I'd create a photographic census of the city. I'd collect portraits of ten thousand New Yorkers and plot the photos on a map. I even had a catchy title: *Humans of New York*. Armed with this plan, I went home to Chicago, packed my life into two suitcases, and came back to the city. Unfortunately there were certain things the subway map did not quite capture. It didn't quite capture those long, empty blocks in Queens. It did not capture that 51 percent of New Yorkers do not speak English at home. *No Inglés.* It also did not capture a certain reluctance, even among the English-speaking population of the city, to let a stranger take their photograph. After six months I was on the ropes. I was sleeping on a mattress on the floor. There were holes in my shoes. My camera had been dropped so many times that the zoom lens no longer zoomed. I was adrift in the middle of the ocean, rowing my little boat, taking on water, when the tsunami of social media lifted me up and set me down in lands unimaginable.

The second attempt came five years later. By that time my wildest dreams had come true: I was a working photographer, a best-selling author. My process had also evolved. I was no longer just taking photographs; I was interviewing people about their lives. I even had a new tagline: "New York City, one story at a time." More than a tagline, it was a mantra. No need for grand schemes, no need for a photographic census; *just one story at a time.* But the demon got hold of me again. I thought that if I could *film* these interviews, I could *really* capture the city. I hired a talented young cinematographer named Michael Crommett. I must mention him by name because of what we went through: hundreds of days of filming, thousands of miles walked, connective tissues

eroded, injuries accrued that will no doubt make themselves known in middle age. After three years we'd collected twelve hundred interviews from all over the city. But at the end of the road, an unsolvable puzzle: How possibly to create a single piece of work from all this? I tried arranging a few of my favorite interviews into a thirty-minute pilot episode. But this attempt ended in the most ignoble, unartistic way: with me complaining to my lawyer that a certain streaming platform wasn't offering enough money. "Don't they understand?" I asked. "We covered the entire city!" An honest man, my lawyer: "That may be," he said. "But you can't see it on the screen."

For the next several years I drifted away from the city: to other projects, in other locales. But then came the pandemic. *Ursula herself.* For months the streets of New York were nearly emptied of people. And how obvious it became: that New York was, in fact, the people. All the rest of it—the trillion dollars' worth of infrastructure, those marvels of modern engineering: the towers, the bridges, the tunnels, the 665 miles of subway track, the beautifully manicured parks, the Michelin-starred restaurants, the world-famous museums, the seven-story department stores, the concert halls, the trading floors, the cathedrals, the libraries, the red carpets, the art galleries—without the people, they were nothing. The entire city, an abandoned theater. Gone dark, gone silent, except for every few minutes, the scream of a siren.

"New York is gone," they said. Gone forever. And if it does wake from this slumber, it will wake to a world that no longer needs it. Globalization, remote work, social media—there is no longer a need. No longer a need for this place! But the city did come back, one person at a time, one story at a time. Slowly, hesitantly, wearing masks at first; but it came back. "It's not the same," they said. And perhaps it was those words—those damned words, that have greeted every generation of new arrivals to this city—that spurred me to try one more time: to capture the city, to see if it was still the same. But also, I must admit: I was selfish. I wanted to see if *I* was still the same. I'd reached the other side of forty, three kids. After two years of isolation my social skills had atrophied. Eye contact had become strangely uncomfortable. Small talk, an impossible riddle. But I did possess a few new advantages. By that time I really *had* photographed ten thousand people. Those dots on the subway map were no longer mysteries to me. I knew where the people would be: what places, what times. I knew that even in the deepest canyons of this city, in its darkest shadows: beneath scaffolds, beneath bridges, beneath the steel beams of elevated railroad tracks—there can be found pools of light, reflected off the tallest skyscrapers, that make for the most beautiful portraits.

So I set out on one final attempt. And it is this attempt that you are now holding in your hands. Let's get this out of the way: I have fallen short once again. Even with my bag of tricks, even with these subdued expectations—it was only last week, on a humid, ninety-five-degree July day, that I ended up broken down on a sidewalk in Flushing, Queens. It was there, sitting across from a Catholic church advertising Sunday services in Cantonese, Mandarin, and Korean, watching a Spanish speaker haggle with a Tibetan over the price of a live crab that just fell onto the sidewalk—that it all became

too much. I was overwhelmed by it: the realization that there was more of New York on this stretch of sidewalk than could be crammed into a book of any size. This city cannot be captured. Not with a pen, not with a paintbrush, not with poetry, and not with a camera. It is a mirage, a fruit that withers on the vine as soon as you reach for it. There is no frame large enough. You can never say: "This is New York." There will always be one more thing, one more person, one more story that absolutely must be included. *"This too, is New York."* After fifteen years of work, thousands of miles walked, thousands of portraits taken, thousands of interviews conducted, I was not much closer to capturing this city than I had been on the day I first arrived. I couldn't summon the energy to work, not that day. I had to go home and lie down. And since I happened to be in Flushing, there was only one way to get home.

It's a beautiful train, the seven. Even in a city of beautiful trains. It's an elevated train, meaning it is filled with light, and it provides each rider, no matter their station in life, the sought-after privilege of looking down on the city from above. As it pulls out of Flushing station, from the left side of the train can be seen a giant steel globe built to commemorate the 1964 World's Fair. Quite an event, no doubt. What must that have been like? To see the entire world in New York? Next the train turns down Roosevelt Avenue, which it will follow for the next several miles. As it crosses into Corona, Queens, the city grows dense; not much can be seen from the windows except for the signage on the storefronts. Posters of the Virgin Mary, posters of soccer stars, posters advertising massive mariachi bands—fifty men deep, their faces glowing with the celebrity of unknown lands. The cuisine alone tells a story: Comida Mexicana, Comida Guatemalteca, Comida Colombiana. Tortas, Cemitas, Picaditas, Tostadas, Chalupas, Gorditas, Arepas. At every stop, the train takes on the exact sort of people who might favor this cuisine.

Around Ninety-Second Street the train crosses into Jackson Heights. One hundred sixty languages spoken in one neighborhood alone. And here the menu really gets wild. In a single two-block stretch, signs for Gorkhali Nepalese, Hornado Ecuatoriano, Al Tawakkul Halal Meat, Thai Son Vietnamese, Riko Peruvian, Onigiri Riceballs, and Dunkin' Donuts. At the Chef CBTM Bistro, Chef CBTM—whoever that may be—advertises a cuisine described as "Indo-Chinese Malaysian Thai Fusion." After Jackson Heights comes the Filipino grills of Woodside, the Korean barbeques of Sunnyside. And again, joining at every stop, the people you'd expect to frequent these establishments. After Bliss Street station the track turns down Queens Boulevard, and here the city opens up again. The entire Manhattan skyline can be seen from the left side of the train, but not for long. As it crosses into Long Island City, the train dips underground for its voyage beneath the East River, and the view disappears. But it is here, if you turn around in your seat, you will be treated to another view: every type of person, a tongue for every taste. All of New York seems to be represented on this train—almost, but not quite. Because the next stop is Grand Central. And it is here, at this storied crossroads, that the seven will take on passengers from the six: the Lexington Avenue line.

It is a meeting of two mighty rivers. Every day the Lexington Avenue line carries seven hundred thousand human souls: on a single line, more commuters than the cities of Chicago and Boston combined. On its journey from the Bronx to Brooklyn it cuts straight through the heart of Manhattan, intersecting every other line along the way, pulling passengers from every corner of the city, every dot. Jamaica: where every year the football field of Jamaica High School becomes a patchwork quilt of silken colors, as Muslims from thirty-six different countries greet the end of Ramadan by kneeling to the rising sun. Coney Island: where furry men in tiny Speedos dispense the sort of hard-earned wisdom that can only come from a childhood spent in the Soviet Union. Astoria: where you can view the Greek Independence Day celebrations from your curbside table at an Egyptian hookah lounge. Crown Heights: where if you stand on a particular corner, on a certain day in December, you can watch hundreds of Hasidic rabbis dressed in black posing for a group portrait. If you stand on that exact same corner, eight months later, facing the opposite direction, you can watch the steel drums, brightly colored feathers, and unapologetic sexuality of the Caribbean Islands marching by in the West Indian Day Parade.

And it is here, beneath Grand Central, where the seven takes on passengers from the six, in this swirl, in this mix, that if you look up from your phone, you might be struck by it: that this train could quite possibly contain the entire city. New York in miniature. An ambassador from every dot on the subway map. And if that is true—then could it be? Could this be the spot? The one spot in the universe, that if you were to draw infinite lines, in infinite directions, extending for eternity, you would never intersect a point with more of humanity, in a smaller place, than this train, at this moment? Of course, I am but one man, with one view, from one seat. I have no way of knowing exactly who was on this train. But I can imagine. I can fill this train with the people I have met over the past fifteen years on the streets of New York City. And if you will allow me this—to switch for a moment, to a parallel track, outside of time and space—then please, stand clear of the closing doors.

The R188 subway train can hold fifteen hundred people when filled to capacity. And this train, for sure, is filled to capacity. With this many New Yorkers crammed into a train, the first thing you notice are the differences. There is every kind of race and ethnicity. Many people on this train are a mix of different races, often several. Even within races there are endless divisions. On car number three there is a woman with multicolored threaded braids who is half Alur, half Lugbara, two tribes that settled along the West Nile in Uganda. Across from her sits a seven-year-old boy wearing a bright yellow Minion hat who, according to his father, might be the first native-born New Yorker of the Hmong ethnicity: an indigenous group from East Asia classified as a subgroup of the Miao people. These differences in ethnicity, however minute, have been the source of discrimination, caste systems, wars, genocides. The crimes of our ancestors make for dark reading, horror-story stuff. And it is by race alone that we have

divided ourselves for much of human history. So I guess it can be seen as an improvement, an evolution of sorts, that in our present day we've reached enough of a racial accord to discover so many new ways of dividing ourselves.

On this train there are people of every political persuasion: Democrats, Republicans, Libertarians, Socialists. There is a woman on car six with fire engine–red lipstick who describes herself as a contemporary anarchist surrealist situationist. There are members of every economic class: working class, middle class, upper class, the 1 percent. Genders, sexualities, even age groups: the Greatest Generation, Gen X, Gen Y, Gen Z. Yes, even the time of your birth will automatically opt you into a tribe. Surely there must be some fire that all of us can sit around. Something we can all agree on: eternal truths, answers to the deeper questions. "Where did we come from?" "Where are we going?" But no, on this train God is called every type of name, wears every type of mask. And each religion splits itself into endless branches. Even the mildest, most indivisible of creeds—"God is Love"—splinters and hardens into the most intractable positions. No ground is ever ceded. Tempers flare, voices are raised: God is Love, or else. *Or else!* But surely we can lower the temperature if only we could have a conversation. But how, exactly? On this train alone eighty-four languages are spoken. Nearly every sound capable of being made by the human tongue. Within each language, different dialects. Sometimes they can be translated, but not always. There are words, like the Mandarin word 德—a worldview that involves actions (彳) guided by the heart (心) and seen clearly with wisdom (目)—that cannot be expressed in a single English word.

Complicating things further, the people on this train do not divide themselves into neat categories. All of these ethnicities, cultures, and beliefs overlap and combine into the most unique combinations. Each person is an island unto themselves. Fifteen hundred islands on this train. And among these, what curious islands. There is a white man with blue hair that calls himself Black Jesus. There is a black man named Tomato wearing a sombrero. There is a woman in full burqa, with nothing visible except for her dark brown eyes and her $1,600 Louis Vuitton handbag. There is a Colombian man who makes his living, one dollar at a time, by salsa dancing with a life-sized skeleton named after his ex-wife. There is a fentanyl dealer taking his five-year-old son to the playground. There is a young blond painter, in a blue silk nightie, who wants nothing more than to bring peace to the world, while living in a lakeside Italian villa and driving a green Porsche. And then there is Disco Danny, who has an unquenchable love of dancing, a modest following on YouTube, and a metal plate in his head from the time he fell three stories in a stolen car he drove off the side of the Brooklyn-Queens Expressway.

Curious islands, pressed together in every arrangement, sometimes only three inches apart. But what oceans between them! On car number three there is a man who grew up in a coal-mining town in northern China, but his family was so poor, they could not afford coal. He is three inches away from a widowed financial manager whose greatest difficulty is finding someone who loves her for her, and not her $18 million

beachfront property. On car number seven there is a young man with red hair who attended a $60,000-a-year private school where he called all his teachers by their first names. He is three inches away from a large black man who used to be named Walter, back when he served as the chair of African Americans for Mayor Bloomberg. Now he wears a shirt that says "Fuck the Mayor," keeps a stockpile of ammunition, and calls himself Hawk. On car number six there is an ultra-Orthodox Jewish man who walks a very narrow path through life: "There is Torah," he says. "Only Torah." Not only is it hard to believe he is three inches away, it is hard to believe that he is in the same city, the same world, even, as Rex: a 250-pound body builder and former male stripper who once, over a five-year period, utilized an ancient Daoist lovemaking technique to bring hundreds of women to orgasm without ejaculating a single time.

Differences, nothing but differences. In a way it is disheartening, all of this diversity. There seems to be no common thread. Nothing to unite around. No glue to hold it all together. Just an endlessly branching tree of humanity: *this too, this too, this too*. Each difference a source of disagreement. Endless kindling to keep the fires of this world burning. Across the globe there are wars being fought over smaller differences than can be found on this train. But at least there they have borders to separate them, walls! On this train, there is nothing. Three inches. With so much combustible material in so small a place, there seems to be no way this city can work. Could all these people peacefully coexist, even for the time it takes to get to the next station? Jessica, a spoken word poet with a completely shaved head, isn't taking any chances. She is carrying a meat cleaver in her purse, which she originally intended to be an art piece, back when she was living as a male attorney. But these days she carries it for the sake of cleaving people. No, there is no way this can work. There are way too many people in here. Not enough light. Not enough space. Not enough oxygen. But it's too late to get off now: *Stand clear of the closing doors!*

As the train pulls out of Grand Central, there is silence. It is a silence shared on every rush hour train in this city. Not exactly what you'd expect with so many people packed in so small a place. But silence is indeed what you'll find. It is the silence of a strange truce. The Truce of New York. A mutual agreement: "No matter our differences, no matter our disagreements, I will not become part of your story, I will not become part of your day." Let us not be naive, it is partly enforced; the NYPD is a standing army in itself. There is also an element of self-interest to the truce. In New York the basic maintenance of your life will depend on the cooperation, if not the goodwill, of people who are nothing like you. Your grocer is Korean. Your barber is Turkish. The driver of this train is Mohammed, an immigrant from Yemen. Even if you are not quite convinced of the brotherhood of man, it would be in your self-interest to conceal this fact. But there is something more here. If self-interest, or fear of punishment, were the reason for this truce—this train would not be so silent, so peaceful.

There is a tolerance in this city—a greater tolerance than perhaps anywhere else

in the world. This is not to say that the average New Yorker is more magnanimous, or more noble than other people. No, not at all. But even the most intolerant of New Yorkers gets a little bump, an extra allotment of tolerance coming from a forced proximity to so many different types of people. After living a few years in this city, you will have had so many stereotypes overturned. The moment you think someone is this, they will surprise you: *this, too*. You will have encountered so many assholes and so many saints of every color, class, and creed. Not only this, but depending on the weather, the lunar cycle, the train schedule, your blood sugar levels, and the hours of sleep you got last night, you will have *been* that saint, and you will have *been* that asshole, in the lives of so many other people, that when you meet someone new, no matter how different they are from you, you might have at the least a sneaking suspicion that, had you been born in their shoes, and walked their path, you might be a lot like them. That if you had been born on the small island of Leguaan, in the middle of the Essequibo River, near the northern coast of Guyana, to a mother who told you on the day you left for America to hold on to God with all your body, all your soul—then you, too, might be shouting the Gospel. As the woman is currently doing in car number two, three inches away from a man in a Spider-Man suit.

Yes, beneath this truce there seems at least to be a grudging acceptance, that no matter where we came from, or where we are going, we are now on this train together. And there are certain stops we must all make. On car number two there is a Bengali girl in a black hijab, who is figuring out how to be thirteen years old. "It's a lot," she says. As it was, a lot. For everyone on this train. There is also a sense, as we move along the tracks, that the journey seems to *feel* roughly the same for everyone. Not everything is felt in equal doses, or at the same time. But there are certain emotions that cross every racial, economic, and ideological line. Tucked in the far corner of car number six are two Chinese American teenagers who, after swapping notes in calculus class for several months, and playing League of Legends for several nights, are now sharing their first kiss, on this train. The dreamy looks on their faces are remarkably similar to that of the fifty-year-old woman on car number three who, after sixteen years of marriage, and a brutal divorce, just went on her first date with an old acquaintance from college. She wore a sundress. He brought her flowers. And she remembered, for the first time in sixteen years, what it feels like to be courted. What a feeling.

There is joy on this train. You can catch glimpses of it, if you look closely. But the joy in this city is mostly aboveground: among family, among friends. The joy of sharing the same meal, watching the same show, listening to the same song. The joy of milestones reached, and job interviews that were fucking nailed. The joy of first discoveries; always a first discovery in this city. And then there is joy for no reason at all. Otherwise known, as fun. Fun is the most underrepresented, unmemorialized of emotions. You can spend all day at the Metropolitan Museum of Art without seeing many works depicting fun. No German philosopher has attempted to explain the peculiar comedy of the man in car number six with the smug face, silk-threaded suit, and $300 noise-canceling head-

phones who has no idea that eight people just heard him fart. But fun is a huge part of this city. It can be found on parade floats, in night clubs, at block parties and intramural softball games. Hanging off the back of sanitation trucks. Shit-talking, a lot of shit-talking. Inside jokes, recycled over decades, funny to only two people in the world, but to those two people—absolutely hilarious. New York City is fun, it must be said. One of the most fun places on Earth. Because you might not know it, in the silence of this train.

In this silence, everyone alone among strangers, not having to be anything, for anyone, you can feel it: there is a heaviness in the air. Everyone is carrying some sort of weight. For most, the weight of loneliness. It is not universal. No, nothing on this train is universal. But nearly everyone on this train has known the pain of the phone that doesn't ring, doesn't light up, doesn't buzz. And then there are the deeply lonely. Nowhere in the country are more people sitting alone in rooms than in New York. On car number two there is a man who, every month, has a three-minute conversation with the checkout woman at his local grocer. And *that* is the person he speaks to most. The weight of grief. The more we love, the more it hurts. The weight of world events, those storms swirling above our heads that, even if you walk your own tightrope, measure each step, can still sweep everything away. The weight of addiction, how we trade our peace for every pleasure: sex, sugar, alcohol, gambling, amphetamines, opioids, and everyone, everyone staring at their phones. The weight of shame. The streets of New York are piled with garbage bags filled with hidden habits: who we were yesterday, who we were last night. "The pain comes from doing the wrong thing," says the man with the bloodshot eyes. "And I'm doing the wrong thing to ease the pain." The weight of trauma. Trauma that sinks into your nerves. Deep wounds from battles fought, monsters fought. And then there are traumas we cannot know, cannot remember. Great, unmet needs from before memory. The weight of bad luck. The weight of being born in the wrong place at the wrong time, to the wrong person.

For some on this train, it is a battle just to live. You can see it, in the black and brown faces especially: the tired eyes, the red eyes, the haunted eyes; minds wrestling with impossible math, impossible puzzles. There isn't enough money: With the sick kids, the doctors' appointments, the parking tickets, the price of food, the landlord knocking, knocking, knocking—it's never enough. But more importantly, more heartbreakingly, there is not enough time. You can see that too: people sleeping in their seats, sleeping on their feet, sleeping on their neighbor. It can take so much time to survive, there is not enough time left for life. No time for friends. No time for spouses. No time for children. On car number four there is a woman with an empty stroller. Just off from her full-time job, she's on the way to pick up her special needs child from school. It might rain today. And she's hoping they'll get caught in the rain, so that together, if only for ten minutes, they can have a little fun. Some on this train cannot stop working at all. They cannot stop, or else. On car number one there is a Venezuelan man in grease-stained coveralls; if he does not stop working, he is able to send $150 a month back home to his wife and young children. He's walked a hard road: last year he spent

five months in a homeless shelter. But the hardest battle, the greatest weight? Returning home each night to an empty apartment. "*La soledad, la soledad.*" But he'd rather shoulder this loneliness than watch his five-year-old daughter starve.

No, it is not easy for anyone, on this train, in this city. It can become too much. It did—become too much—at some time, in some way, for too many people on this train. On car number four a teenage girl is holding back tears. "I did not ask to be born," she says. "I did not. I did not." And it would become too much for many more, if everyone were fighting alone, on their islands. But there are mothers on this train. On car number six there is a woman holding a bundle of pink balloons who, despite her crippling depression, despite her anxiety, despite being able to do very little for herself, is on her way to J. Hood Wright Park to throw her daughter Journey a fifth birthday party. There are fathers and sons and daughters and brothers and sisters on this train. There are husbands and wives and partners. There are aunts and uncles and cousins and best friends. On car number six there is a bartender who has lived in seven different apartments in the last seven years. "But as long as my dog is OK," he says. "I'm good." Pressed against the wall on car number one is a young woman in an Amazon delivery uniform. On her phone she keeps a picture of her best friend Brianique, who took her own life four years ago. "I'm living for her," she explains. "I know she sees me. She sees me doing everything that I can."

There is love in this city. For most it is waiting at home. But if not at home, then a phone call away, a block away, two doors down, three stops south. There is love at bus stops, in barber shops, on bombed-out baseball fields in the Bronx. In hospitals, in offices, in coffeeshops, in classrooms—so much love in classrooms: unsung, unpaid, long after the bell has rung. It's in the churches, the mosques, the temples, the synagogues, the Atheist Club meeting in room 4b of the public library. There is love, often anonymous, in circles of people all over this city: sharing grief, shedding shame, with bloodshot eyes and trembling hands. There is even love in the darkest places: beneath bridges, beneath railway tracks, in jail cells, in crack houses. Wherever there are people, there is love. And nowhere are there more people, packed in a smaller place, than New York City. There is everything else here, God knows. But alongside it, among it, between it, despite it, behind it, there is love. Love, too. Which means, of course, there is love on this train. There is even, on this train, a man named Love Train. He walks eight miles a day through the city, pushing a trolley stacked with battery-operated speakers, playing music carefully chosen to match the demographics of each neighborhood.

Less than sixty seconds after leaving Grand Central, the train pulls into the Bryant Park station. It arrives in silence; the truce has held. Some new passengers get on, but even more get off. There is still a swirl, still a mix. But the moment has passed. This train will never again reach the same mass of people. As it moves along the line, it will slowly empty, everyone going about their lives, never to be together again. This city is so large you can disappear in it. But also, it would not be possible to meet again. For this was a train of ghosts. People I met on some sidewalk long ago. It was a train of

past chapters, former selves. Everyone long since moved on: to new discoveries, new friends, new loves, new battles, new wounds, new wisdom. Sometimes moving forward, sometimes sliding back. But never the same. No, never the same. Everyone changing, shifting, like the city itself.

The end of the line is Thirty-Fourth Street, Hudson Yards. This is not my stop. But it is where I sometimes get off so that I can walk home along the High Line. The High Line is one-and-a-half-mile greenway running through the heart of the city—a "park in the sky," built on top of an old, elevated railroad track. Twenty years ago the railroad track was slated for destruction. But local residents had a better idea: they formed an organization—Friends of the High Line. Petitions were signed, millions of dollars were raised. Today the High Line is one of the most innovative public spaces in the world—all thanks to its friends. These friends of New York can be found everywhere: sipping champagne at ritzy galas, picking up trash along the Hudson, planting lavender bushes in community gardens on the Lower East Side. All of them linked by a common debt, some shared sense of reciprocity: To this place—to these people—who have given to me, I will now give.

One of the High Line's exits is near my apartment: a metal stairway leading down to a sidewalk on Twenty-Third Street, just west of Tenth Avenue. On the underside of that staircase there is a large number seven, painted in bright red paint. For the thousands of pedestrians that walk by every day, it has no meaning. But for passing ambulances it signals the location of FDNY Emergency Medical Station Number Seven, which sits just across the street. Eighty ambulances are dispatched from this station to emergencies across the city, which means a steady dose of the city's unofficial soundtrack: the scream of sirens. It's a horrible sound by design, the siren. But it serves as a shrill, insistent reminder of something foundational to this city. Something so commonplace, so taken for granted, that it has almost become invisible. In this city, no matter who you are, no matter how poor, stepped-on, downtrodden, vulnerable; no matter your economic contribution, your criminal record, your social standing; such a value is placed on your life, that if it is ever in danger, all eight million citizens have been deputized with the power to summon a machine—a machine designed solely for the purpose of saving lives—to deliver you to the nearest hospital.

At the bottom of the stairway, there is often a man in a wheelchair who begs for change. Ronald Robertson is his name—his father's name. Though he has never liked it, so he goes by Ronnie. Ronnie is a Vietnam War veteran who worked at a local grocery store for twenty years before losing both his legs to medical complications. Now he survives off the kindness of strangers. Half the money he collects from panhandling, he gives to his three daughters who live in a nearby apartment. Ronnie can stay with them whenever he chooses. But since he does not get along with the mother, he prefers to spend his nights beneath whatever scaffolding he can find in their area. But in the early morning hours of July 11, 2024, there was no scaffolding to be found. And it was raining that night. So at 2:55 A.M. Ronnie made the decision to sleep where he had

never slept before: beneath the High Line. As he situated himself beneath the staircase and prepared to fall asleep, he heard a noise: not quite a cry, more like something trying to cry.

At that very moment a twenty-year-old Dominican Mexican night doorman named Kelvin Suarez was returning from his lunch break with a chicken cutlet panini in his hand which, for various reasons, would never be eaten. Kelvin was new to the job. A full-time mathematics student at Fordham University, he was only able to work one night a week. This night. As he neared the entrance of the HL23 apartment building where he works, he noticed a man in a wheelchair approaching what appeared to be a small doll lying on the sidewalk. Kelvin continued into the lobby, but before unwrapping his panini, something told him to walk back outside for a second look. And it was then, Kelvin would later explain, that the world began to seem very unreal. There, beneath a bright white fluorescent light, was a newborn child. Kelvin had never seen a newborn child before. Not in a hospital. And certainly not on a wet sidewalk, at 3 A.M., next to a pool of blood and a legless man of unknown relation. For four long seconds these two men looked at each other. They looked up, at the ledge of the High Line. They looked back down, at the baby. And together they reached the only conclusion that, however unlikely, seemed to best explain the unexplainable scene in front of them: this baby had fallen from the sky.

At that very moment an ambulance was pulling up to the curb in front of EMS Station Seven. Behind the wheel was Patrick Fiemer, a twenty-four-year-old former rugby player from Breezy Point, Queens. Asleep in the passenger seat next to him was Mia Chin, a twenty-six-year-old Chinese Ecuadorian rookie EMT who was completing the second of back-to-back eighteen-hour shifts. Mia, it must be said, was having a tough week. Seven days earlier, on the night of July Fourth, right before the fireworks, an addiction counselor had driven his Ford F-150 into a group of eleven people while driving drunk. Four people died. One of them, a woman, was in Mia's care. Mia would later discover the woman's red-threaded bracelet while cleaning out the back of her ambulance. No, it had not been an easy week. And on this night Mia was very much looking forward to getting home. As she gathered her belongings into her book bag, there was a knock on the driver's-side door. Patrick rolled down the window to find a young man in a doorman's uniform who, in a strangely calm voice, delivered a cryptic message: "There is a baby on the floor."

At that very moment a newborn child was lying on a sidewalk in New York City. Without warmth, without touch, his life slowly draining from his body. Could there be a deeper loneliness? After forty minutes, an eternity, he must have sensed that no help was coming. That indeed, he was the only living thing in this world. When suddenly there appeared four strange shadows above him. What exactly the child thought of those shadows: what he believed them to be, what sort of connection he felt, cannot be known. But as with seemingly everything on the streets of a modern city, this moment of contact was captured on surveillance video. And you can clearly see it. For whatever

reason, after lying motionless for several minutes, just before Mia bends down to scoop him off the pavement—the child lifts his arm, and he waves his hand.

Minutes later an ambulance pulled out of EMS Station Seven, Patrick behind the wheel. And this child was driven through the city, to begin his own journey, to face who knows what battles. Because there will be battles, no doubt. This child will begin his life with his own share of weights. But on this night, during that trip across town to Bellevue Hospital, he experienced something miraculous. With no name, no tribe, no identity except for being a citizen of this city, this child was given a privilege reserved for emperors, kings, gods. During that five-minute drive he crossed almost every avenue in Manhattan: ten full avenues. But not once did he stop. Not once did he slow down. In response to the scream of a siren, this city, this beautiful city, set aside its laws, bent, bowed, ever so slightly, to make way for this newest, this most vulnerable, this most innocent of New Yorkers. Who now, wrapped in a blanket, in the arms of a stranger, was still not quite sure about this place. But at the very least, he was now quite sure, there was someone else in this world. ■

"She was in traumatic arrest when I arrived on the scene. Later when I was cleaning out the back of the ambulance, I found her red-threaded bracelet. It just reminded me that she was a person. She was someone's daughter, sister. She had a whole life. It had me thinking a lot about, you know—tragedy, and how it's random. The next week was tough. There were times when I would try to fall asleep, and I'd see the faces of people who were suffering. It's hard for me to talk about. And as a woman on this job, it can be hard to show emotion because I don't want people to think that I can't handle this, you know? Though I do believe those two things can coexist. You can be empathetic, and also be resilient. I never stopped loving this job, but I needed to know that someone was going to make it, that what we do matters. Of course it does. But when you've recently lost one of your patients, it can be hard to remember that. So that night, when I held that baby in my hands—it was like, 'Oh my God, he's alive.' It felt like a miracle. Because I really needed him to be alive."

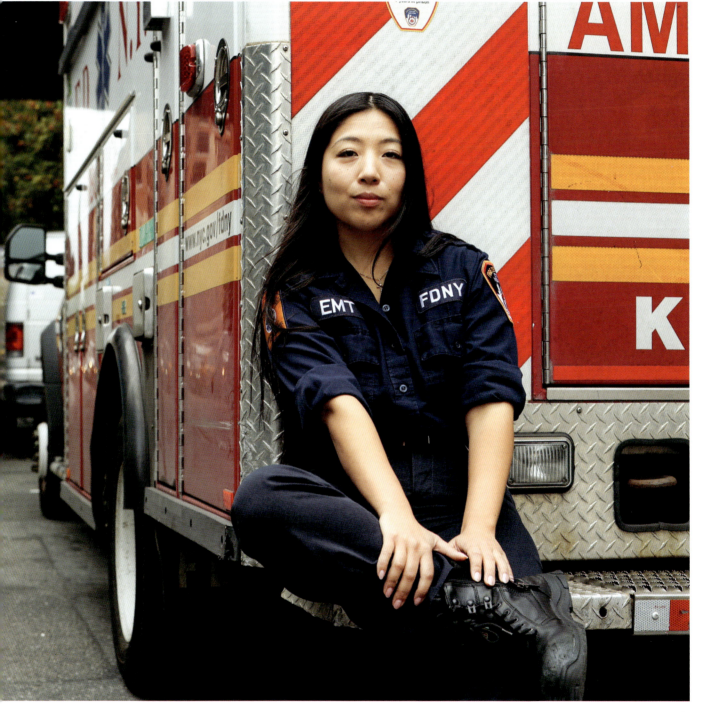

"I'm trying to figure out how to explain the world in a way that feels approachable, hopeful, and not overwhelming."

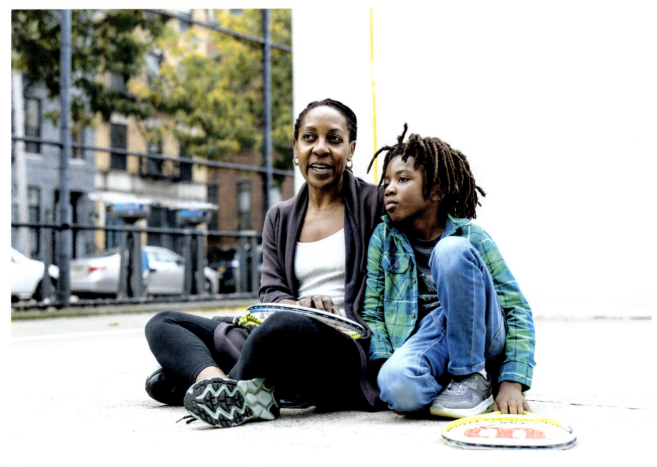

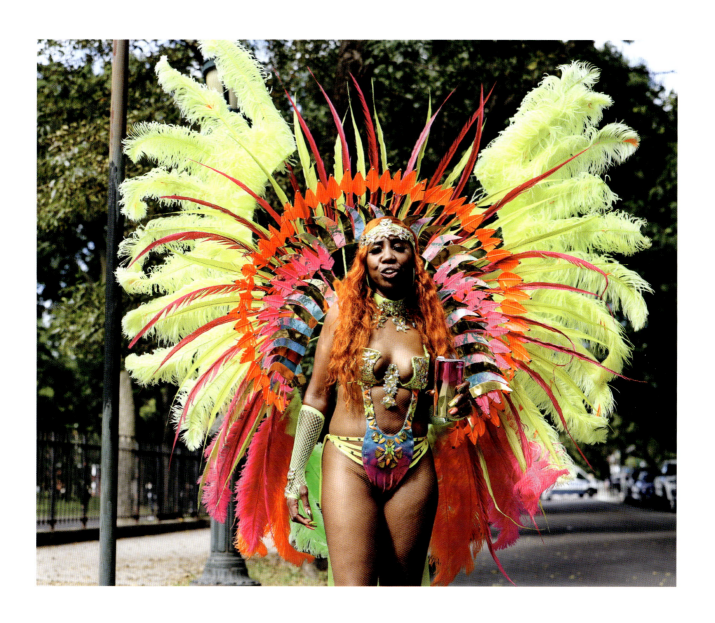

"Trinidad is a Carnival country. We have Africans, Indians, Chinese, Middle Eastern, Jewish; all of it together on that island. And everyone likes to have fun."

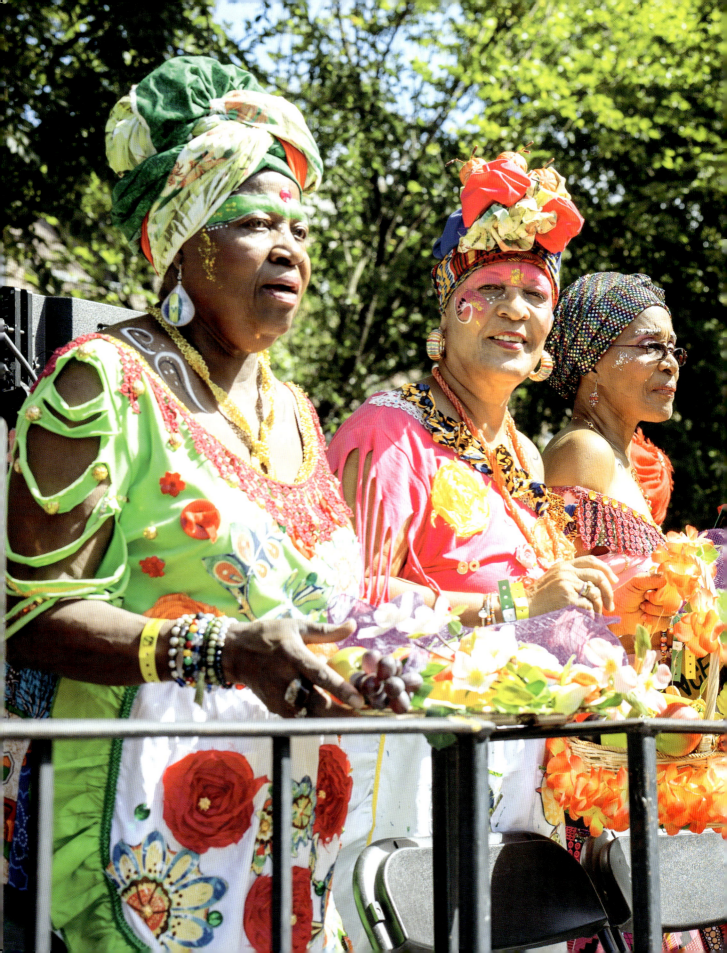

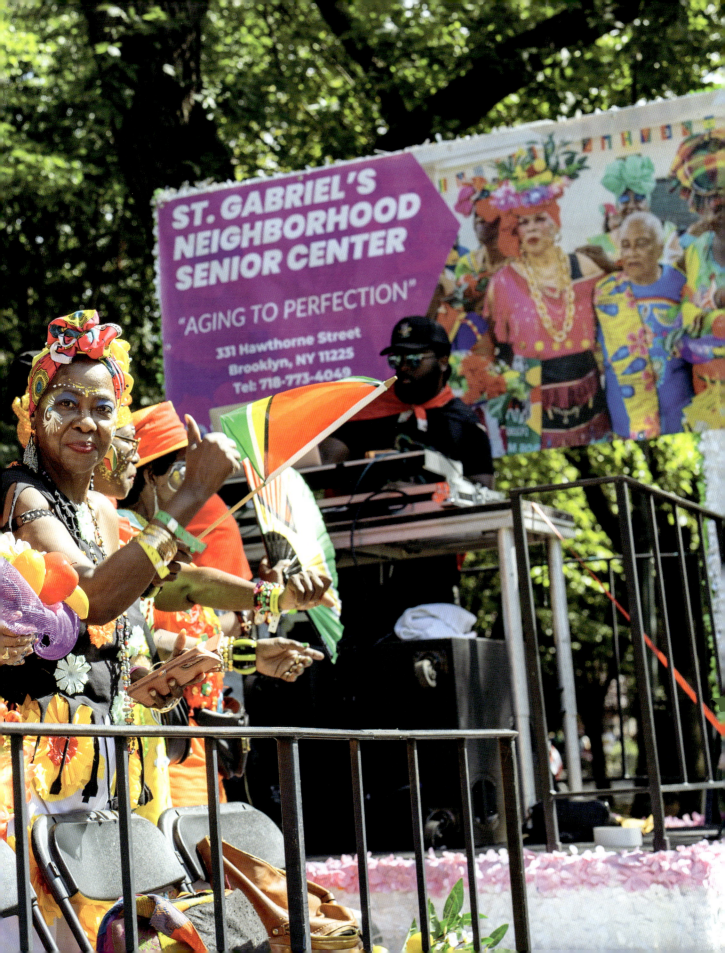

"You never think you'll get old, but you do. When you're young and an old person is walking slowly down the sidewalk you think: 'Oh my God, they're in my way.' Then you get older, and you're like: 'I better be careful, or they might fall.' Then at some point, it happens. You're like: 'Oh my God. I'm gonna fall.'"

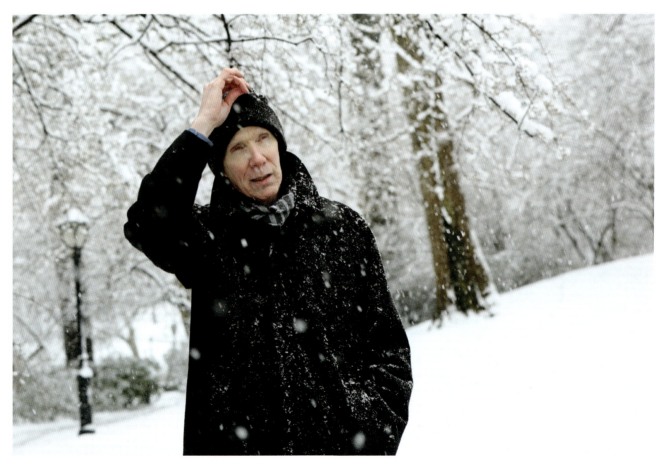

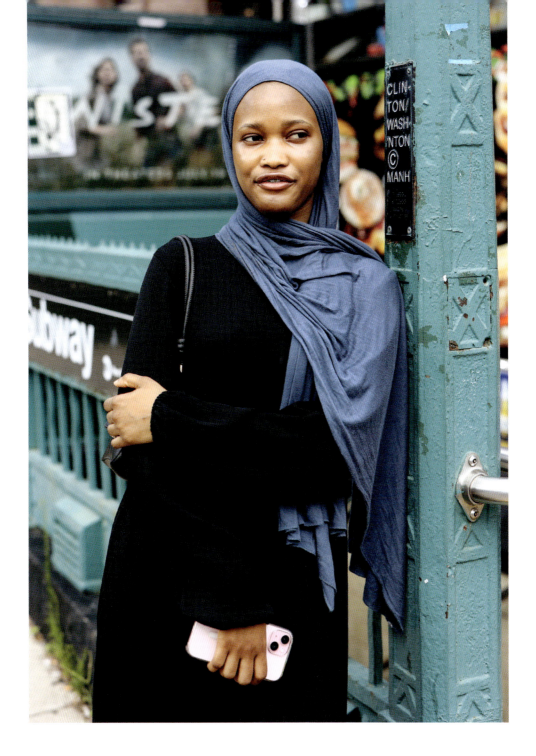

"My brother is still getting bullied to this day. This boy is in tenth grade. It's like: When are you going to stop letting people walk all over you, and stand up for yourself? That's the main difference between me and him. He doesn't want any problems. I'm like, bring the problem."

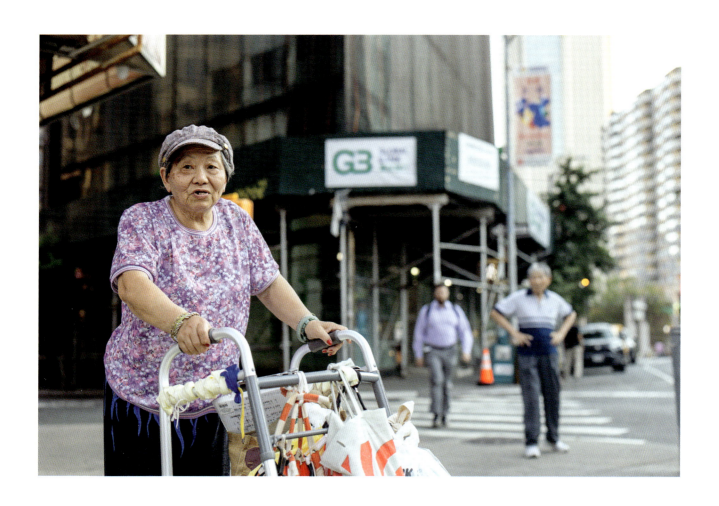

「你好的時候,他們會妒忌你。你不好的時候,他們會笑你。」

"When you're doing well, they're jealous. When you're doing bad, they laugh at you."

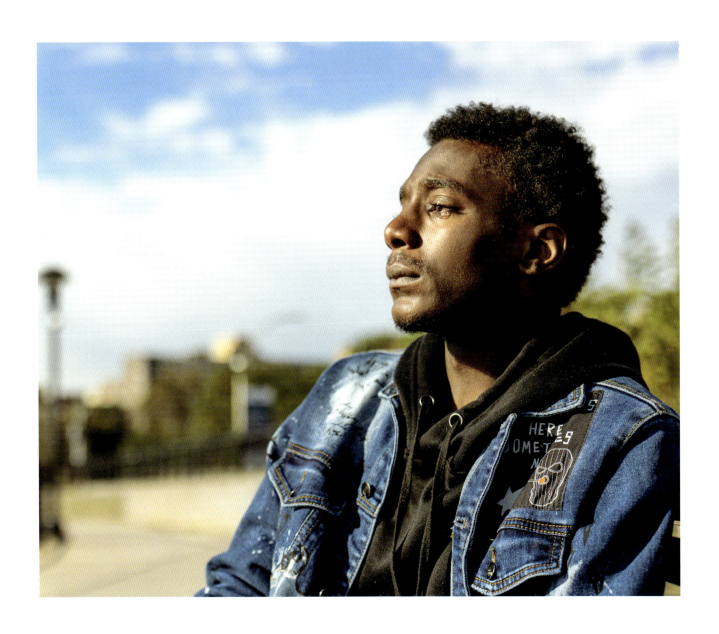

"I'm just so tired of being controlled."

"Thirteen. It's just, a lot."

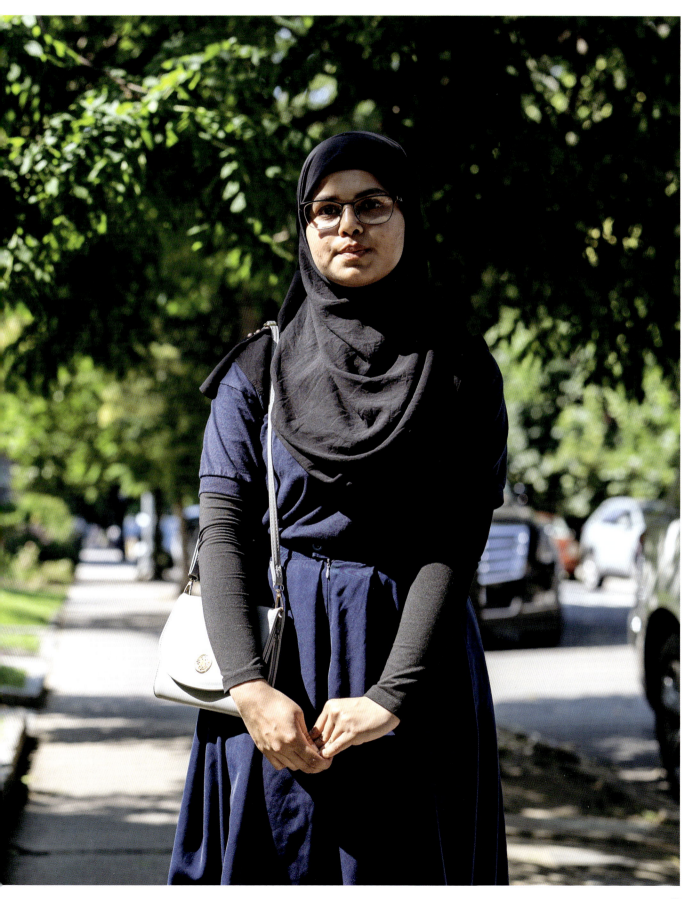

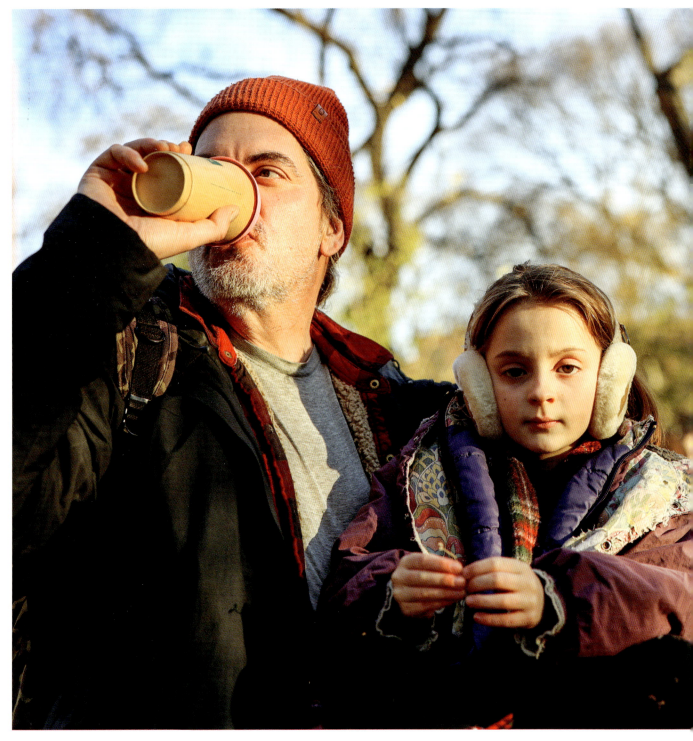

"They tell you not to be on phones, and they're on phones."

"Picture it, okay? New Orleans. Bourbon Street. I'm on vacation in college with my three best childhood friends. Zach is there with his parents. He's got his mom and dad with him. Somehow we all end up on the balcony of the same bar, we've got beads in our hands, we're yelling to see boobs. Well, I'm yelling to see boobs. That was just me. But Zach had a perfect mustache. He used to grow it much longer and curl it with wax. I will say that I'm normally not into that. Normally you've got to be six-two. But you know, I liked his energy. His whole family seemed nice. They weren't like normal New Orleans Vacation People. We ended up adding each other on Snapchat, that was the thing back then. Then we agreed to meet up the next day after he finished with his gator cruise and I was done going to the strip club. That night we walked along the river until the sun came up. I remember doing handstands, but mainly it was just a bunch of conversation. Then at the end we kissed. Just kissed, because I was leaving early the next morning. I thought that would be the end of it. I thought: 'I'm never going to see this kid again.' But two weeks later I'm taking his virginity in a Las Vegas hotel room. There was something going on with his stomach. Right after we finished he went to the bathroom and started throwing up. He was trying to keep it muffled, but I could hear it. I called my girlfriends and said: 'I don't think he likes me.' But it's been love ever since."

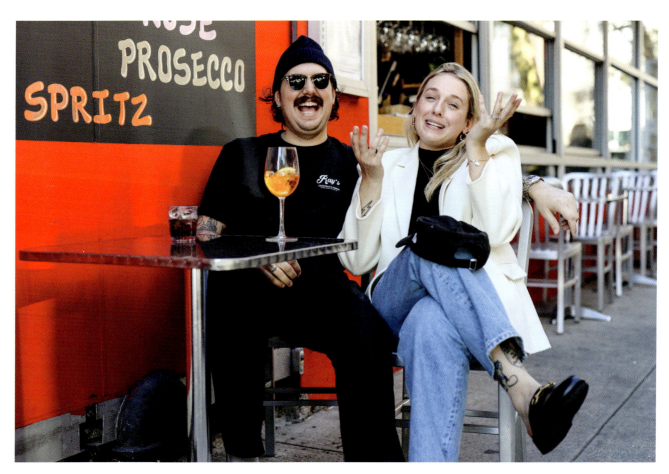

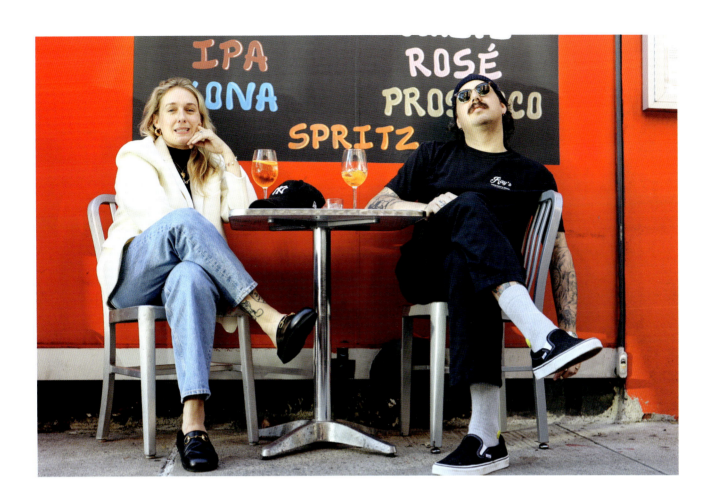

"We still need some dogs to die before we can have a kid. So right now Zach is a stay-at-home dog dad. I'm the one that works. I wear a lot of suits. I make the decisions, I make the reservations. Zach shows up properly dressed and excited for the night. But we can't both be me. I'm literally a power top. There can't be two power tops. Somebody's got to lay back and say: 'Keep doing that. That feels good.' Can his contentment sometimes spill over into laziness? We're working on that. But there's a lot I need to work on too. I've taught him how to do his taxes and he's teaching me to calm the fuck down."

"I told him not to ask. Love was never on my priority list. I'm rural South, HUD housing, food stamps, only child of a drug-addicted bipolar mother. Zach's family sits down together for dinner every night. I love that for him, but it makes us very different. So when we first started dating, I told him: do not ask me to marry you until I turn thirty. Fast forward 365 days later, and he asks. It was lovely. He was lovely, the ring was lovely, the idea was lovely, so I said yes. We eloped at the same hotel in Vegas where I took his virginity. And it's been seven years. We've been through it all: funerals, infidelities, addictions, sicknesses, miscarriage. A lot of hard shit. And it's been harder for Zach than me. If there's a good guy and a bad guy, I'm the bad guy. I'm the one that's tested the relationship. It's just a hard fucking city, you know? I found myself doing things that I said I would never do because I grew up with addicts. There were three separate times when he found me in a bathtub and had to take me to the ER. That's a hard thing to say, but it's a true thing. Anyone else would have left after the first time. But he stayed. He did more than stay. He showed up every day excited to be my husband. And it's not because he's scared to leave. It's because he believes in love, and he believes in me. I'm not saying I'd ever put him through those things again, but it's kind of beautiful that we've gone through it all, and we're still having a drink at our favorite restaurant on a beautiful Sunday. When you lay it out front to back, it's been a beautiful love. In a fucked-up, Sylvia Plath, head-in-the-oven kind of way."

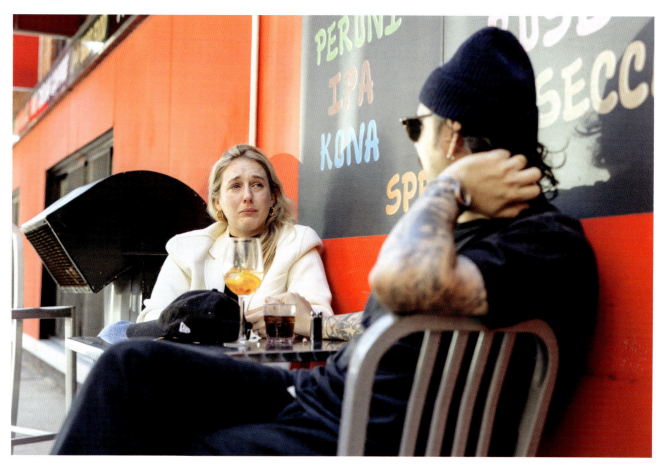

"One day I turned around in Spanish class, and it was like: that is not the Kevin that I know. Something was different. He got mad fine, I'm not gonna lie."

"There are so many days where I'm like: Is it all working out? Am I doing enough? Is this enough?"

"I'm not going to say I regret having my daughter. But the situation I was in, I would not have wanted to have her. She came to this life with me having nothing. We was in the street. I had nothing to give her. I didn't have no blanket. I didn't have somewhere she could call home. I didn't have somewhere she could feel warm, feel love, not be somewhere she don't know where she at. Hospital to hospital. Doctor to doctor. It was hard. It was hard to stay calm, because I didn't have no help. But I'm a calm mother now. I have a home now. For a long time we was in a shelter, but now I have a home. Because I didn't give up. I could be a crackhead, right now I could be a prostitute, but I didn't give up. Because I want to be somebody. I am somebody. I am somebody right now. I'm not gonna say that I've been a good mother to my daughter—and that gets to my soft part—because, you know, your kids come to this world for a blessing. They come here for love. And I put her through a lot of stuff. Stuff you don't put a kid through. And nobody, no child, should have been put through that."

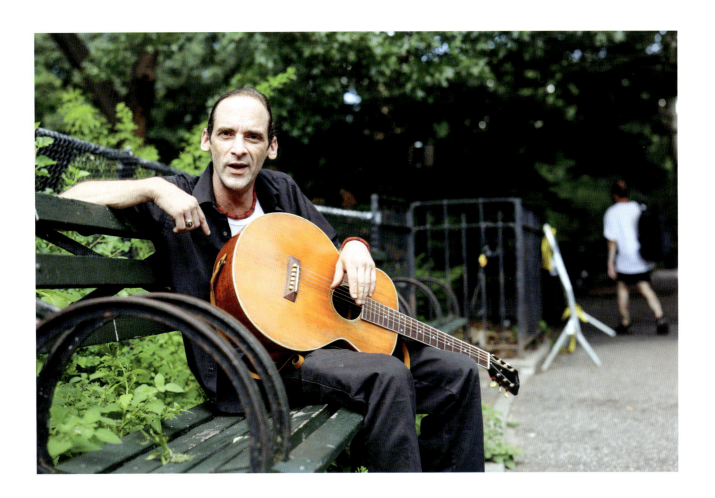

"I play old traditional songs; one-hundred-year-old-plus songs, American songs, black American songs. There are moments of joy. But I don't feel joyous. Not when I'm waking up every morning to a pack of lies that's been going on for hundreds of years, if not much more than that. The way these structures are built. The legacy of a country built on racism and sexism and the idea that some humans are only half a person. A country that has never treated the world, or its own citizens, through a lens of true equality. You can't make a living as a clerk these days. You can't even eat healthy food in a million little towns across the country. So many things are stifling people in their health, in their well-being, in the sense of value they get out of their work. These facts are so difficult, so upsetting, it can run people into depression. It can run people into panic."

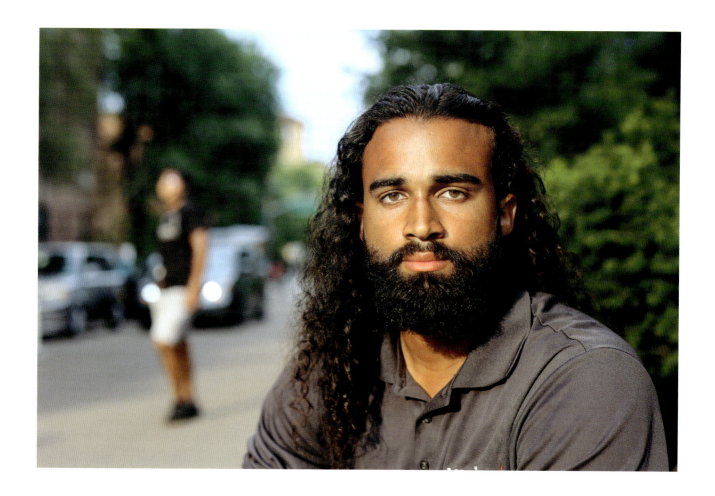

"I'm eighteen now. I've moved into a little place in the Bronx. I started this new job two months ago. I'm a sales rep: selling cable, phone, and internet door-to-door. But it's been rough. It's only commission. And for the past two or three weeks, I haven't done a single sale. I make a little money on the side with my photography business. But you know, things are getting hard. I'm not worried about myself. Because I've had to live on bare bones in the past. But my sister isn't doing well. She's rebelling, and not going to class. It was hard coming to this country. We had to go through the exact same situation. But she was younger than me, so you know, it's been way tougher for her. And then there's my dad; he's still back in the Dominican Republic. I had this dream of one day saving enough money to bring him here. So that we could all be together, and he could stay with my sister while I went to college. But he fell into a coma recently. It was just for two or three days, but when he did wake up, he'd lost a lot of motor functions. He couldn't speak. He couldn't take care of himself. Now that he's sick, it's gotten a bit scary. It's like a ticking clock. I'm just afraid of not being able to accomplish, like, stability. Enough stability for me to enjoy the time that I have with these people. Because even if I achieve these things—if it takes too long, there might not be anything left to enjoy."

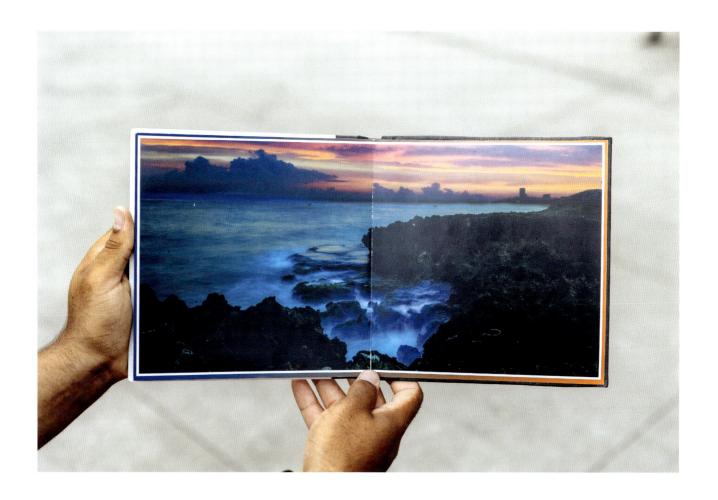

"I carry this portfolio around with me everywhere. It was a free sample from a printing company; they gave me a voucher to make a photo album. This picture is probably my favorite that I ever took. It was during COVID; that was probably the toughest time for me. I didn't even want to be alive. It just felt easier to give up, you know? To not even try to have a life, so I wouldn't have to go through the struggles of having a life. I ended up going back to DR for a year to live with my dad. I guess you could say it was healing. For one year I didn't have to worry about where I was going to sleep at night, or what I was going to eat. I had somebody else to keep me alive. My dad took my sister and I all over the island that year; we saw more places in DR than we'd ever seen. I'm not even sure how he did it. He didn't have the money; and every time we got back from a trip, it would be rougher around the house for a couple days. But he pulled whatever strings he could so that my sister and I could have a good time. He'd take us fishing. We didn't even have rods, we'd just use a bottle with fishing string attached. And it was on the way back from a fishing trip that I took this picture. We passed this spot, and I was just like: Can we stop? It's right by the place I used to live with my dad, when I was a kid. I'd seen it so many times, but I'd never noticed—I'd never seen it look like this. I've never seen my country look anything like this. It looked like one of those ethereal pictures: a place that you could never actually go."

"He doesn't have no sibling either."

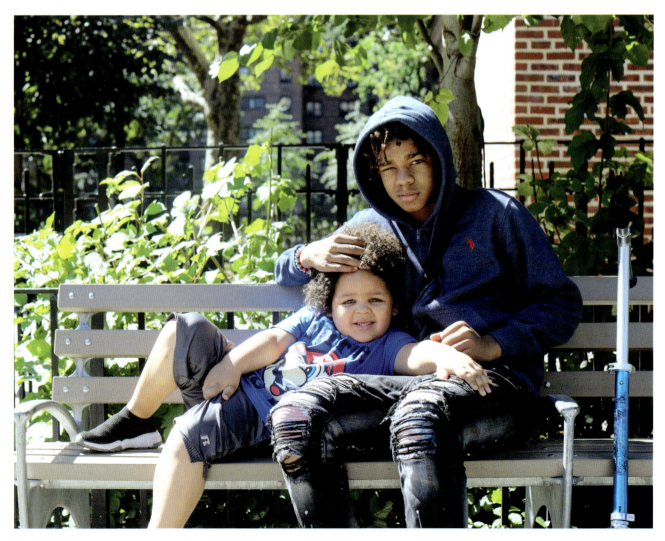

"I just remember my mother working. She worked in a factory in the Bronx, making jam. It's not that I don't like her. I just feel like I never knew her enough to like her or not like her. I don't have a relationship with her because society needed her to work. And to be frank: society takes all immigrant mothers from their children."

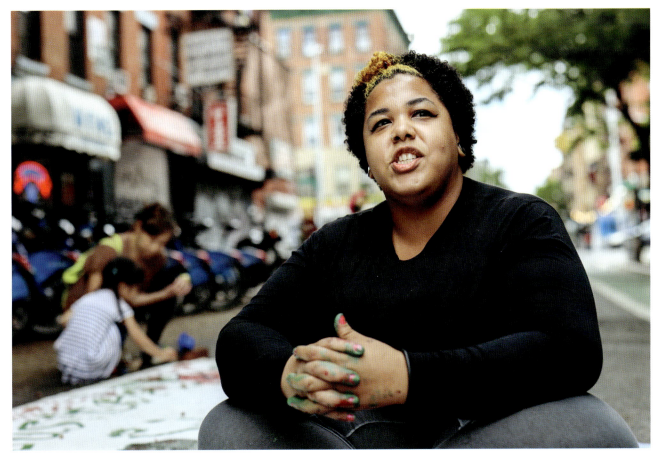

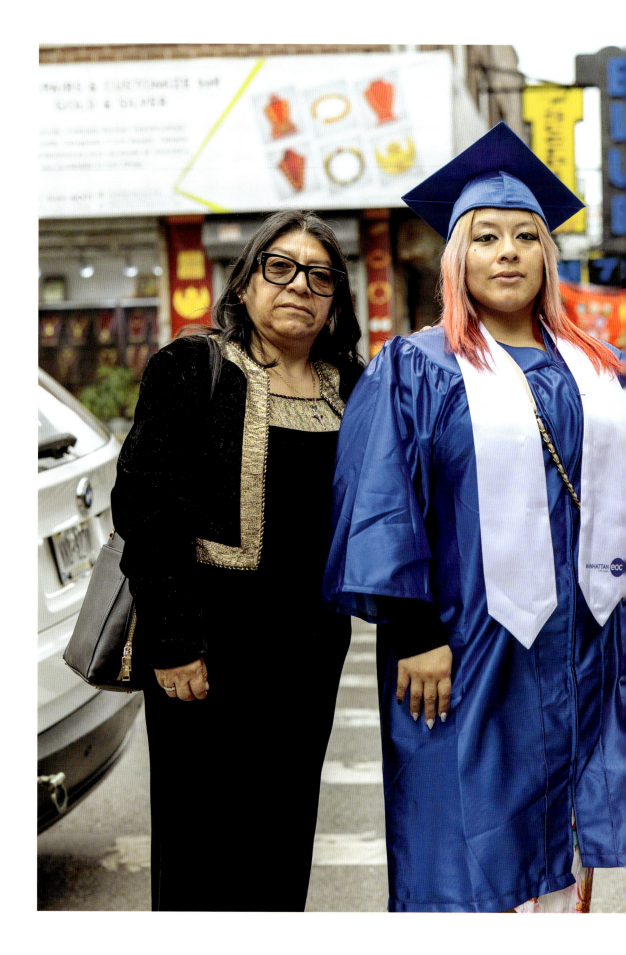

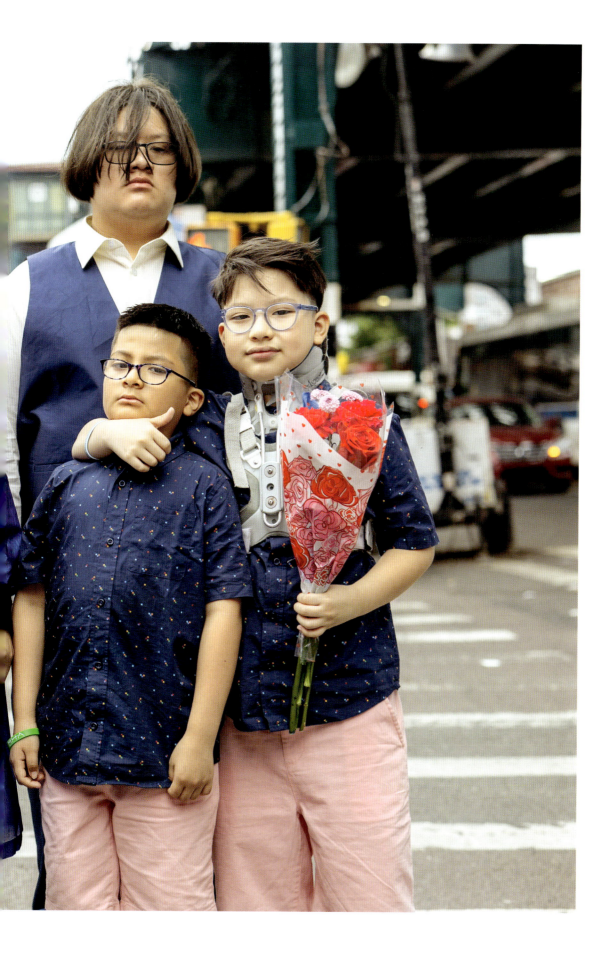

"He's going to be—he is—the man who will dance around the living room with her and make silly faces and tell her silly stories and tell her that he loves her all the time and take her on great adventures and read her amazing stories and make cool shit with her and go on long walks with her and put the world right for her. Just the way they look at each other. She can't see shit. But he sees a lot. It's different than he looks at me. It's so pure. He notices every change in her face. Every noise that comes out of her. Just having someone doting on you like that. I just think how lucky she's going to be. And being able to see that energy between a father and daughter. Even if I didn't get to experience that myself—just to be around it now, it does a lot of healing for me. I feel like so much is slowly repairing in my cellular being. I lost my dad when I was young. Things were heavy dark. I've always associated love with pain and tragedy and loss and grief—but knowing that I can let go of that, and experience love in a light and beautiful way. It's exciting. Like, love is fun. Love is pretty fucking fun."

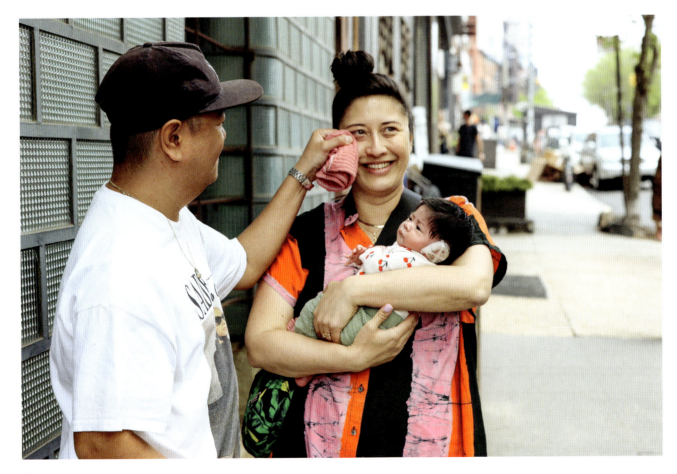

"I used to be a quiet person. But then I found a group of friends. And they were loud. So I was loud. And now we're loud together."

"He's a great father. But it was thirteen years of not being loved the way I deserve. Or want, right? Or need, even. Now that the journey's come to an end, it's like: 'Wow, I'm really not who I used to be.' I used to be so spontaneous, even with something as simple as driving. I'd drive all night just to spend a day at the beach. But after we started a family, my husband drove. It was just our flow. Then it became a crutch. Then it got to the point where I couldn't do it anymore, especially with my kids in the car. I'd lost that part of myself. Right before my fortieth birthday we got in a big fight. It wasn't the end, but it was close to the end. That night I bought myself a birthday present: one ticket to a resort in the Dominican Republic. Just one ticket. He'd up and leave no problem, especially if it's work-related. So why not me? But right after I booked the ticket, I got so scared. I almost canceled. But my sister was insistent. She's a mother too; she said: 'Stephanie, you've got to go. And don't you dare take someone with you.' It was only three nights. But when I say I smiled the whole trip, I mean it. I met so many other solo travelers. There was this old Russian woman; we saw each other everywhere. She'd float by me in the water. We took salsa classes together. She didn't speak English, but every time she saw me, she'd smile so big. A few days after I came home, I was alone with the girls. My older daughter had a birthday party deep in Queens. Normally I'd have said no. But I said: 'You know what? We're doing it.' I booked a Zipcar. I hadn't driven in years. I was panicking the whole time. My twelve-year-old was navigating, all of us were laughing the entire way. But we made it, didn't we? When we got there, I said: 'Well, girls, we can drive to Queens. I guess we can drive anywhere.'"

"I just want to get out of my house. I don't want to hear nothing from her anymore. I love my mom. She came from nothing, from basically the dirt. And I can't hold her accountable, because she was sick. She was in the hospital for so much of my childhood. But now she's in my life and just commenting on everything, and I'm like: 'You wasn't even around.' It feels like she's hovering over me, making sure that my life is stable so that she'll always have some pockets to dip her hands into. She's already asking me for money, even now. It's like: I thought I was the child. I understand you want some help, but I'm already not making enough. I'm coaching at a soccer camp. I'm trying to get myself through school. You're not helping me through school—it's just me. She keeps talking about how she wants to move out of New York, and how she wants to build a house. With what money? With the money I make. She says things like: 'I gave birth to ya'll. I took care of y'all. So don't y'all think you owe me back?' And I'm just like, I did not ask to be here. I did not, I did not."

"There's nothing wrong with safe: it made me a good daughter, and a good student, and a good employee. But I've reached a point where I want more. I want something different, instead of something safe."

「我靚唔靚?」

"Do I look pretty?"

"We literally just began the process of separating; they're going to their mother's tonight. And I'm just not sure what I'm supposed to do to help make that process healthy for them. I'm doing all the research I can. I'm talking to friends, I'm reading books. But in my darkest moments I think about how I grew up in a home where my parents were together. I'd rebel against one, and kiss up to the other. And I am who I am because of that structure, that predictability. So I worry. But you know, maybe it will be the same way for them, just in different houses. There's a saying: two homes, one childhood. It's a cliché, I know. But that's what I'd love for them to have."

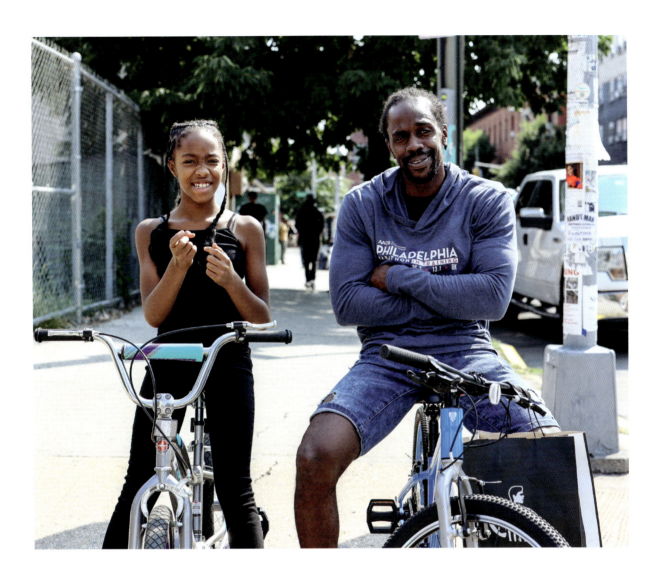

"He dresses basic."

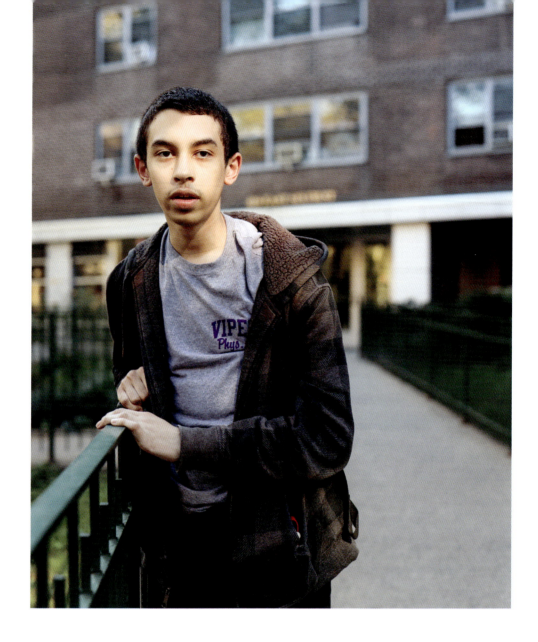

"I've had a dream since I was little, to make a game that's really successful. I have drawings in my bag, like everything I could think of. It's like a whole tree of ideas that keeps going and going and going. But then sometimes there might be a branch that has things, like, I don't know: a bad guy with a mouth on his stomach. Or eyeballs on his fingers. And I'm afraid that might be in the 'weird zone.' So I'll kinda trim that one off. But I don't want to trim it off because it's my creation and I want it to grow and stuff. But at the same time I don't want people to be like: 'Oh, the person who made this game is different than everyone else.' But the thing is—I was inspired by things that were odd to begin with. You know, like weird anime ideas and stuff like that. I get my inspiration from weird things. But when it comes time to make the weird things, I'm like: 'I don't know, I don't want to make the weird thing.'"

"I don't want to have like your stereotypical hero, you know. I want a hero that was kinda roped into the whole thing, and he's like, afraid of stuff—you know? I should probably just refer to him by his name: Leo. His name is Leo the Chameleon. And you know, Leo was just like, regular. He wasn't a hero. He wasn't off being lazy or anything, he was just afraid. He's genuinely afraid. He's like: 'I don't want to be doing any of this stuff.' But then as the game goes on, you know, he'll get more into it. I want him to be able to gain more, like, bravery. And eventually he'll kinda see—maybe not that the role was meant for him, but that he has to fulfill it. He has to finish. And maybe along the way he'll kinda end up, like, loving it a little."

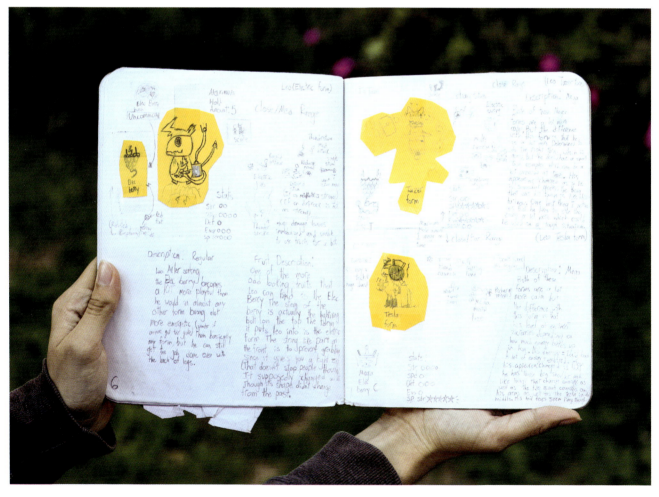

"It was the end of a sixteen-year marriage. I'd just turned fifty. I wasn't young anymore. And I knew what it was like to be single in New York; I didn't feel equipped to do it again. We started the divorce process a week before the pandemic hit. None of my usual coping mechanisms were available. I couldn't get a drink with friends, or go to the gym, or go for a run. I was just doing my best to white-knuckle through. I met Bryon as part of a Facebook Group for Black UVA alumni called 'Hoos Getting Fit.' Normally we post our fitness goals and achievements, but during COVID it became much more about emotional support. One night we had a Zoom happy hour after work. Things got intimate pretty quickly. People were sharing personal things: 'My parents are ill, my child is immunocompromised—my marriage is falling apart.' Bryon sent me a personal message afterward. He said: 'I also know what that's like, when you think you can love enough for the two of you.' He was much further along in his divorce process, so our first few phone calls were a lot of me dumping my shit on him. He was pretty open from the beginning: 'I can't believe anyone would ever leave you. I really want to take you to dinner.'"

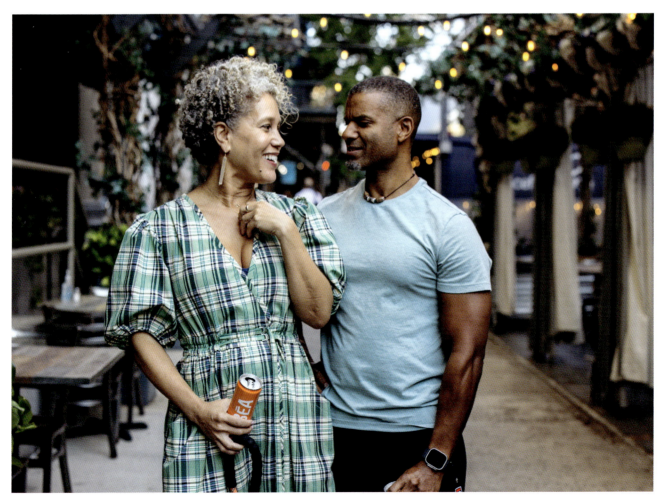

"He'd always had a full beard in our video calls, but he showed up clean-shaven. The restaurants had just begun to reopen, so we ate outside at an Italian restaurant. I took a photo of the way he was looking at me. After dinner we took a walk through the West Village. It was a warm summer night. I was wearing a sundress. He held my hand. He got me flowers. He walked on the outside of the sidewalk, which I hadn't seen since my father. It all made me feel so beautiful, and desired, and young again. I felt courted. That's it. I had forgotten how it felt to be courted."

"Eight months ago I was sitting behind her in calc, and I asked for help on a question. Then I just kept asking for help. I'd say 10 percent of the time I actually needed help; mostly I just wanted to talk to her. We started playing video games together online. Then one night we were on the phone until four or five in the morning. She was speaking differently than she normally does at school. And it was completely dark in my room. I don't know—it just felt like we were more close. I'd had feelings for her for so long. I wasn't quite ready to tell her. But I was so tired—right at that point of losing consciousness—and I guess it made me brave. So I said: 'I really like your voice.' A few days later we rode the subway home from school together. It was pretty late, since we'd stayed to watch the basketball games. And by the time we got on the seven train both of us were pretty tired, so we're leaning on each other's shoulders. Our faces are getting closer and closer. And I was at that point where I was losing consciousness, so I was feeling brave again. I whispered: 'I want to do something right now, but I don't know if I can.' And then she turned away. I thought I'd messed up. But then she turned back, and she looked right into my eyes. Then I leaned closer. And then she leaned closer. And then it happened."

"Finding time for them, that's the hardest part. For my autistic son especially; because he's the one that needs me the most. I work full-time. And as soon as my work schedule stops, my mom schedule starts. I'm on the way to pick them up right now. I know the bond is there. Oh my God; they're so attached to me. But I feel like they only get to see the strict mom, the military mom. The school is always asking us to do more academic things with them. So it's a lot of: 'Let's do homework, let's read books.' Then after that it's: 'We have to eat, we have to take a shower, we have to go to bed. And let's do it fast. Because you need to get to sleep. You need your rest, because we have so much to do tomorrow.' I feel like what I'm missing most, at this moment, is fun. There's no time for fun. I don't want them to only see me as a mother. I want them to see me as a friend, a best friend. Someone who will do crazy stuff with them. I heard that it might rain today. So I'm hoping, really hoping, that we get caught in the rain today."

"It was ten years ago, so I've pretty much fully recovered. But it was a brutal divorce. Our kids were twelve and six at the time. I was hoping our lawyers could handle it, and it would be quick. You know: 'I get them for Christmas, you get them for Thanksgiving.' But then the back-and-forth started: 'I can't do this. I can't agree to that.' It's like a snowball: little by little it gets bigger and bigger, until suddenly this massive avalanche is coming toward you. And at some point you kinda have to say: 'Well, if you want full custody of my children, I'll do or say whatever needs to be done in order to not have that happen.' And that's when the nastiness comes out. All the stuff you thought would never come out. And when you've been with someone for twenty-three years, it's a lot of stuff. Things discussed in private, vulnerable moments. Things you never thought would leave the intimacy and respect of your marriage, laid bare in the starkness of a courtroom. It's almost surgical. There's bright lights on everything. There's no love to it, no compassion. You can't say: 'Well, yes, that happened. But it's not who I am. I was having a bad day. I was having a vulnerable moment, with a person I should have been able to trust implicitly, who I never thought in a million years would betray me like this.'"

"He text cheated. Then I cheated, cheated. Because I'm competitive."

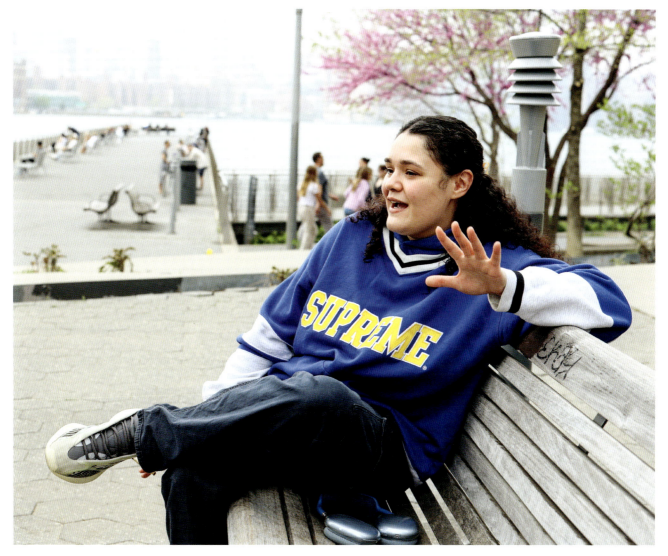

"My father was something called a *txiv geej*. In our culture it's a very respected position. At funerals he would play an instrument called a *geej*; it looks like a long flute with six smaller flutes attached. And its song is supposed to help the spirit pass on to the next world. My dad wanted nothing more than for his sons to continue the tradition. And not that I'm the golden child or anything, but he especially wanted me to learn. He'd make us practice for hours every day. When we were kids it was kinda cool. We'd play at Hmong New Year celebrations, and everyone would watch, and they'd be very polite. But as we became teenagers, it was like—this is not cool. We were living in a small town in Wisconsin—not a lot of Asian folks in general. I was focused on trying to get by every day. I just wanted to hang out. I guess you could say I became more American. We had so many arguments over it; there was a lot of: 'I don't understand. This isn't why we brought you to the States, not for this.'"

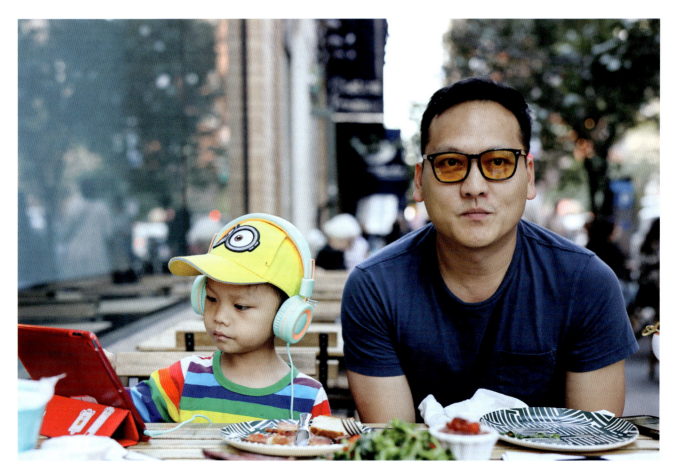

"I was very hurt by it; obviously you want your dad to be proud of you. But he was very hurt by it too—that he didn't have a son who was observing the religion, playing the instrument, following his footsteps. It might sound selfish, but I think it was more selfless than selfish. He thought that if I didn't follow the religion, our spirits would go to two different places. It's what he truly believed. And he wanted me to follow his footsteps after death as well. Toward the end of his life, he finally told me: 'You're a dad now. You've become your own man, and I respect whatever path you choose to follow.' And I was so thankful for that. At his funeral one of his best friends played the *geej*. My father left a recording of exactly how he wanted it played; it's almost as if he was providing the exact coordinates of where he wanted his soul to be."

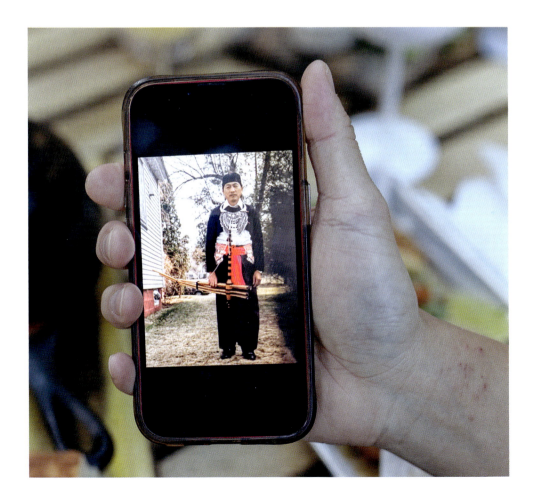

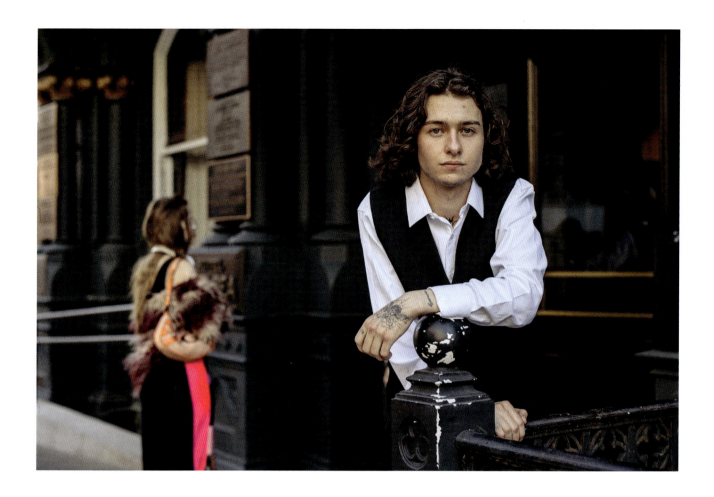

"I was visiting a friend in New York. By then I was like bones; I was using all the time. And at some point my friend finally tells me to leave. It was 5 A.M. I had nothing but a hoodie, and it was negative degrees. In one hand was a bottle with forty-five pills of Xanax. In the other was my cell phone—with my mom's contact open. It was either make the call or take the drugs. When she picked up the phone I broke down. I apologized for everything. I told her that she was right, and that I'd been using this whole time. She told me: 'It's OK, I just want to get you help.' I'll be nine months sober on Sunday. In a lot of ways I feel like a child again. I started using when I was twelve, so there's a lot I never learned about being a person. I'm learning how to talk to people. I used to never call my mom. Or if I did, it was something negative: I need something, or I want something. Now I'll just call her to see what she has going on. She tells me about her interior design stuff, or maybe a house that she's trying to sell. I enjoy hearing about that stuff. My relationships feel real now. For the longest time, I wasn't even a person. There was no Jake; it was just drugs. Now I'm actually a person. And that's a big motivation to keep going to my meetings, and to keep picking up my phone. Because if I relapse now, it's going to hurt everyone who's gotten to know this side of me."

"My family is from China, really conservative Christian. I've had to repress a lot of things. But it's not like they're evil people, you know? They're human beings too. And I can see how they reason. Because before I had this, um, sexual awakening, I was also very closed-minded in that sense."

"This is my little brother. I'm hoping his generation can do better. I feel like my generation gave up on life. Everyone I know at least, everyone from high school. We suffered through the pandemic and couldn't fully experience high school life. I think a lot of us, at some point, were like: What's even the point of going to school? If at any moment something major can happen, and everything can come to an end. I might have to go to war one day, to fight in a war that we got involved in for no reason. For what? I'm not even part of this war. It's hard to not be overwhelmed by it all. It makes me want to just relax and be forgotten. Forget the world, be forgotten by the world. Our teacher was like: 'It's up to you. You guys are the next generation.' But why us? The generation ahead of us couldn't fix it. How are we going to fix it? We're already making our own mistakes, and the generation after us will do the same thing."

"I was four or five years old. Me and another little boy were exploring each other in the bathroom. I was still in my Adam state. I was in the Garden of Eden. We had no concept what we were doing was wrong. But my mother took me down to the basement, put olive oil on my head, and brought over people from the church to pray over me. It didn't feel like a healing. It felt like they were trying to get something out of me. The only way to deal with stigma like that is to return to the earth. Because Earth loved you first. And Earth is gonna love you last, I hope."

"My mom was a witch. Now she's a Norse Pagan. I think she just finds the whitest religion she can possibly believe in. It's like, all right, Carol, do your thing. I'm here to support you. Then I have an edgelord older brother, who's all: 'I'm a Satanist.' OK, Andrew. Let's calm down. My dad is more of a Mexican Catholic guy. He just copes. He's really banking on the whole last rites thing, so he's kinda sorted. Honestly, I wish I was religious. At least they have something. Because for me it's like: 'Oh shit, there's nothing next.' And that doesn't sound nice. But ultimately life is just a series of chemical reactions, which is a depressing way of thinking about it. But I mean, I'm pretty sure that's what's happening here. Even these thoughts—they're just a series of chemical reactions, and one day the reactions end, and you can't think anymore. I don't even want to think about it. My therapist was like: 'You should really stop thinking about it.' I've actually chilled out a lot from when I was at my worst. Here's something I use to comfort myself: ultimately my body is going to decay and I'll get recycled back into the earth, right? And maybe a mushroom will spring up from my body. That's a new form of something-or-other. And when the Earth finally comes to an end—my molecules will still be there, in some form. Just floating through the universe, forever. So that's nice, I guess. That's a comforting thought."

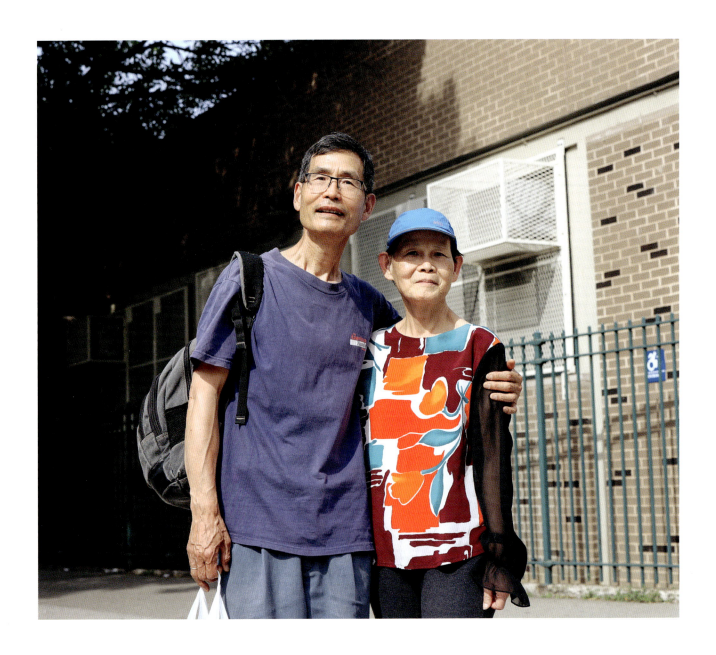

"My wife help a lot of people. She was director of career training program. She take care of people: the new immigrants, the garment factory workers. She help to train them, so they can work at American factory company. Thousands of people, my wife help them, so they can work five days a week, and have time for family. Every time we go to restaurant in Chinatown, somebody recognize her. We sit down, we eat meal, and when we finish eating—our bill, somebody paid. Always, somebody pay our bill."

"He is very nice, reliable. People pleaser. I say: 'You need to clean up,' and he clean up all junk in the basement. He is the person responsible for all the garbage."

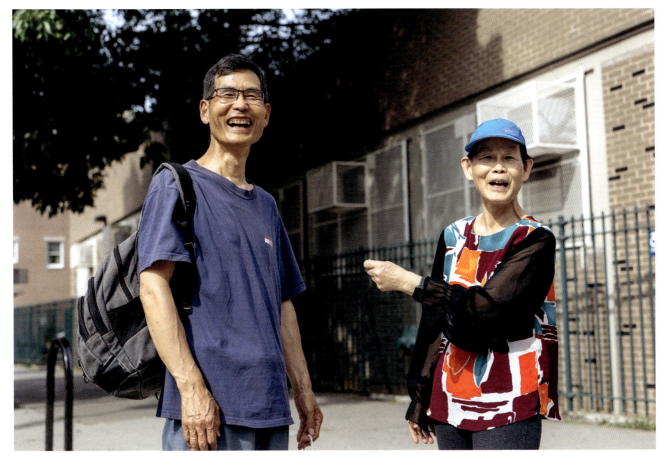

"One of my first days in New York—I went running with a friend in Central Park. I pointed at one of those big apartment buildings on Seventy-Second Street, and said: 'God, I'd give anything to live there.' But the devil hears your prayers too. Ten years later I was jogging home to that very same building. I could see the light on in our apartment, and I didn't want to go inside. I was in a marriage that I didn't want to be in. A job I didn't want to be in. I was drinking daily, way too much. I said: 'God, I'd give up everything if I could just start over and be happy.' That very night I got in an argument with my husband, and that was the end. When I first applied for this job, I felt like it was beneath me. I was angry at my situation. That first day they tried to send me to pick up trash along the Hudson. I said: 'No, no, no. Anywhere but there.' I used to jog along the Hudson; I was afraid some of my old friends would see me. But one day I got in trouble, and the boss said: 'It's the Hudson or nowhere.' My phone bill was due. I didn't have a choice. I've been here for a couple months now, and I can't believe how long I was avoiding it. I love the sun. I love plants, I love water. The funny thing is, no matter how many times I used to jog down here, I never really saw it. I'd be so focused on me, or what I was trying to achieve, or the person who was in my path. Now I see the greens and the blues and the yellows. The view is just different when you're picking up trash."

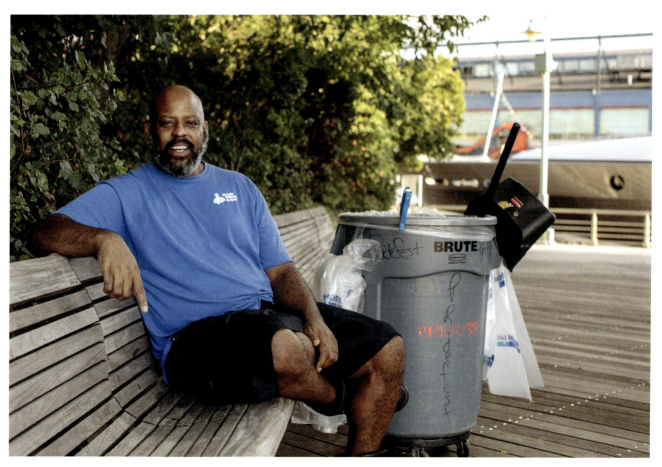

"I'm older than a lot of the other fathers. And I want to make sure if there's ever a ball game, I'm not the worst one out there."

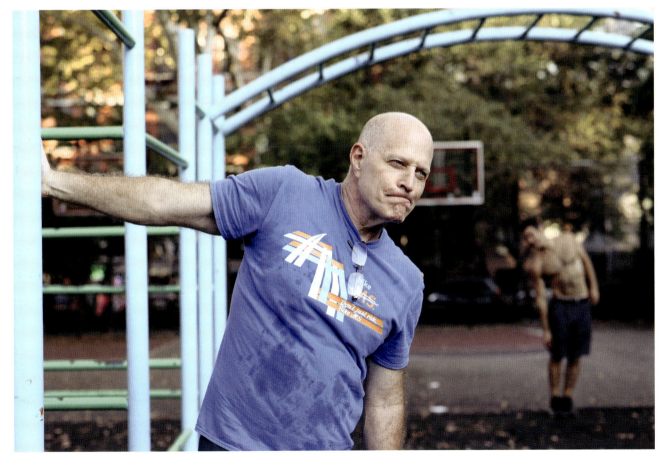

"My teacher has no hair and he really wants everyone to be quiet."

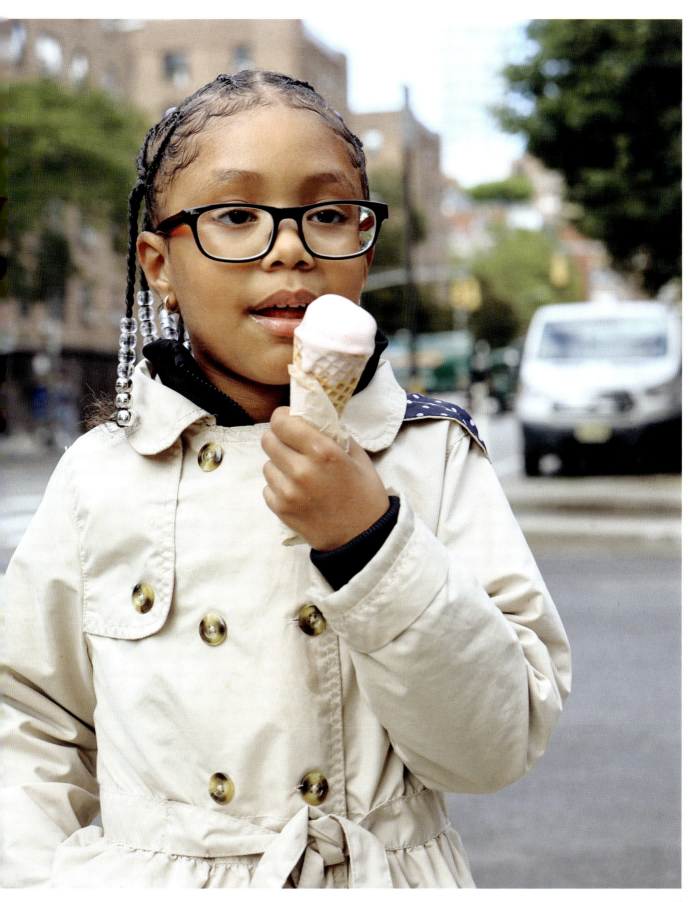

"I tattooed freckles on my face in the shape of my zodiac constellations."

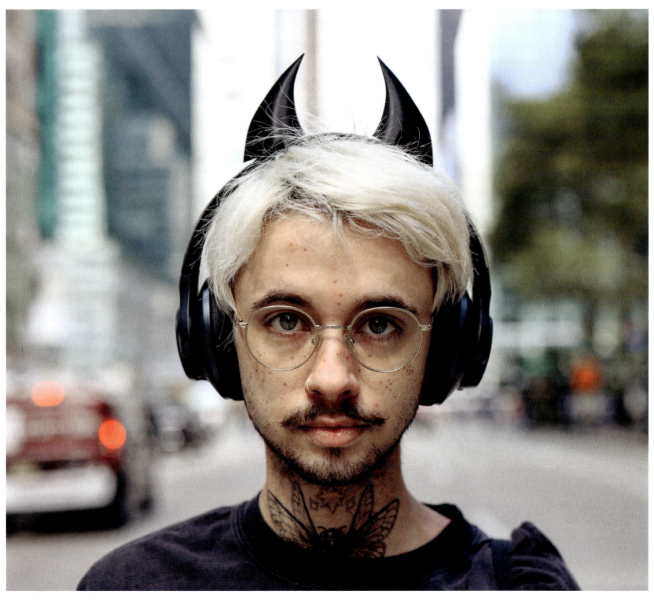

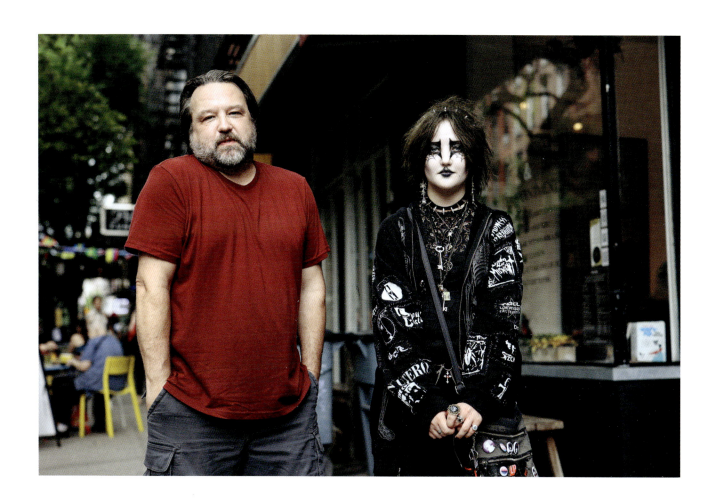

"It's a hard balance. Right? I'm trying to understand how to set boundaries, and when to let kids figure it out and grow. I've tried to let him make some small decisions, then a little bit bigger decisions over time. My biggest fear is that he's gonna get hurt, right? When I say 'hurt,' I mean, like, you know, fall off his bike, or trip off the sidewalk, or get kidnapped by aliens, or something."

"I haven't ridden a bike in a few years, I don't trip very often, and I am an alien."

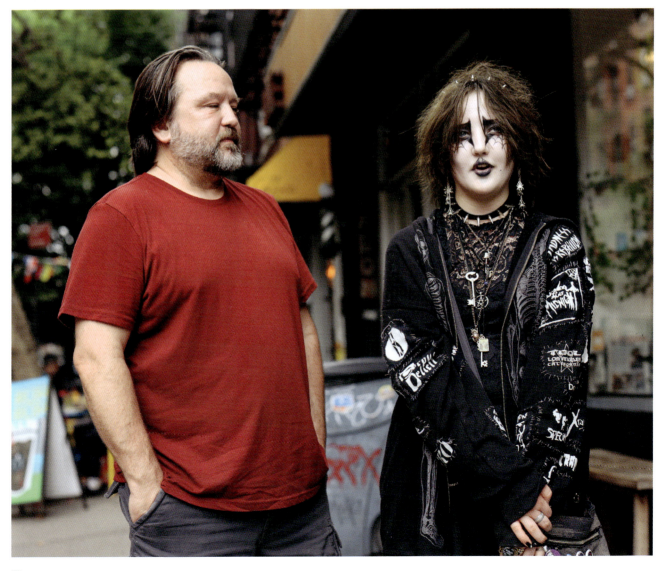

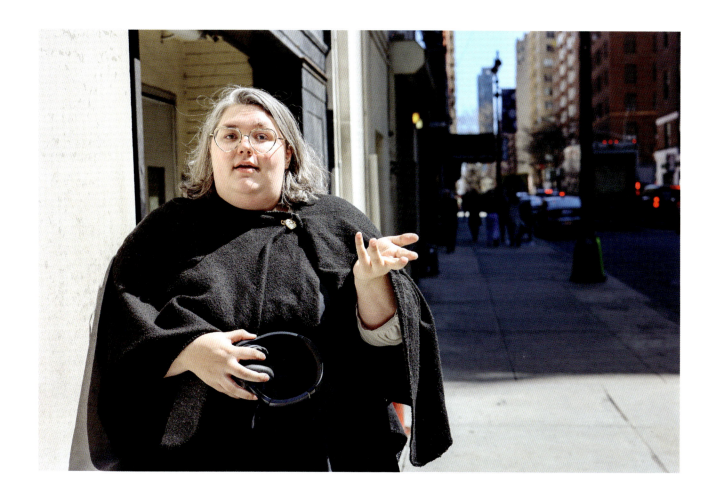

"We have a cabinet in our apartment called the Witch Cabinet; it's full of knickknacks: tarot cards, random rocks, bottle caps, buttons; there's a whole beaver skull in there. Our walls are covered in murals. Our windowsills are covered with random bunches of dried flowers that we meant to put in jars. She could describe the relationship better. She's better with words than me. But if there's such thing as a platonic soulmate—Emme is that. She's the first person I send anything. My God, absolutely anything: 'I want to try this video game, I want to try this recipe, I want to try this restaurant—so you're going with me.' I have a favorite podcast called *The Old Gods of Appalachia*. Emme's never even heard of it. But they're having a show tonight, and she's coming along. We've been roommates for seven years. It's the first time I've ever lived in a home where I was allowed to speak up about things that bothered me. Emme taught me how to do the 'friend call-out.' You know, like: 'You're my best friend. But what you're doing is really fucking shitty.' The first time it happened, it was a big 'oh yeah' moment for me. Like, oh yeah: there's a way to talk about hard things without yelling at each other, or ignoring each other. She's helped me work through a lot of stuff. And I've tried to help her with some things too. She's not exactly where she wants to be right now; sometimes she blames herself. It's like, girl—you're the hardest worker I know; it's obviously the fucking job market. She also has no idea how pretty she is. It's like, girl—are you seeing what I'm seeing? Then one time she actually said: 'I'm not that fun.' Not that fun? Girl, you light up a fucking room."

"I want to be star."

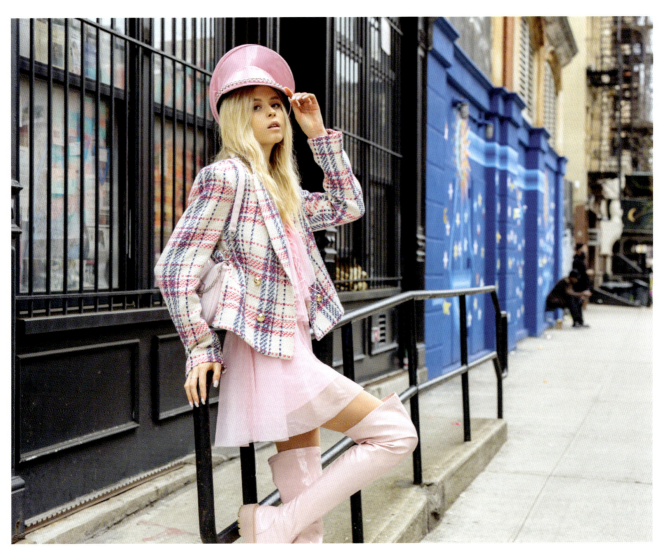

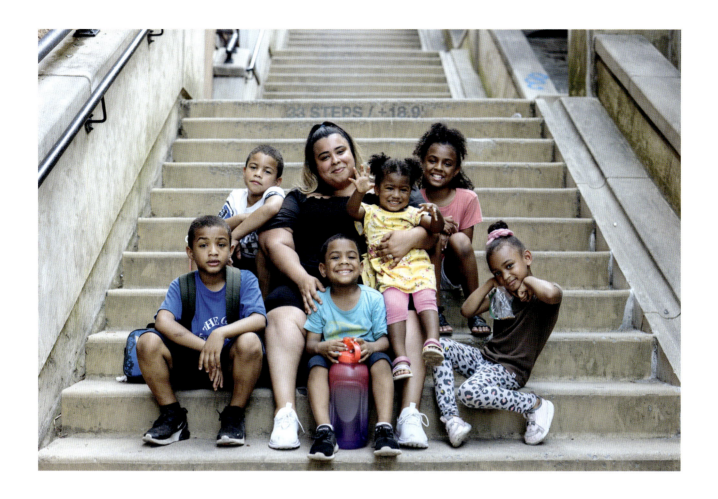

"I'm trying to be gentle on myself. It's funny. I'm so good with everyone else; I make space for everyone. Now I'm trying to understand that I can make mistakes too. Sometimes we all just want to have gratification. Some people do it with other things; I do it with food. When I'm feeling overwhelmed, I tend to eat more than I should. But the kids are getting older now: they're sleeping, they're feeding themselves. Now it's my turn to give back to me. I'm ready to start working again. Nurses can be any size, I've always said that. But I don't feel comfortable telling others how to take care of themselves if I'm not doing it myself. It's going to take work. But I've worked really hard in so many other areas of life. Nothing comes easy, right? Doing nursing school with five kids was very hard. I'm ready to get my life back. I want the energy and strength that I'm going to need, for the longevity I expect."

"One lesbian couple drove up from Philly and I handed it off to them in the car. Not my favorite way to do it, but it works. That baby was born yesterday. And I've got another one being induced in six hours. That'll be my twelfth in two years. Then there's three more on the way. I'm what they call a 'known donor.' It's a whole community, a whole thing: there's forums, websites, apps. It's like a parallel economy. A viable sperm sample is $700—just for a little bit. And the fertility treatments can be thousands. Not everyone can afford it; that's where I come in. Everything is kinda handshake. I don't charge the mothers. And they don't expect any financial support. As for the insemination—there's different ways of going about it. Some use IVF. But it's like fish. Fresh is better than frozen. Menstrual cups work well. I'd say 25 to 35 percent of the women I've actually had sex with. There wasn't romance, exactly. A couple times they'd never been with a male before. The last one said: 'Let's soldier up, and get it done.' But not everyone meets my criteria. Some women want it to be anonymous; I don't want that. I want to be involved. I explain to each one: 'This child will be born into a larger family. I have eighteen other children.' I'd like as many as God will give me. Why put your entire bloodline into one child when you can spread it out? Eighteen is a holy number in Judaism. And the next one is thirty-six, so I'll reassess then. My ultimate goal is to find two or three of the mothers who will be sister wives, because I'm gonna need help with all this. But I know one thing: it will never be boring. It will be fun. I play in a softball league. And I'm hoping twenty years from now, I'll be able to field an entire team of my kids."

"There was an altercation. I'd given my ex-girlfriend some money to get her hair done. But then we got into an argument, so I was like: 'Give me my money back.' She bit me, I pushed her, she fell. Then she went and got her mom. Her mom cut me, on my hands. So I went and got my sister, because my sister is a fighter. So my sister is fighting her mom, then two other girls came out of the building and jumped my other sister—the one who's not really a fighter. I'd drank three bottles of Hennessy, so I kicked one of those girls in the mouth. Then she went to get her brother and her cousin. I warned her: 'If your brother and cousin come outside, I'm going to kill them.' But a few minutes later, here they come. And in my head, I think they're coming to shoot me. Because if you kick my sister, and I'm from the streets, I'm coming to shoot you. So I took my gun out and shot my shots: boom, boom, boom. Nine shots. Then the gun jammed. I was trying to unjam my gun so I could kill these people, but my friend started screaming that the cops were coming. So I ran off, straight to my sister's house in Maryland. And that's where they finally caught me."

"Ask my aunt, she'll tell you: when I was a little kid, I wanted to be a lion tamer. I wanted to be an astronaut. I wanted to be everything. But all that shit went south when my dad died. I remember asking God: 'Why did you take my dad? Why didn't you take my mother?' 'Cause she was the one that hit me with belts, cursed me out. My dad was the one saying: 'You're great, son. Get it together.' But when I was eleven he died of stomach cancer. And after that I had a death wish. I started doing so much to destroy the community: I've fired guns in front of children; I've sold drugs to pregnant women. Bad things kept happening: my sister died, my grandfather died, one of my girlfriends aborted a set of twins at five and a half months, broke my fucking heart. When I was nineteen I gave my mother some money, and was like: 'Yo, Ma, I love you.' Then I went to my sister's house in Maryland to kill myself. I was smoking weed, drinking liquor. I had a gun to my head, praying for the strength to pull the trigger. Obviously it didn't happen. I woke up on the carpet. Then just a few months after that, I'm firing nine shots at a group of people."

"It's hard to change, especially in the same neighborhood. People just think you're acting funny. They're like: 'I know the old you,' which they think is the real you. When I came out of prison I had three goals: learn to love myself, develop a healthy relationship with my mother, and help build my community. I started during COVID with Community Building Fridays. We provided food for people. We handed out like five hundred meals. We got the park fixed. The park was fucked up for four years, right? We had Channel Two come out, had the councilwoman come out, and they're finally fixing the park. Now I'm partnering with this organization called Connected Chef; we got a $100,000 grant from the assemblyman to start a community hub and do free grocery boxes. And here we are. Today we gave out 35 food boxes and 126 juices. Every single person I've hurt has forgiven me. The people that I tried to kill, we're all friends. It took a lot of work. It took a lot of patience. It took a lot of conversation. One of the girls, the one I kicked in the mouth, she said to me: 'Yo, Ray. I was so mad at you for so long, but with all the stuff you're doing for the community, I can't stay mad. Thank you for loving us.'"

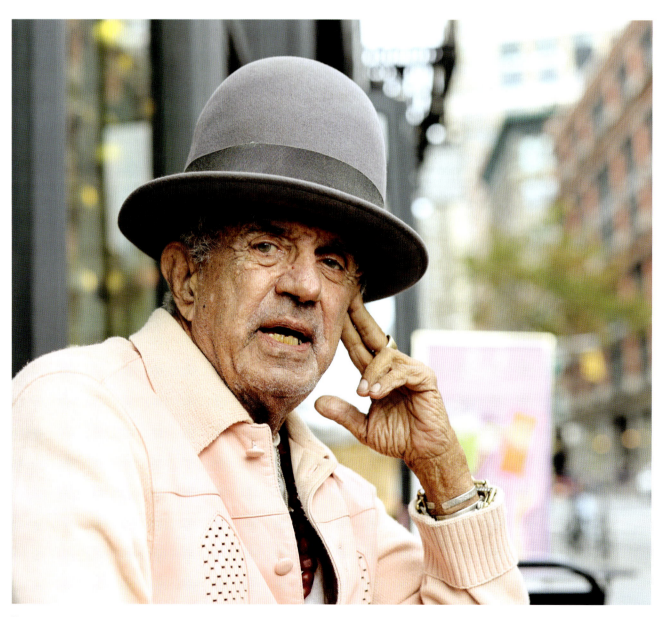

"I knew if they ever found out about me, I'd end up like Johnny Yablonsky. Johnny was soft, he was feminine, he was clearly gay. The neighborhood guys would make him blow them; then beat the shit out of him. He always had a lot of bruises, and absenteeism. He was so defeated. I've always assumed he killed himself. And I didn't want the same thing to happen to me. It was a lot of fear, and shame. The fucking shame. I participated in my own self-negation. I laughed at all the jokes. I tried to tighten up on the masculine stuff. I'd stand in front of the mirror. I'd practice my walk, my diction, the movement of my hands. Somehow I managed to make it out of that town alive. During our first Christmas break at college, I went with my friend Howie to visit his family in Long Island. Afterward he dropped me off at the airport. He thought I was flying home. But I caught the Greyhound bus to New York City. I put all my stuff in a luggage locker and started walking down Fifth Avenue. It was night. It wasn't lit up like today. All the storefronts were dark; it was like lyric poetry to me. Unopened boxes full of mystery. All I knew was I had to get to Greenwich Village. I kept asking people—is this the Village, is this the Village? They kept saying: further south, further south. Finally I get to the corner of Eighth Street and Sixth Avenue, and I'm waiting for the light to change. And this guy starts hitting on me. A few years older than me, good-looking. His name was Charlie. And he put a spell on me immediately. From the very first moment, I had a hard-on for Charlie Bacchus. I felt safe with him. He took me to my first gay bar. Then afterward we went to his mom's loft apartment on Washington Square. She happened to be in Rome. So it was just me and Charlie Bacchus, in this gorgeous apartment, with the door closed, cut off from the rest of the world. There was sex, beautiful sex. First time I'd ever had sex with my shoes off. The next morning I came out of the shower and wrapped a towel around me. Charlie said: 'What are you doing? Take that off. You're beautiful.' He said it so gently, like someone looking at a painting. And it was my first profound lesson in shedding shame."

"I try to be invisible. Because the moment someone realizes there's a camera, it's not natural anymore. It's a show."

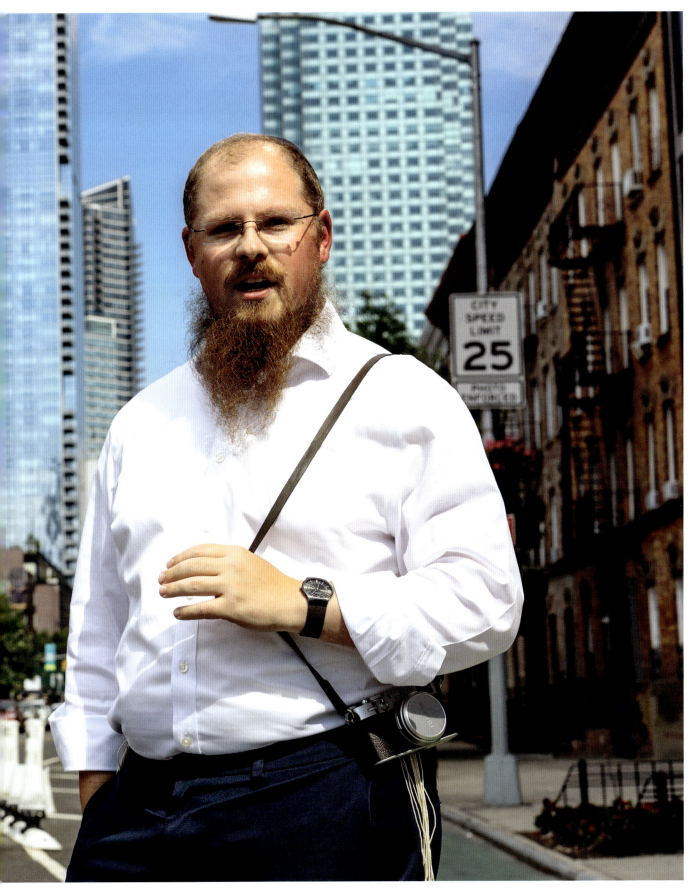

"I'm learning what it means to be an adult. Now I understand why you guys are so angry all the time."

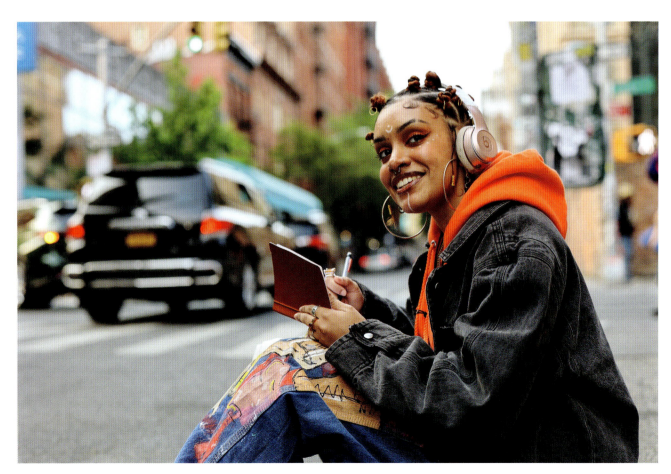

"My parents used to tell us: with what little you have, be a blessing to others. But my father also said this: don't let people smell your money. Because the aroma gets in them, and they start to make that money theirs. They start to think: I need it more than him, he can give some to me. And they'll come up with a thousand reasons to get it from you. Don't get me wrong, they're real reasons. But six months later: here comes another one. For my whole life I've been the person people come to. But I'm almost sixty now. I'm not where I want to be, so I'm slowing down on the giving. I still want to be a part of the whole thing: pay it forward, be blessed to be a blessing. God is love, but God is also discernment. And I can't let other people's emergencies cause me to have an emergency."

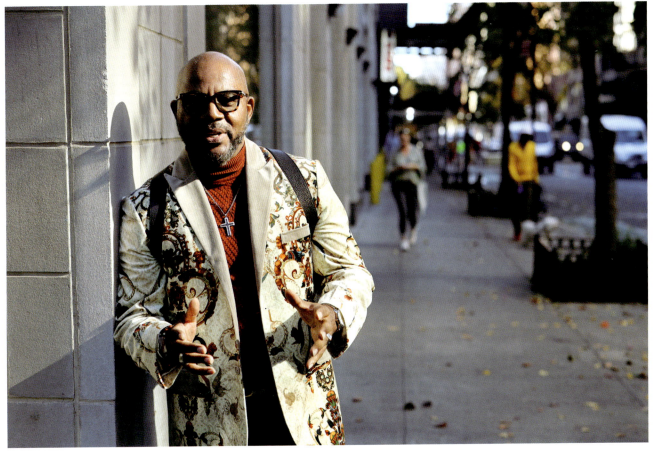

"I did digital art for twenty years. I jumped into technology when it was still just X's and O's running on the screen. It was kind of magical. Like, it was really magical for a while. There were a tremendous amount of possibilities to create in new ways. I watched it go from X's and O's to what we have today—which is essentially the same X's and O's, only a lot more of them, flashing much faster on the screen. Everything has been reduced to a format: the distribution of information, distribution of ideas, the distribution of art. Two hundred fifty-six shades of gray, 1080 by 1920 pixels. Sixty frames a second. But that's not what reality is. Reality isn't analog. It's waves, it's energy, it's flow. It's a much richer world we live in than exists in that medium. What I'm working on now is a Lumia panel. It's handmade. It's imperfect. Eventually it will be going into a structure that uses air currents to make it move. When the light hits it—real light: no frame break, not a flicker. When the light hits it, the viewer sees slightly different images in each eye. They're off by just a couple microns, but it's enough to cause a conflict. A conflict about color. Instead of seeing a particular color, you're going to see a range of colors. And the range keeps changing as the day changes, as the sun moves across the sky, as air currents move through the house. With all those natural variables: the wind, the sun, your position, your eyes moving, the person looking at it—there's never any repetition. Those variables keep it totally, infinitely variable. Just like what we're experiencing now."

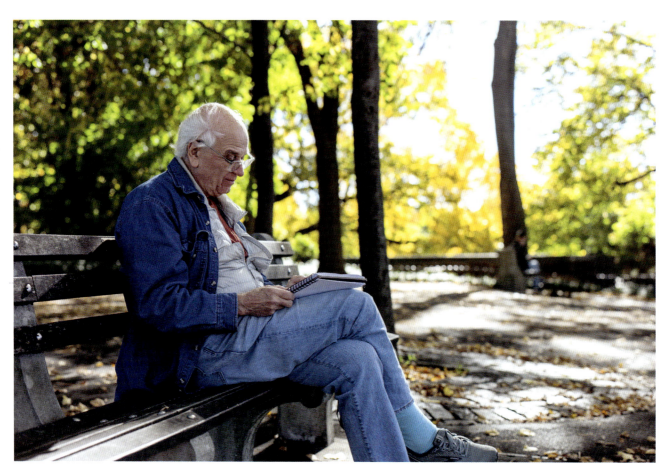

"You know how when people text, they make all kinds of spelling and grammar mistakes? Not me. I'll reread everything. I'll go back and fix it, I'll put in the comma. That's who I am. I take pride in everything I do. You either have it or you don't, and less people have it now. I think it was the digital revolution. When I first started working there were typewriters. If you made a mistake, you had to redo it. You had to be careful, you had to get it right—until the computer came along. I remember my boss was so excited about the computer age. He said: 'It's going to be great! We're going to have a paperless office!' I knew better. I told him: 'We're going to use a lot more paper, actually. Because you can reprint everything. And nobody's going to care anymore.'"

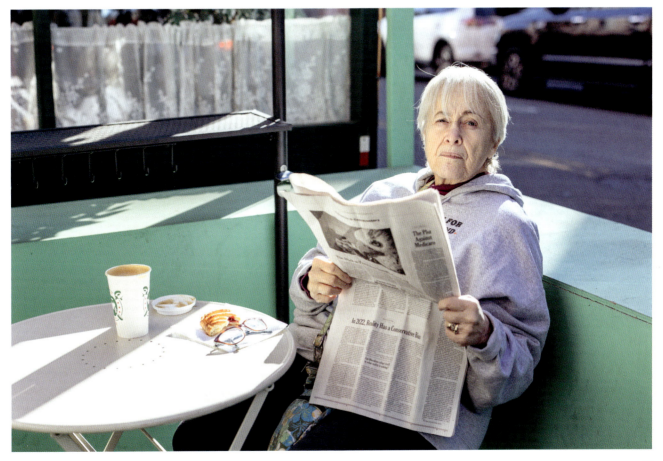

"I've been doing good work lately. My schoolwork, I mean. God that sounds so nerdy. But this year I've been trying to make school less about the grade and more about doing work that makes me proud. To put it bluntly, I wrote some good fucking essays this year. There's this one paper called The Term Paper. Every junior has to do it. It's six to eight pages. Just say the words 'The Term Paper' to a sophomore, and they will cower in fear. It's supposed to be the culmination of everything you've learned about literature. Everyone begins by making their proposal to the teacher. The coolest thing about essays, as opposed to, say, math, is that they're one of the only chances you get in high school to say something original. So I was like: 'Let's go, let's push it.' We were supposed to choose one book. But I told my teacher: 'There's an author I love named Kazuo Ishiguro, and I'd like to compare two of his books.' She told me nobody had ever asked that before, but she let me do it. And for the longest time it seemed like I'd made a huge mistake. It took me six months. It was such a complicated argument, it took me almost twenty pages. I felt so tired. I had no idea if I was going to finish on time. Even with an extension, I turned it in fifteen minutes before the deadline. But when she gave me the paper back, she said something I couldn't believe. She said: 'This is graduate-level work.' It was the proudest moment of my life. It's only been sixteen years, but still. Writing was never my strength. I think back to my crappy little paragraphs about *To Kill a Mockingbird* that I wrote in seventh grade. Even in eighth and ninth grade, my essays were still pretty shit. But I started really working hard to make them better. And I just kinda kept working. And it wasn't just six months that went into that paper. It was those six years of getting better. And I don't know if it will get published or anything, that's probably not something I can do. But for her to say that, it means my work is getting close to what people are actually doing out there in the world. I'm not sure if this makes sense. But it made me feel like I'm finally part of the world. Instead of just in it."

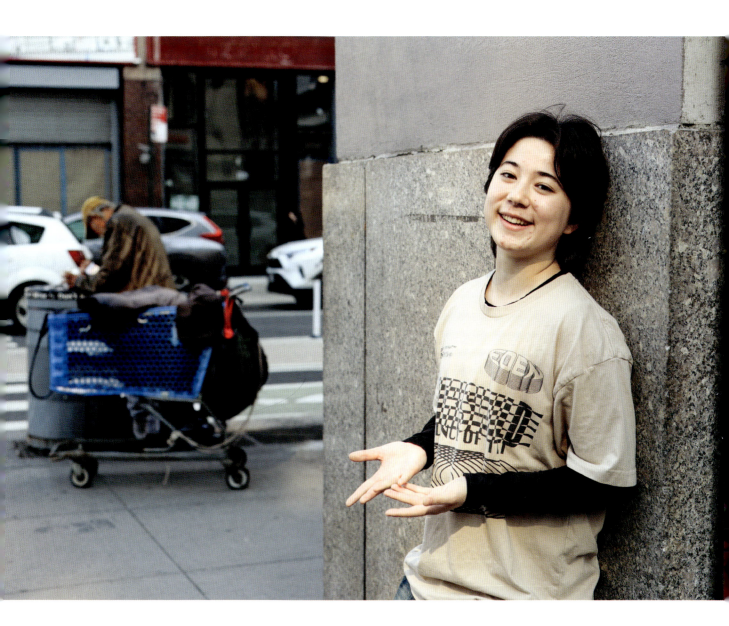

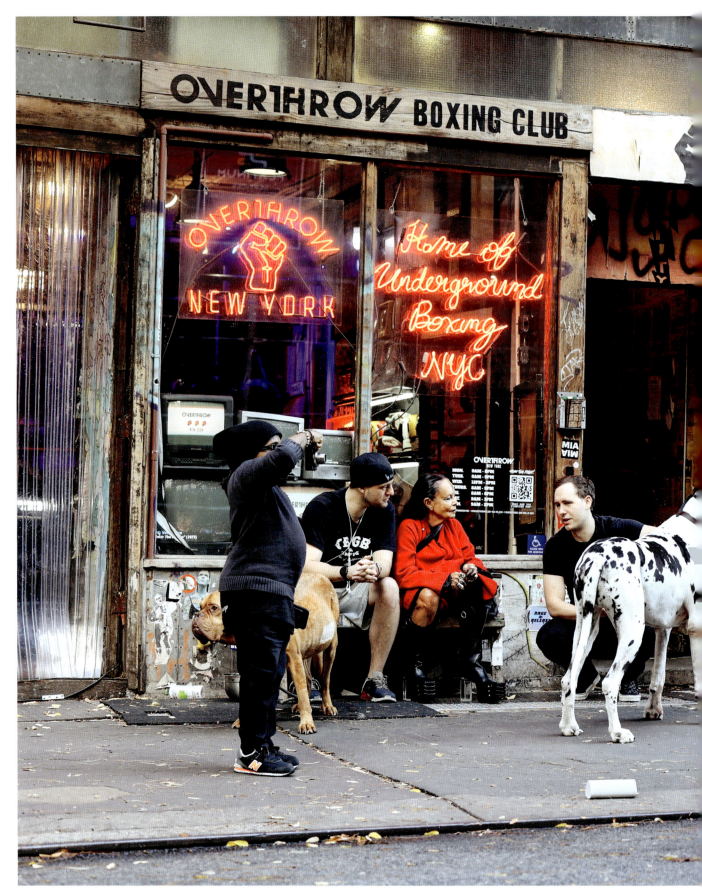

"It must have been terrifying for my parents. It was moment to moment, paycheck to paycheck. At one point we were living in a one-bedroom apartment with eight kids. It was chaos. There was always something happening: fighting over the remote control, or whose clothes, or whose shoes. But we also had each other for happiness. All of us were going through the same thing. The whole family shared a single camera—a point-and-shoot. Everybody got a turn. That camera got used a lot. Today if you go into my dad's home, you're going to find a bunch of albums. Whenever we get together, we'll take them out. It's mainly just photos of the day-to-day stuff: birthdays, holidays. Maybe a picture of us all sitting at a table, eating a meal. But if you think about it real quick: that's what life really is. Some of my happiest moments are just eating with my family. Nobody's thinking about what happened before we sat down. Nobody's worried about what's going to happen when we leave. We just trying to get this food. That's love to me: food, laughter, and a lot of people."

"When you grow up in that kind of life, adults don't look at you like you're a kid. And you don't look at them like an adult. You're on the same level. You're just two people talking, two junkies. My first memory of cartoons was watching Speedy Gonzales and Slowpoke Rodriguez. You know—the fast mouse and the slow mouse? I thought one of them was on coke and the other was on dope. As a little kid, that's what I thought. Because it's all I knew."

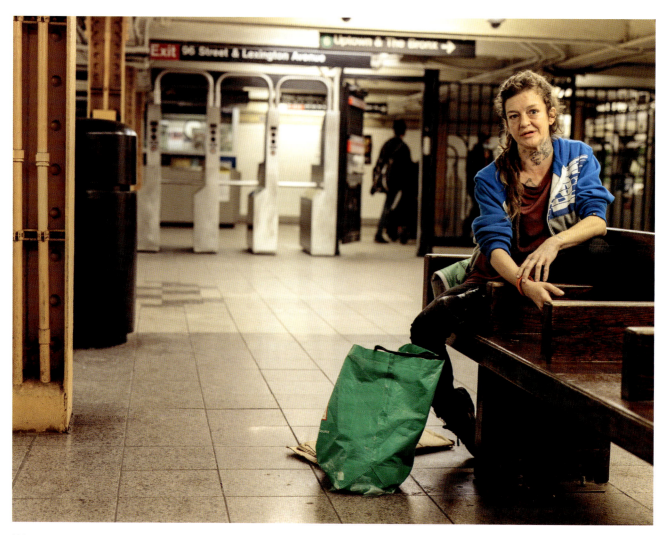

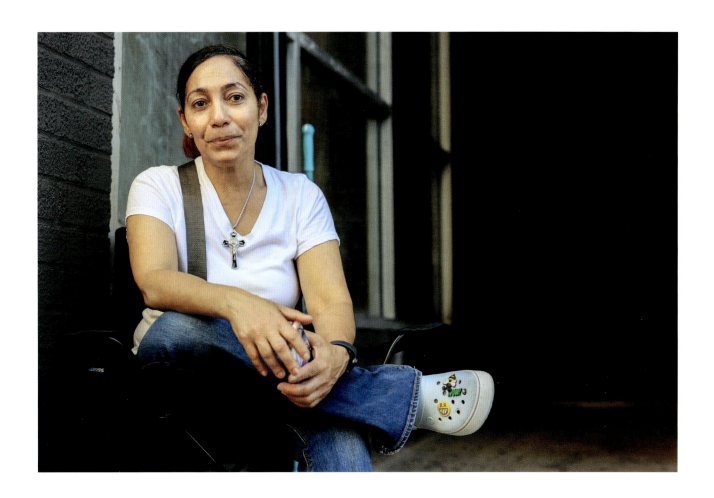

"Crie a mis hijas completamente sola en este país. No hablaba el idioma. Pero gracias a Dios, ahora son profesionales. Lo más difícil fue mantenernos unidas durante la adolescencia. Siempre les decía algo. Era una frase de una telenovela que vi cuando era niña, sobre una madre soltera con sus dos hijas. Siempre que sus hijas tenían problemas, ya sea en la escuela, el trabajo o la vida, ella les decía: 'Tienes que hablar conmigo. Porque cuando madres e hijas están juntas, el mundo tiembla.'"

"I raised my daughters all alone in this country. I didn't speak the language. But thanks to God, they are now professionals. The most difficult part was keeping us united during adolescence. There was something I always told them. It was a quote from a telenovela I watched as a little girl, about a single mother with her two daughters. Whenever her daughters had problems, whether in school, or work, or life, she would always say: 'You must to talk to me. Because when mothers and daughters are together, the world trembles.'"

"It was dark in that house. But behind the house there was a garden. It was a lush garden; my grandmother had a beautiful green thumb. I'd look at all the flowers. I'd study the shape of their leaves. I'd spend hours watching bugs. The house backed up to the Van Wyck Expressway. So I'd climb up in a tree, and watch all the people go by. I was just going through so much, you know. Horrible things were being done to me. Horrible, terrible things. So I'd use whatever I could. I'd pay attention to anything that made me happy. That's one thing I can do: pay attention. It comes from something within me. We all have it. But you know, I tap into it. I still do. Just this morning I took a beautiful picture of a flower. I'm just so grateful, I'm telling you, I have children now. I have grandchildren. I'm an educated woman: I read, I write. I went to college in my fifties and graduated with a 5.0. I'm proud of myself. My kids are proud of me. I'm just so grateful. I'm so grateful that I came out of the darkness. And maybe that was my journey: not to make money, or be some huge success. Maybe my journey was to recover."

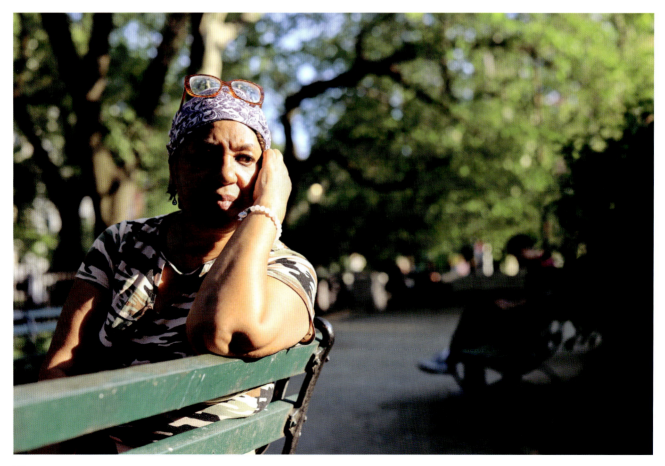

"I'm waiting for something to pop, for my business. When you are practicing faith, like building your faith—I feel like you're challenged a lot. Sometimes you get some no's. More no's than expected. But I'm trying to be patient. That's the hard part. Because there's this feeling of wanting what I want, now. But I'm trying to trust the timing of things. And appreciate the blessings I have now. I have tribe, I have community, I have good health, I feel loved, I have freedom. All I need is a big fat check so I can invest in my business, being real. That would be really great right now. But other than that, I'm Gucci. I'm good."

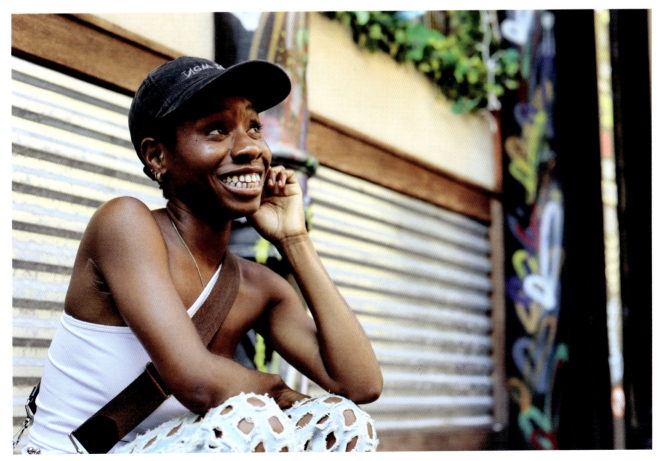

"I had no desire to have a kid. It was my partner Maira's idea. But Maira is right, usually. And Maira was right again."

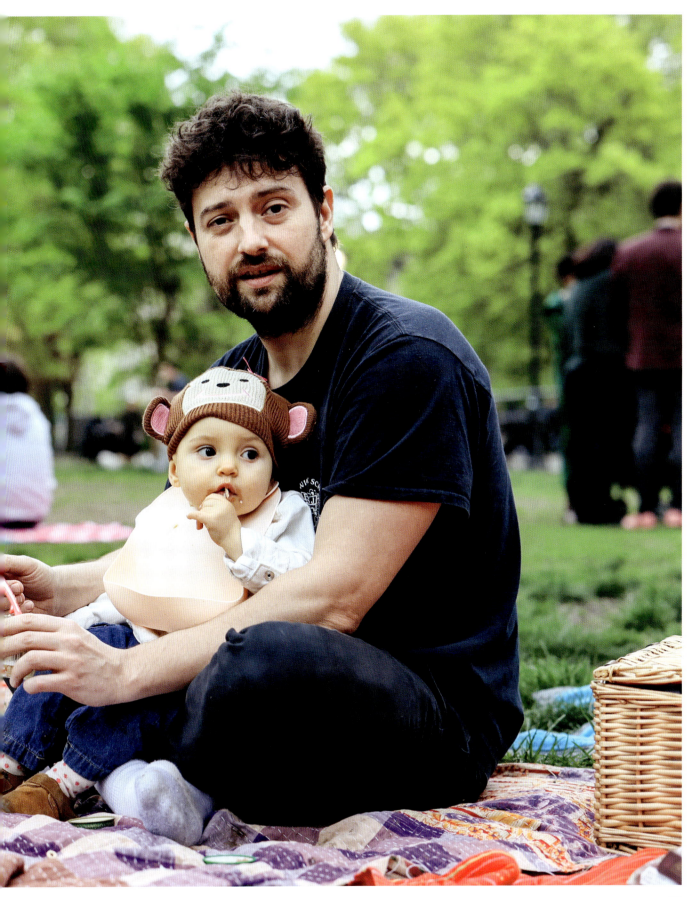

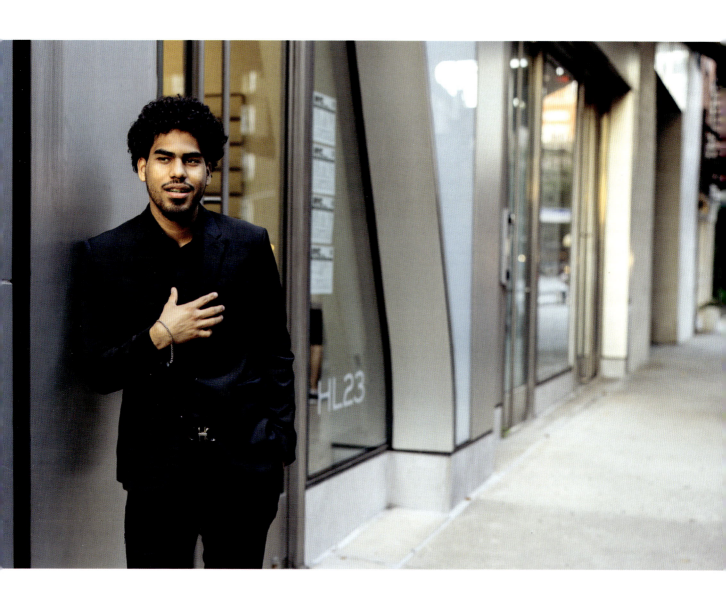

"My mom has expressed this to me—if I had not been born, they wouldn't be together. She's also told me that as soon as I leave the house, she's going her own way. Both of them were immigrants. They met one night when he went to eat at her restaurant; she was his waitress. You know, they got together, had fun and whatnot, and nine months later I came along. All of us shared a bedroom until I was eighteen. It was just their bed, my bed, and a little desk in between. They both worked every day. And by every day, I mean Monday to Monday. Between them it was just enough to afford rent, utilities, and food. They had a lot of arguments about money. There was a lot of high school drama. They would set aside their differences for the sake of my future, but it wasn't ever no real romance. The only time they would show affection is my birthday parties. Whenever we took a group photo at my birthday party, there would be extra love. Right now I'm a junior in college, so I'm almost out of the house. It's funny. They've actually been a lot more lovey-dovey lately. They've been hugging and kissing in front of me, saying 'I love you' and all that. Sometimes I get weirded out. I'm like, are you guys for real? Do you even want to split up anymore? But then my mom tells me: 'Yes. Definitely, yes.'"

"It was day fifteen of COVID. I'd been eating Wendy's for fourteen days straight. Bacon whatever-the-hell-it-is. A lot of good, hot, cheesy nastiness. I was starting to feel it, bad. It was like: 'I gotta move.' Plus I wanted to let people know: 'This is New York. We're not going anywhere.' I can go about eight miles before I run out of charge. You gotta be respectful above Fifty-Ninth Street. A lot of elderly people up there. They've got sensitive hearing, so you've got to be mindful. Normally I'll play Sam Cooke, Otis Redding, Elton John—all the old good stuff. But after Fifty-Ninth there's no limits. That's when the city kicks in. Anything goes: disco, hip-hop, house. I'm competing with the sirens and trucks, so the louder the better. I got these dual fifteen-inch speakers at a really good electronics store in the Bronx. It's called 'Going Out of Business.' That's not the name, but they've had that sign in the window for twelve years. Corner of Third Ave. and 149th. Tell them Love Train sent you."

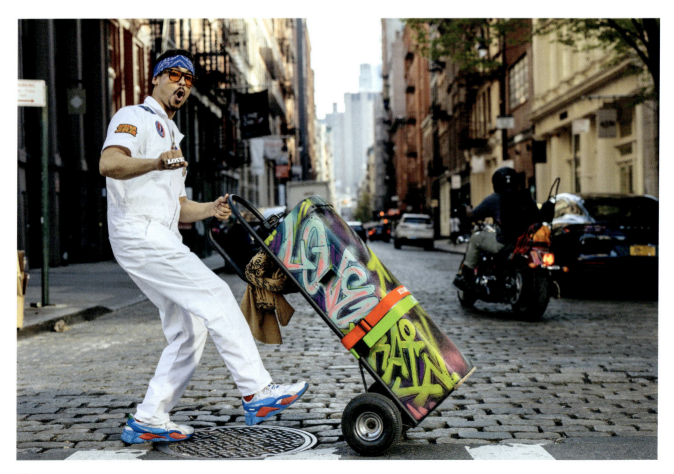

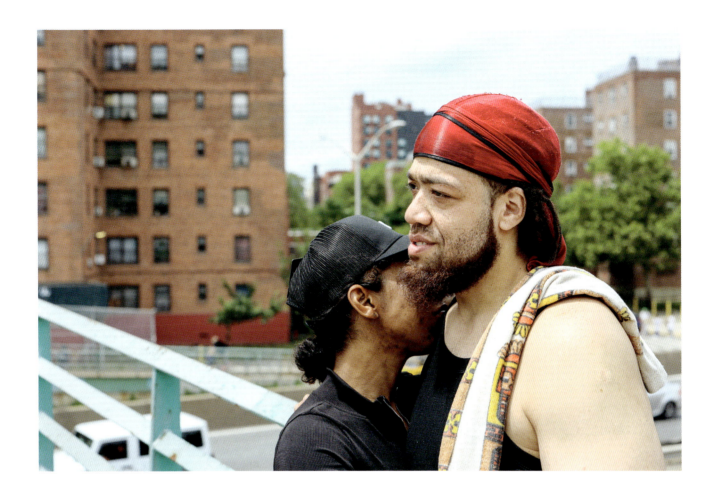

"I just finished my third state bid, the longest. Ever since I went through those doors the first time, it's like a spell has been cast upon me, pulling me back. Every time I'm going back on that bus, it's a familiar feeling: you know exactly where to fit in, where to go, what to do. They make it so comfortable in there you don't even mind doing a little time. It's not that you forget you have a family, because home is always on your mind. But it's like another home; a place you just get to float. So many responsibilities are taken off your plate. You don't have to worry about no meals. Don't have bills to worry about. You don't have to worry about your kids: getting them to school, picking them up. You're just in there, like a free man."

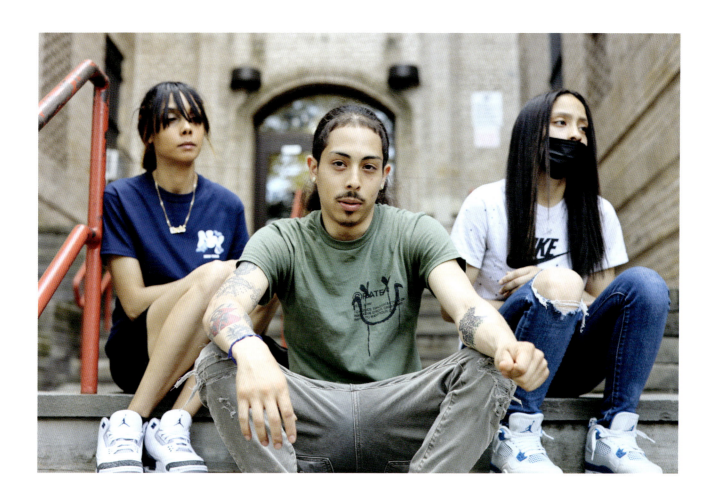

"I'm not ungrateful for nothing. We always had shelter. But let's just say our parents didn't appreciate each other enough. Little things would blow up fast. One bad communication would affect the next one. They didn't know how to maneuver like that, you know? And it fell back on us. There were times we were made to feel older than we should have. Having to work concessions at Yankee Stadium when I was fourteen, off the books, 'cause my family's going through it. Having to make sure my siblings are good. I won't say I was robbed of anything. I don't like to speak about it like that, not at all. But at this age, I shouldn't know what life is about. Not like I know what life is about. Growing up was—life. You know what I mean? And life ain't easy."

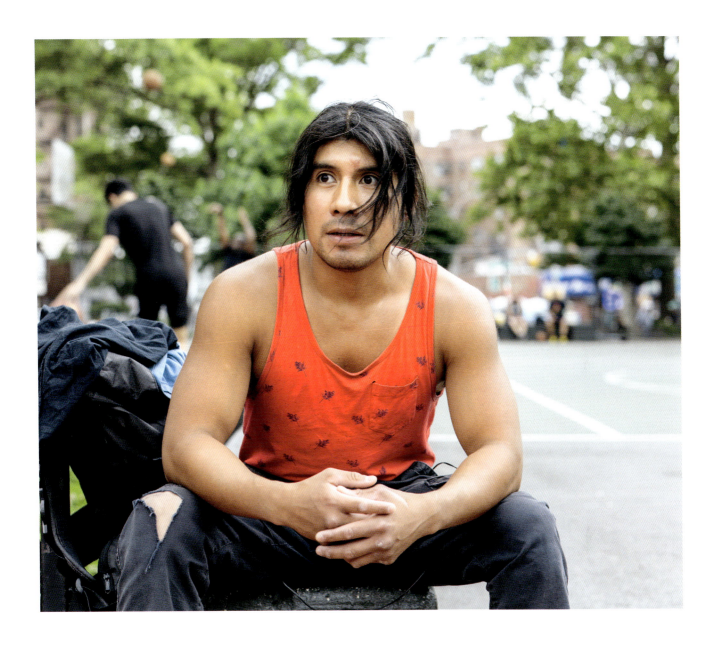

"He always got home at seven. If he was ever late, I was hoping he got in a car crash. Or got stabbed in a robbery or something. And when he did come home, it was like—fuck, he's here. I visited him a few years ago. I thought maybe he just didn't like kids. And now that I was an adult, there could be a relationship. When I got to his apartment I wasn't sure what to talk about. I think I brought up boxing, because I knew he liked boxing. But he immediately took control of the conversation. There was no back-and-forth, he just wanted me to listen to him talk, talk, talk. It felt like I was a kid again. At one point there was something I wanted to say, and he shut me down real quick. It was like: I don't want to be quiet no more. That's when I swung at him. He ran into his room and locked the door. A lot of people say it doesn't do anything, to get revenge. Or that it makes you feel worse. But for me it felt good. I liked that he was the one feeling vulnerable. I liked that I could finally hurt him."

"She forgot us. There were four of us in our friend group, and she was the one who was usually the most available. She was the one who always wanted to meet for $1 samosas and talk for hours. But then suddenly she was never available. We'd text her, like: 'Do you want to hang out and stuff?' And she'd never reply. So yeah, we felt like we lost her to a man. We were like: 'You want to be with a man, fine. Go with him.' We didn't talk for almost a year. Then one day she posted on Instagram that she had COVID. She was like: 'Pray for me,' or something like that. And I was concerned. We were still fighting, but I 'liked' a few of the comments. Then a couple weeks later me and our other friend went thrifting. We started talking about how long it had been since the four of us had all been together. And so we decided to call her. The best part was we never even had to talk about what happened. As soon as she arrived, we started fresh again. It was that simple. We finally got to know the guy. And after we got to know him, we were like: he's not trying to steal her. You know, he's making her happy and contributing to her life and all of that stuff. Right now we're practicing for the wedding dance. It's a Bengali wedding, but we're obsessed with Bollywood. So it's gonna be a Bollywood dance. And she's super nervous. Because the dress weighs more than her."

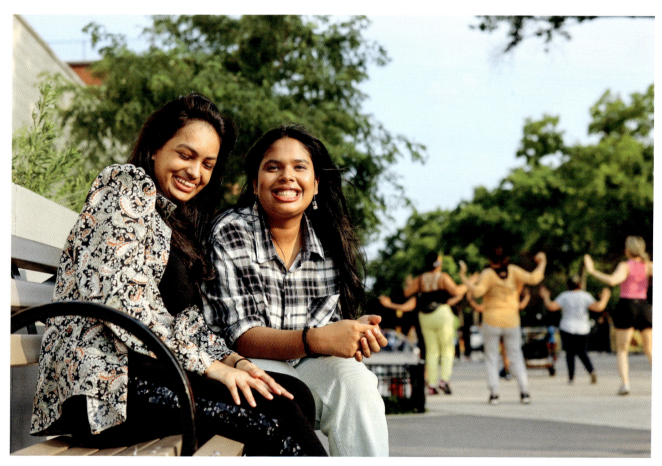

"Our mom wants us bonded up."

"Que a donde va uno, vamos los tres."

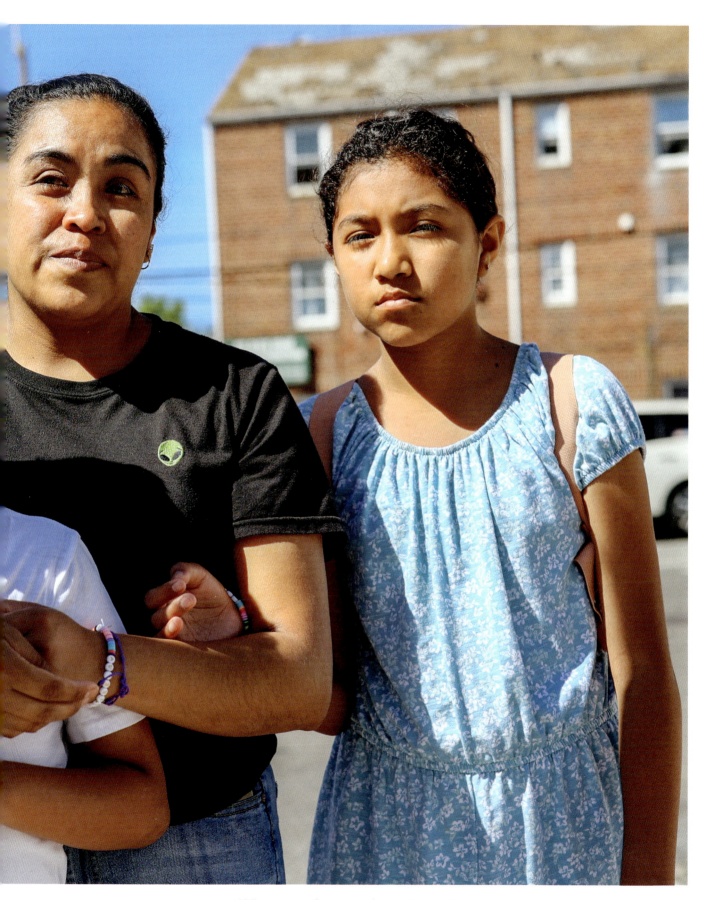
"Where one of us goes, three of us go."

"When I was fifteen I was trying to lose weight by eating tomato sandwiches. And man, it actually tasted good. You put salt and pepper, and some mayonnaise. That's all I ate. Only problem is I live in the Bronx around a lot of Spanish people, and they always got nicknames and shit. So now my name is Tomato."

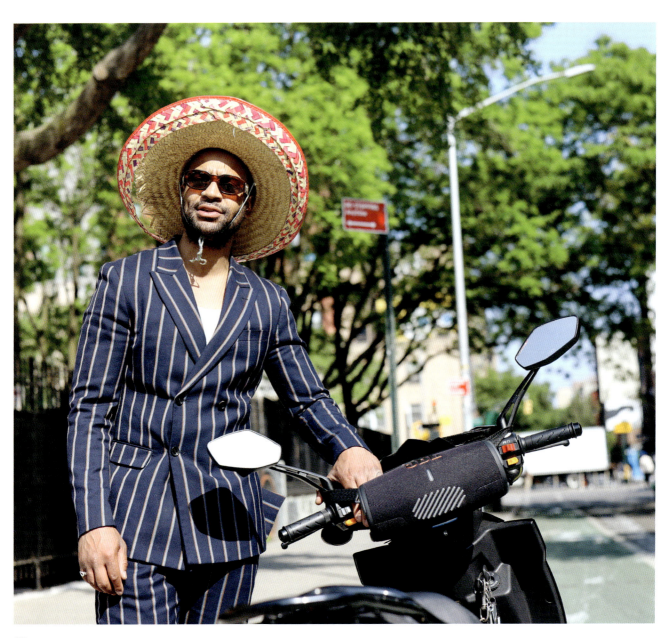

"They call me Oreo. Like the cookie."

"It's the postpartum that hit me. But I have to get up and fight through it, every day. I organized all this myself. I want her to know that she has people here who love her. I grew up hard, honestly. I struggled. My mom was there—but she wasn't there. She was young, she was partying, she was never home. I can only remember having one birthday party; at the skating rink. So that's why every birthday is important to me. I want her to remember this. I want her to remember every birthday."

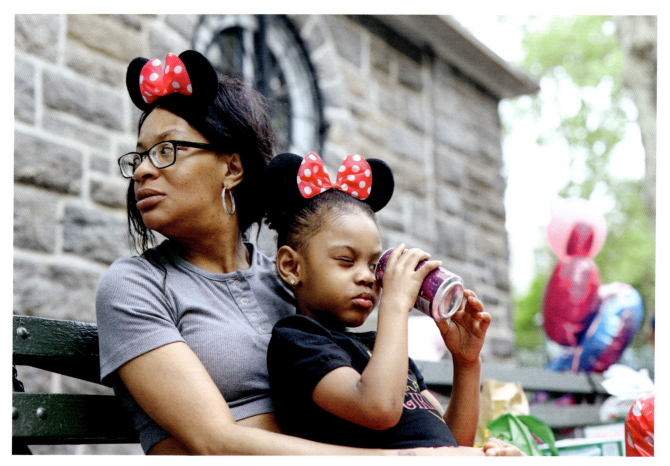

"I came to the city at the age of twenty-two; it was a perfect time to be in the New York City jazz scene. I got to sing on stage with Dizzy Gillespie, Joe Williams, Betty Carter. I ended up falling in love with another jazz singer. We became a duet, had some success, raised our children on the road. But then we fell apart, and so did our careers. I was never able to build it back to what it had been. Now I'm watching my kids succeed more than me. It makes me feel like I did my job as a mother: I was able to pass down everything I know. But it can be painful, too. Because they're doing everything I desired most: they're on stage, sharing their talents, being recognized. There's a voice inside me that says: 'You deserve that too. There's still time. You can still do that.' But that's not the story I need to tell myself anymore. I don't need a story to help me fight. I need a story to help me feel good in the moment. There's this more mature part of me that says: 'Relax. You did a good job. You did a lot of stuff.' The earth life only offers so many types of experiences. And I got to play so many parts: I got to be a singer, yes. But also the faithful daughter, the free-spirited girl who went off to explore the world, the pot-smoking hippie, the wild woman, the fool, the lover, the wife, the scorned woman, and the giving mother. Now I feel like I'm getting back to the Kim I was when I was five, before the story began: joking around, singing to my cat, singing to people on the street. Being happy for everyone else's success. Not worrying about getting ahead. And believing that I'm exactly where I was always supposed to be."

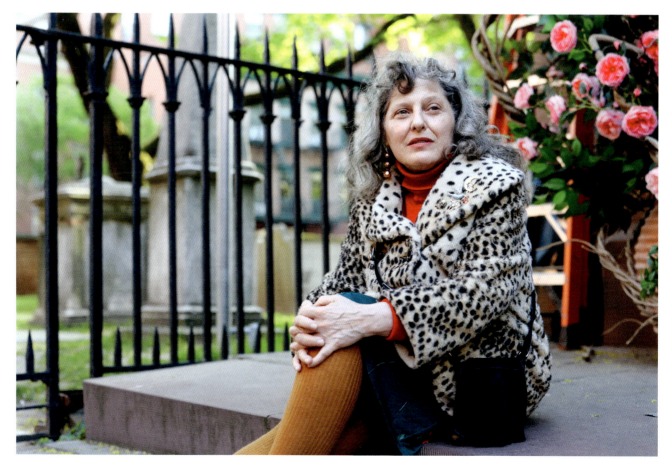

"The first song I ever wrote was in this park. I was thirteen. It was me and two other girls. We jumped the fence and sat on the grass and wrote in the sunshine. We made a rule that we wouldn't write about boys, so the song was called: 'Not to Write About Boys.' We thought it turned out awesome. And two days later we played our first show in this same park. Writing a song feels a little different now; it can be easy to get caught up in the pressure: the deadlines, the expectations, what people think. One wrong word and it becomes too cheesy, or too cool. The only way I know how to do it is to write for the fan in myself. There's a songwriter in me that writes the song, but I listen as a fan. Both parts have to weigh in, but the fan gets the final vote. When the fan inside me says: 'I get that. I feel that. It makes me so fucking happy.' Then I know I finally got it. That's when I know it's done."

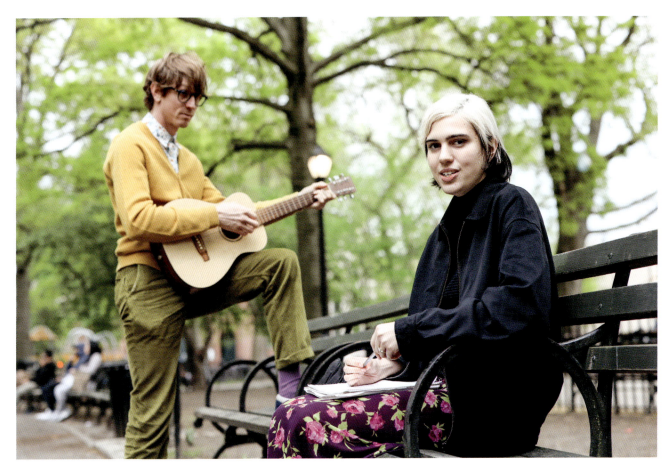

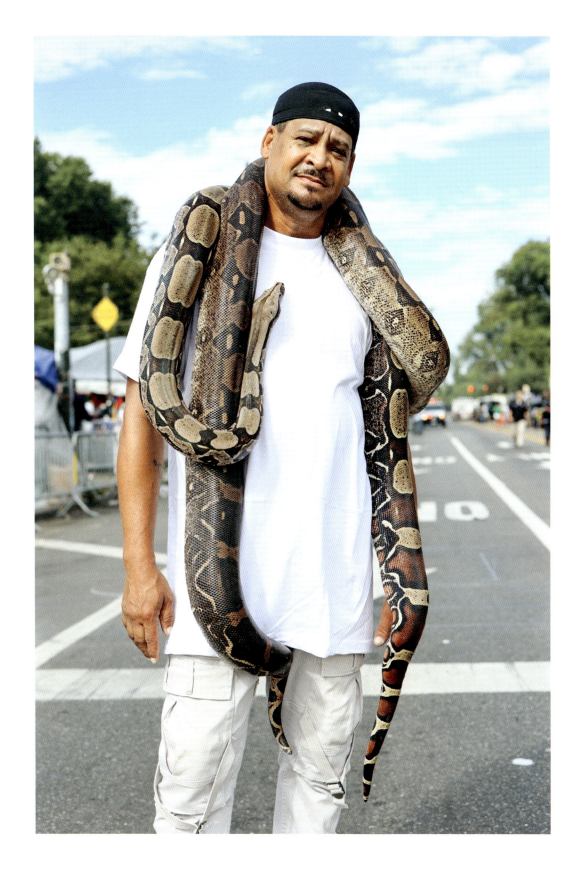

"I like when they bite me."

"Like, porn star–level sex. Ever since I was a teenager. I worked as a Chippendales dancer for a long time. I used to have long, red hair. I've been on the cover of romance novels. And I've also been gifted with great hands. I once wrote a book called *The Extension of The Female Orgasm*; I lost it in an old computer. But needless to say, I can make things happen with the human body. I'm kinda lucky downstairs, and I've done the work. There's pumps and stuff that can make your ding-ding thicker and longer. But mainly I've been gifted with the willingness to listen. When women give you guidance, and you're willing to listen, there's no limit to what you can do. I once provided thousands of orgasms over a five-year period, without ejaculating a single time. It's called Mantak Chia's Microcosmic Orbital Energy Raising. It's a Daoist lovemaking technique where you don't release your seed. You pull all your vital energies back into you, and spiral your electric body to create a really powerful connection. Too powerful, honestly. It needs to be disclosed. Because most people don't even realize you can take sex way deeper into an abyss of orgasmic pleasure. It's intergalactic if you do it properly. But there's a dark side. One time I went to somebody's house that I hadn't seen for two years. We were just having dinner. But then I go to the bathroom, and I open the vanity mirror—which I know I shouldn't do—but I did, and there's an altar to me. With all these pictures and different candles. I had to learn that I was hurting people emotionally, spiritually, and even physically. Because they're probably never going to reach that level with someone else. Imagine having the perfect steak at your favorite restaurant, then eating nothing but dirty sock soup for the rest of your life. I never wanted to hurt people. I love people. I'm trying to be a better person. And part of being a better person is to put the other person's feelings first. So now I tell people right from the start—the complete honest truth. 'You're an amazing person. And enchantingly beautiful. But I'd rather just be friends, instead of having amazing sex that is probably going to make you hate me.'"

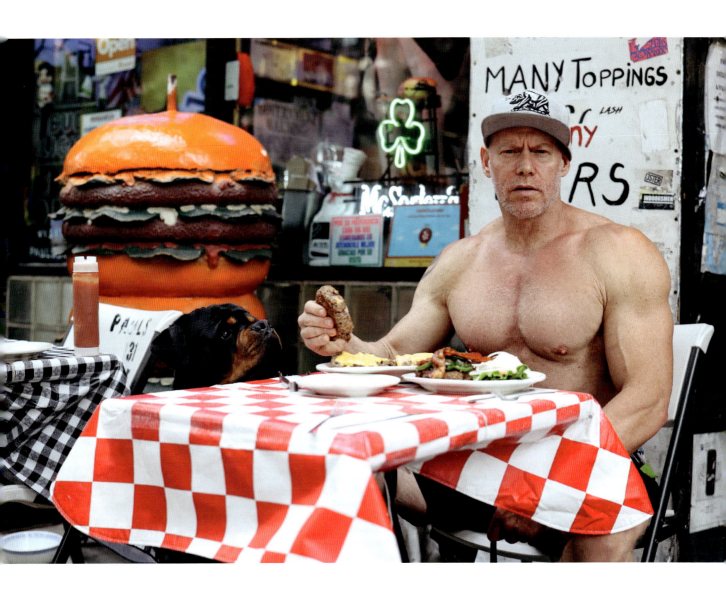

"I've been this size since I was nineteen. I know what I look like. When a guy like me makes a move, it can be frightening. So I always let the woman lead. I know that when she's ready, she'll let me know. She'll give me the cues. When that happens, I'll usually begin with the magic wand trick. This is important. I'll ask: 'If you had a magic wand, what would be your magic man?' I give them the freedom to tell me how they want to be treated. One thing I've heard from a lot of women is: 'Wow. You don't go down on me like a guy.' That's because I've done a lot of listening. Most men just put their whole face in it. That's way too much. That can sometimes hurt, especially if there's stubble involved. I'd personally recommend shaving your face right beforehand. Shave that shit down until it feels like a baby's ass. But at the very least you've got to lead with the lips. Use the tongue very gently. Don't go straight for the clitoris, one o'clock will do the trick. Aim for one o'clock. You can't go wrong with one o'clock. But don't live there. The entire area is sensitive. With men it's all about the penis. But with women— it's all about everything. Except the butthole. This is an important one: the balloon knot is not for you to touch. Ever, not even once. Unless you're asked. And even then there are preparations involved unless you want the whole house to smell like baby diapers. So always ask. Always, always ask. Ask if she's comfortable with fingers. Ask if she's into verbal. A lot of women want to be talked to. Others don't want to hear a fucking word. It scares them. So you better ask. Also—and this one might be surprising—a lot of women don't want to go face-to-face. If you're kissing them, or being too intimate, they might lock up. They'll make it very clear with their actions and words that the intimacy scares them. It's a heartbreaking thing. Because it's obvious there has been some trauma. If that happens, just stop. Stop everything and just hold them. Don't even ask them about it unless they choose to tell you. Maybe sex comes later, when they're comfortable. Maybe it never comes at all. And that's fine. Your only job then is to be the gentle soul that they need. For as long as they need it."

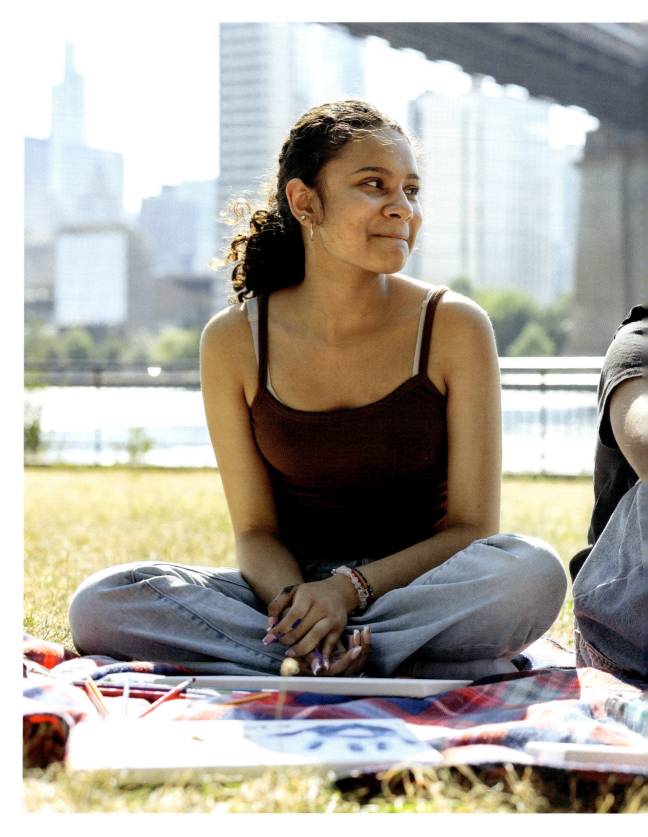

"My dad is still 'iffy' about him."

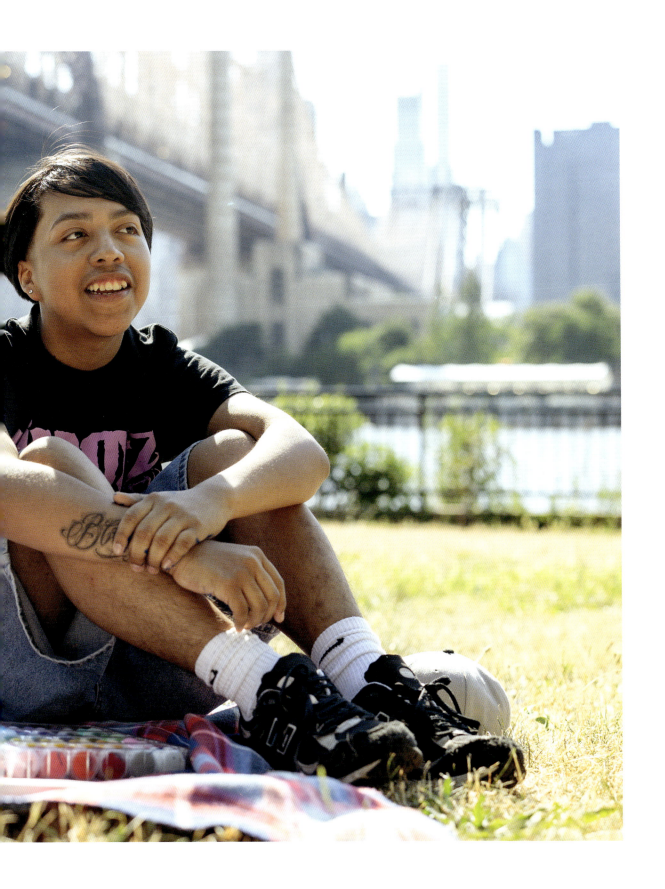

"None of the decisions I made led me to fame or wealth, but they have led to really rich relationships. I just kept leaning into the people I cared about. I chose a job that allowed me to work remotely for thirty years. It allowed me to be home a lot with my wife and three daughters. Never missed a game. Never missed a school play. I picked them up from school every day at 3:30, unless I was traveling. I wasn't a road warrior or anything. I only traveled a handful of days every month. And whenever I had to catch an early morning train to meet a client out of town, I'd be doing this calculus: 'I have to do this now, so that we can be together later.' They were always my first priority. And they still are. We don't get to see each other as much. But I get this warmth every day when they ping me and tell me they're doing something. And it goes both ways. I gave a speech for work the other day. It went really well. And they were all excited to hear about it; high fives and cheers all around. This morning I had a little time between meetings. I was sitting at a little bistro, and I had a little virtual lunch with my daughter who lives in Paris. She was making dinner there. And we had a little chat. No other description necessary, right? It was wonderful. I just feel incredibly lucky that I get to do those things—and that they still want to do it. They still want to spend time with me. Maybe because they trust me. I try to be supportive and nonjudgmental. But I think it's mainly because I was so involved with their daily lives: all those plays, all those practices, all those trips home from school. That's a lot of conversations. It really accumulates over the years. I really got to know them. They're my friends."

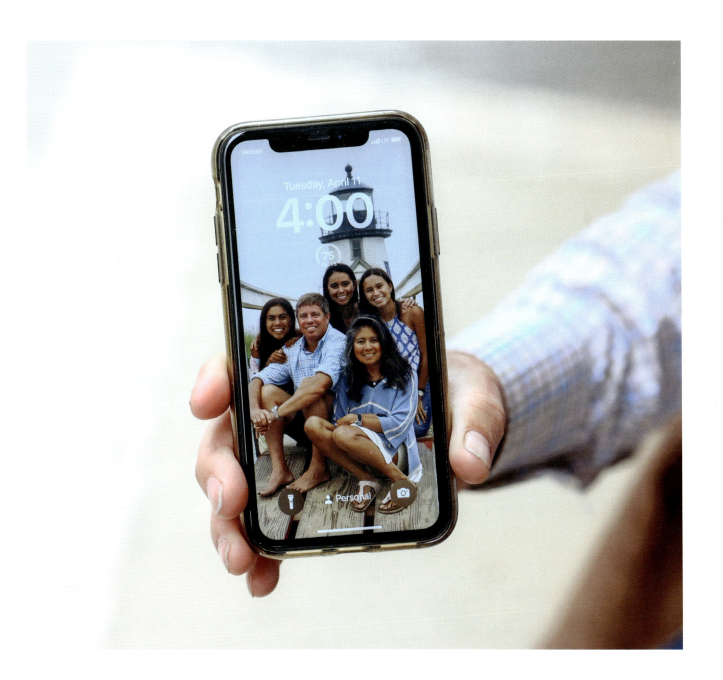

"When I was sixteen I signed up for lessons with a famous Russian ballet dancer. She was a little lady; told me that I danced like a lobster. Not exactly encouraging, but when I came down the stairs after my first lesson, Eartha Kitt was waiting in the lobby. Not that she was waiting for me; it was for someone else. But I saw it as a sign. I thought: 'I'm on my way.' A few months later I made my debut dancing to bagpipes at the Scottish Highland Festival. Then after that I got a gig at the Wine and Cheese Festival. And I never stopped. I wasn't good enough to do it full-time. I had to work as a Spanish teacher for thirty-three years. I was competent; my kids did well on the tests. But I wouldn't say I was beloved. And when your name is Mr. Bate, the kids are going to call you Masturbate. It's unavoidable. But each day when that 2:42 bell rang after eighth period, I got on a train and headed to my second life. I've danced it all. I was a flamenco dancer. I learned Afro-Haitian, Afro-Cuban, Afro-Brazilian. I danced in the Sambadrome during Carnival. I danced with an Appalachian clogging company. I've danced in every major theater on Broadway. My specialty was screwing up the choreography. I've actually heard audience members say: 'Oh no, not him again.' But I always figured out a way to work. I've played every kind of character role. I've played Von Rothbart, the evil magician. I've played Nutcracker. But the role I loved best was Handsome Haldor. He was a total flop. But in his mind—he was the most magnificent man in the entire kingdom."

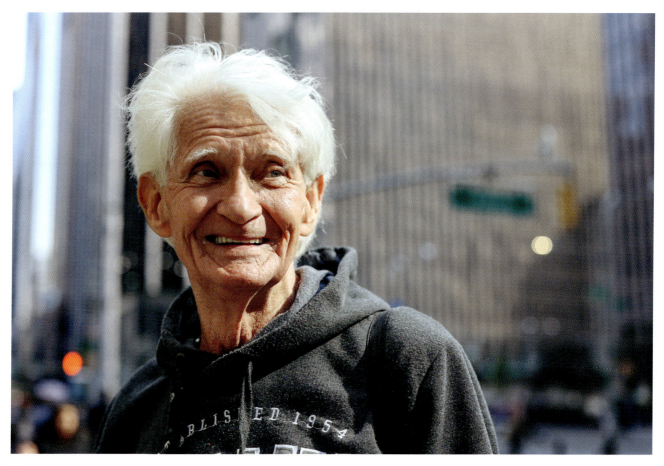

"I've never been a sports person. But I just spent three years locked in my apartment. I've cycled through all the arts and crafts already: painting, ceramics, you name it. So I wanted to try a sport. And let me tell you—it's a whole new level of pressure. Because there are other people involved. They told me that pickleball was a sport anyone could play. I took them at their word, and it's been torture ever since. I started with a class at the YMCA; they advertised for people with 'mixed abilities.' But when they say 'mixed,' that means mixed with advanced people. During my first game, I flew. I mean, I actually flew. Balance is a big issue at my age. If you don't balance, you fly. And I flew. The teacher said: 'If it's out of your range, just let it go. Let it go.' Everyone was sympathetic. I think they were impressed I didn't go straight home. But after the first game, you know, people have expectations. I couldn't serve, I couldn't return. Nobody said anything. But when there's a bunch of stuff you're supposed to do that you can't do, and every time you play, your side is zero—people start to notice. They try to act like they don't care. But this is New York; there's limited time on the courts. They care. After my third game I was like: 'See you later.' But I'm going to keep trying. Winning isn't important. I'm not a competitive person. But I'm the kind of 'not competitive' that's not competitive because I know I'm going to lose, so you know what? Yeah, I'd like to win one."

"The school wanted to create some new after-school programs. I'd run track in high school. Was I good? No. But I ran. So I volunteered to create the track program. The minimum to form a team is eight girls. Luckily I'm a cool teacher. I'm not rushing them to be grown. And I know the memes. So I had some girls who signed up just to be around me. In the end I found my eight. Nobody had any track experience. But these girls had playground reputations; they were fast. We just needed to build up our endurance. At our first practice we ran around the track one time, just to see how we were feeling. I ran out front to show them how it's done. At one point I turn around—I got girls walking, I got girls stopping. My goal was just to finish the season. I wanted them to learn commitment. So when they grow up they can determine their own way without somebody pushing them. We were a little nervous on the morning of our first meet. Some of us were panicky. Some of us were crying. I told them: 'We don't need any MVPs. We don't need any Rookies of the Year. Just don't stop running. No matter what—just don't stop running.' All of them raced in different heats. Then the scores started coming in; it was like: 'Whoa. What's up. We winning this?' A lot of the girls placed. Our captain, Jaziah, was second out of twenty-four girls. That was the day we became a team. I started buying Gatorade. We chose a team name. Every time I gave a suggestion, they'd be like: 'That's corny. That's corny.' They're in that phase of like, they hate everything. But when we got to Baby Got Track, that hit. BGT, baby. BGT. Now before every meet we do our BGT chant to give us a little bit of that braggadocious energy. Tomorrow is the championship. We know that we can do it, and we're gonna show that we can do it. But no matter what happens, these girls have already inspired the entire school."

"From all sour-faced saints, deliver me, O Lord. I don't want to be with a grouch, a crab, a crocodile in a moat. The grumps are a small minority. But they're vocal. Yes, the grumps are vocal."

"I smoke weed religiously."

"The question everybody wants to know is: Why don't the aliens contact us if they're really here? The answer is simple: because it would melt your psyche to contact beings from another dimension. Whether it's ghosts or spirits or deceased relatives or past lives or future lives or aliens or Bigfoot or fairies, all of it will melt your psyche. Because you've been programmed by The Empire to believe those things don't exist. Unless of course you're an indigenous person raised on traditional shamanic ceremonies. I learned all this by talking to other humans on other Earths in other universes, so I'm trying to not blow your mind right now. When you're talking about other dimensions you have to use a lot of metaphors—so just imagine Earth as North Korea. You've probably seen enough documentaries to know what's going on in North Korea. The North Korean people are completely mind-locked and brainwashed, and they have a completely inaccurate understanding of the rest of the planet. Well, that's the same thing that's happening here. Earth is the North Korea of the multiverse."

"I used to think about death a lot but now I don't think about it as much because I do other stuff."

"My father died before I was eight years old. But that gave me enough time to experience him deeply, and to have deep memories of him. He'd already been through World War II: the Normandy invasion, Omaha Beach. So for him to survive all that, and live long enough to become my father—was already a miraculous thing. I was very loved, very welcomed, very cared for: my parents were thrilled I was their child. And I wasn't easy, I was a willful kid. When I was younger I traveled quite a bit. I haven't been to every place, but a lot of places: Greece, Turkey, Alaska. And this wasn't just going on tours. It was real, vagabond stuff. No reservations, no plans. Just deeply experiencing another culture and another place. I've done every kind of work, from agricultural labor to factory work. For twenty years I was a social worker with seniors. But I can't even call that a job, it was a service. We really took care of people: brought them meals, helped with housekeeping. It was an absolute calling. Sometimes I wouldn't even go home, I'd just find a place to sleep. I was a total workaholic, and now—I'm a total playaholic. I come to this park to listen to jazz piano. I go to Juilliard to listen to student recitals. There's going to be a Dixieland ragtime ensemble near Macy's. There's nonstop free music in New York. I mean, it's endless. The opera just started. They play it on the big screen at Lincoln Center. That was very exciting to see: a lot of talent, a lot of drama. I'm just grateful for good health to enjoy it all. So many people wake up in pain. But I have my health, and I have a home. I mean, it's not a home. But I have a place. A safe place to rent. It's just been a blessed, beautiful life. The perfect life for me. I found it very, very rich. Very deep. And I think all of it was a blessing. All of it, miracles and blessings."

"My mom would say that I just need to be right, all the time. So maybe it stems from a personal flaw. But the reason I love math is that it holds at all times, in all instances, necessarily. So no matter what you throw at me—this thing is going to be true. And if you want to be right—that's the level you have to play at. Most people put their faith in some sort of higher presence to get that security. But I want that 100 percent intellectual guarantee, and that's going to require a mathematical element. There are things like computer science, and physics, and chemistry, which you can call applied math. But even those things are tainted by the physical world. Physics describes the universe as it is. But the universe is just one configuration amongst infinite possible configurations of the universe. If you can find something that is true in all possible universes—you can stand much firmer on that. And that's what I want to find. Something that is necessarily true at the highest level of the hierarchy. I want that God POV."

"Even if you found The Truth, no one would agree with it anyway."

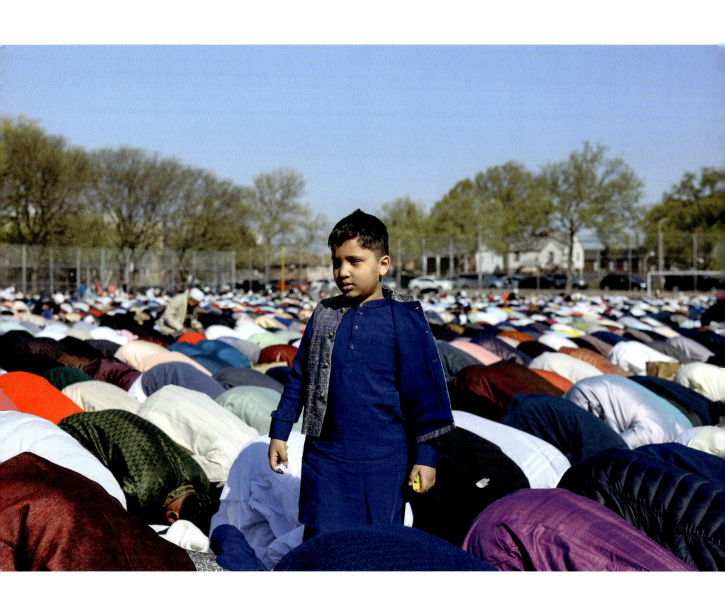

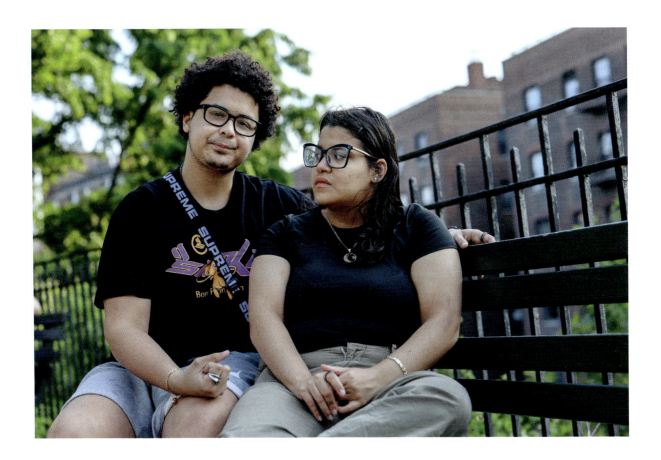

"Growing up I was very much in my own head, my own world. Instead of getting a babysitter, my mom would just go to work and leave me at the house. We didn't have a TV or anything. And when there's no one to talk to, you just become your own friend. I'd look out the window and try to imagine myself doing things. Like: 'What would it be like if I was standing on that roof? What sort of things would I see?' But if you do that too much, at some point you get lost. It's hard to explain: but I never felt alone. It's like you don't feel lonely if there's never anyone else there. But things are different now. When she's not with me, I wish that she was. I know what it feels like to be alone."

"The cousin thing doesn't even really fit. He came to live with us a lot when we were growing up, so he's more like my brother. Everyone called us the Giggly Twins. Because we were always together. And when we're together, everything is funny."

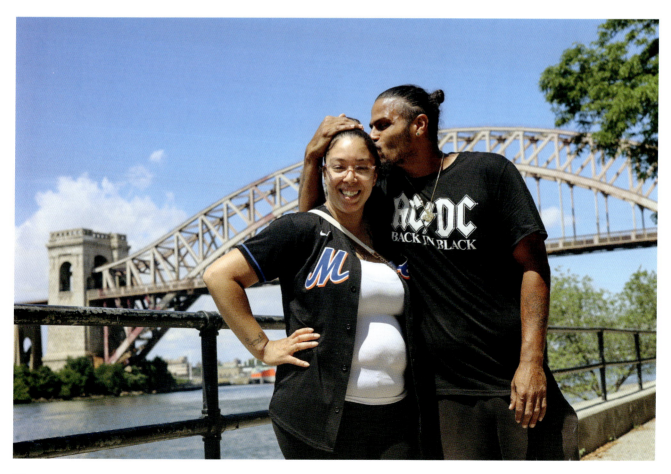

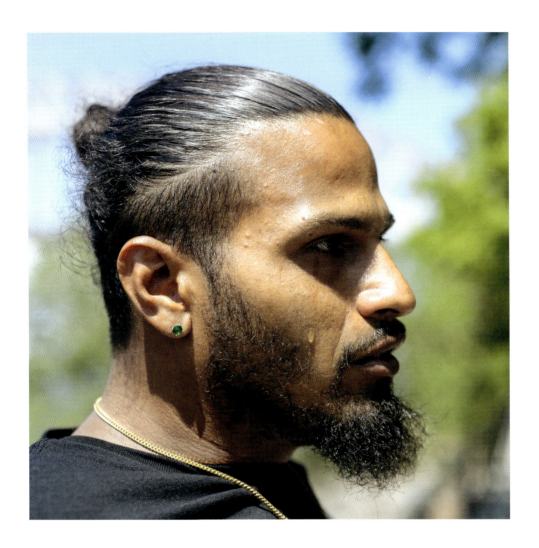

"She's always reminding me to stop and breathe. It helps with my anger. Especially these last three years, being away from my son. Going for so long without seeing him, then when I do get to see him, hearing him call out: 'That's my dad! That's my dad!' And seeing that want in his eyes. I know those feelings, 'cause I grew up without a dad. So seeing him feel those same feelings that I never wanted him to feel; it hurts inside. But she's always reminding me that we can still make amends, despite the things that we put our children through. She reassures me that I'm a great father. And everything I do is a step forward to getting back into my son's life. That it's not all in vain. And I need that sometimes, because it can get so overwhelming that I just want to give up. But I can't do that. Because my father gave up, and I know how that felt."

"The person who hurt us, hurt both of us. But it affected us differently. I isolated myself. I started taking drugs when I was twelve, maybe thirteen. But she just moved on with her life. I could never understand: How can she be so happy, while I'm stuck in my head and constantly thinking about it? It was exhausting to me. She was exhausting to me, especially when we were teenagers. I couldn't stand to be around her because she was so light and positive and funny. Everything was always so cool, and so good. It felt to me that she didn't want to face it. She just wanted to accept that it happened, and move on. But I couldn't move on. I didn't have that choice. I couldn't just choose to not think about it. I remember the bad things, and how they made me feel. And I never want to feel that way again. I couldn't just go back out into the world like it never even happened. I know that there are a lot more good people than bad, I do believe that. But there are bad people too. And they can really hurt you deeply if you give them your trust. So I never trusted anyone. Three years ago it reached a point where I felt completely hopeless. It was all so exhausting. I was exhausted. Exhausted from carrying these heavy feelings. Exhausted from making bad decisions. Exhausted from the drugs. It felt like nothing was ever going to change for me. Around that time we went out to dinner with my mother, and we finally had a deep talk about everything. We'd talked about it before, but maybe this time I really meant it. I decided that I have to let it go. I just have to let it go. I still have dark times when I don't want to study or work. But when I'm in a bad mood, I'll turn to her. Her happiness doesn't make me feel worse anymore. It motivates me. It inspires me. Now she's the person who can most easily put me in a good mood. I let her be a part of my bad days. And because of that, she's also become a huge part of my good days."

"No story,
 no lesson,
 no meaning."

"The kids are oblivious right now. They just think they're at the park. I'm the one who's got to figure stuff out. I've got enough money for us to get home. Then I've got to find a way to get something to eat. I've got to pay bills. We're starting to get foreclosure letters in the mail. It's just impossible to make ends meet right now, unless you've got school. I'm educated, but I just don't have any degrees. I have no way of showing to a job that's never met me: 'Hey, I can do this.' Plus I never know how it's going to turn out, and that alone scares me. Maybe I'm just a pussy, I don't know. I'm not proud of the stuff I'm selling. I've seen what it's done to my mom, which is why I don't use it. I don't want that for my kids. I don't want it to fuck up their life like it fucked up my life and my mom's. That's how I actually learned about it. Seeing how she'd fight to get that shit, no matter what. I know I could be selling to someone else's mom. And yeah, it sounds evil, or whatever. I hear that little voice in my head like everyone else. But I weigh what I need more, and I need stability. I need money: money for my kids, money for me, money for all of us. So I block that little voice out. I'm on autopilot. Quick exchange: I get my money, they get their fentanyl."

"I've been trying to be on social media less and less. I don't know, something is shifting. There seems to be this pressure to always focus on the worst thing that is happening in the world. And beyond that, to be vocal about it. To take a stance on every piece of bad news. Sometimes that pressure can come from two different sides of the same issue. Maybe this time is different. But it's hard to remember a time when there hasn't been some issue that everyone is being collectively made to feel like they need to speak about. I'd never dismiss the importance of advocacy. I'm on my way right now to a big rally for bike safety. It's been the deadliest year in history for New York's cyclists, and people are trying to fix that. So I want to do my part. I don't think we should ignore the horrors of life. But it's helping no one if we fixate on them. Nothing will ever change if people feel hopeless. There are so many things that people could ingest that would give them hope, and make them excited to do what they do. But I'm just not seeing very much of that anymore. Less and less people seem to be sharing the beautiful song they just heard, or the beautiful art they just saw, or the beautiful Halloween decorations that just went up on Eighty-Seventh Street. For better or worse, all I ever see anymore is: 'This is a problem. This is wrong. We need to address this.' And when that's all there is, maybe people feel shy about breaking that up with something that brings them joy. And that's a shame. Because the things going on broadly in the world are important, for sure. But so is this. So is this gorgeous day in the heart of fall."

"I'm turning forty in August. Three kids, full-time job. All my kids are under the age of seven. The amount of mental energy it takes, you know, juggling all of them and the constant questions about nothing. I mean, 'Mom is busy, please, just give me a second.' My husband tells me that it's just the season we're in. We'll get back to it. But I just want it to slow down so I can pause and breathe. Everything just changes so fast, you know? When you're a little kid, and you turn into a teenager, it's like: 'Oh, I'm changing now.' But you've been coached. You're prepared for it. Then you go from teenager to college. That's a big change. Then from college into your twenties, still changing. But at some point you kinda feel like, I'm an adult, and I'm done. But you just keep going. It's like, oh shit, no, no, I'm going to keep changing. And these aren't like the earlier changes. These aren't the ones you get to plan for. Well, some of them are, like: 'We're moving to a new place.' Or 'I'm going to get a new job.' Those you can be ready for. But as you get older shit starts getting thrown at you that you're not planning for. Dodgeballs. And you've just got to pivot. And all of the sudden you realize—that moment in time, right before the dodgeball—that was the last time you saw the old you. And you didn't even get to say goodbye."

"It felt like freedom, maybe; but I was spiraling. There was a hurricane in my head: certain addictions, and impulsive decisions that could affect me for the rest of my life. Other people would see it, and they'd say: 'He's so fun.' But nobody was looking at me, really. They'd never have noticed if I was hurting myself, or if I slipped away. I got good at floating around and giving people what they want—just enough positivity—so I could get through the moment and leave a good impression. But I can't do that with her. When I think a certain thing, she reacts. She wants to know more. And when I feel a certain way, she feels it too. Nobody's cared like she cared, you know? I feel seen. I feel found. Like there's something outside of me. Sometimes when I'm sleeping, she'll do this thing. She'll reach over and touch my face. She'll just hold on to it. And that's the image that keeps coming into my head when I try to describe her. She touched my face."

"We've got to get Jessica's flowers ready. She just became a florist, today is her first event, and she's freaking out that we're going to be late. I'm telling her, 'Jessica. Relax. I'm a phenomenal driver.' Me and Jessica have the same birthday: March second. I've got a birthday card from her on my bed stand saying: 'You're a beautiful person, put you first.' She's always dropping gems like that: 'Don't weigh too heavily on things. Nothing is permanent. You're always exactly where you're supposed to be.' She is a visionary. A pourer of love. A light. But punctuality is not her strong suit. I got here at 8:30 A.M. My job was to drive, but nothing was ready. So I'm like: 'At least give me an apron.' We've been out here making flowers all morning. The block is lit. Somebody brought us mimosas which is maybe why I'm like 'woo' right now. Two little girls came by and we gave them custom bouquets. It's crunch time now and Jessica is starting to do the bumblebee, buzzing all over the place. I'm telling her: 'Jessica, relax. You're right on time, and exactly where you're supposed to be.'"

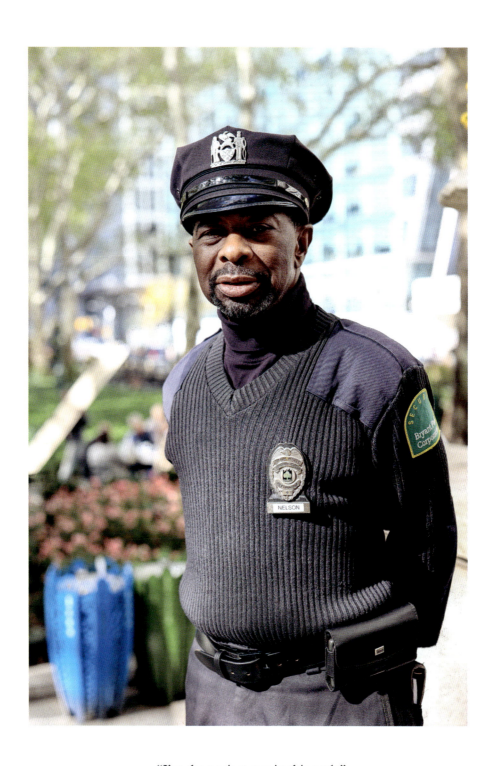

"I'm the nosiest guy in this park."

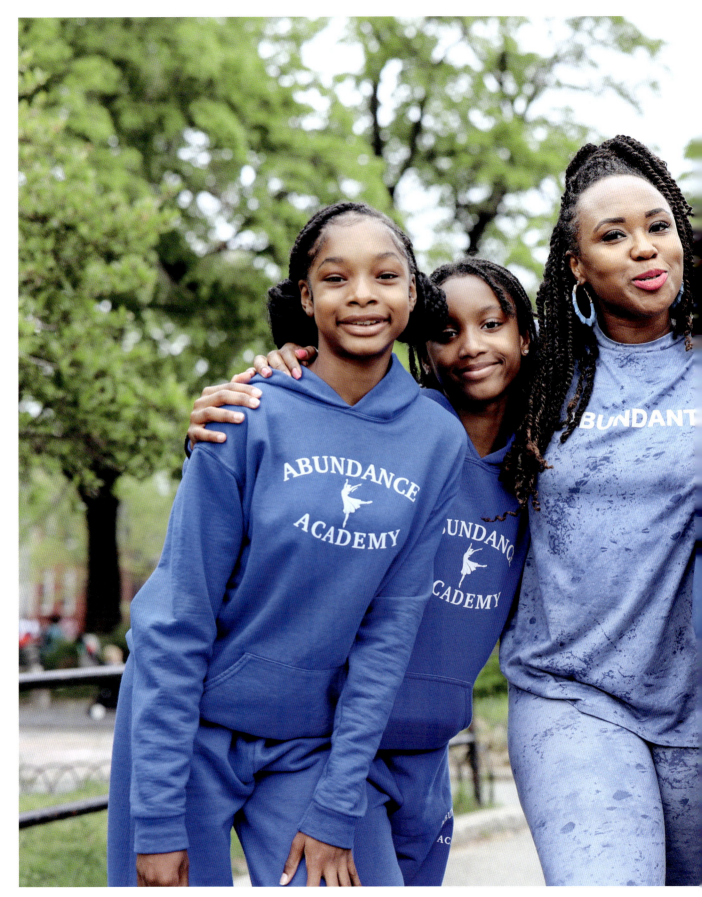

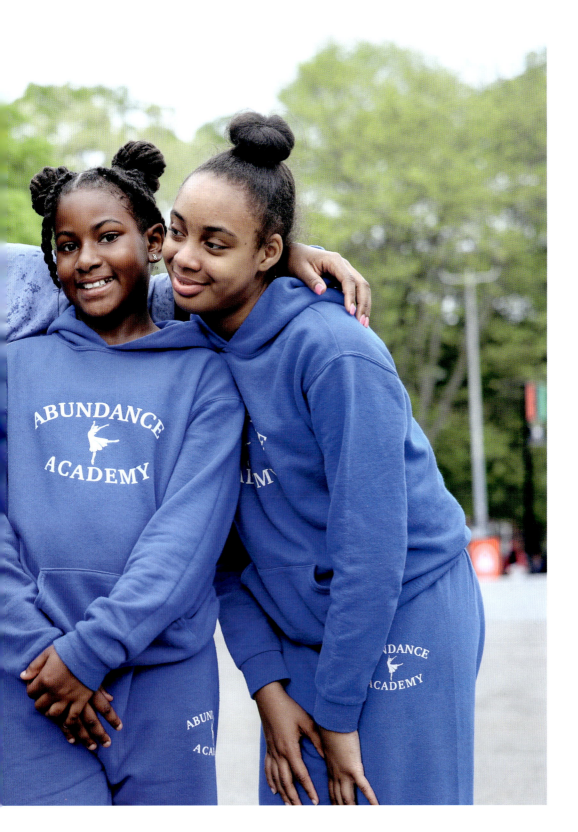

"These are my dance children. They are facets of me. They are me, poured into a little me."

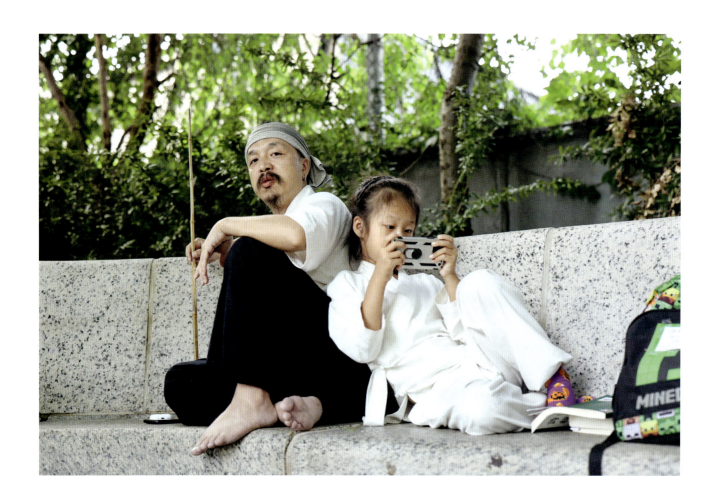

「在传统的中国文化中,最重要的是将'德'传授给下一代。现在让我向你解释这个'德'。它与人性和人心的知识有关,特别是道德律。西方哲学家康德曾经说过:'有两件事让我心生敬畏:头顶的星空和我心中的道德律。'在现代教育中,许多关注点在星空。但'德'所关注的是道德律。」

"In traditional Chinese culture, the most important thing is to teach '德' to the next generation. Now, let me explain this '德' to you. It's about human nature, and knowledge of the human heart—specifically, moral law. It was the Western philosopher Kant who said: 'Two things fill the mind with awe: the starry sky above me, and the moral law within me.' In modern education, much of the focus is on the starry sky. But '德' focuses on the moral law."

"The universe is my best friend. She's my BFF. I talk to her all the time. She's in every person that I meet. Every person that smiles at me. Every person that tells me I'm doing a great job. Sometimes I look up into the sky, look at the sun. You're not supposed to look right at the sun, but in that vicinity. And I thank her for all that she's given me. I ground myself in gratitude. And I express fully what I want with pure intentions. It has to be with pure intentions. When I ask for my art to grow and be successful, it's not for my ego or anything—it's just because I love it. Because I want to sustain myself and keep practicing. Then once I have a larger platform, my goal is to heal the world and help bring peace. There's so much to do it can be overwhelming—I don't know where to start. But with the universe everything is possible. I tell her: help me. Shift the plates in my direction so I don't have to singlehandedly be a savior. Align me with the right people and places and movements so that I can help bring peace to the world."

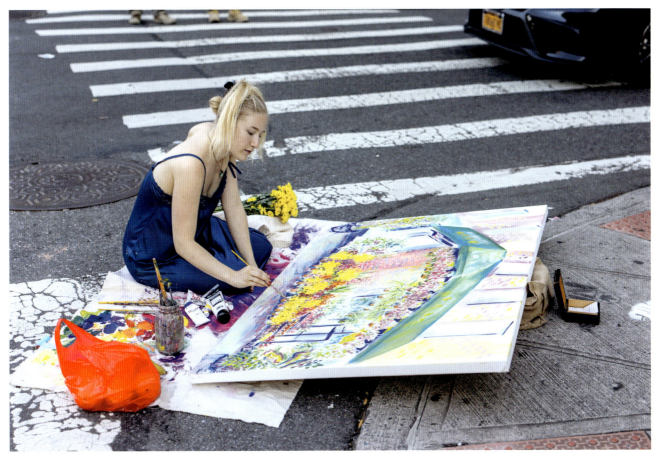

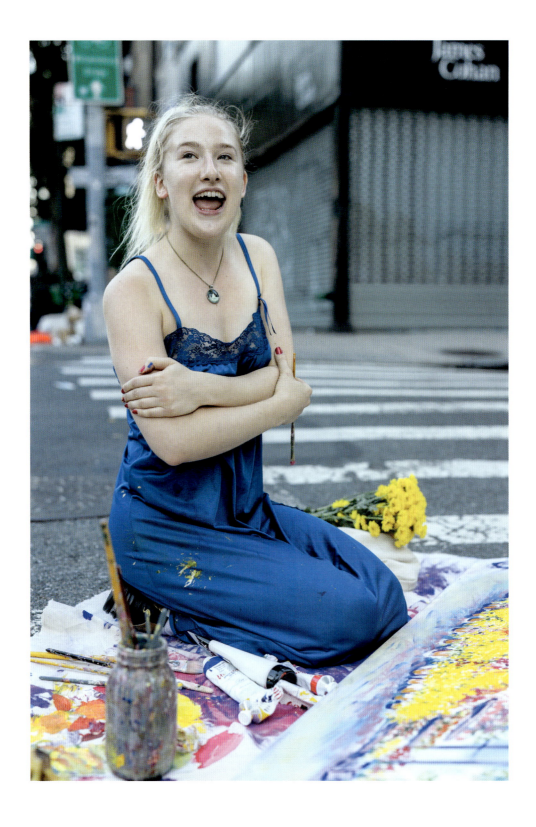

"I'm trying to sell these paintings and make this money. I'm a material girl as well. I have visions of all the places I want to live and how I want my life to be and you know, it's a pretty glam, luxe life. I want my beautiful homes and my beautiful friends to be there with me. There's a building on the corner of Grand and Orchard, I've painted it. It's a pink building. That's the building I want in New York. Then I want my pink house on Lake Como, with the beautiful balcony that I paint on every morning. My beautiful vintage armoire and, oh! My fainting bed! I'm gonna have a fainting bed—that type vibe. I've also done lots of visions of the nearby café where I'll eat my breakfast every morning. Everyone there knows me. As soon as I walk in the door, it's: 'Aila! Aila! Ciao, Aila! Aila bella!' I'll do little sketches and give them all away, so I always eat for free. I'll do gigantic panels. I'll be in all the major museums, and they'll throw parties for me. Lots of balls. Lots of galas. I'll pull up to the galas in my forest green Porsche with my little driving gloves and my driving scarf and my sunglasses. And the universe will be there, of course. She's everywhere. She's my art. She's my love. She's the lake. And she's the Porsche."

"I'm sixty-three and I'm still what you'd call an emergent artist. So yeah, it's frustrating. Sometimes I question: Why the fuck do I keep doing political art? I'd make it so much easier on myself if I just said screw it all, and just went for beauty. Art for art's sake. Maybe that's enlightening enough. Why do I always have to say something? Probably because I care. Ever since I was a little kid, and I started reading the newspapers, and realized that this world is a fucking crazy place—I've cared."

"Here it's very hard to know if someone is genuine. I'm not sure about other parts of the country, but at least in New York City. Back in Ghana a smile means: 'Welcome,' or 'How are you?' It means the person wants the best for you. But here it's very hard for me to tell where it's coming from. Sometimes the moment a person gets what they need, the smile goes away."

"I'm from Florence, Alabama. There were ten of us cousins, and everyone lived on a single strip. We were kinda country. We were outside in the dirt and grass, all day, every day: four-wheelers, out in cornfields, on trails. It was all about having a good time. And when we got to high school it was the same thing: everyone would just meet up in the parking lot and have a good time. The only thing is, nobody ever really leaves Florence, unless you're a star athlete. Somebody getting a good ACT score, and getting a scholarship for academics—that's not a familiar story. And when you haven't seen anyone do stuff, everything seems hard. When you tell people: 'Hey, I want to move to New York City,' they'll tell you it's the worst decision you can make. So yeah, I resented it a bit. I started to think: 'If I stay here, y'all are gonna hold me back.' Now that I'm in New York, it's the opposite. I'm surrounded by so many people, doing so many things: everything seems possible. But it's also made me appreciate Florence a little bit more. I realize that a lot of things that set me apart, I learned there. I try to make sure that all my interactions are authentic and enjoyable. Even now, I'm trying to make sure you leave feeling like you had a good time."

"I'm taking a break from school until I figure things out. I guess I have rebel traits. There were just so many things that felt out of my control, and it bothered me. You have to wake up at this time. You have to go do this. You have to go do that. It's like I didn't have any originality. There was a certain point when I realized that everything—this whole routine that I had, had been given to me by other people. And the weird thing is—whenever you try to remove yourself from that equation, and stop doing what other people want, you kind of get ostracized and outcast. That's kinda what happened to me. I have a great family, but it's full of strong personalities. I had so many people telling me: do this, do that. They said it was a 'respect' thing. You know: 'I'm the adult, so you should respect me.' But I never understood that. Because at what age do I get this thing called respect? Nobody in my family could ever answer that question. Is it when I have a kid? Is that it? Or is it when I'm paying a certain amount of bills? At what point do I step up on the pedestal?"

"We've crossed paths a few times over the years. So I walked up to him. I told him: 'I'm also a painter. And at some point—I'd love to do a collaborative piece. You know, if you're interested in things like that.'"

"When you listen to old people, they're always complaining about their body, right? So get on it."

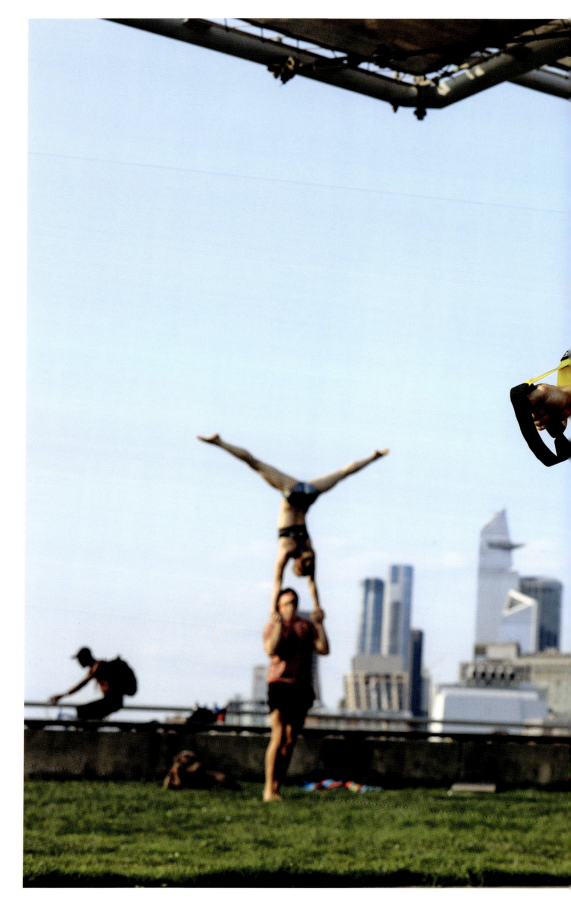

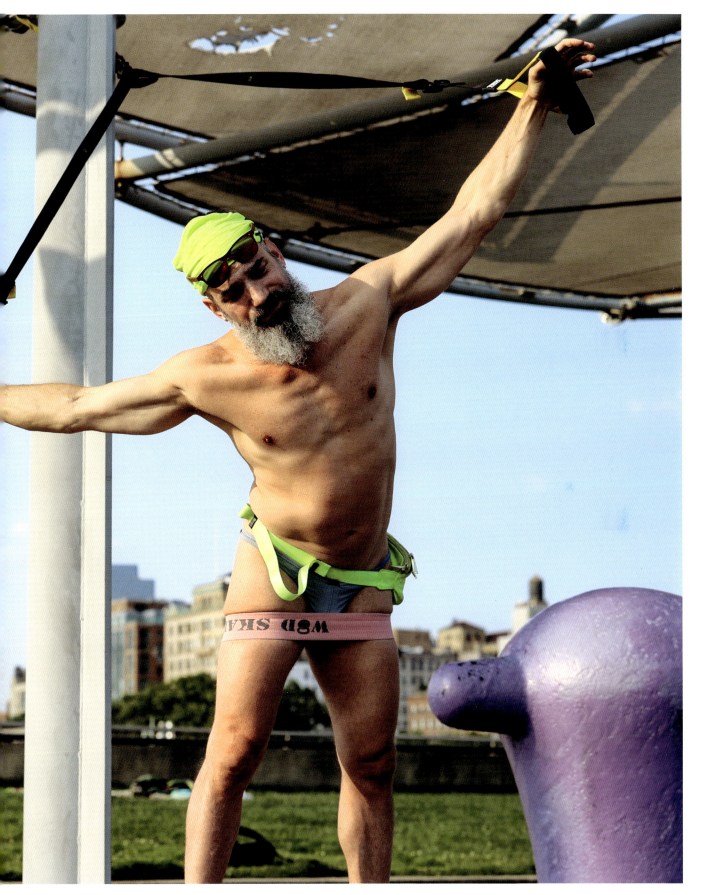

"I'm on the 'what the fuck is going on' path. And I've been on the case for a while. We're this animal that learned how to communicate. We became vicious. We're making a mess, trying to learn how to not murder each other. We've almost got it. Sometimes things happen, still. But we've come this far, and we didn't come with a manual, right? So we're trying to figure this out. We've cut down on it. We're doing great."

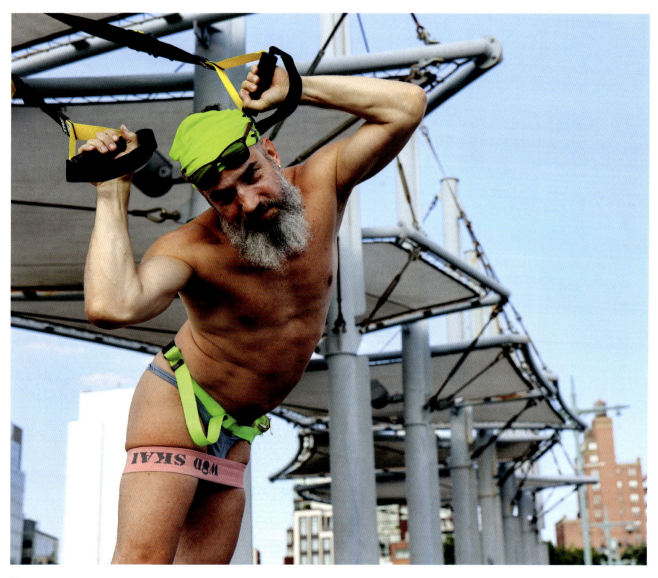

"God is not friend. God is king. God is master. But I love my life. I have everything I need. This is life I want. Some people are slave to phone. I am slave to God. Other people change their God every day, like socks. When God stops working for them, they try a new one. But our God never changes. That's the difference. But that's OK. Everyone can believe what they want. We're not looking for people to come to us. Who will come will come. But I know the truth. That's why I study Torah all day long. In the Torah, God says: 'Want to connect with me? Follow my law. If not, we're not connected.' That's it. It's not a game. Other people my age go out, drink, fight, do other stuff. That is like animal. And people do it because they have no law to stop them. Torah gives me rules to be a man. Follow God, help other people, especially Jewish people. There is no right or left. There is only what needs to be done. There is only Torah. And after this world comes the next. You work good this month, the paycheck will be good. Right? If you follow the law in this world—there's nothing to worry about. If you don't follow the law, well—it's not a game."

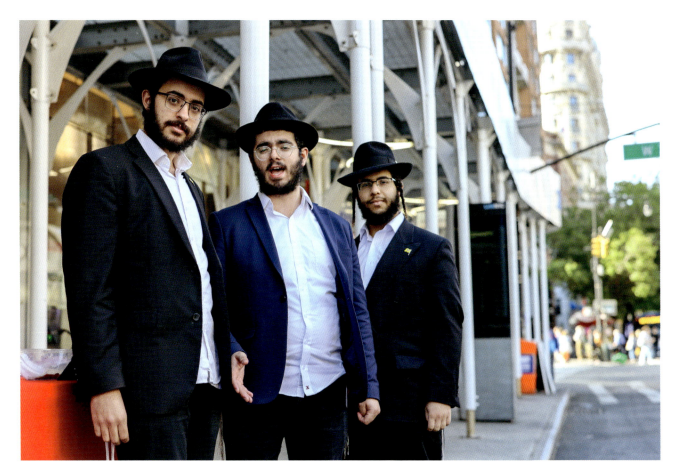

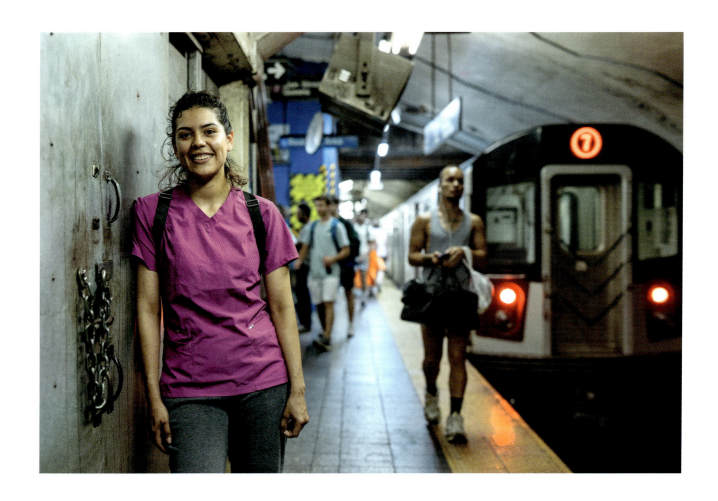

"Right now I'm cleaning apartments. I like it; it's very good work. When I worked in restaurants it was a lot of pressure. But when I clean, I listen to my music. I put on salsa songs. I hope they don't have camera, because I'm always dancing around. It's very good work. And people love my work. When I'm done cleaning, people come back to their homes, and they feel so much peace. They feel like, Ahhhhh. I'm grateful for my work, it really brings me joy. If I was still in Nicaragua things would be much tougher for me. So I'm grateful to be here. I'm grateful for my hands, my feet, my legs, for being able to breathe. And I'm grateful for my happiness. It might sound a little crazy, but I think happiness comes from God. And so I'm grateful for my happiness."

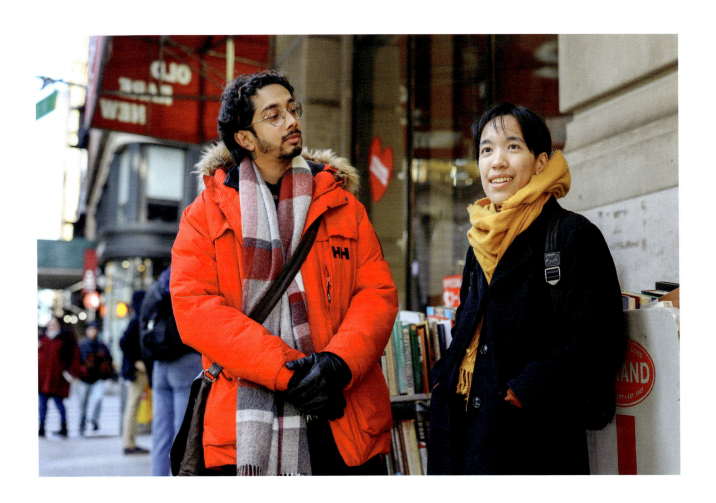

"It's a really small thing, but housework. He does more housework than me. It's one way he shows that my time is just as important as his."

"I was a slut and a whore for the algorithm. I couldn't do it anymore. You can never feed it enough. You start out making art, and hoping that the door will open. You're looking for that viral moment so it opens up the door and you can do the thing full-time. But you start to compromise just to get the door to open: guessing what it wants, debasing yourself, alienating yourself. Until you're not even in service to your art anymore. You're in service to the algorithm. Deep down every artist just wants to be seen. Everyone does. And that's how it controls you. The algorithm makes you behave in a certain way, create in a certain way, in exchange for being seen. And if something can change what you do, it can change who you are. And I didn't sign up for that. I didn't sign up to become a content creator. Art was supposed to be a way for me to be in search of, in service to, in community with. It was my ministry. Art was supposed to be my ministry."

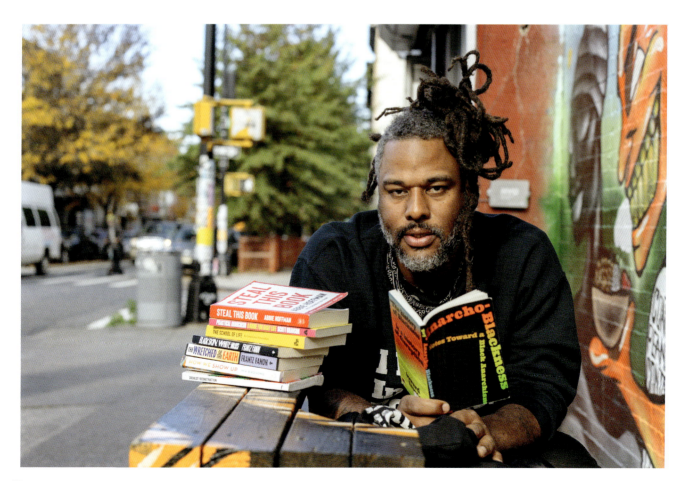

"First rule of being a roadie is never shit on the tour bus."

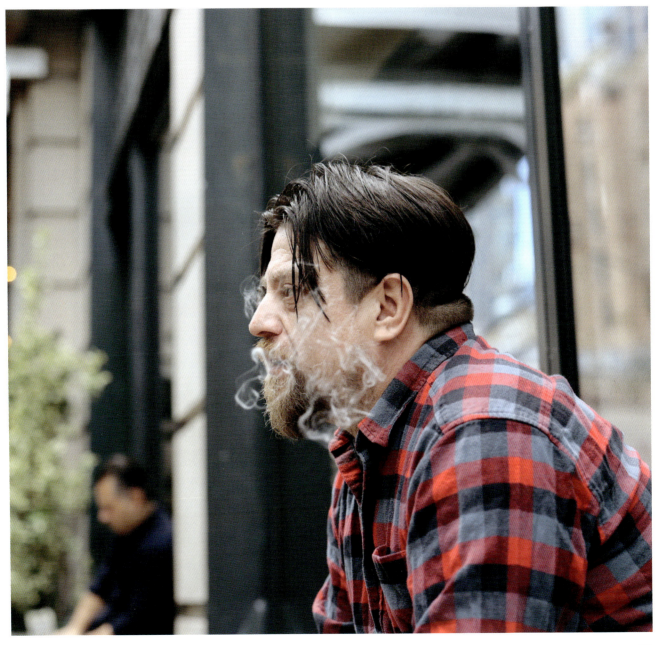

"It all came so fast. They held these conferences at our college, and all the sudden Morgan Stanley and Goldman Sachs are coming. It felt like I was gonna miss the boat if I didn't jump on it now. Suddenly I'm in New York. I've got a job in investment banking. I'm young, I've got all this money, we're going to clubs and doing drugs and all these crazy things. I was very addicted to Adderall. I'd stay up for forty-eight hours straight. I'd get hyper-focused on one thing, and it would feel like this particular task was going to set me apart from everyone around me. And then you get that validation, and it becomes this vicious, vicious cycle. Who's going to stay in the office the longest? Who can tough it out? Who can most tough out how shitty this is? For me the big wake-up call was breaking up with the girl I thought I was going to marry. She was awesome; she really cared for me. And I took it all for granted. She'd try to pull my attention away to do the smallest things together: sit on the couch, read, watch TV. And I couldn't even do it. Sometimes I would go twenty-four hours without talking to her. I'd be so wired into work, staying at the office all night, working on some Excel sheet way harder than I had to be working on it. And ultimately she decided that I didn't care for her. The night before we broke up, we were laying in bed, and she was like: 'I feel like I don't even know you.' I remember telling her: 'I'm about to get out of here, and become a different person.' And thankfully, I did. But for that relationship—a little too late."

"Absolutely everybody wanted to fuck me."

"If I could start over completely, I'd work with animals. But I wouldn't want to be a vet. I'd want to do something without the whole rigorous schooling of going to school. The dream, dream, dream is doing the animal stuff. But on an island. I went to Puerto Rico and there's like, this animal rescue that has a ton of cats that live there. Maybe Puerto Rico doesn't need another one, but there are a lot of other islands in places like South and Central America that have a lot of strays. So get ready for this: I'll build a whole retreat. It will be part cat shelter, part yoga studio, part vegan smoothie bakery. Maybe we'll even do yoga with the cats. Cats have healing frequencies. When cats are laying on you, purring on you, they're healing you at a frequency that humans don't have. It's like a calm, focus frequency. My source for that is the internet, so it might not be true. But it is known."

"I got this tattoo when I first came to this country. I was an illegal alien. I'd come from a Catholic family, in a Catholic country, and my entire life I'd been told that my sexuality is a sin. I barely spoke English. I didn't have health insurance. And I'd just been diagnosed as HIV positive. So I was feeling this desperation, and that's when I put it on my fucking arm. I decided: no matter what, I am going to say gracias."

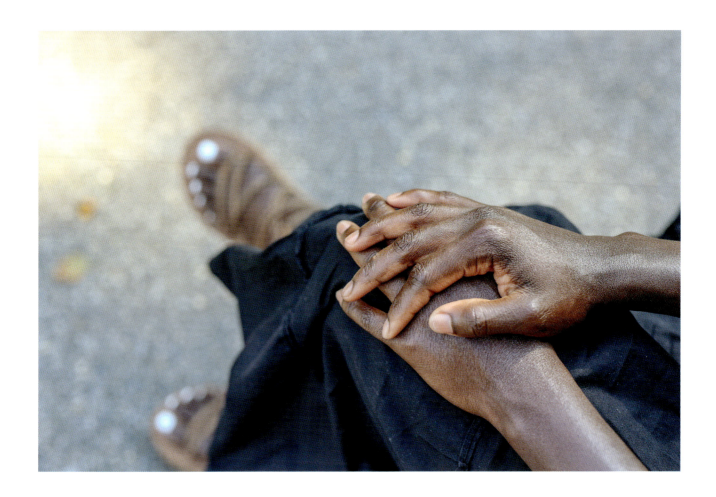

"He was a mentor. The leader of a huge religious organization: intelligent, charismatic. Everyone respected him. I was a teenage girl. My father traveled a lot. I never had any boyfriends. I wanted affection. And for him to give me attention, it was like—I wanted that. I did want it. I wanted him to look at me. I would dress for him. It makes me sick to think about now, but I would choose my clothes solely to make him look at me. I wanted him to say that I was pretty. I wanted his attention. And because I wanted it at first, you know—I felt like I gave myself to this person willingly. That's why I didn't report it for so many years. Because I felt like I was tempting him. He waited until I turned eighteen. And every time he abused me, he encouraged me to share the responsibility. He used the word 'we.' Always 'we.' He'd say: 'We're not supposed to be doing this. You're making me do this. I don't want to, but you're making me do this.' Every time it was over, he'd say: 'Now go to church and confess. Confess to tempting an older man.' I sued him last year, thanks to the Adult Survivors Act. I expected him to fight it tooth and nail; deny everything. But a couple days ago he sent a statement to my lawyer, basically apologizing for everything. When I got the letter, I thought of the child me. All I did in my mind was hug that child. It's like: you can forgive yourself now. There was never any 'we.' He knew you didn't have a father figure. He knew how you'd respond to the attention. He knew how you'd respond to the guilt, and the shame. He knew everything. It may have felt like you were choosing, but you weren't. You were chosen."

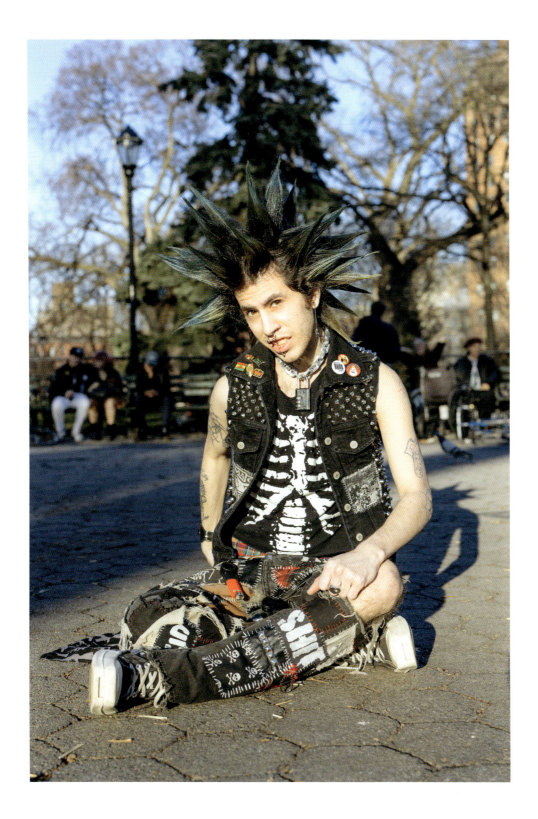

"I was sexually abused by the principal of my high school. I've had a little problem with authority ever since."

"Creation is different than production. Creation happens on the mountaintop, where the world doesn't matter. Where you reach into the depths of your solitude for a gift. Then you come down here, to the marketplace. You come back to the mortal world to let them know that there are mountains to climb if they choose."

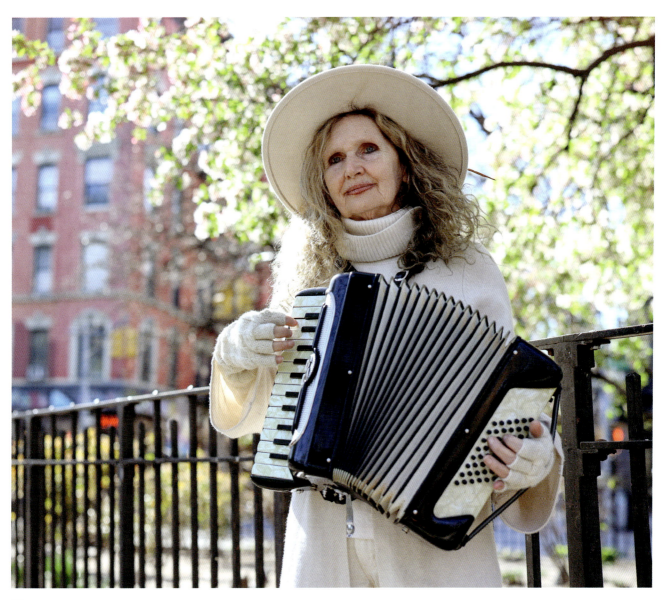

"I was reading Nietzsche since I was fourteen. It was an intellectual ascent but a spiritual descent. Nihilism comes from the same root as 'annihilate.' And when you begin to question the conscience, and start to believe that morality is a false construct, you break whatever laws you need to break to subsidize your addictions. I bottomed out in this park when I was twenty-four. I was emaciated, my skin was gray, I was missing a few teeth, my hair was falling out: I was gone. I came to this park to die, but even death didn't want me. And when you wake up in a pool of your own vomit, and there's a rat chewing on something you regurgitated, you don't cry out to Nietzsche. You don't cry out to Kant. Van Gogh can't save you. The poets can't save you. A real reckoning goes on. I knew my soul was no longer my own. And even if I didn't believe in God quite yet, I began to believe in the devil. I knew that there was evil, and I knew I had to fight it."

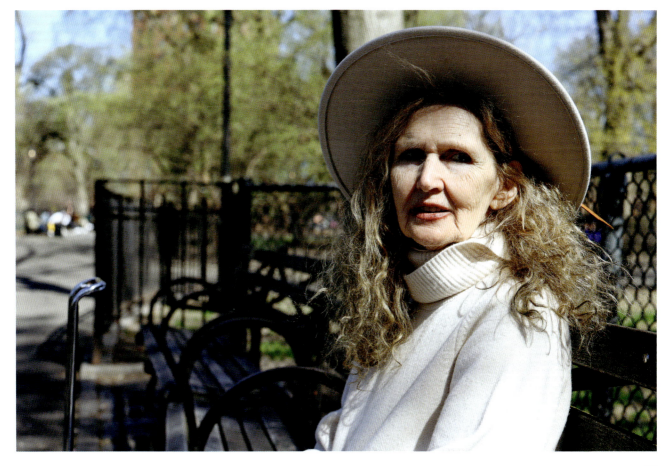

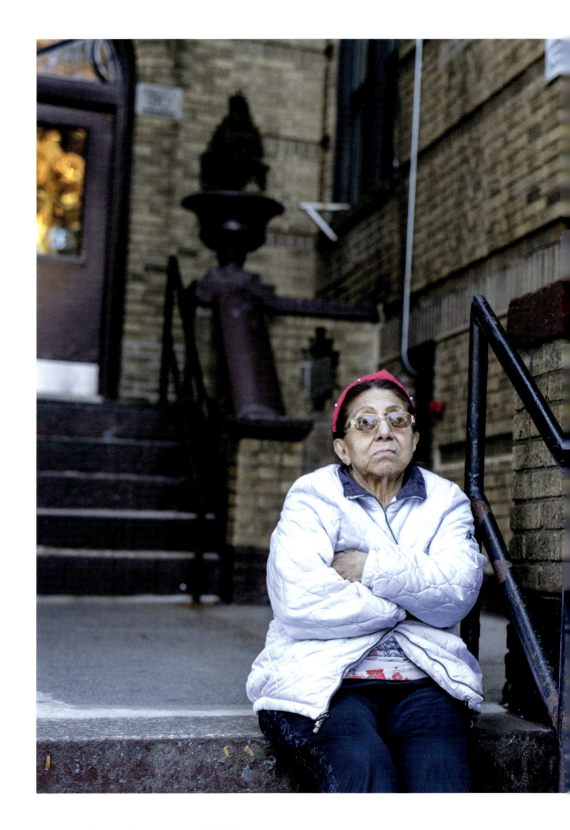

"She was fierce when we were kids."

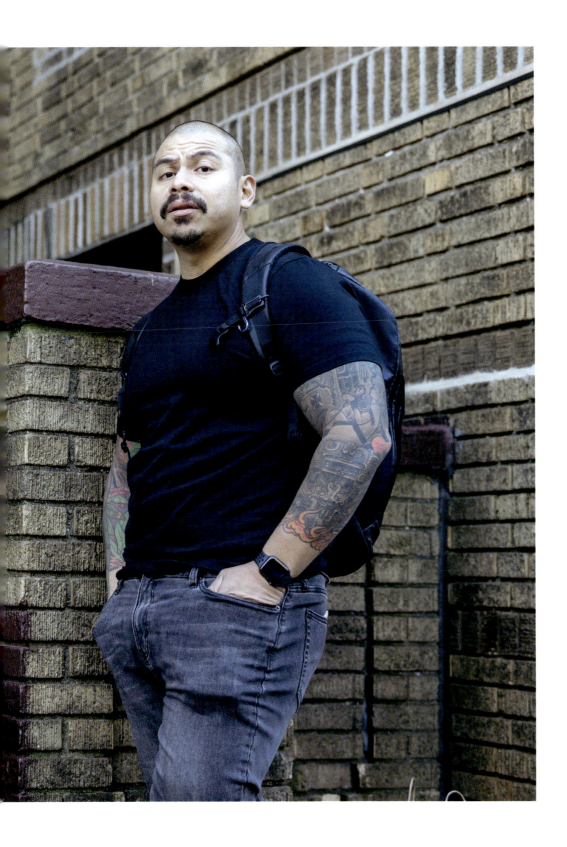

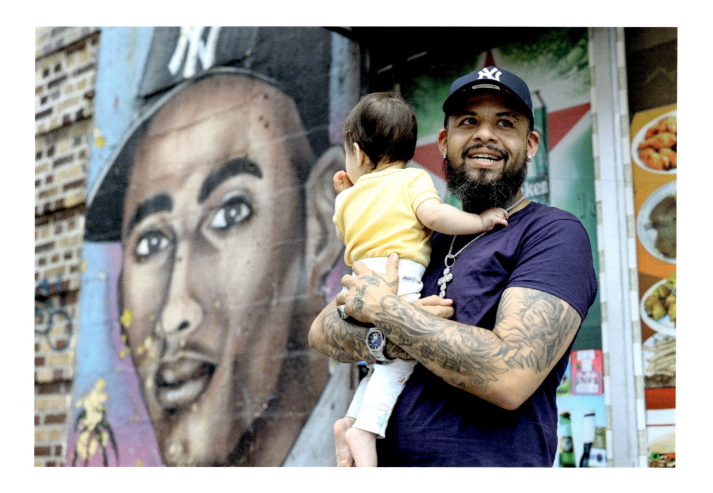

"The mother and I fell apart way before the baby was even here. I wasn't trying hard enough to find work, to be honest. I was stuck all day in the apartment. All the bills and everything fell on her. And when everything falls on somebody, they're thinking: you're not doing your part. So she gave me one month to move out. I could have taken the easy way out. My tax refund came out to eight grand. I could have taken that, gone back to Florida, and started over. But the baby was coming. I felt like: yo, this is a life—you know what I'm saying? How can you leave a life behind? So I gave half my tax refund to the mother, and made a challenge to myself: try to find a way to keep a roof over my head, so I can stay here with the baby. All I had to do was go down the block. I found this place called Hope; they help you find jobs. I told them I was good at cleaning, and they got me a job cleaning a school. That's how it started. Now I've got a permanent position in the cafeteria. The money ain't there yet, but I got benefits. The baby's got health insurance, she's got dental. This is what I do it for, this is the struggle right here."

"I've been divorced yesterday, five years. I was a good Catholic wife. I fit the bill. Puerto Rican, check. Talks like Mother Teresa, check. Looks like Clark Kent, check. My husband was thirty-nine, I was twenty-six. And I'm like: 'Oh, he knows better.' He gave me the Range Rover, the house in Sagaponack, the black dogs, the whatever. The everything. I was a Hamptons queen. Prada shit. Aye. Hermès. My husband was best friends with the designer. I was with Mr. Hermès. Aye! Everything, honey. It was very detailed: 'Oh, let me fix this. This shouldn't be here. Put it here instead, or it'll look stupid on the pictures.' You ready for my first joke? The Hamptons is like an ass without a hole, and I was in it. I'll say it again. An ass without a hole. Beautiful on the outside. Rotting on the inside."

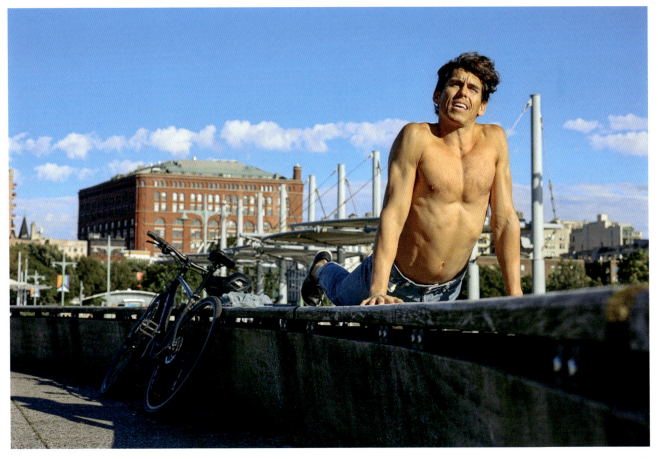

"I'm discovering all this shit because I've done a lot of psychedelic medicine. With doctors, shamans that are legit. It's called bufo. Toad venom. Five times. Five bufos, five people, five. Maria the hurricane hit the same month I got divorced, right? Whatever. I'm in love with myself again. The toad venom showed me everything. I felt it. I felt the wounds. My life started like *The Little Mermaid*, alright? Perfect. I was a triathlete back in Puerto Rico. I was a breaststroker. I'm Ariel. I'm literally Ariel. Holy shit. Then it turned into *Lord of the Rings*, motherfucker. *Lord of the Fucking Rings*: part one, part two, part three. You can bang your head against the wall forty thousand times, or you can open the door. That's what I do. I open doors. Smoke the toad venom and two seconds later you're out of this planet. It's a near-death experience. You don't think things. You don't see things. You feel. You feel it all at once. All the trauma. All the trauma, it was in my hips! *Puta*! You feel what it means to be a Hamptons queen."

"I don't want him making the same bad choices I made. No graffiti. But especially no bad graffiti, inside of train tunnels, at a very young age."

"I want to be with her, but she doesn't want to get married."

"Well, she doesn't want to get my name tatted."

"We gotta get married first. I'm from Kentucky."

"That means she has no faith in the relationship. In New York, we don't get married. We get tats. We get tats. A tat is more than a marriage out here. A marriage is shit, a tat is everything. In New York a tat means more than a marriage."

"But then she could leave anytime, and I'll have got this girl's name tatted. My mom would be like, what the fuck?"

"See? No faith in the relationship."

"We've only been together three months. She just became single."

"That means nothing."

"Her ex has her name tattooed. On her neck!"
"No, no, no. That means nothing, that means nothing. Every person I've dated has my name tatted."

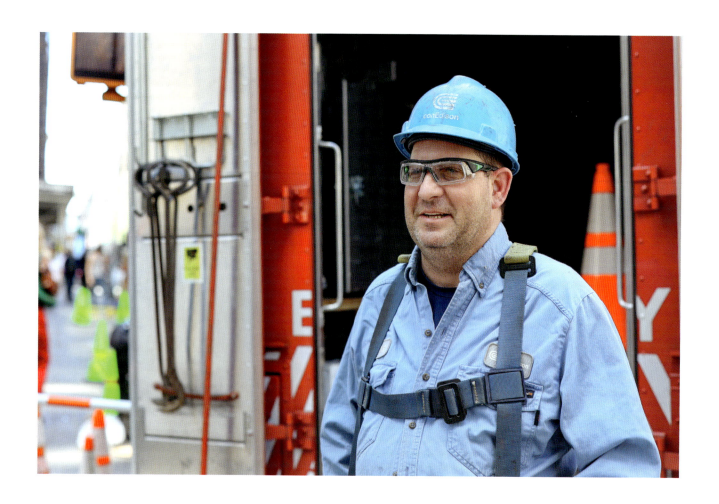

"Just the other day a video popped up on Facebook. It was only five years ago. We were in the park. I was pushing her on the bike, letting go. We used to have so much fun together. We'd always get ice cream. She's a strawberry girl. I'm a vanilla guy. Chipwich, actually. I'm a Chipwich guy. She'd give me a hug afterward, tell me I was the best dad ever. We were such good friends. But now it feels like we're so far apart. She doesn't want to talk to me anymore. Even when she's upset, she'll ignore me and go to her room. It's like: C'mon. I was fifteen too. I know what it's like. But she'll come back, I know that. They always come back. But it does feel like you're getting your heart ripped out a little bit. But look, I get it. She's figuring out life. You have to back off. You have to give them space. 'Cause if you charge after them and get all aggressive about it, you might push them away forever. But they always come back, right?"

"I was literally my dad's whole world. That's what my mom says."

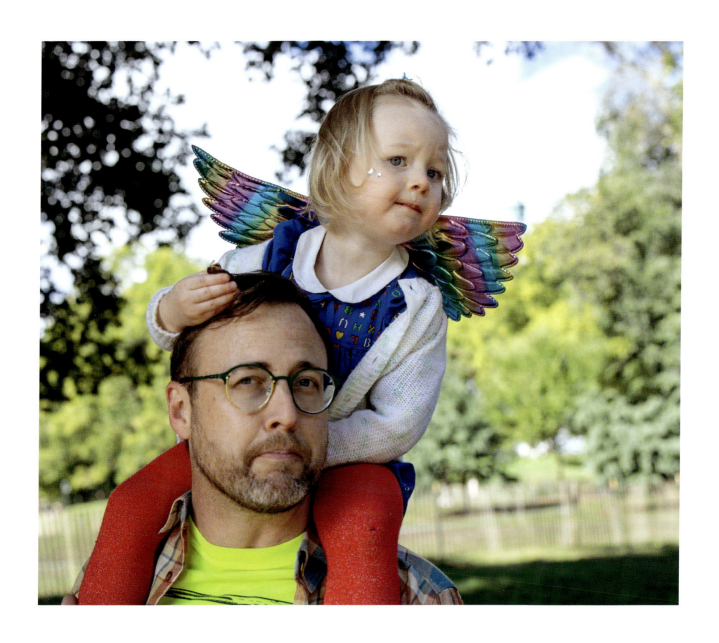

"We call her Hurricane Harvie."

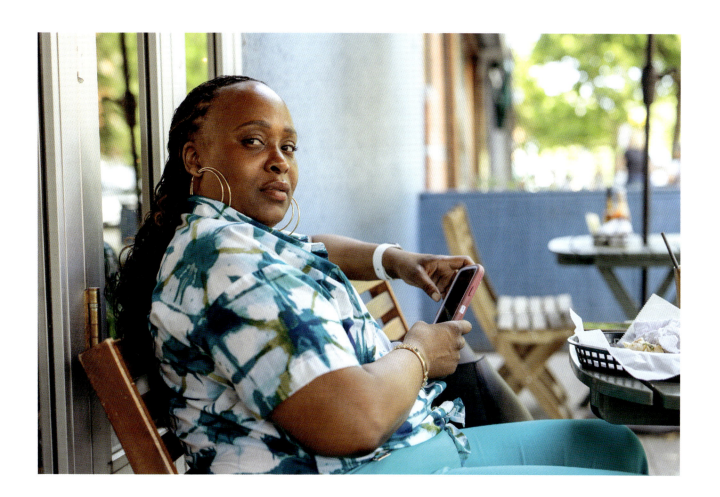

"She's a good kid. Graduated college. A little hesitant to move out, but a good kid. She said to me recently: 'You're not allowed to tell me what to do anymore. You can only advise me.' So when she went to buy a car, I advised her: 'Get a used car.' But she insisted on buying a new car—an expensive, new car. Then a few months later she stops paying me her share of the rent. Anywhere else, she's going to get evicted. But she thinks that because she's my daughter, I'm not gonna do anything. So I revoked her access to the parking garage. She never said a word about it. Just came home from work each day like everything was normal. I had to call the people at the garage, and be like: 'You cut her off, right?' Then a few days later the parking tickets started to come. Every day in the mail, parking tickets. So now I'm like: 'What the hell. How do I fix this?'"

"In 1974 I drove off the side of the Brooklyn-Queens Expressway in a stolen car; three stories high. Landed in someone's front yard. They had to cut me out of the car. I got a tracheotomy. Metal plate in my eye. I've been hit by a number five train. Kicked heroin, dope, coke, pills, and methadone. Hit by another car in 2009; got a new hip from that one. Look at me, all the shit I've been through, and still dancing. I'm as strong as a motherfucker. I want to stay alive until I die."

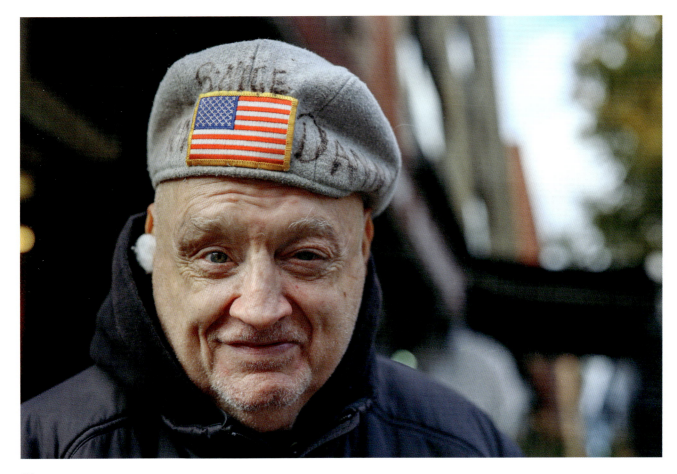

"I had a job in tech for six months. For once it felt like things were on an upward trajectory, but now I'm back to serving. I can pay my bills, which is good, which is great. I love doing that. But it would also be nice to know what life is going to look like in a year. I'm not even sure what I would do, if I did know—but at least then I'd have some peace. It's the not knowing that really wears you down."

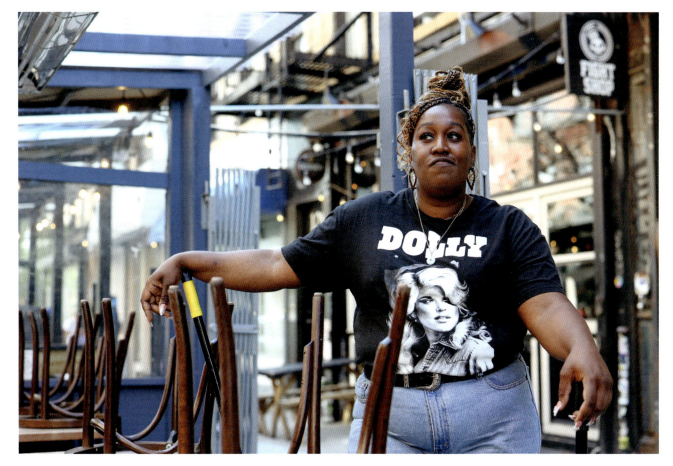

"We aren't really trying to help each other here, because everyone I know in the Bronx just wants to leave the Bronx. My family right now is in a position where everything is not so great. But once I get where I'm supposed to be, everything will be fine. You've just got to focus on yourself and keep hustling. I've still got time. I've still got time to grow. It's not like football and basketball, where you've got to be tall. There's a lot of people in the majors that are my height. I keep my grades solid. Nothing so crazy, but not bad. I keep them in the middle. I just feel like we spend too much time doing stuff that's not going to help us in life. Like all this multiplication, all this dividing, sitting down, learning about chemicals and stuff. None of that stuff is going to help us in the real world."

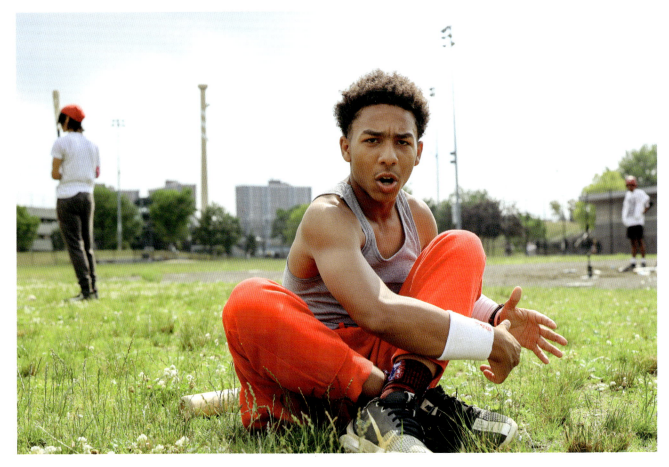

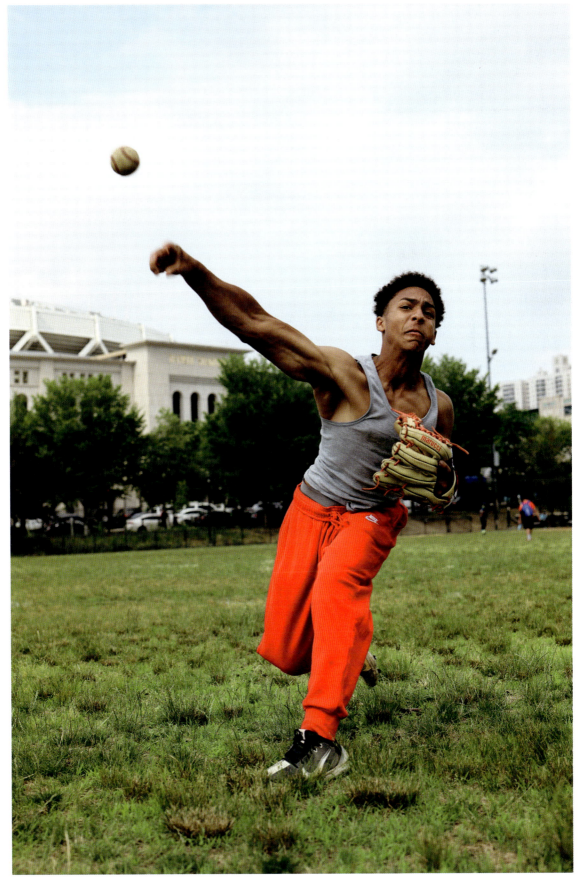

"It's been forty years, and it gets better all the time. Because you grow closer together when you go through things. You understand each other more. I'll tell you some basic things about him. He's very, very bright. He's always reading. He's always learning new things and he loves to share them with me. He gets happy when I'm happy. That's a big deal, you know? I mean, it really makes him happy, when I'm happy. You can see it. Other people can see it, but I can certainly see it. He really cares, you know? And not everyone has that. I'm really very fortunate. I have someone who cares. What more could you want, you know?"

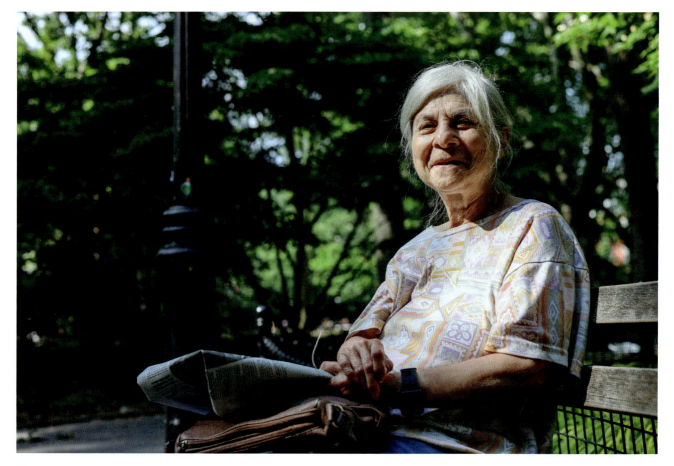

"I'm the one who calls out. I'm the one who corrects. I'm the one who rephrases. I've had plenty of people be like: 'You can't tell me what to say.' But if you're allowed to say whatever you want, I'm allowed to react however I want. Right? Maybe what you said seems trivial to you. But the little things are easier to fix. And they help build a foundation, so that the bigger things are easier to address. And also: Do the big things even matter if you don't care about the small things?"

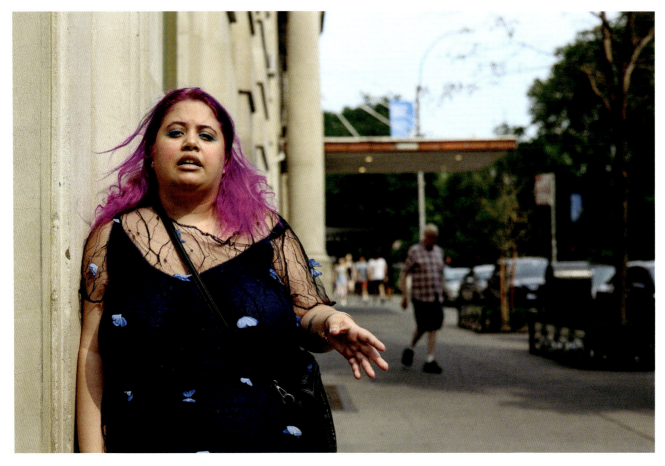

"There's a woman in the grocery store, at the checkout stand, that I see once a month. She's very nice and very kind. We'll have a two- or three-minute conversation. And that's probably the person I talk to most. I'm retired, and I live alone. In my apartment I have this whole movie memorabilia collection on my walls. Posters from the forties: Greto Garbo, Joan Crawford, Judy Garland. All the female actresses that appealed to the gay men of my time. Who is there to give it to? I'd hate for somebody to just throw it away when I'm gone. I read somewhere that the average lifespan of a New Yorker is seventy-five. And I'm seventy-four. So I'm constantly hearing the tick, tick, tick. I probably shouldn't care about the posters, but I do care. It's little things like that. Little things that creep into my head about death, and dying, and what's going to happen. Tick, tick, tick. But when I'm out on the street with my camera, I get away from all that. For a few hours I'm able to get away from myself, and it becomes about observance. I also find it much easier to be alone when I'm among people. The distance makes it comfortable for me. But I'm also able to feel that I'm somehow part of the world."

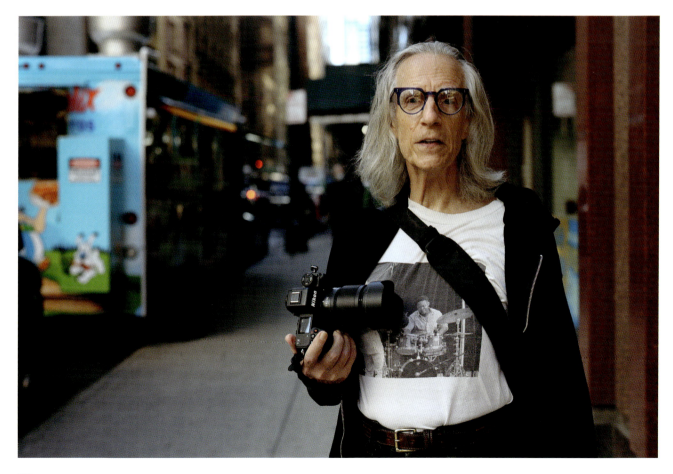

"He doesn't love me, that's for sure. You can project human qualities onto these things until they bite your ass cheek. He bit my ass cheek. Middle of the night, wife asleep in the bed, I bend over to pick something up, and he bites me right on the ass. He's very dangerous if he doesn't get his way. If you aren't accommodating his wishes, he can screech you right into the ground. He won't go in his cage. Our entire apartment is filled with driftwood from the Hudson. He likes to sit on the driftwood when he watches TV. He'll take food off our plates. If anyone is talking, he has to be there. He wants to be part of everything. And the worst part is they won't die. They live to be eighty or a hundred. You know the saying: 'This too shall pass'? Not the umbrella cockatoo. This too, shall not pass. There's no hope. That's the horror of it. I told this to a nine-year-old girl in the park. This girl was a genius. She says: 'You'll never have to say goodbye. You have an infinite pet.' It was the darkest thing I've ever heard."

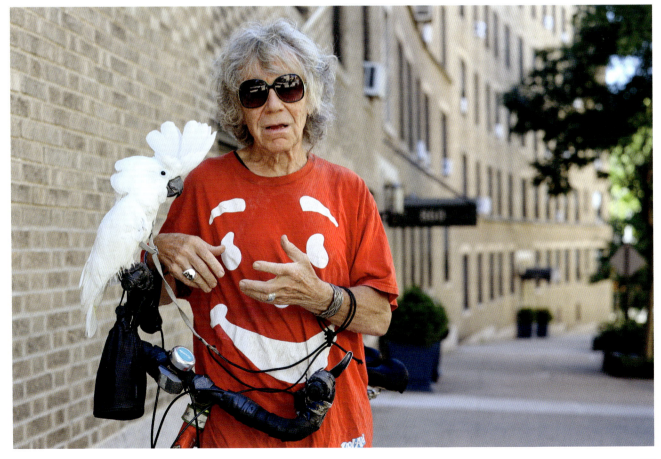

"I haven't been seventeen for very long. But I will say, aside from the schoolwork, it's really a wonderful time. I have the freedom to go wherever I want to go, but not a ton of responsibility. I can walk out of my house with my dog, and go for this walk, and not worry about much more than getting back home. I do need to finish a 650-word personal statement for my college applications. It's not an easy thing—to describe yourself in 650 words. I don't really know who I am yet, though I am growing more comfortable with not knowing. At least that means other people aren't defining me either. When I look at older people I admire, to be honest, I do define them a bit—by their careers and accomplishments. I guess it's just the easiest way to understand them, because I haven't experienced much of being older. When you're seventeen you haven't done much. But there's also freedom to that. Because there's not much to define you by, other than the moment."

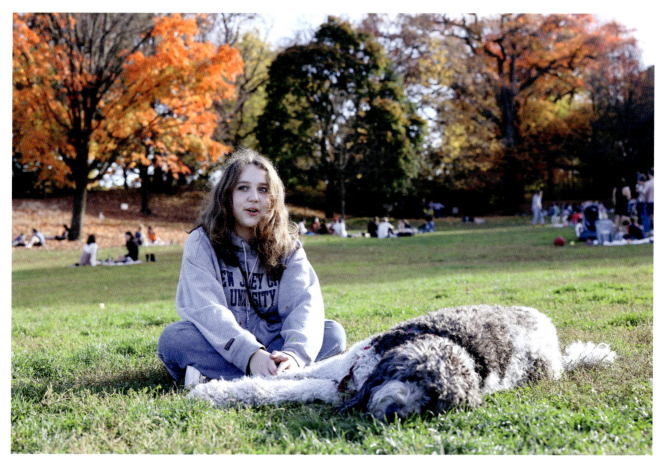

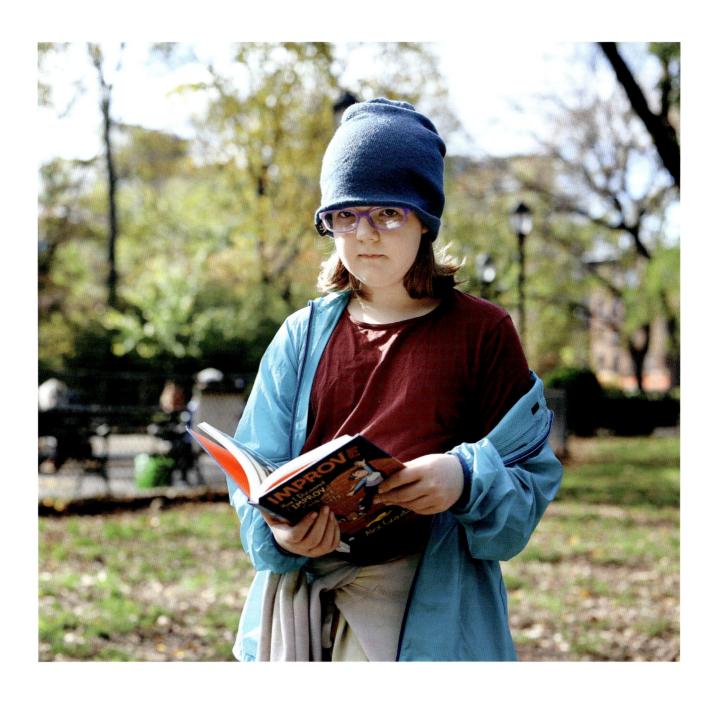

"Grown-ups get the worst mail. It all comes in the same long, white envelope and inside is boring stuff that you have to do."

"My best friend committed suicide when we were fourteen years old; I'm living for her right now. I'm trying to push myself as hard as I can because she wasn't able to. Her family didn't have the money to buy a headstone, so I'm working on it. I'm almost there. Just a few hundred dollars away."

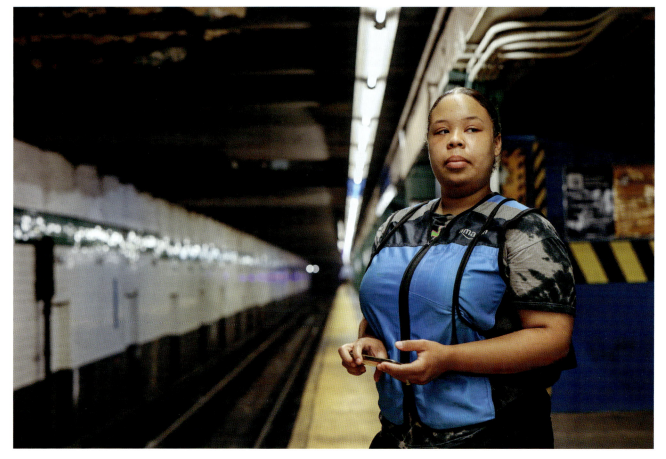

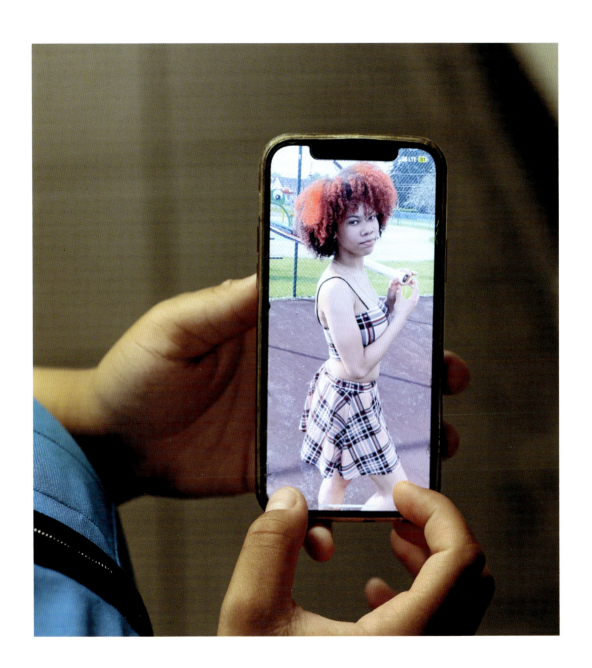

"I was a miserable fuck for a lot of my life. For thirty years I was drunk: boozing, womanizing, fighting. It was horrible shit. But they say that regret is vain. Because when you regret something, what you're saying is: 'I could have done it differently.' And no, you couldn't have done it differently. Because it's done. It's done."

"I definitely have like, ADHD. I can't work in an office. I can't be like, doing something that's mechanical and mundane. I've got to keep moving. I just love the chase. I'm going to become the biggest event planner this city has ever seen. The plan is to get some funding, get some angel investors, then start sending blind emails: 'Hey, my name is Richard—.' Well, I'm still figuring that part out. First I'm going to formulate my branding."

"I was a diplomat at the embassy of El Salvador, but they fired me when the government changed. I was fifty years old. I'd never broken any laws. I had a house, I had savings. I had an MBA. I thought it would be no problem for me to become a resident. My first application took two years. I spent $25,000 on lawyers. After I finished the paperwork and the interviews, it took them nine months to say no. But I still had hope. I sold my house to keep paying the lawyers. I didn't want to jeopardize my application, so I couldn't work. But I still had some savings. I was still paying my rent. But it's been thirteen years of trying, and money doesn't last forever. Recently I moved into a women's shelter. It's really not bad. You have your showers, you have a bed, you feel secure. But I don't talk to anyone, because I'm afraid that when people learn I don't have paperwork, they'll call ICE. So I keep to myself. I spend all my time at the library, looking for an NGO that can help me pro bono. I still have hope. I can't wait to be out of the shadows. It's hard to feel like you have no purpose. Even though I am almost a senior, I can still work. I still have time to make a contribution."

"When time's up, it's up. All I seek is that I should die in a way that doesn't intrude on anyone else's life."

"My first end-of-life patient was a ninety-seven-year-old man. He had a much younger girlfriend; she was seventy-four. But they loved each other so much. Back when their spouses were still alive, the four of them had been great friends. They would double date together. And when their spouses passed away—the two of them became a thing. Every day she would come over for lunch. I'd always cook a little meal for them. I'd prepare the table; I'd lay out my little candles and my little flowers. As soon as she arrived I'd put on music and dim the lights, then I'd leave the room and go wait in the bedroom. They would cuddle and snuggle. And the beauty of it was—even though he couldn't control his fluids at that point, she never minded the smell. Her love for him was so great that they would still kiss and all that good stuff. When the doctors said that it was time for him to go to hospice, he said he didn't want to go. He told them that he wanted to come back home and die with me. I was with him in the end. My patients never die alone. Never, ever. One week after his passing I was hired by his girlfriend's family. She had terminal Alzheimer's, and I ended up staying with her for seven years. I fell in love with her. We were family, just family. She used to be a tap dancer. We'd sing together. And if she didn't feel like singing, I'd sing. Even near the end, she always knew when something was wrong with me. When I wasn't being the Gabby that she knew—she would always know. When the doctors said it was time for her to go to hospice, her children said: 'We want her to die with Gabby.' In the final days she wouldn't eat, she'd lock her jaw. But she would always eat for me. One night I could see the fright in her eyes, and I knew it was time. My patients never die alone. Never, ever. So I climbed under the covers with her. And she passed away in my arms."

"In our political philosophy class we're learning about this guy John Rawls. And he talks about how whether you're rich or poor, and even really if you're talented or talentless—it has nothing to do with you. It's arbitrary. So much of your life is shaped by the position you're born into. And I happen to have had a really lucky roll of the dice. I had, like, great parents. I lived in an apartment on the Upper West Side. I went to a private school where I got to call my teachers by their first names. I had wonderful friends, cute dogs, nice vacations. I had the greatest roll of the dice ever. Yet I walk five paces outside of my front door, and I'll see someone who had a shit roll: sleeping on the streets, just trying to survive. It's like: What did I do to deserve this? Nothing. I could easily just fade into the background and do whatever is great for myself and my family. I don't think anyone would notice, or blame me. Not everyone needs to change the world. My girlfriend didn't have as much privilege as me, and she is very focused on her dream of owning a house. I think that's wonderful. I hope she accomplishes that, and I can live with her in that house one day. But I've lived in a house. I've lived a lavish life. I've had a lot of pleasure, I've had a lot of joy. I don't need to constantly pursue that, you know. I'd love to try my best to use this 'everything working out for me' to do something for someone else."

"I don't like New York City. I'm just stuck here for a while."

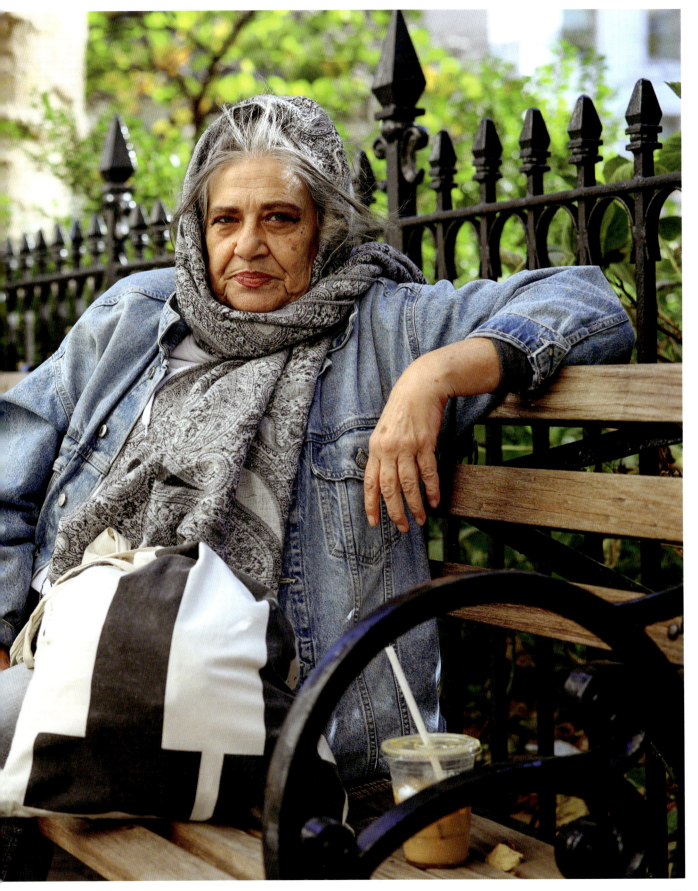

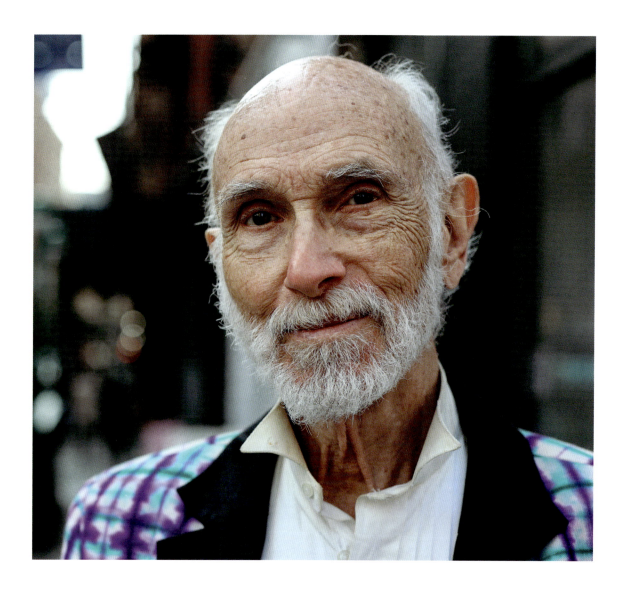

"Those that know, do not say. Those that say, do not know."

"Obviously you've got to track your numbers. We've got different indicators to help us measure: how many new friends we invite to church, how many friends actually come, and then there's baptism. We believe that baptism is the gate that allows us to really develop our relationship with God. My goal is to baptize one hundred friends by the end of my mission. I'm halfway done; I'm at thirty-two. At first I had to get over my fear of talking to people. Then after that it was just bulldogging my way through Mandarin. They gave us a nine-week course at the missionary training center, so I've got a good vocabulary. They call it a missionary vocabulary; just enough to get people to come to church. After a while you pick up a few additional key words. I have to work: wǒ yào gōng zuò. No time: méi yǒu kòng. Not interested: méi yǒu xìng qù."

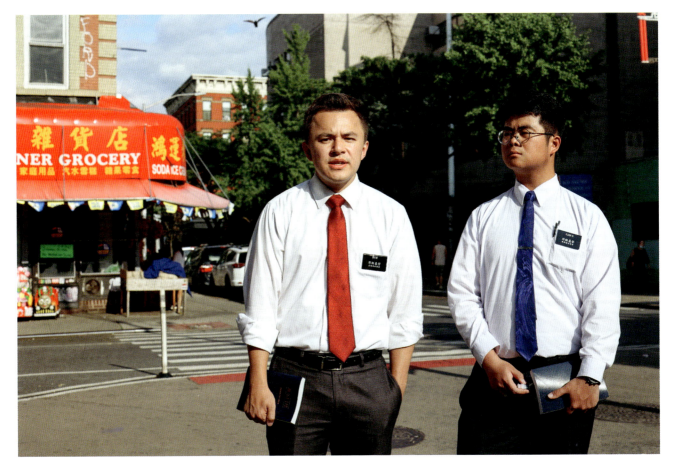

"I grew up in the church. But I had some friends who weren't part of the church, and they seemed to have a broader take on the world. I appreciated that. I wanted to see the other side of things. In a lot of ways it was a really fun lifestyle: a lot of highs, a lot of lows. I was doing what I wanted in the moment, and not worrying about what anyone else thought of me. But I wasn't working toward anything. I got through college, but that was it. I didn't know where to go. There were definitely some nights when I felt broken. I felt like I'd given up my identity as a son of God. That I was just some guy: it didn't matter what happened to me, my choices didn't matter. I was just another guy, on a planet with billions of people. And I guess that kind of crushed me. It felt like I didn't really have a story of my own to tell. In the Book of Mormon, there's a man. His name is Alma the Younger. When he was young he kind of rebelled against the church. But then he had this huge, humbling moment where God shamed him for what he was doing, and he comes back to the church. Let's just say: I look up to Alma a lot."

"I've got this book—it's kinda like a diary. But it's not a diary of my thoughts, it's a diary of my work. It has everything I need to do: assignments, deadlines, goals—stuff like that. And whenever I finish something, I check it off the list. It keeps me from feeling overwhelmed. I'll be fine if I keep checking things off the list. All I have to do is keep that rhythm going."

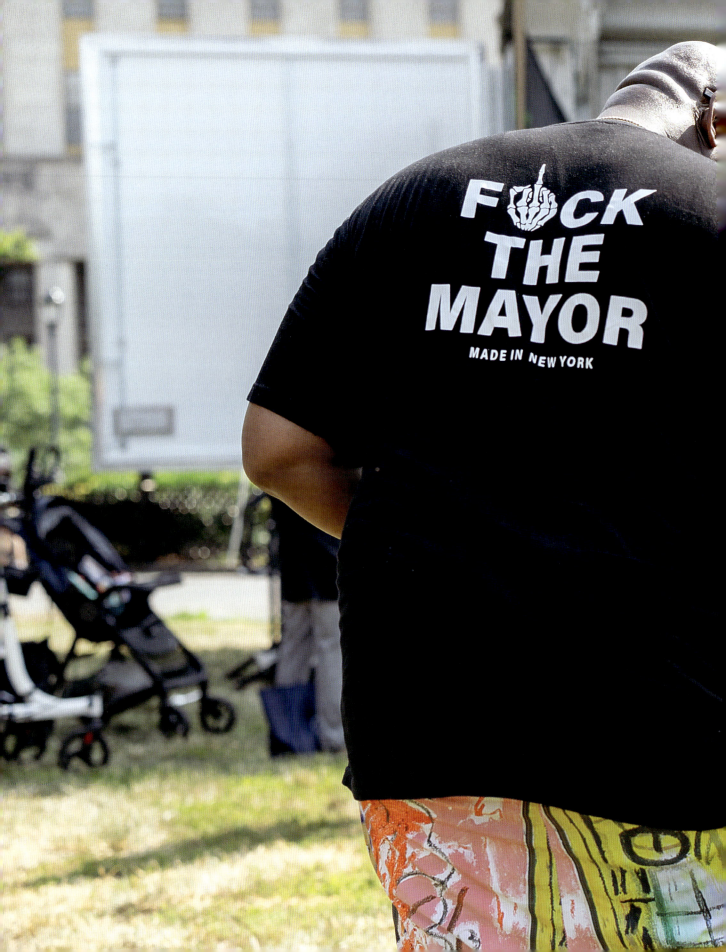

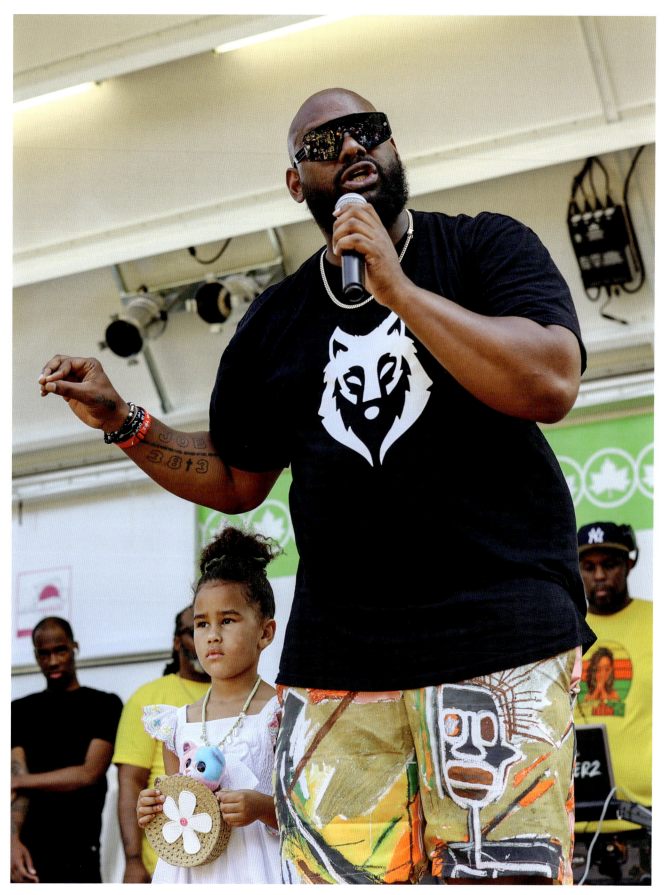

"Black liberation. That's what we need. Does it mean separation? Yes. Does it mean segregation? In a lot of ways. We need a strong, independent black community where we do business with other people, but we own and control the politics, the production, the businesses, and the real estate. I'll give it to you straight. No fucking chaser. The problem is white people. The power-hungry, capitalistic, greedy white man is Satan on this planet. They are demons on Earth. The worst demons. Like using people's hair in their seat cushions, resting feet on babies kind of demons. First you have the hardcore racists. Then you have people who racism benefits—those are the capitalists. Then you have the people who are innocent and unassuming. Maybe they really don't mean no harm. But are they standing up to racism? Then they're part of the fucking problem. Now, if you are an ally, I mean, boots on the ground, showing up—if you will die for me, then I will die for you. We will go to the end of the road together, white folk. I'll fuck with you. But these crackers coming into our neighborhood, these gentrifiers bringing along their increased police presence, impacting the mental health of our kids. The ones who ignore me when I'm out here trying to get them involved in a political process. These motherfuckers who push the rents up so high that people who grew up around here have to move out. These people who want to call the cops on people sitting outside, listening to their music. Fuck you. That's what I'm talking about. White people get so fragile—they want you to explain you're not talking about them. But I'm talking about you. Fuck you."

"She shares me with the revolution. I'm in the middle of a war. On any given day we could be marching on a precinct somewhere, armed. I'll have to call my daughter with a tactical vest on, with AR clips strapped to my vest, with an AR in my hand and a nine on my hip, and I'll have to explain that the police are bullying people. And Daddy has to take a stand. When Jaheim McMillan was killed in Mississippi, the sheriff said: nobody better not come down here and march. I went down there with fifty other people armed with assault rifles, six thousand rounds of ammunition—and we marched straight to that sheriff's office. They cut off the lights and vacated the premises. Like, we made them respect us. We made them know: you will not kill our babies. You will not kill us and just get away with it. Laughing at the vigils we hold. Laughing when we march. Laughing in our faces. I'm not some kind of monster, but understand a little logic. The threat of violence is something that nobody in America wants. Say that a cop kills an innocent, unarmed black person, and they let that cop go. If somebody snatches that cop, or if somebody kills that cop's mother—then the game will change. Police talk down to us in a way that they would never talk to you if they weren't wearing a badge and a gun. But once it becomes real to them that they are mortals—once their mortality becomes real to them—they will think twice about how they treat people. And I'm here to help the people draw a line in the sand. If it's one of my loved ones, there will not be a march. There will be violence."

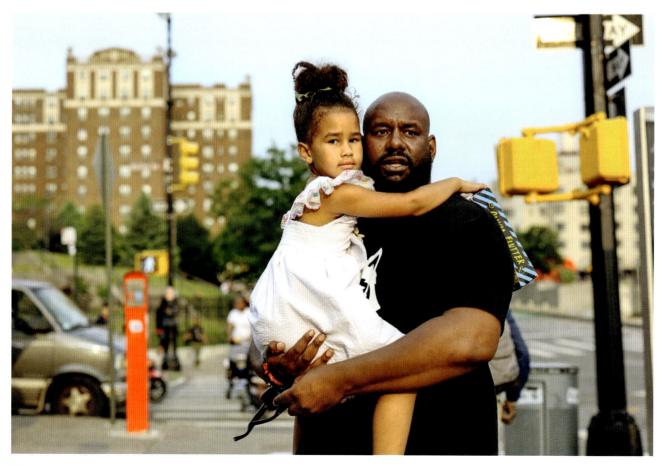

"I was a pure, green kid. Two-parent household. My parents sent me to school in khakis with a sweater around my neck. And when I tell you I was a pure kid, that wasn't a cool trait in the South Bronx. I got bullied. And I hate bullies. My chief antagonist is someone who has more power than me, knows they have more power than me, and leans on me whenever they can. And there's no bigger bully than the American government. When a sixteen-year-old black kid encounters a police officer, they are encountering the weight of the entire US government. Fucking bullies. But my parents taught me to play ball, liberal ball. Education is the only way to beat them. Keep yourself clean, and dress nice. Intern with the right people, get the right jobs, make the right connections, then eventually you'll land in a position to bring about change. I worked as a paralegal in the District Attorney's office. I was a liaison to the community, setting up educational programs and gang awareness workshops. I was playing ball. I was playing liberal ball: yes, the system is fucked up. But we can change it. We can change it from within. At one time I was chair of African-Americans for Bloomberg. But I know better now. I know that the more you play ball with them, the more they change you and the more you become them. You become part of the problem, an impediment to the liberation of black people. America respects power, violence, strategy. So the more you say: 'Let's peacefully protest'; the more you say: 'Oh, there are good police'; the more you say: 'Go along, get along, don't make too much noise'—the further you push us from liberation. White people want you to play the peace game. They want you to keep talking nice, because once you get mad—you'll mess around and come up on some freedom."

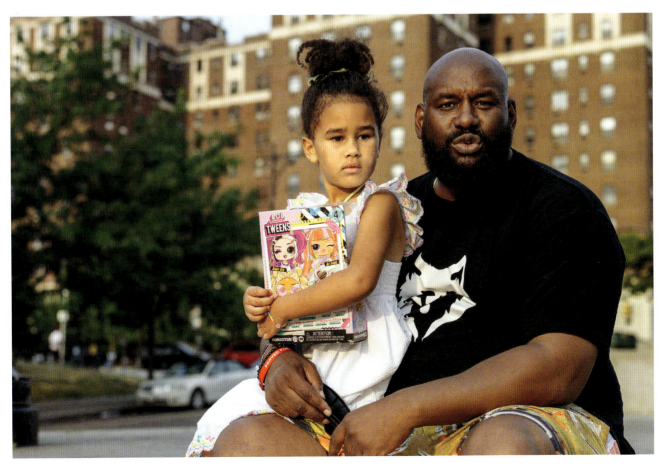

"He came up to me in the hallway of our high school one day, and I said: absolutely not. I was an honor student. He was smoking weed, running around, getting in trouble. My parents had moved our family away from the inner city for a reason—and it was to get away from all that. But I knew his family. I knew where he'd come from. And also: sometimes I can see things. I'd pay attention. I'd watch him with his friends. And I could tell: this is not him. I knew he didn't see himself in that space forever. And that's been the most beautiful thing, of like, everything. Watching that transition. Seeing it all from the beginning: him figuring out that he was worthy of more. It took a while. There were times he messed up, and I won't make excuses for that. There were lulls. We'd date other people for a while, but every time he'd come back hard. And not just like: 'I'm sorry, babe. Please take me back.' He'd put in more effort. He'd grow. And now he's gotten to a place where he has a much better understanding of his existence. He's a vegan. He meditates every day. I've seen him stay up for twenty-four hours, go to work, then come home and still be present. He's a nurturing father. He's a protector. It wasn't always in him. But it's in him now. And not to toot my own horn, but I saw it. What I saw was this. Exactly this."

"If we're going to the beach, I'll make a whole beach bag for the two of us. But he'll just pack the stuff for him and nothing for me."

"Maybe I could be a little more like him. Taking care of each other, I guess. But in that specific instance, I have got very specific things I need for beach day. I cannot sit all day in a wet swimsuit. I'm going to need a second swimsuit. And a cozy outfit to go home in."

"I find the matching kind of cringe. But he loves it."

"Many years in America, man. I have learned. The best thing to do is never talk to nobody. I do construction. If you go construction site, and you play tough—nobody touch you. They think, maybe, you a little crazy. Years go by, nobody will touch you. But then one day you decide to be more happy, be more smiling. Open up your heart, and say something nice. Bam! That's when they fuck you. It's my experience, man."

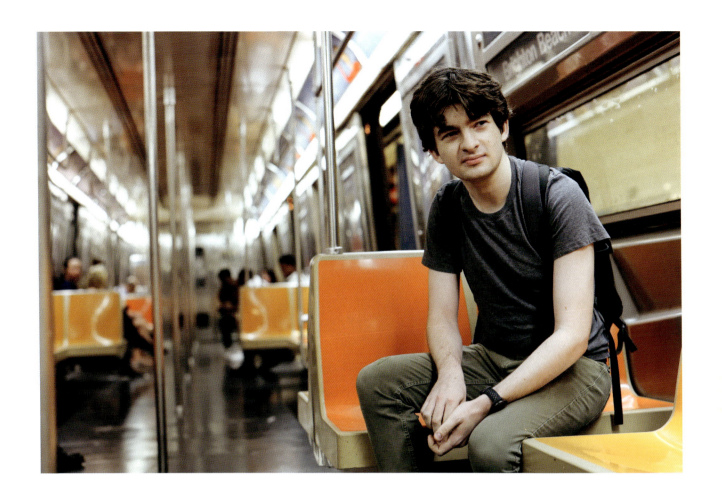

"I used to think of myself as an introvert, but I wouldn't really call myself that anymore. I think it was just a way for me to justify my isolation."

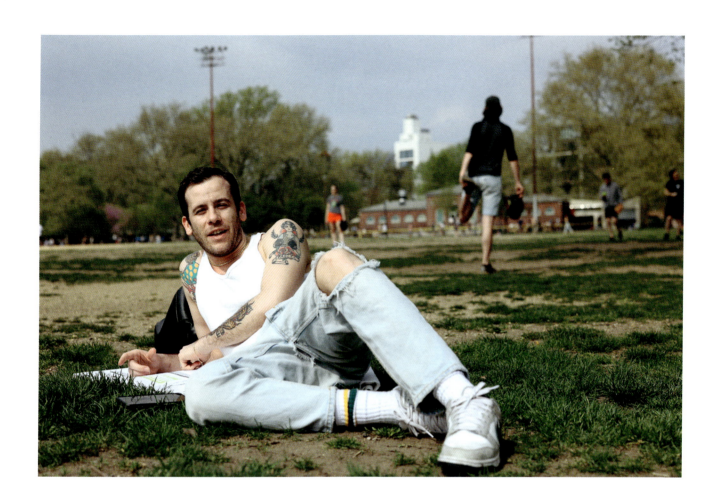

"When I was young my father opened a restaurant in Genoa. He bought it for cheap; it used to be a Chinese restaurant. There was a giant dragon on the wall. He couldn't afford to renovate. So he just left the mural on the wall, and named his restaurant The Dragon. After one year the restaurant failed, so he went to work on a cruise line. Every birthday, every Christmas, he was away from us. But still I took from him a lot of things. I never cry in my life. I solve every problem, every stuff, every bullshit. I'd never left Italy in my life, not even on holiday. But now I'm in America. And I make a lot of money. A lot, I'm the best in my company. The dragon is a promise. When I go back home, I'm going to buy back the restaurant. It won't make money; but I don't care. I only care that it's ours."

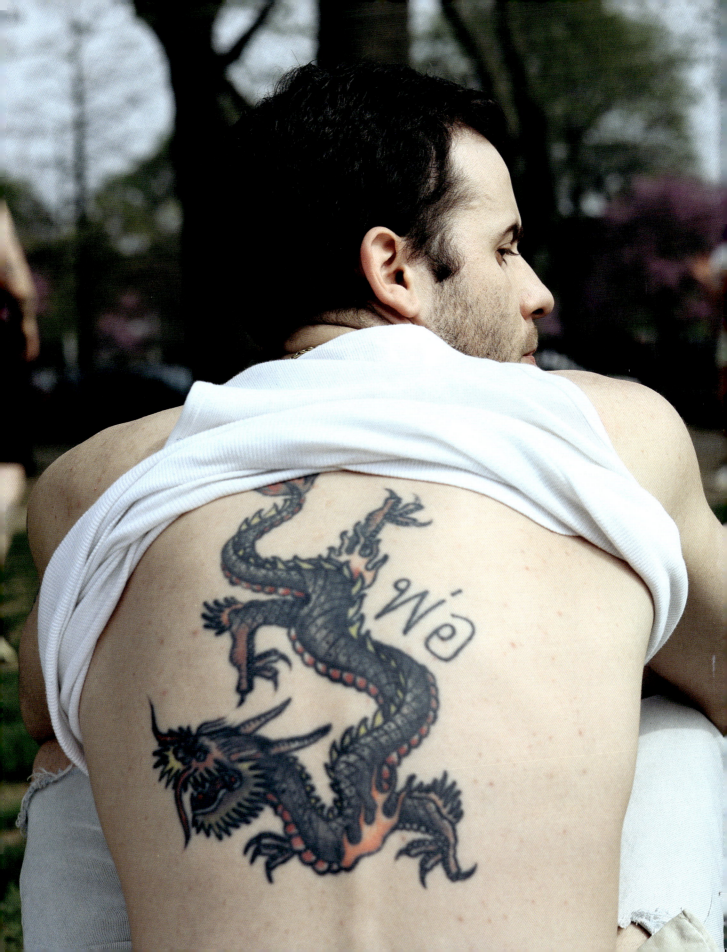

"There was a bad breakup, sort of. It was eight months ago. I'm past it now. But I had to experience that for the first time. I don't think I handled it as well as I could. At the time I couldn't grasp that maybe it wasn't anybody's fault. Maybe I just wanted to be with the person for longer than they wanted to be with me. But accepting things that you don't want to happen is really, really hard. It's like: 'Why do they get to walk around, and keep living their life, while I'm miserable all the time?' It didn't seem fair. So I might have reacted in a way that was disproportionate, to make the person feel more guilty than they needed to. Sometimes that's your only recourse when someone hurts you: feeling aggrieved, and making it known. Not that it keeps you from suffering. But there is a sense of power in it. It allows you to redistribute the pain that you're feeling. You can make their life a hassle for a bit, hurt their feelings, tell everyone they're a big asshole. When the truth is: maybe they were just living their life, trying their best, and you got hurt. There's not always a villain. Sometimes you just get fucked up by somebody exercising their own autonomy."

"It can feel like hamster wheel shit. My mental health gets in the way. I forget there's a sun sometimes. But if I died today, my testament would be my community. It's this huge queer community. Every color of the fucking rainbow. I've walked among some of the most beautiful humans on Earth. I forget that sometimes. I need to be more respectful of that. I'm living a life that a lot of people want. I'm surrounded by love."

"I do freelance construction. It can be good, if I ever happen to be building something essential. But too often I'm doing a job for some guy that works on Wall Street, or a lawyer that just made a $100,000 deal. His unhappy wife is sitting at home, bored. So she's like: 'Let's remodel the kitchen.' So she hires some guy to design a new $75,000 kitchen to replace the one that was perfectly fine to begin with. It's like: Why am I doing this? Every once in a while I like to get out of here and volunteer some place where there's been a disaster. I went to El Salvador for three months after the civil war. I went to Louisiana after Hurricane Katrina. These are the times life feels most meaningful to me: when everyone is outside their comfort zone. When there's no heat, no electricity, no running water. When there's a situation to struggle against, and everyone has to work together at a foundational level. I start to feel deeply connected to the people I'm helping; I feel their pain, and their loss. And being able to do something meaningful to change that—it's when I feel most alive."

"The body knows so much, but we try so hard to figure it all out in our minds. The truth is in the body. It's the only place that it really is. A light touch can be very penetrating. I don't interpret the body. I follow it—follow the breath really carefully, and the way that the body shifts. People think that they're resting—but when I touch a certain place, they realize they're not. They might discover that some part of them is valiantly holding on to something, just bravely holding on. I never go to the chest right away, because that's the center. I'm not trying to catch people. So much of my work is predicated on safety—so to head straight for someone's heart—you don't do that right away. But when there's a broken heart, there's quiet. Even when the person is breathing, the chest barely moves. It takes a tremendous amount of effort to hold on like that. It takes a lot of work to stop your life. And sometimes noticing that, is all it takes. I'm not trying to change it. Because that would mean using other muscles to make it stop. I'm just trying to notice it. And by noticing it, it might become a little easier. Maybe it will begin to soften on its own. You don't want to have an open heart all the time. There are times you need to protect yourself. But you know, it's nice to have a choice."

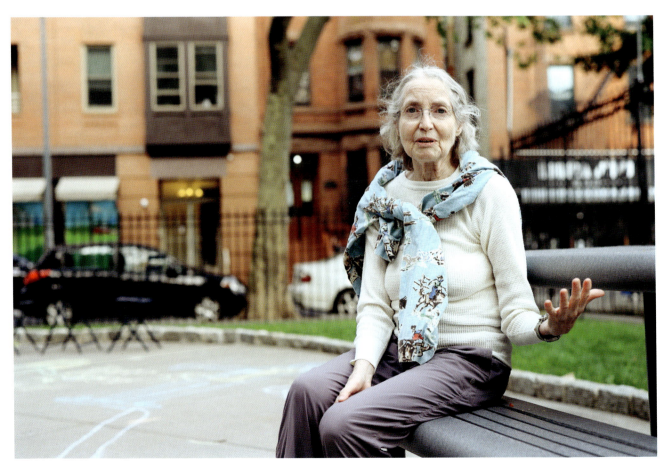

"I never thought I'd be alone. I didn't want to be alone. We went to couples' therapy for twelve years. Little did I know—he'd be coming from one girlfriend's house, and he'd go straight to another's when he left. It took his whole world blowing apart for him to change. He lost our marriage, he lost his family. The kids were eleven and fourteen at the time. But he landed on his feet. Men in general seem to land on their feet better. Maybe that's not true, but it seems to be true. For the longest time I didn't want to go anywhere near a relationship. Then when I was finally ready, I didn't know where to begin. But he fell in love immediately. She was two years older than him, and he was proud of that—that he didn't replace me with some beautiful, young thing. He'd been a sex addict when we were together. But he stopped that. He went to his addiction group five times a week. He did the work. And as far as I know, he never cheated on her. They had a wonderful partnership. She had a lot of dignity. She knew what she needed and what she didn't, and I was a little envious of that. Because I never knew how to ask for what I really needed. She had him working in the yard, fixing up her house—she had him. They had a really, really good relationship. So, you know—he got to. And I didn't."

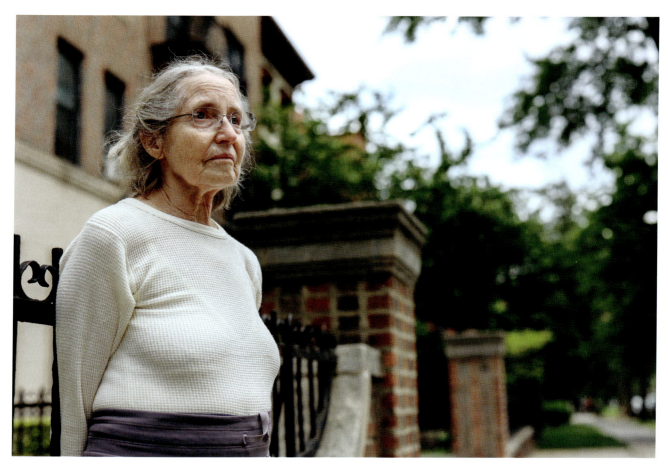

"I just learned multiplication. Multiplication is math. But it's a little harder than doing plus. You have to divide. Then you do like minus ten."

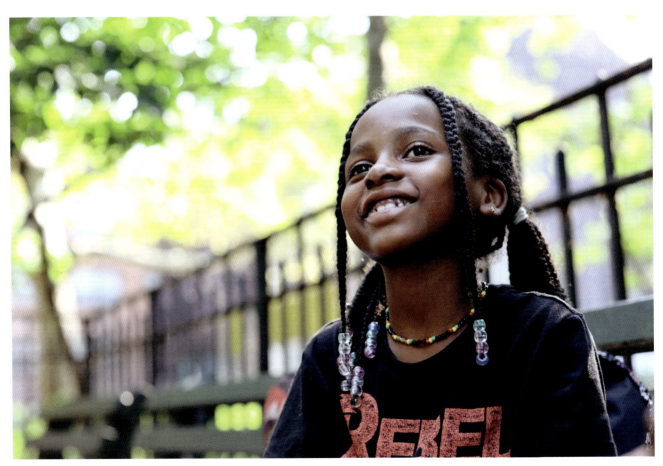

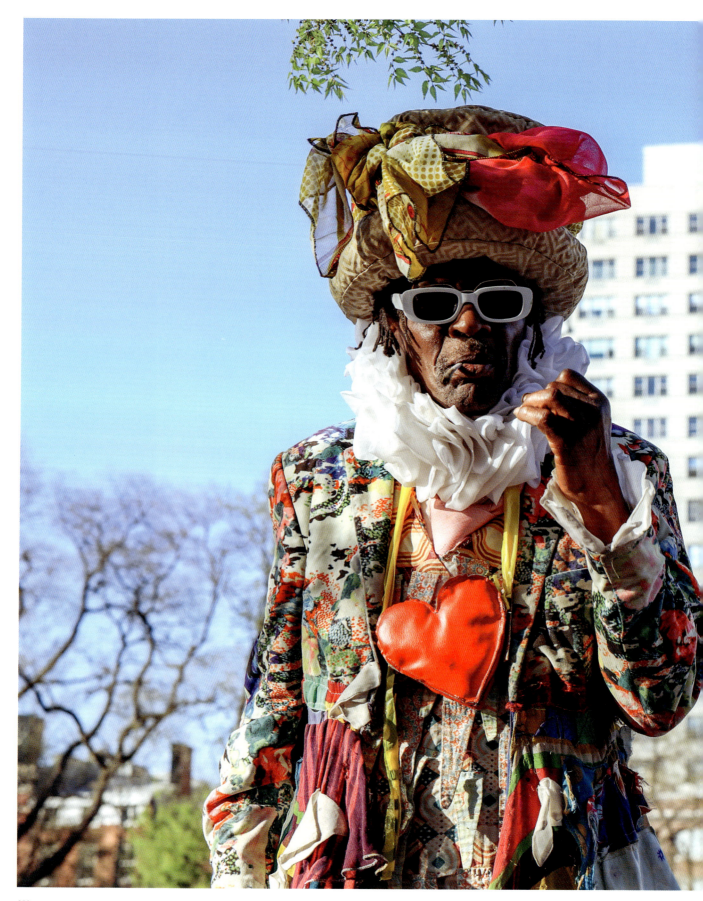

"This is one million dollars' worth of homeless."

"First thing I do in the morning is open the door and look for *The New York Times*. It's rare that it's not there at 6:30, but if it isn't there—I get hysterical. I really get hysterical. I feel that something's cut off. I call down and say: 'Where's my paper?' And they say: 'It's on the way up.' It's a sad excuse for interacting, I know. I wish I had something else to worry about. I have a great apartment. I have two nice sons that are attentive; one of them helps me with all my bills. All I have to do is stack them up. My life is too smooth. I'd like to be challenged in some way, but I don't know how to do that. I don't know where to look. Maybe if I lost all my money, I'd feel more alive. It would force me to think, and force me to make changes. It would wake me up. Because right now I feel half asleep."

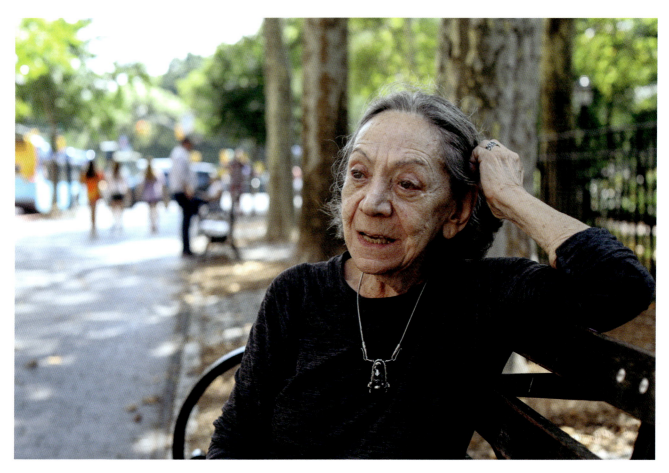

"If I'm driving to the game and I'm feeling sad 'cause something bad happened, I'm gonna keep that moment kinda private. If I need to talk through it, I'll call someone. So when it's time to step out of the car—I'm happy. I like to keep that image. This guy, Jay, he's always happy. If you talk to Jay, he'll brighten up your day. Sometimes it drives the guys at work crazy. I work in Sanitation. Our shift starts at 5 A.M. These guys are coming in from all over: they're tired, they're dragging. But I'm whistling. I've got my Dunkin' Donuts coffee. I'm saying: 'Good morning, bro. What's up? We're about to make some money.' The guys call me Smiley. Billy started that. He said I'm the only one who comes to work smiling. But I'm like: How can you not be happy? Maybe it's just the way the dominos have fallen for me. I have great friends, a great career, a great family. My brother is like my best buddy. Been dating a girl for three years. She teaches dance to little kids. We go out dancing together, salsa dancing. Yo, she's great, man. It's like, how could I ever have a bad day? Been that way since I was a kid. Nobody could put me down. In the morning I'd be like: Another day of school? Let's do it! And listen, when I got home, if Grandma made the skirt steak, with the rice and beans, and the plantains. She'd be like: 'Yo, Jay. Tonight I made your favorite.' And bro, I would get hyped."

"If my family is happy, I would rate myself as doing good. Yes, I am doing the nine-to-five every day. But it's not like every day is going to be the same. There are so many things happening in that nine to five. Yesterday I did not meet you. Tomorrow I may not meet you. So every day new things are happening. I think in this present world, everybody is working for someone. You may not know for whom you might be working. But the truth is, you are. Even if you are a CEO: your company is making a product, so you are serving other people. And that means having to do things you might not like. I don't need to be the CEO of a company. I don't even need to be remembered. There have been so many billions of people who have passed this life. It's not like you remember each and every person. But still, as I have said, each one served other people, and left."

"I've got this goal to be liked by more people and simultaneously not care if they like me."

"I just interviewed at a hedge fund. The position is called quantitative researcher. We work with alternative data sets: things like consumption, or credit card purchases, or satellite images—and use those to potentially generate alpha for the actual traders who work with these data sets. In layman's terms, it just means making a lot of money. But more important than the money is the clout. What I've found with my peers is that what a lot of people are looking for is guaranteed clout. Status is a good synonym. It's when—even while you're resting—you feel proud of yourself, or better than other people. You don't have to think twice. You don't have to make an effort to justify where you are in life. You don't have to remind yourself to be grateful for the things you have. You just naturally know that you're better. Even now I'll sometimes be walking down the street, and I'll think: 'I went to an Ivy League school. I'm guaranteed to make at least $300,000 after graduation. I'm definitely in the top 0.1 percent, probably.' But I still have to justify it a little bit; there's a mental conversion that goes on. Ultimately I want to get to the point where I don't have to think for thirty seconds to know I'm doing well. I want it to be my resting presence."

"I started the business with my ex-wife. We opened five offices in New York and one in Jersey. She wanted to stop there. She said: 'That's enough, let's start making a family.' But I wasn't ready for kids. When a business is growing fast, that is not the time to stop. Now I'm starting over without her. I've already opened three offices, and next year I'm planning on having at least fifteen more. And once I get there, I'm going to want more. I don't think it will ever be enough. When you say it's enough, that means you got tired. And I don't think that's ever going to happen to me."

"I don't really like people."

"I do what I have to do to keep up with my addiction. Right now I do delivery with a bike. That works for me. I make enough to buy my pills and eat, and the pills keep me calm. But you can only relax for so long. Eventually I'm going to have to start doing what everyone else has to do: get a car, get a place, you know. I try not to think about it."

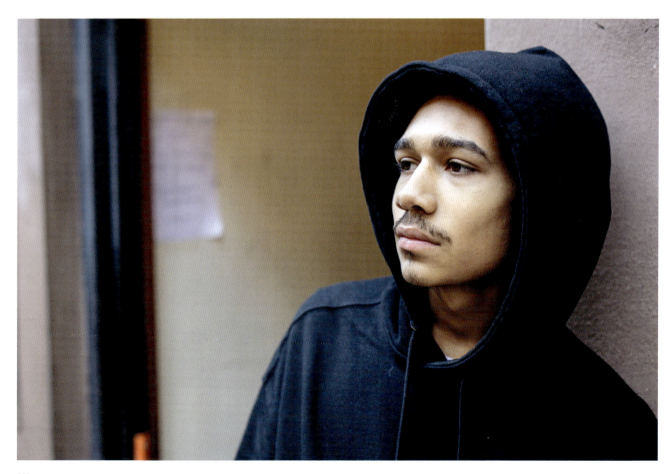

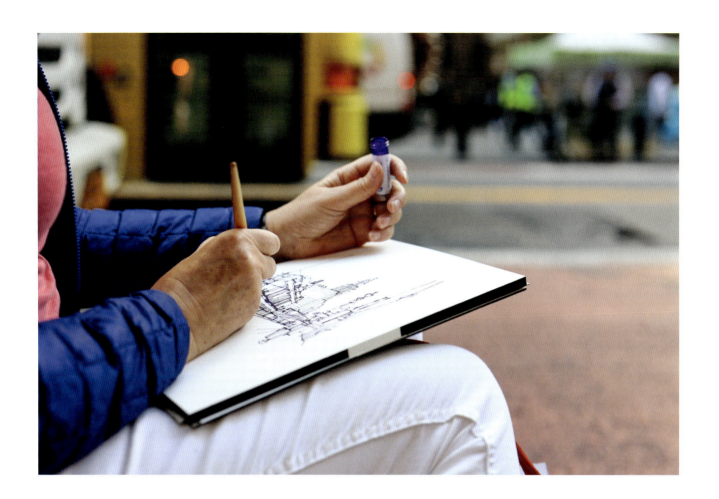

"Usually I'll start drawing at the bit that first caught my interest. And I never know how the final sketch will turn out—that's the exciting bit. It's hair-raising, in a way. There are so many unknowns: the weather, the light, all the things happening around you. It wakes you up. It forces you to pay close attention to the world."

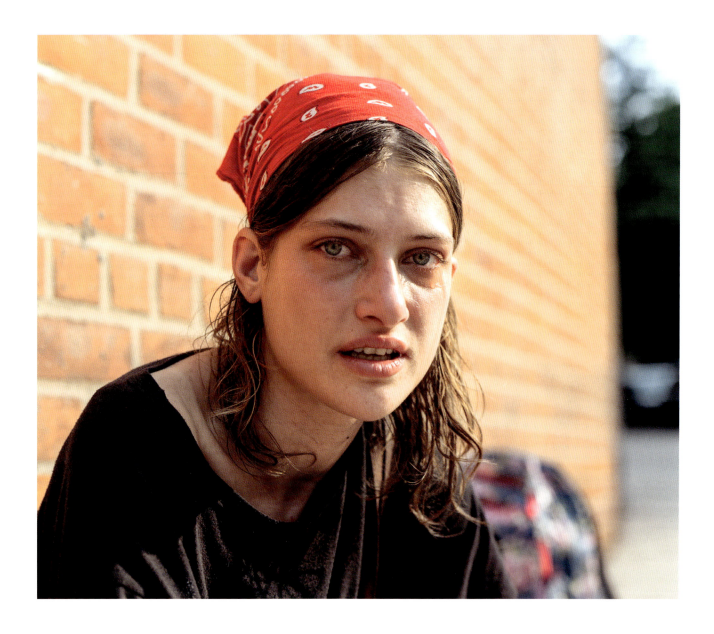

"It's going on seven years now. I was functioning until I lost my apartment, then my job. I was living with this one couple for a while but they kicked me out. But I try not to think about how long it's been. I've read books about heroin addicts who changed their lives around twenty-six, so you know. I'm still young. I just want to get back to my life. I'm tired of waking up and needing it to not feel sick. I'm tired of being homeless. I want to start talking to my family again; that's the biggest, I think. The not speaking to my parents. I missed my mom's birthday. And my sister's birthday; just two days ago. I really am blessed with a good family. I mean, my parents were strict, but I can't blame that anymore. I've been trying to figure out the source of it. I think part of me just wanted to try everything. You know: What's it like? But I think there was another part of me that wanted the attention, I guess. Something I could do so that people would like, ask me: Are you OK? Some way to share the pain. I tried to kill myself once, when I was fourteen. I don't know; I had such a good life. I was just so mad at myself for being so sad."

"I'm doing the wrong thing, to ease the pain. And the pain comes from doing the wrong thing, that's where the pain comes from."

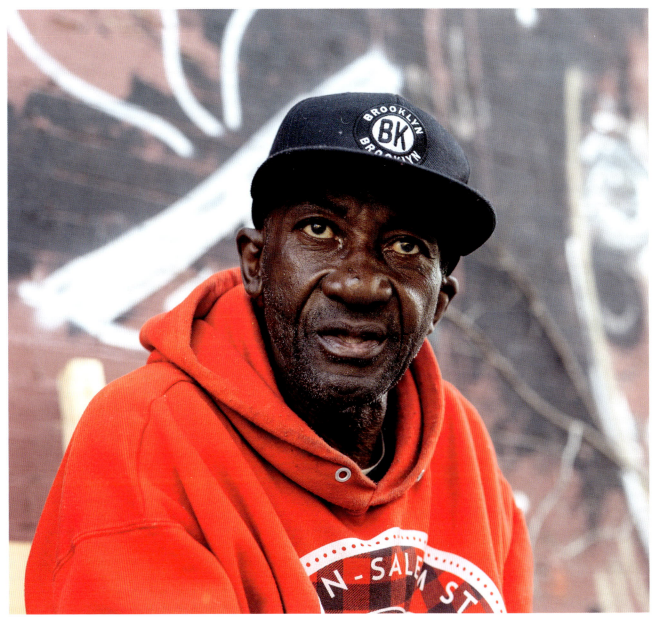

"I grew up in the projects in the eighties; it was not easy at all. It was drugs, it was gunfights, it was a lot. It was easy to see myself as a street girl. I wasn't able to realize: that's not me, that's just what I'm around. Me being the youngest and all, I didn't know nothing until I was able to know. And by the time I knew, it was too late. I was already angry: angry at life, angry at my siblings for the lifestyle we had. One day I was yelling and screaming; it just so happened that I was looking in the mirror at the time, and I saw the devil. I literally saw the devil: angry, wrinkled, burning flames of fire. That's when I knew. That was one of my thinking moments. One of my real, big thinking moments. It was like, no, this is not who I am. That's not me. I am a child of God. And something has to change, because I'm not the person I just saw."

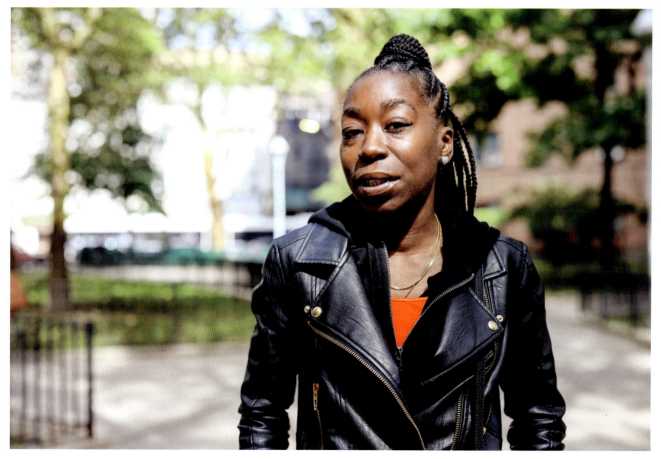

"We went to a used car lot with a bunch of vans, and the guy was like: 'I'll get you approved for a loan, no matter what.' We were like: 'Well, if we can afford the van, then there's no excuse.' We were twenty-four years old. It seemed to be the right call. We were doing two hundred shows a year. They weren't two hundred good shows, but two hundred shows. I just wanted the numbers. We played bookstores, record shops, church basements, that kind of thing. Nobody made any money. Sometimes we'd get twenty or forty bucks as an appearance fee, but that would only be enough for like, a third of a tank of gas or something. That's when the credit cards began. They just started arriving in the mail. I sorta developed this strategy where I stopped making payments. We'd be playing in some place like Boise, Idaho. And my address was in Texas. So how were they ever gonna find us? I thought if I could just keep running from them—maybe that'll work out. We toured for ten years. Never hit it big, but I would rather lose so hard than quit. I'd rather fail spectacularly and find a new worst-case scenario. And I've been there—several times over. I'm taking a little time off the road right now. I'm working as a sound engineer and living in the van while I pay off the credit cards. As of a few weeks ago I finally own the van. It's got 213,000 miles now. It sounds like there's a family of squirrels under the hood. But it's definitely got a few more tours in it."

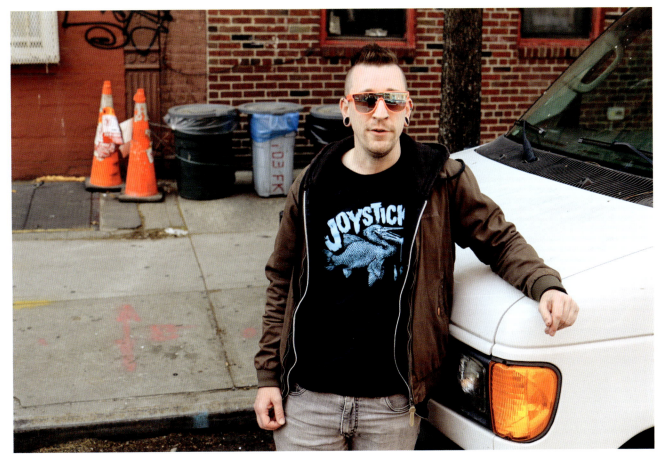

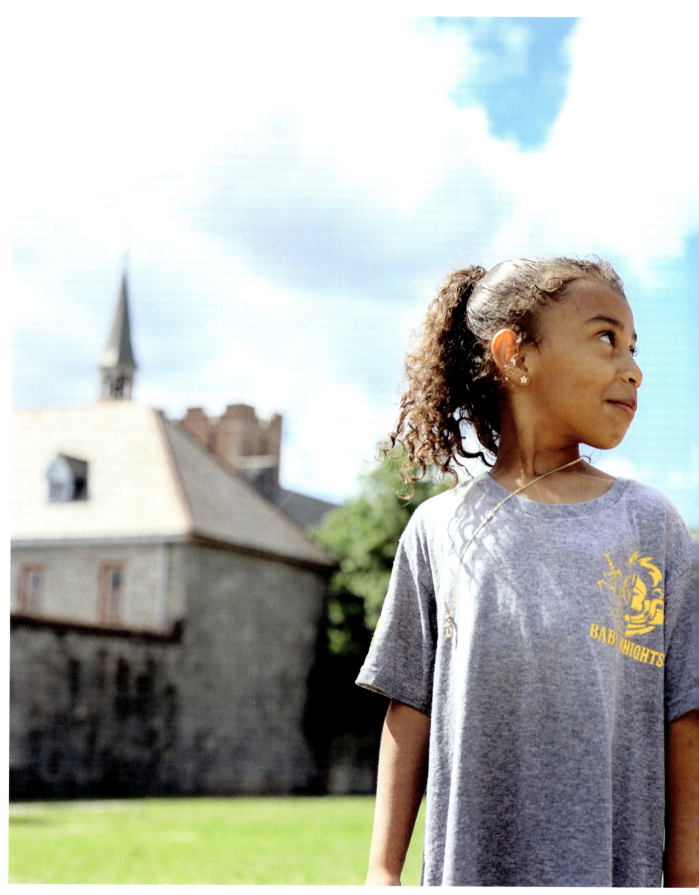

"To me she's the most prettiest girl in the whole wide world."

"My wife has my back. More than the girlfriend. If I ever got in trouble, my wife would be there—so I love her too. But it's two different worlds. My wife and I fuck, but when my girlfriend is in front of me—it's like: I need that now. We found each other at that perfect moment in time. Extensive track records: multiple partners, multiple situations. Then we came together to reach the zenith. I know my role. I can bring her to a certain point. And a big part of my satisfaction is getting her to that place. Every time is different, or we'll go through phases: do one thing for a month, put it down, pick something else up. It's never gotten old. For the longest time I didn't know her husband's name, or where he lived. But things got too blurred. A couple years back we got caught. It was my fault. I was drunk; wife got the phone. In therapy my wife was like: 'Why don't you do that stuff with me?' It's like, look, nobody checks every box. It's impossible, impossible. If your wife checks five, and you got six other boxes—you're going to check those boxes somewhere else. This whole monogamy thing is just a story. It's made up. It doesn't work. Look at nature—the males fuck different females, the females fuck different males. She was like: 'But you took a vow.' And I do feel bad. I'm sorry to disappoint her. But it's like, you knew this. You can't be so naïve that you think all the sudden the leopard is going to change his spots. When we first got together—I was cheating on the girl I was with."

"I made this hat from toilet paper rolls."

"Every time Muhammad Ali had fights, the blacks would show out. There'd be pictures in *Jet* magazine. Everyone would be by the ring in their macrame hot pants and gold belts. I was inspired. I took a pair of pants and cut them so fucking short my pockets were coming out the bottom. Then I put on a baby blue ribbed Lycra sweater. I was all of maybe nine years old, but I felt like the world was mine. I strutted over to my best friend's house, and rang the doorbell. I said: 'Is Brad home?' His mom took one look at me and said: 'Oh no, baby. He ain't here.'"

"It's nice when my kids give me a hug and all that jazz. I even participate—in the same way an actor would participate. But I'm not overwhelmed from within or anything. My wife is a different story. It's night and day. The kissing, the hugging, birthdays, Christmas, all those tropes. But when I watch them it's like I'm looking at a painting. Where there's love and happiness and joy and anger, but I'm just an observer. I can't remember it ever being another way. I had a very uptight English upbringing. My mother would never dream of saying, 'I love you,' or anything like that. Annoyed the hell out of my brother. He thought she didn't like him. I told him: 'You're overthinking that one, mate.' She did what needed to be done. Who cares if it was connected to a feeling? But I get it. Feelings are about connection and all that. They don't cost money. Not to be all John Lennon about it—but love is a powerful thing. I can appreciate that. As a concept."

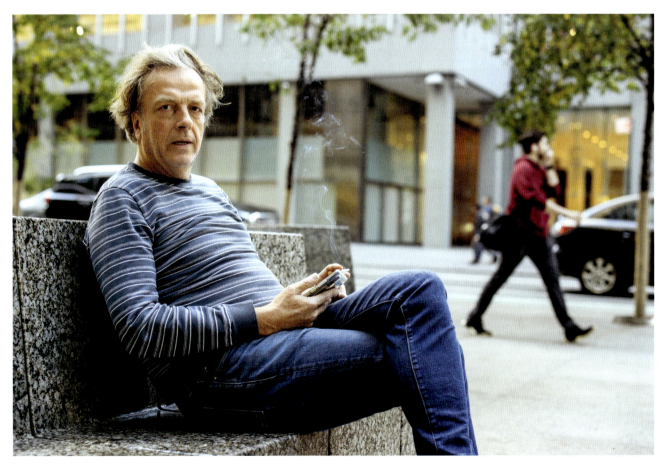

"My downfall was when I first got a Kindle. I read stuff my eleven-year-old self should not have been reading. My favorite romance novel was called *The ABCs of Kissing Boys*. I read it multiple times. It's about a girl who's never been kissed, but she ends up falling in love with the next-door neighbor. It gave me hope. I'd never been one who was sought after. I'd get these big, all-encompassing crushes, and they'd always just devastate me. But every time I read a romance novel, it was like: it can happen to me too. If my own life was a romance novel, I'd say I'm still in the first act: a small-town girl moves to New York to land her dream job at a romance publisher. The only position she can find is at an academic publisher, but at least she's in the solar system. On weekends she works at a bookstore called Books Are Magic. And maybe one spring day, somebody will walk in: boy, girl, doesn't matter. They'll buy her favorite book. Then they'll keep coming back to buy the books she recommends. She'll become the first person they text whenever they want to chat. This girl loves corgis. So whenever they see a corgi, they'll text her a picture. There will be fights. Because this girl has never been able to stand up for herself. But she'll feel safe with them, so she'll stand up for herself. She won't be made fun of. Or judged. She'll be able to say the most inane things. And every time she finishes a romance novel, they'll let her talk about it for hours. They'll be charmed. They'll never say: 'My God. It's the same plot over and over.'"

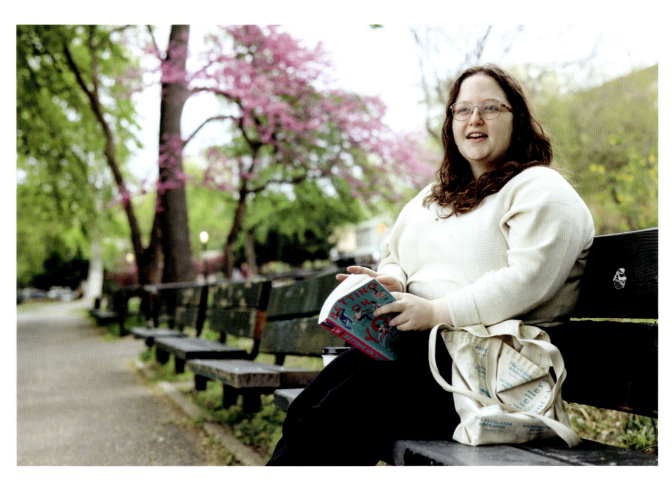

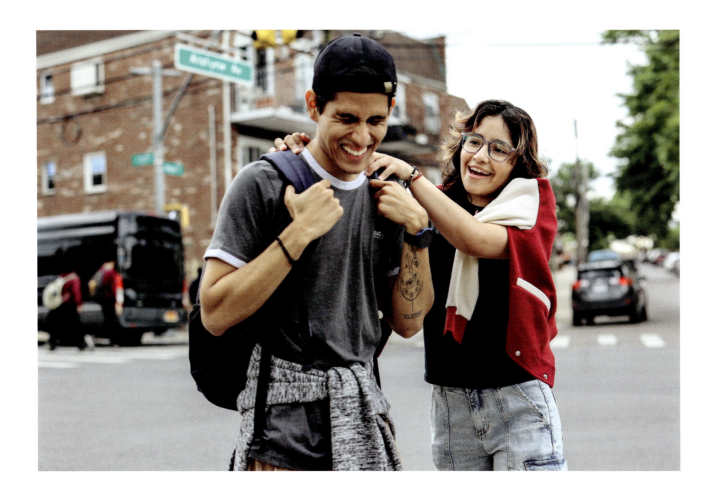

"We work together. We make crepes, Japanese crepes. I'm actually his manager. It's really hard to be a manager because we're all friends. There's five of us: four girls, and him. But he's one of the girls. He's not like a 'man's' man. He's kinda sweet. But he's not a very good employee. He's always on his phone. I tell him: stop looking at the phone, but then he just brings it into the bathroom. He goes to the bathroom like a thousand times a day. That's how lazy he is. And I'm pretty sure one of the other girls has a crush on him. They're always making inside jokes. And she's always getting close to him, like this."

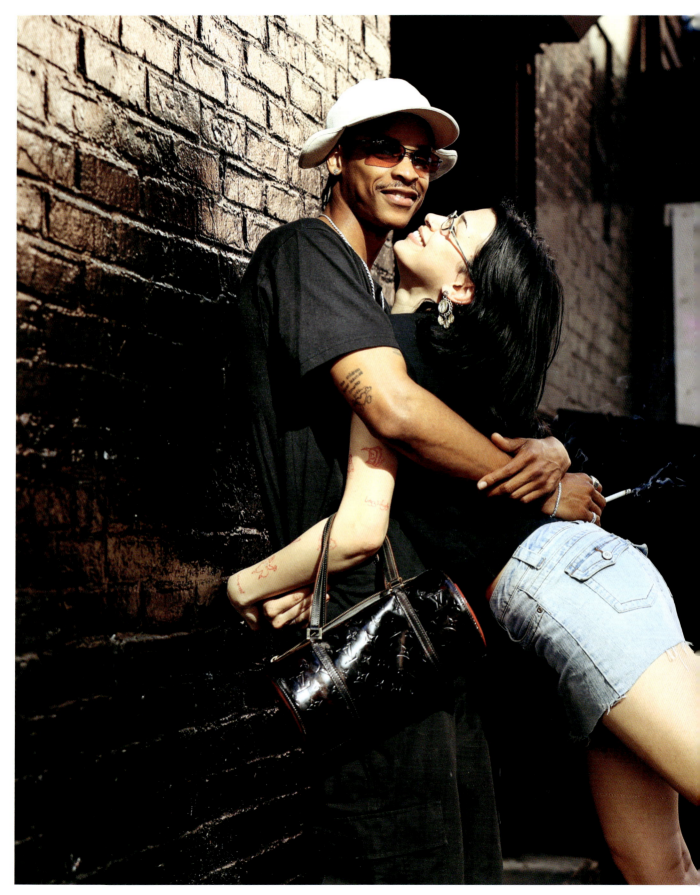

"Right after we met, I was in the bathroom taking a shit and she came in and sat on my lap. I was like no fucking way. That's when I knew she was the one."

"I think when I'm old I'm going to have gray hair. It's already turning gray, so I'll definitely have gray hair. Maybe I'll have bulked up at that point. My dad has skinny legs and arms—but he's buff in the middle. So hopefully I'll be that. I'll probably just be sitting around. But not in a rocking chair or anything—just on the ground. Maybe in a boat. I think it would be cool to have a boat. I used to always make fun of straight dudes who talked about fishing. But now I'm thinking: maybe I should fish. Really learn to survive off the land. Like gut the fish myself and gross out the kids. Not my kids necessarily, but maybe my siblings' kids; I'll be the best worst uncle ever. I'm also hoping that I'll have drawn a lot of stuff by then. Maybe even published a few books. And hopefully there will be a nice handful of people who really like my stuff. They'll think it was a nice contribution to the world. And they'll care when I die. But mainly I'm just glad I get to be an old man. I could never imagine myself as an old woman. Like, I couldn't. So the future was just—nothing. But now I'm here. So I feel like I can't be too upset about anything, you know? Because when I looked at the future, there was nothing. And now there's something. And that's everything."

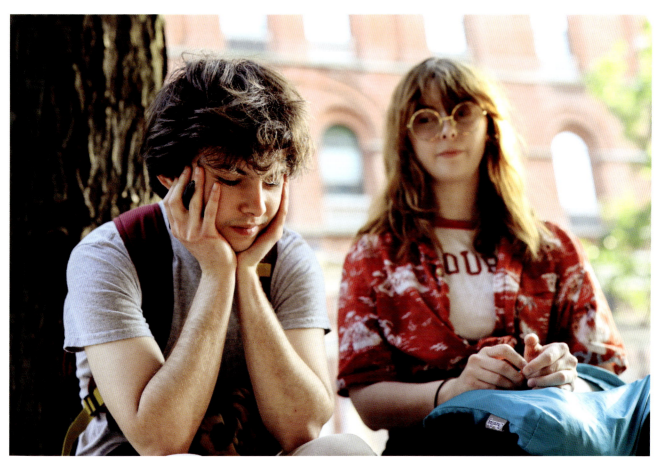

"Summertime and Christmas. That's when I have her. Been that way for seven years. When she's not in school, she's with me. Then at the end of the summer I bring her back to her mom's house in Florida. Those drop-offs are the worst; I almost miss my flight every time. I hug her, say goodbye, put my stuff in the car. Then I always gotta come back again and get my last kiss. On the wall in my closet we keep track of her height. And every time she comes back, she's grown like two inches. That's a lot. That's a lot I don't see. But she knows she can call me for whatever, which she does. And whenever she's here she gets to be the CEO of our lives. She's not a dictator or anything. But she's the president. I'm the people. When she says we go, we go. She wants to go to the pool, we go to the pool. She wants to go to the beach, we go to the beach. We came here today for the Juneteenth celebration. Been planning it for two weeks. I'm supposed to be at work today, but I took off early. There's a bouncy house and face painting and all kinds of good stuff. But she didn't want to do any of it. We stayed for two minutes. And now we're back to feeding the animals; same thing we do every day."

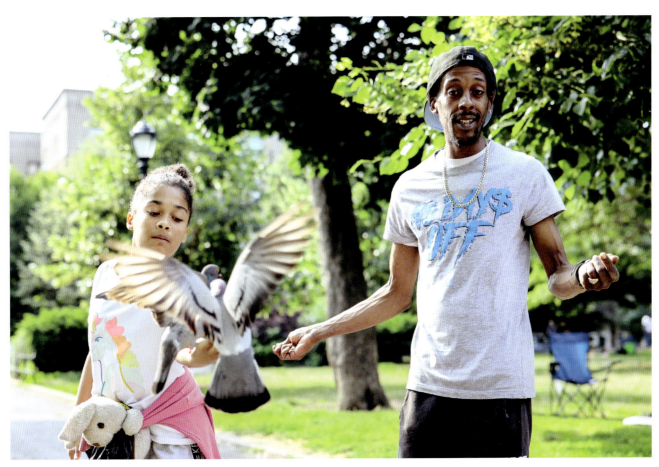

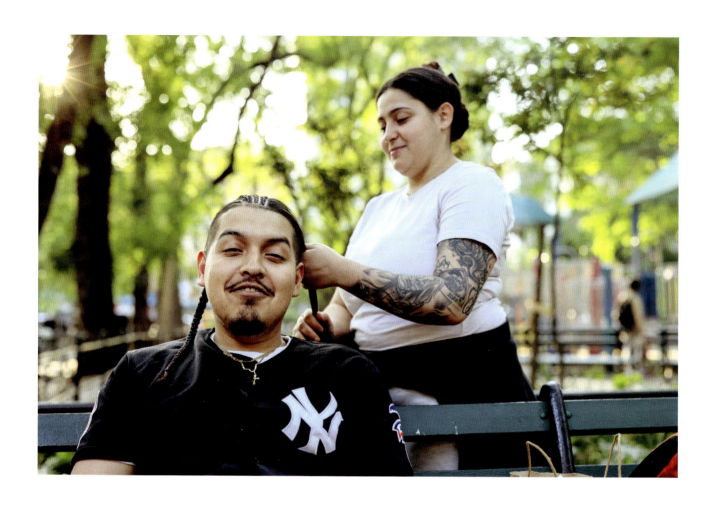

"We began as friends. I'd just started growing my hair long. And that was when she was like, you know: 'I could braid your hair.' And then she did it. And it was fire. After that we got into what we got into. It lasted two and a half years. Loved everything about her, truthfully. I wanted to keep trying. It wasn't my decision to break up. But people grow apart, I guess. Sometimes you've got to just move on. Keep it gangster. Except you can't trust many people with your hair. Only thing is—now I gotta pay for it."

"I have been to the realm of the spirits. It's in the fourth dimension. It looks like the Parthenon in Greece. I was taken there by a child between the ages of eight and ten. You enter in darkness, then after about two hundred feet, the light is there, and it's like the light of the moon, and that's the doorway. And when I walked through the doorway—I saw all of them. They're all there, in this great big hall. And I'm looking at them, thinking: 'Why don't they leave?' The door is right here. It's open. Then suddenly they all stopped talking and looked at me. And the little boy looked at me. And I looked at them, and I looked at the little boy, and I looked at the door. And I said: 'Fuck it, I'm out of here.'"

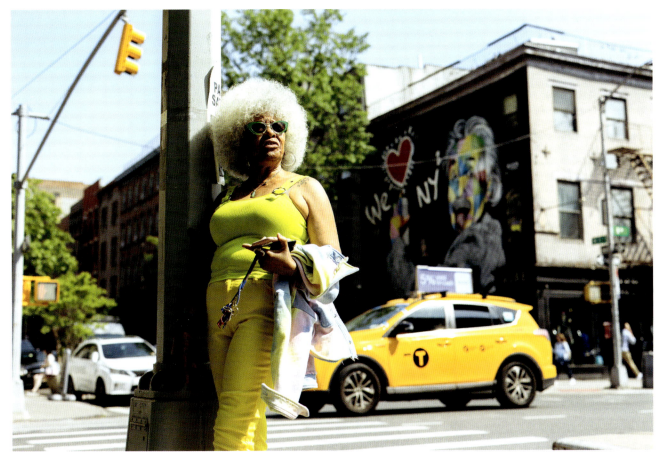

"They were immigrant parents, so a lot of the emotional stuff was uncharted territory for them. My mom wasn't much of a communicator. Her way of saying sorry was to cook our favorite meal. I guess you could say her love language was food."

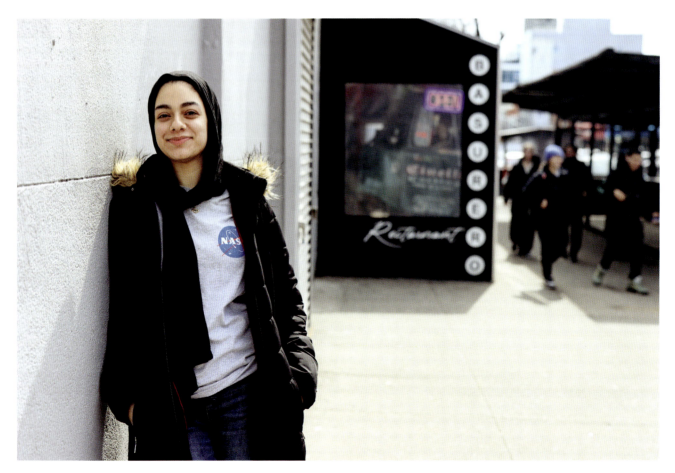

"A lot of time life can feel like you're swimming, no matter what. But when the anxiety gets really bad, it's like you're kinda starting to bob up and down. And then you get anxious about the bobbing, and that can kinda trigger a spiral where you start to drown. That's pretty much what happened to me."

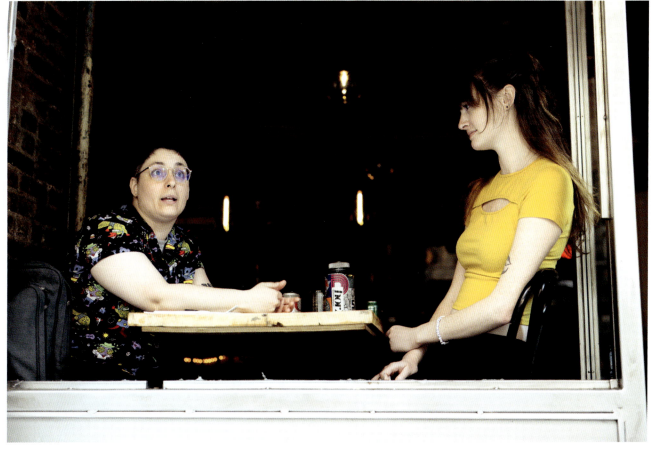

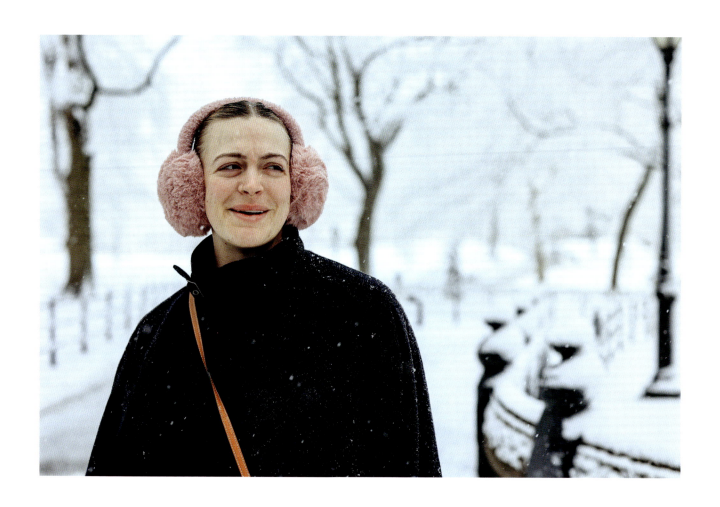

"I have a hard time asking for help. I'd prefer to keep up the façade that I have some idea of what's going on."

"If I'm not moving forward, I start to get a little panicky. I get fidgety. I've got to do something: to be better, to be stronger. I normally do my ruck on Fridays: fifteen to seventeen miles. Not a lot of people will do it, so I'll get it done. I just get it done. As long as it's in the books, I'm fine. It means that I'm slightly better than yesterday: my stamina levels, my mindset levels. But if I don't do it—there will be this little nagging thing inside me, because I failed. I failed to carry through on something that I knew I was supposed to do. I could have grown by a certain percent if I'd done that ruck, but instead I've slipped back. I'm in the red now. I'm weaker. And when you start to become weak, it bleeds into the rest of your life. The challenges you go through every day will seem bigger instead of smaller. Maybe you'll become a little lazier at work. Maybe you'll want to take a bit more time off. Eventually you might become so weak, that you decide to settle. You'll build a throne with whatever you have, and say: 'It's enough. It's good enough.' You'll sit on your throne. And the moment you sit on that throne, it becomes your coffin."

"It took me a long time to figure out that not being able to get my homework done doesn't mean I'm a bad person."

"I started when I was six. There was one goal: to be a principal dancer. I went to one of the best ballet schools in America. Then when I was fifteen I got invited to Germany for an intensive. Every morning I'd be at the studio by 7 A.M.; I'd be in my pointe shoes by 8 A.M. We'd work for nine hours every day. You can never reach a level of perfection, ever. Which is so frustrating. It drove me crazy half the time. It drives everyone crazy. You'll watch your role models in rehearsal, and they'll do the most amazing thing you've ever seen. You'll think it's perfect. But it's not enough for them. They'll be like: 'Fuck, that didn't work.' It never ends. Every little thing you do in a performance means something. Sometimes how you come down from a step is as important, almost more, than the trick itself. There are some dancers who can do however many pliés, or their grand jeté is absolutely insane. But they have to know how to come down, and they have to know how to be still. Otherwise it's just a trick show."

"I'm twenty-one right now; this is supposed to be my peak time. But I'm taking a break. I used to see people who left dance, and I'd think: 'How could you ever do that? You'll never find something else that requires all of your energy, all of your heart.' But now I get it. There's so much else to do. I've been hanging out with fashion students, interior designers, photographers, chemistry students. There's just so much out there, and for me it had always been just one thing. Even when I had downtime, it was resting, or rehab, or Pilates. I never had time for myself. I could never be like: 'Oh, I'm going to try something new.' But now there's time. I have so much free time. I've been doing nothing for a year now: so many naps, and hanging out. I'm learning that I love hanging out. Like, I really love it. I've been spending a lot of time at Tompkins Square Park; I grew up around there. I see kids from my elementary school, during their recess. They're just playing on the playground, having fun. It's like: I used to do that. That used to be me."

"You walk into some of these homes—and you know, it's pretty hard to see, when you're living so comfortably and so many people aren't. I live comfortably in a nice apartment with my brother. We grew up in a small beach community in Queens, where everyone knows each other, an hour south of greatest city in the world. It was almost like one big playground. No streets at all. No real crime, no real drugs, nothing really going on. We got to ride bikes and kind of bounce around: baseball in the field, football in the sand. Summertime was always the beach. Our parents disciplined us the right amount to make sure we weren't running amok. But they were always there. You never felt unloved, even when you were getting yelled at. A couple minutes later, it's 'I love you,' and they give you an explanation. I played four years of college rugby that, you know, I loved. And they came to my games in places like Tennessee and South Carolina. The two of them are something else. I don't know what else to tell you. I would like for the Mets to win the World Series. That'd be pretty cool. No, no, no, but other than that, I mean, I don't know, I, I just, I really love where I'm at. I'm so grateful for it every day. And it's truly amazing, you know?"

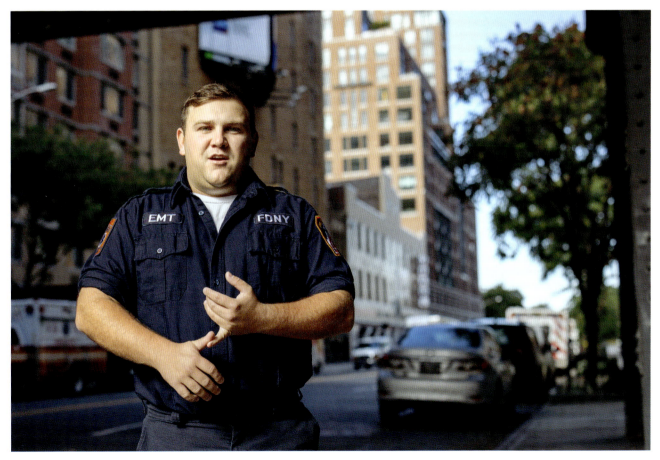

"I came in from playing outside to find my mom sitting in the kitchen chair. The oven door was open, gas was streaming out. She had just enough strength to get up, push me out the door, and lock it. So, yeah. I've been an old man since the age of ten."

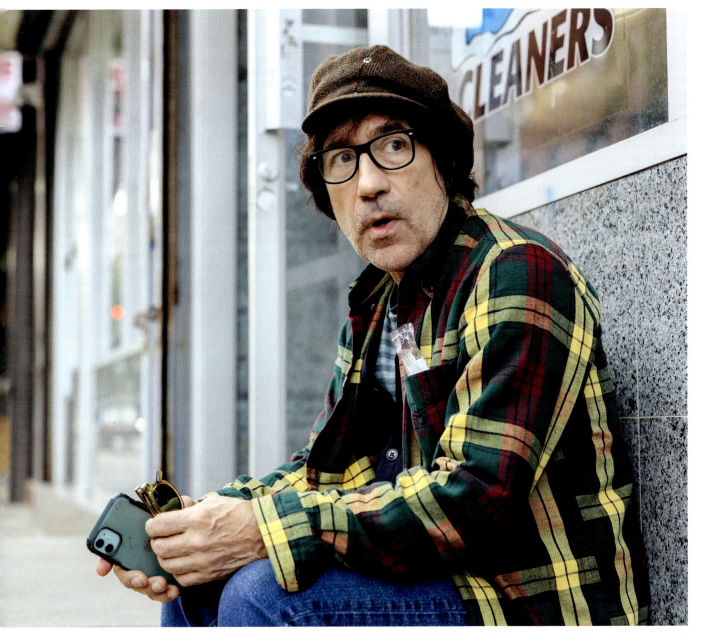

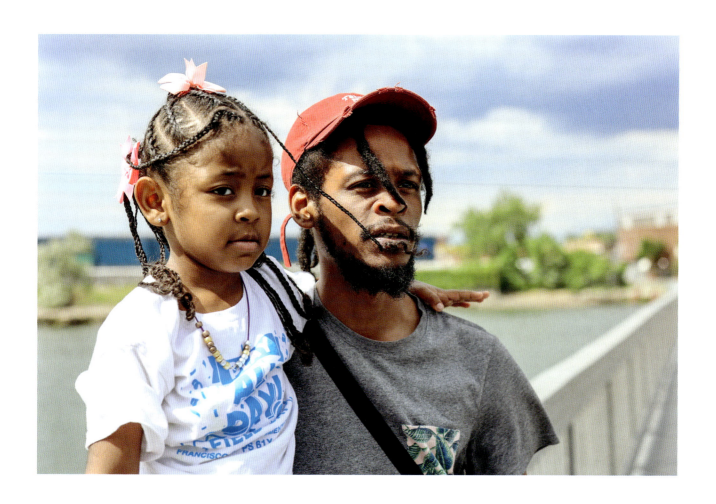

"Still have my drinking habits. Still have my smoking habits. But ever since she's been with me, she's always had food. She's never been in no ACS situation. No life-threatening situations. No hospitals. Doctor trips here and there, but that's normal with kids. It's amazing that I've made it this far. Being a single father, as young as I am. 'Cause it's not easy. I'm just trying to maintain peace for her. That's what I'm trying to believe: that a peaceful household will make a peaceful kid."

"They set me up. They couldn't catch me for what I was actually doing. I was sticking up store after store, but I was too slick. So they paid some bitch off; said that I robbed the QuickChek she was working at. Never saw that bitch in my life. Locked up for decades, for no goddamn fucking reason. They wanted me to die and never come out. Putting medication up my ass, making me shake like a fucking leaf. How would you feel not having sex for seventeen fucking years? Now I'm out. And I want revenge."

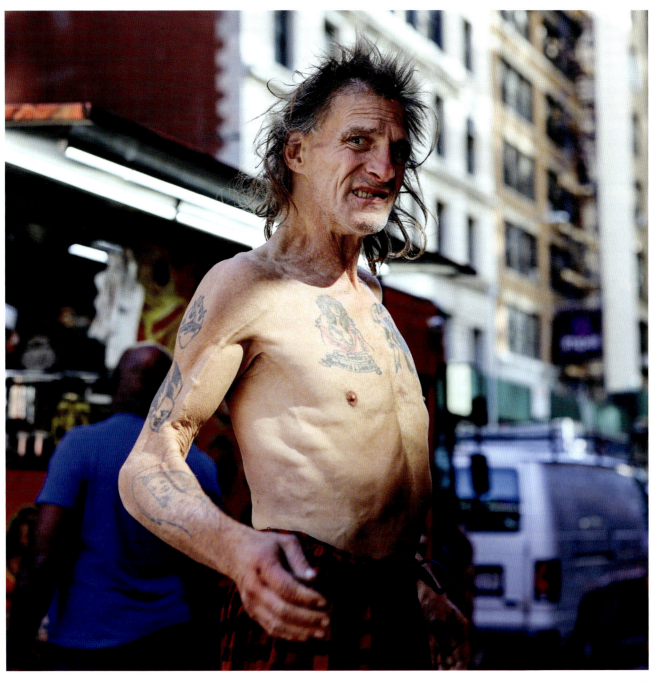

"I was bitter, for years. I was real bitter. Everybody gets angry. That other side can come out. It's a dangerous side, too. That side, it'll get me killed or put in jail for the rest of my life. It comes out when I feel threatened. When people press certain buttons or hit certain nerves. But really, how would you feel if your mom died while you were in prison? They pull you out of your cell and say, 'Sit down.' And then you have to go back to your cell. How would you feel about that? All those fucking years, you could have spent them with your mother. When I came home from prison, my sister said: 'Go in Mommy's bedroom and open the drawer.' It was filled with envelopes. Every single one of them had $1,000 in it. $150,000. My mother made wedding dresses. Think about that. Think about all those wedding dresses, just waiting for me to come home."

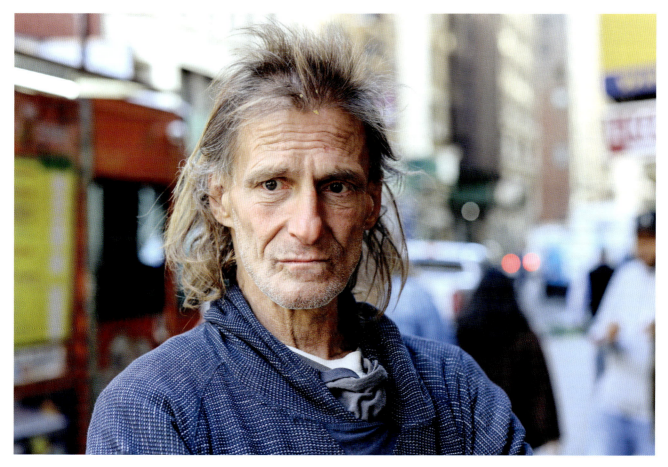

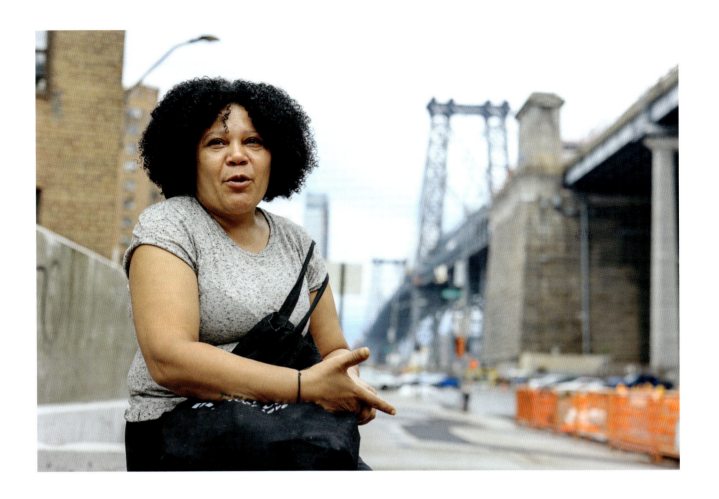

"What would be enough? I'm not at enough, I know that. I think enough would be getting to the point where I don't have to worry about how I'm going to pay the rent, or how I'm going to pay the bills, or how I'm going to eat. Enough would be being able to take an actual vacation. I've never really been anywhere. I mean, I went to Puerto Rico. And Florida once when I was a kid. But I've never really been anywhere. I would love to go somewhere. Like somewhere so—magical. I want to see animals and just something so beautiful, maybe Arizona. I have an obsession with Arizona. It's something I tell my daughters: way beyond here, there's a whole 'nother world. And I want you to get out there and experience it. Because everyone I know who's done that says it changes your life forever. And I want their life to be changed forever. But now, lately, I'm kind of like—I want that for me too."

"She woke me up the other morning and was like: 'Daddy, it's nail polish day.' And it was on. I was like OK, let's do it. Just dive into it. She did a sloppy job on Daddy's nails, but I enjoyed it. Well, I didn't enjoy it. Not like that. You know what I mean; I enjoyed her enjoying it."

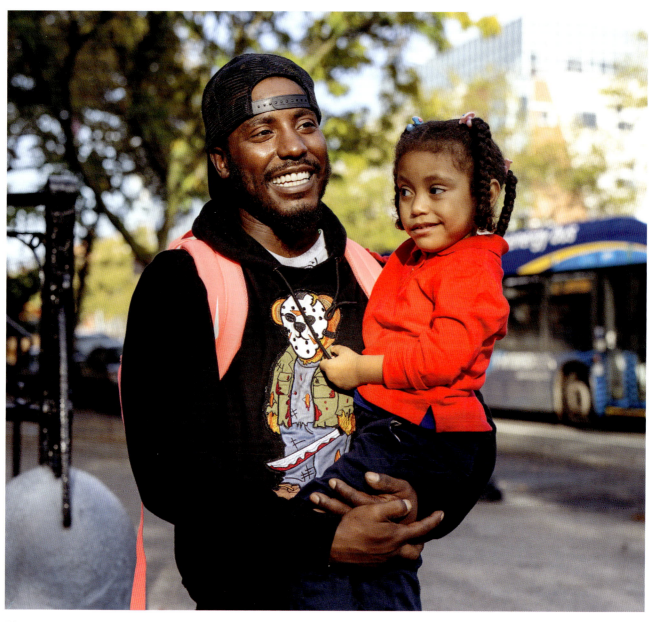

"I peaked in high school. I was probably number one in the country at one point on pommel horse, maybe even the world. All I did was homework and gymnastics. Five or six hours a day. Ten hours during the summer. No movies, nothing like that. I remember being fifteen, sixteen; I'm crying. The pain was so bad I couldn't sleep. The flesh is dripping off the sides of my hands. I'd tell my dad: 'The flesh is coming off.' But it didn't matter to him. He was tough, he was a tough guy with me. Any little mess-up, I wasn't trying hard enough. I don't want to say he was tough in a bad way; he's deceased now. Let me say it in a good way. He had, um, beliefs. Every day on the way to practice he'd make us say a prayer: 'Heavenly Father, please help me become the greatest gymnast in the world.' I had to say that every day. I had to say it between every routine."

"I used to be super nihilistic as fuck: hated the world, hated a lot of people, really dark fucking shit. But I grew out of it. Just getting out more, talking with people. You realize not everybody sucks."

"This is the first time I've been in a relationship where I feel like no matter what happens between us, we're gonna stick with each other and figure it out."

"We have different fathers, so he's big. He's a big dude. But he's still my little brother. He was more of a mama's boy homebody. We didn't hang out much. All my skate spots were downtown, so I'd never be home. Maybe he looked up to me in some ways: I had a more exciting life than him. But I was also a mess: drinking, drugs. He never fell into those traps. He kept a low profile: worked at Home Depot, video games, movies. He's not even on social media. I respect it. This is an old-school cat: watches the news, loves his wrestling—just a real, easy dude. My stepdad bounced three years ago, so it's just the three of us now. We've got to stay tight. Ever since I sobered up, I've been trying to get him out more. We get steak dinners and shit. There's usually some convention going on in Jersey. We went to a nineties wrestling con and met some legends. Went to a porn convention and met his favorite porn star. I've learned a lot from him. Just from him being him. He's got great common sense. And even though he's quiet, when you get him going—he's funny. It's like: 'Dude, you're steezy. You're sick.' I can't even put words on it. He's just my brother."

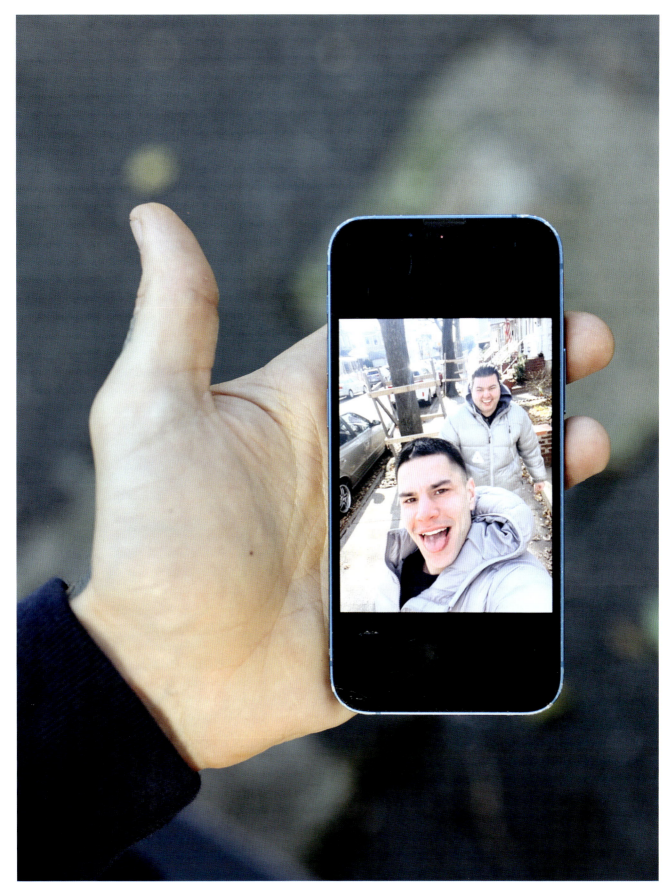

"It's not just about income equality. There are all these issues globally: the refugee crisis, systemic racism, gender inequality. I don't think liberal capitalism provides many great answers for those. There has to be a sort of system to unite all these disparate issues. And if you want to build socialism, why not start at the place you work? It's a brick-oven pizza place. Been open for twelve years. Thirty-two tables. We moved covertly for a long time. We have a really strong organizing committee, so there's no leader. But yeah—I'm on the committee. Everyone plays a role. I'm not good at making spreadsheets, that's not me. But if I happened to catch someone on a smoke break, I might say: 'Hey, I saw how the manager talked to you. Maybe we should do something about that.' To be fair, not everyone voted. But everyone who voted, voted yes. And we just became the first unionized independent pizza restaurant in New York City. We want more money. We want breaks. We want assistance getting health care. And you'll understand, I want to be a little careful here, because we're heading into contract negotiations. But let's just say this is where the battle ends, and the war begins."

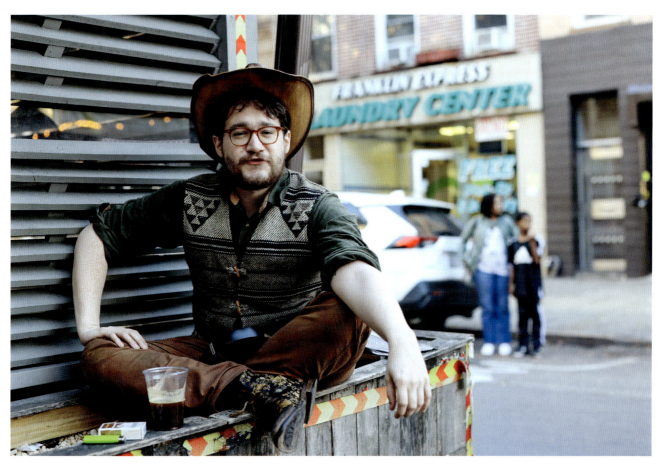

"It's possible to build your soul in a city. It can become like a parent, especially if it feels safer than home. In Saint Petersburg there were a lot of public spaces that were just like this: where art and culture are accessible to people. In the evenings after school my friends and I would go to the Hermitage Museum. We took our art very seriously: the less-cool kids knew some of the older stuff, the cooler kids knew Impressionism. The museum is inside of this giant palace; it's an amazing maze of rooms. And it only cost a dollar. So instead of hanging out on the street, everyone would go there. All of the security guards were retired women, like grandmas. So there was a certain peace. It was the best version of the world available to us at that moment in time. When your home is abusive, when you don't have any warmth, or order, or traditions—there's a hollowness you can feel. You can't build anything if there isn't good ground for building. But in this museum, we were surrounded by order. We were surrounded by the history and legacy of a great city, a great culture. And we were part of that too. It was a choice. We were making a choice. We could choose to identify with that—instead of what was at home."

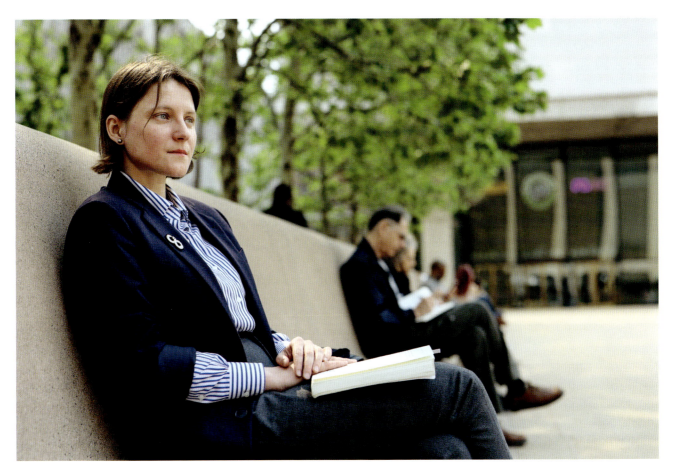

"Electricity may have been cut off a couple times, but Mama always came through."

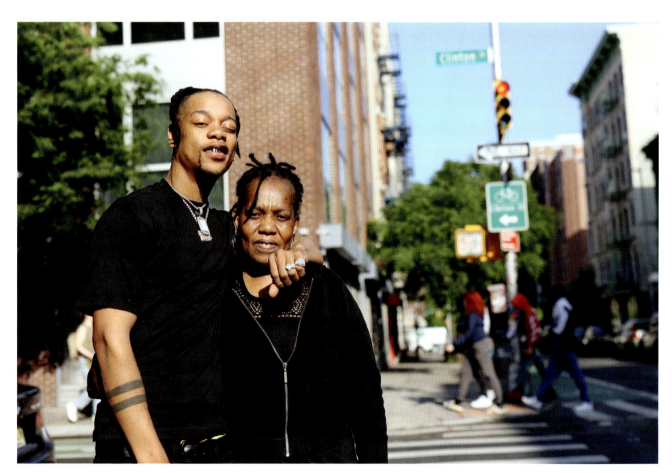

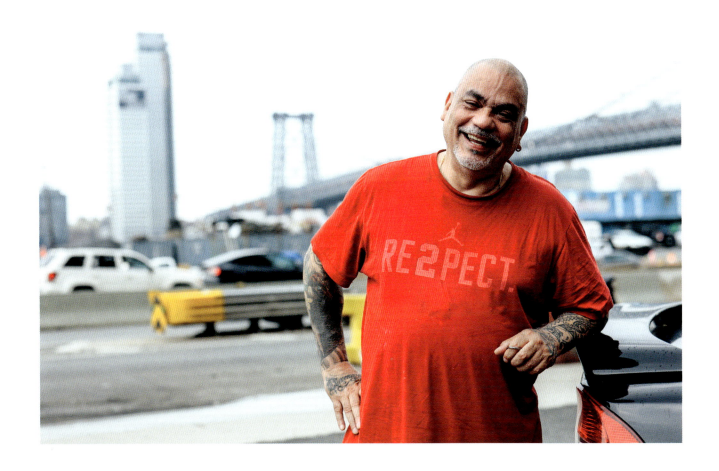

"My niece is getting married in Puerto Rico. One, I don't want to go. Two, they're going on a cruise to do it. But I said yes, because I wanted to please everyone. I put a $500 deposit down. But after I got off the phone, I started thinking: 'Damn, we're going on that boat.' My wife is telling me not to worry. She's telling me: 'The boat is so big, you're not going to feel the waves.' But you know what a big boat looks like, in the middle of the ocean? It looks like a speck. That's how big the ocean is. It'll make a gigantic-ass boat look like a speck. The bigness of the ocean will swallow you up like a fucking blob. And everything lives in the ocean. Think about it. Sharks. And I've heard all that bullshit, about sharks being misunderstood. No, no, they are not misunderstood. They are hungry. And they want to eat."

"I never once remember my father saying: 'Oh, let's go to the water park.' He'd spend all his money on friends and girls. And when he did come home he was always screaming, always hitting—for every little thing. Now that anger is inside of me too. It comes from the inside. I'll start to get mad, and suddenly it's all over me. But whenever that starts to happen, I think: 'I'm not going to be him. I'm not going to be him.' I'll walk away and calm down. Then I'll come back and apologize. I'll say: 'What you did was wrong. But it was also wrong for me to speak that way.' I try to show him respect. Even though he's a kid, he deserves the same respect as any person—even more, actually. Because an old person knows what's going on, and he doesn't. He's a super kind boy. I haven't noticed any anger in him at all. Not at all. Sometimes I worry that I need to push him a little harder to be tougher. Because he's just so kind—I mean, look at him. Look at him."

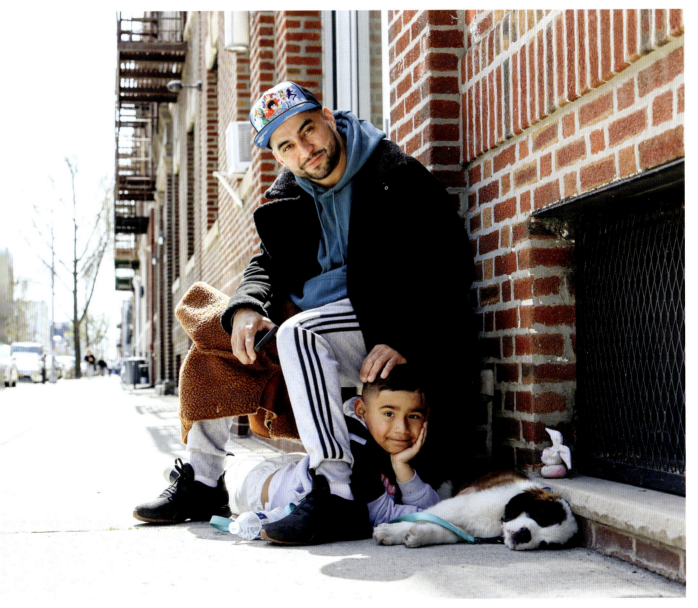

"The neighborhood isn't what it used to be. I came here straight out of high school. No money, pretty much no housing. But it was beautiful. There was a Chinese market on the corner that sold dollar beer. All my friends would gather there at 5 P.M. No need to text or call, we'd all just show up: the skaters, the girlfriends, the locals, the old heads. Imagine forty people just mobbing the streets. Then we'd head off to a bar, or go to an art show, or go to a party. It was chaos, but it was beautiful. My friends tell me that I romanticize the past. They're like: 'Don't forget, back then you were always saying how miserable you were.'"

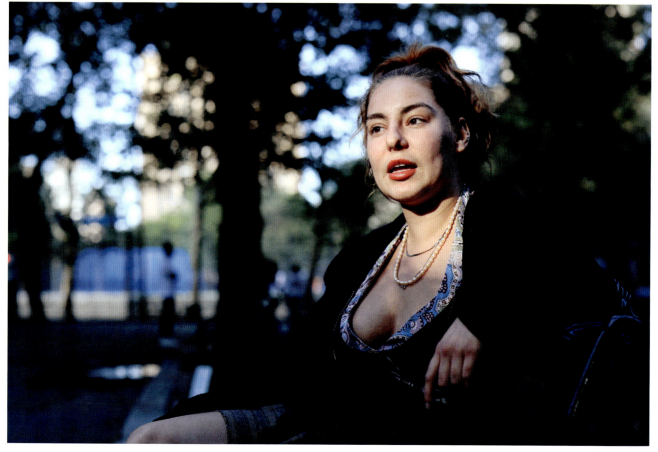

"If you put on ridiculous things you can kind of take control of the narrative by directing people's attention to the things you want them to see."

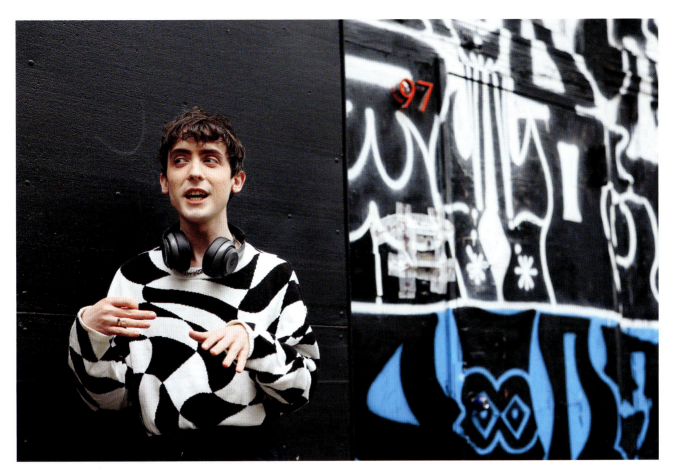

"The doctor has told me to expect a couple more years. Before the diagnosis, my happiness was usually automatic. I worked as a children's librarian, and that might be the only career where you get told 'I love you' three or four times a week. Maybe it happens with teachers too, but so many little kids have said those words to me over the years. And I miss that. I was damned lucky to have that experience. These days the happiness isn't automatic anymore: with the pain, and the fear, and the having to pee all the time. But I still choose to do a lot of things that will make me aware of the beauty and loveliness of life. It's not magic. I don't stop thinking about the scary stuff, I just find moments to push them aside with the ridiculous. There's so much in life that's ridiculous. Every Saturday morning I watch *Popeye* on Turner Classic Movies. It's so ridiculous. Olive Oyl is so obnoxious. And you know, she has all these men after her. It's just really funny. And Popeye is so full of himself and somehow manages to come out of everything, eat his spinach, and win. Then there's my laughing yoga classes, which I can't do in person anymore. But I do them online. There's this thing we do where people will get in lines of three or four, and we'll pretend to have a boat race. Everyone rows as hard as they can. Someone chooses a winner, and if you lose you get to create a big scene and make an ass of yourself. It's ridiculous. And then there's you. You're ridiculous. You're stopping random people, presumably to entertain yourself. You're sitting in the middle of the street. I mean, think about it. It's pretty dumb."

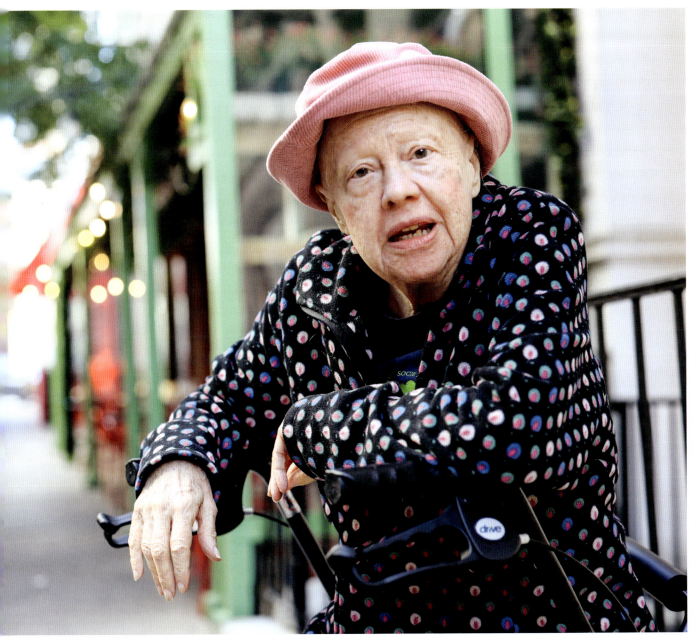

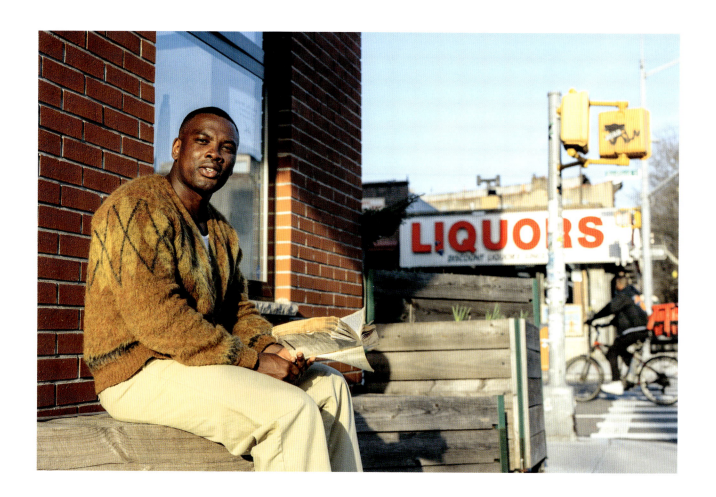

"He was more than my brother; he was my best friend. I wanted to be him. He was more athletic, had more friends, got more girls. And things were going great for him. He was managing a pizza place. He had two kids, my nephews. But after he lost his job he started dealing drugs. He didn't last two months in the streets. Benjamin thought the world was like our family; he was too trusting of people. And Detroit is a very dangerous place to be trusting of people. The Detroit Police Department did nothing: no leads, no investigation. It's like he wasn't even human. After his death I forgot about school. I dropped my classes, started drinking more, partying more. There was a lot of sex, a lot of meaningless sex. Nothing seemed to matter. It was dark. I was so angry at God, because how could he let that happen? But it's been four years now. And looking back—if he hadn't been killed, so many other things don't happen. I'd have never left Detroit. Benjamin was the one who always told me: 'You're special. You don't have to stay here.' But if he hadn't been killed, I'd have never come to New York. And if I don't come to New York, I don't meet my best friend, which is my wife. Our wedding brought my whole family together for the first time since Benjamin's death. It was love and joy again. My mom walking me down the aisle, after losing her son. It just meant the world to her. And if I hadn't met my wife, we wouldn't have a son on the way. We're naming him Benjamin."

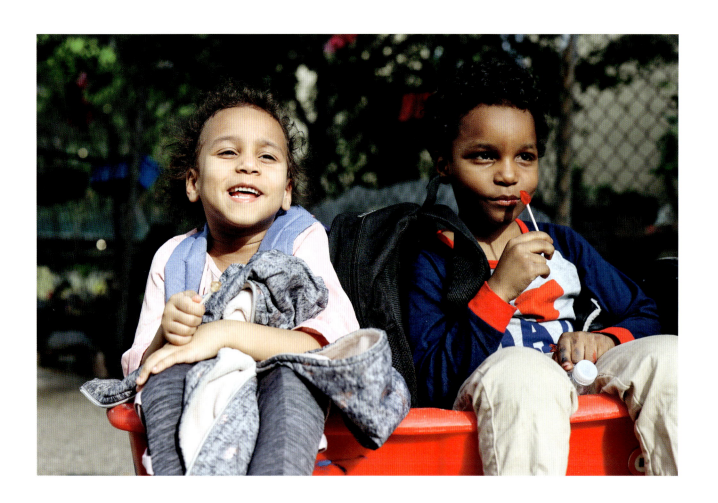

"Everyone cares about me because I love them because they love me."

"They told me they loved me constantly, chronically, every day. They gave me a good home. They cared for me. They did all the basics, and above all that: they worked hard to put me in a great school district. But no matter how much they provide, your parents can't give a shit for you. I made every bad choice a high schooler could make: TV, video games, pornography. All the stuff that you use to not think about stuff. It's immediately gratifying, maybe the first fifty or hundred times. But after the two hundredth time, that stuff becomes who you are. I guess the whole time I was just hoping that someone would come along and tell me exactly what to do with my life, or else it would just come to me. Maybe that happens for some people. But for the other 90 percent of us, we have to make the conscious decision to just go. At first I told my dad I was joining the Marines. He's an attorney. It certainly wasn't what he would have chosen for me. But he said: 'If this is what you want to do, you're going to visit every branch. You're going to make an educated decision.' On the day I signed with the Coast Guard, I remember telling him: 'I just want to be a good man.' That's as far as I'd gotten. That's the only thing that I knew for sure. I didn't know where the path was going to lead, but I was just tired of not trying. I figured it was better to just start walking and see what the hell happens. Because I know what happens if I don't do anything."

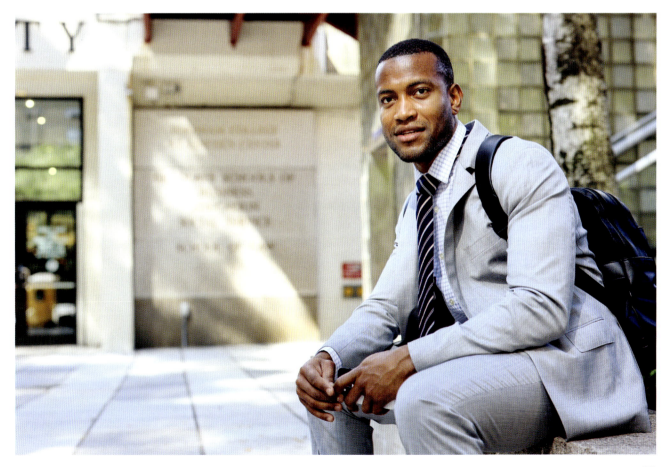

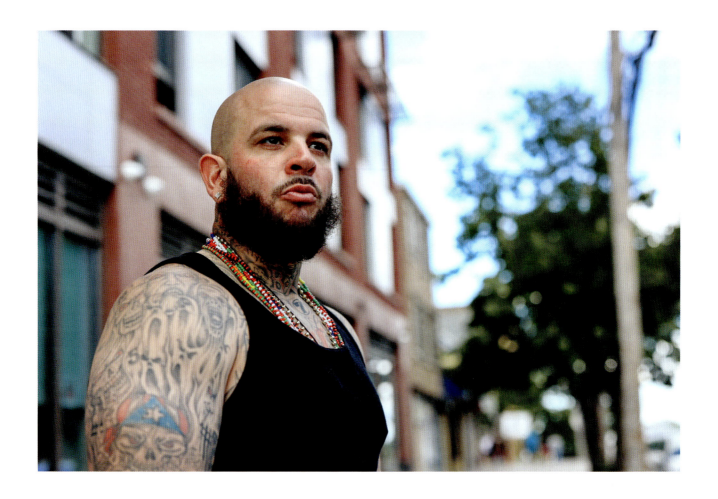

"It might seem like this neighborhood is messed up right now, but it used to be way worse. Now there are cameras everywhere. If someone kills somebody, it's gonna be on camera. The shooter ain't gonna last too long out here. But back in the nineties, a person could get murdered, and you'd see the killer the next day, just walking around. That's the environment my mom raised me in. She was a single mother, trying to teach me how to be a man. She taught me to never stand down. If the guy is bigger than you, then pick something up. But never back down. And as a kid, you listen to your moms. I'd always be outside fighting. And when my little brother came along, she'd send me outside to fight his bullies too. When you inflict violence, it's a message that is immediately understood. If you hear some dude said something about you, meet him with aggression. Then, even if you're wrong—even if you find out later that he didn't say shit—at least everyone else knows that they can't just talk. 'Cause look at what just happened to the guy I was wrong about. You know? That's how to make sure you're never a victim, in these streets out here."

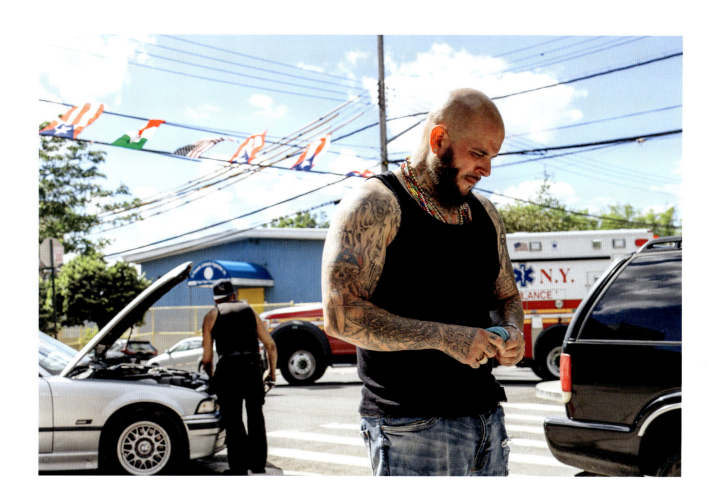

"This is my car. I'm always by myself. I call it a one-seater. Even though it's got two seats, I call it a one-seater. Because you don't see people in my car. Being in prison made me, you could say, like, numb to family and friends. I was given a seventeen-year bid, and five of those years were spent in the hole. Ever since I got out, I've tried to apologize to people I've hurt, like, yo: I'm not that person anymore. But they still think about that person, you know? Even the people I'm good with, even the people I care about, I can see it in their eyes—there's like, a hint of fear. They're thinking: 'If I fuck up, what will happen? What might he do to me?' And it makes me feel like I did something wrong. I don't feel good, knowing that you're scared of me. So I just stay away from everyone. The only person I had, he's gone."

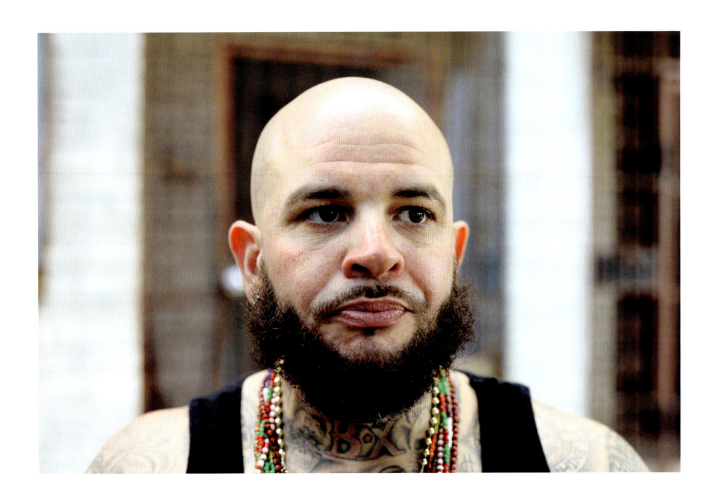

"A lot of people would say that my little brother was just like me. Because he was trying so hard to be like me, sound like me. But behind closed doors, this fucking kid was a genius. He got a scholarship to some high school in Massachusetts; it was like a college campus. He was around all these different types of people: he's learning words, his grammar is getting more, you know—up. Meanwhile I'm stuck in the streets. But the thing was, he looked up to me too much. And the guidance I had for him, it wasn't good. One day he told me he had a bully at school. I'm the one who always took care of his bullies, so he said: 'I want you to come over.' I told him the same thing my moms always told me: 'Don't stand down. Pick something up if you need to.' And that's what he did, he stood up. And when he stood up, he pulled out a knife. The kid did the right thing; he told. He didn't say his part, that he'd been bullying my brother for a couple of days. But he told. And the school looked at the situation: one of these kids is paying tuition, the other kid is on scholarship. And they threw my brother out. Suddenly he's back in the street. Now school is not an option. And he's looking at his older brother, who he envies. So he got caught up. He got caught up in my life, and they murdered him. Kidnapped and murdered my little brother. After that, six months later, I went to the feds. Copped out to seventeen years."

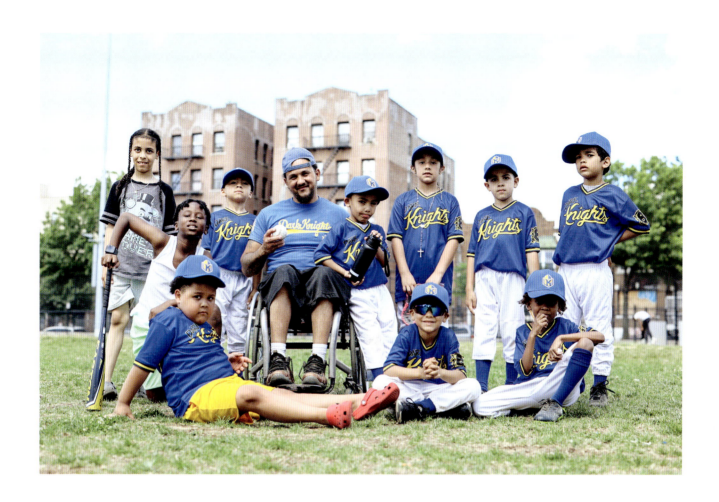

"Some of these kids have been with me four years. I've seen them go from not knowing how to catch, to knowing how to catch, to getting baseball ready. And we don't just come, play baseball, and leave. It's not 'come play ball, I'll see you next week.' It's everything. It's a family. We barbecue every two weeks. We have a lot of events with the kids: trunk-or-treat, Christmas giveaways, birthday parties. I pay for a lot of the stuff myself. It's sad, because some of the parents . . . well, maybe they just don't have money. Because I refuse to think that they don't care. Because if you don't care, and just leave them in the street—so much can happen, so easily. I talk to them a lot about my injury. I tell them how before I got shot, I was doing a bunch of wrong things: fighting, dealing drugs, all that stuff. But God is good. God gave me a second chance. That's what I tell them: it doesn't matter how the beginning of your story starts. It's where you finish."

"What's wrong? You OK?"

"My family, they're fighting a lot."

"Your family be fighting?"

"And they're fighting today."

"You're OK. OK? They love each other still, OK? You don't need to get sad, alright? Listen. Look at me. Grown-ups fight sometime—but that don't mean we don't love each other, OK? They still family, and they love you, and they don't want to see you sad. So you gotta be brave. Go get a hot dog and I'll talk to your uncle and your brother. I'm gonna go talk to them. Don't let that bother you."

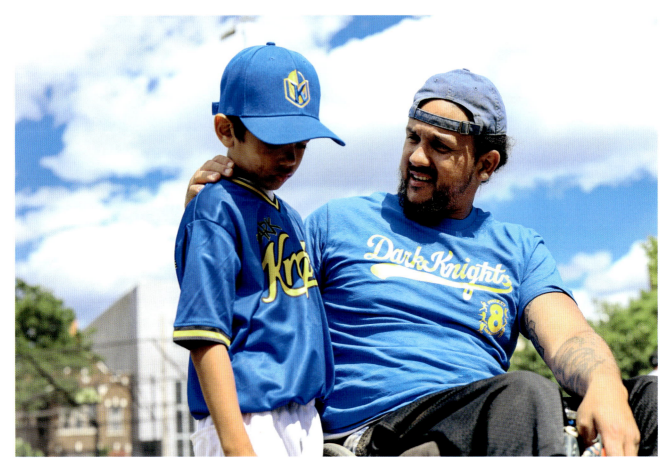

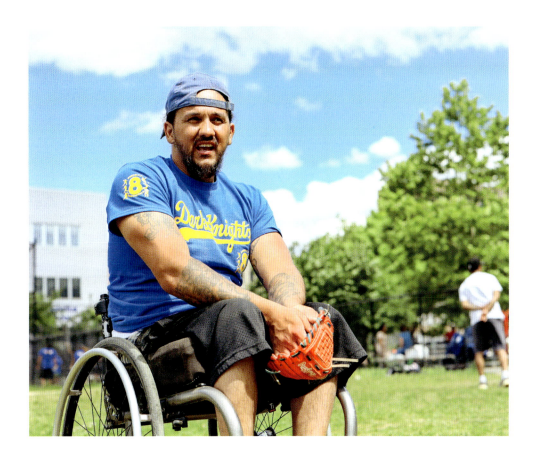

"I hate to see it. When I see something like that, it's heartbreaking because, you know, kids only want to be happy. My thing is to see kids smile. My thing is to see kids have fun. You know what I'm saying? Kids are innocent, and for someone to steal their joy—it's like a bad thing. But that's the community we live in. Instead of pulling each other to the side like responsible adults, sometimes they get carried away and start fighting in front of the kids. There's not enough good role models in our community. And if I can be a good role model, if I can keep them on the field and off the streets, even for an extra hour so they make it home that night, then my job is complete. That's it. That's the finish line."

"What all the kids are doing now, on TikTok? I did that years ago. Years, and years, and years ago."

"Stop signs? I don't care about any of that shit. Don't have a license. Don't have a license plate on my bike. I'm an outlaw through and through. I take it very seriously. The way I look at it, there's a law of government and a law of man. And I follow the law of man. Right and wrong, that's it. And the government don't do right. I'm not trying to make myself a martyr. They already won. Darkness won. I'm just taking care of me and my own and doing what I can to keep their claws out of my back. I've got a half-mile dirt drive that goes way back up in the woods, and that's not far enough. They tried to pin me with some multimillion-dollar drug ring, and this is what I told them. In the courtroom, while my lawyer is elbowing me in the ribs to shut up. I said: 'Listen, man. You're fucking with a bunch of hillbillies trying to get high. All we do is fucking work on cars and bikes and snowmobiles and four wheelers and then go riding, and afterward we try to get naked with our old ladies.' I'm just giving people that I care about something that they're going to get elsewhere, that I can get them for a way lesser price and make sure the shit ain't fucked with. What's the problem with that?"

"I was just listening to music, thinking: 'What can I do to get noticed, beyond what I'm doing right now?' Right now I'm at the bottom: I'm an associate. It goes from associate, to senior associate, to vice president, to senior vice president, to director, to managing director. And in my opinion, every step is better than the last. You get more responsibility, but you also get more trust to carry out that responsibility. Climbing the corporate ladder is what's going to allow me the opportunity to do the things I want to do when I'm not working. So yeah, the ladder is fine with me."

"I went to the psychiatrist one day. I felt like Tony Soprano. I was telling her about the Ninja Turtles. Not the new ones. Those episodes are garbage; they disrespected the Turtles. But the old ones. Where they teach you honor, and how to be a good person. The psychiatrist told me I have a hero complex. Never heard that one before. I guess what she was trying to say is that I'm a hero. Exactly what the Ninja Turtles do—I do that stuff on the side. I'd say I'm most like Raphael. The *sai* is his chosen weapon. Not many people know that the *sai* was an Okinawan police weapon. It's made only for defense, because Raph is a protector. And I see myself as a protector. My job out here is to observe and report. But I've also helped so many people who were lost. One time somebody fell and I helped them up. Then there was the day that a building caught on fire. I went inside to tell people that the building was on fire. That got me in trouble. The boss said: 'You're not a fucking fireman. Never do that again.'"

"When I got out of jail I couldn't find how to get from point A to point B. I didn't want to bring that prison thing out to anybody in the world. That's not what Deshawn is about, so I came out here and started singing. One of my first days out here, I heard a kid say to his friend: 'Spider-Man is my hero.' That had me intrigued. There was a hunger there, to learn about this spider hero. I'd never even heard of this movie before. But I watched it nine times, like real into detail. At first I was skeptic. But the guy in the movie, this Peter Parker, he was skeptic too. When he was threading the needles, and putting the suit together, he was having doubts, he was debating: 'Should I put this on?' But when he put it on, his brain started elevating. His brain started showing things to Peter Parker. Like 'Yo, we can do this.' We can become the spider. And when you become the spider, it's unstoppable. The spider is unstoppable. I went to Amazon and typed 'Spider-Man, spider suit.' And when it came to my doorstep I went straight into my room. I jumped into the suit for the very first time, and my energy went so strong. It's like I was like a little kid again. Alive again. I became one with the spider. Like me and the spider could never be separated. Nothing could touch us, nothing could see us. It was power. I don't know how to tell you, but I felt achieved. Achieved. Like I achieved something in me. When I started thinking about the children of the planet, and how much they loved the spider—it's like this power surged through my body. I thought: 'let me go outside and see if this is real or not.'"

"Who I was, as in my name, Deshawn. Part of him died in jail. I viewed the world as tainted by dimness, by darkness. And I started not caring. I gave in to the darkness. I felt broken. Part of me still feels that way, like I ain't worth nothing. And that's why I stay spider. Deshawn and the spider became as one, an entity that can't be broken. It can't, it can't get broken. It's kind of hard to explain, but the spider and me, we love each other. He's my best friend. I'll say it bluntly, I love my spider. We talk about life. The spider feels like it's my protector. When I'm not the spider it's like a shadow comes over me and says: 'Nah, you ain't happy no more.' But when I'm spider I get strong. My energy goes completely up. It's a warm energy, like being a kid, and I love, I love being a spider. People want to take pictures. It makes me prouder. But when Deshawn is by himself, Deshawn feels there's no love around him. The love gets dim. I feel vulnerable. Deshawn gets judged. Some people come at me like: 'You're a fake spider. Do a backflip.' It's a test. It's a test. They think Deshawn and the spider are two different people. They try to separate the two. But it's an entity that can't be broken. Sometimes there's a disagreement. Sometimes there's a debate between Deshawn and the spider. I feel like I'm letting Deshawn down by becoming the spider. Sometimes he feels left out. Like the spider became more than Deshawn. Like the spider took over. He says that it's not good to overshadow the person that was there before this fight even came into his life. And I don't want him to feel that way. Like he's dying. I don't like to use that word, but sometimes I feel like I'm making Deshawn die. To become a spider."

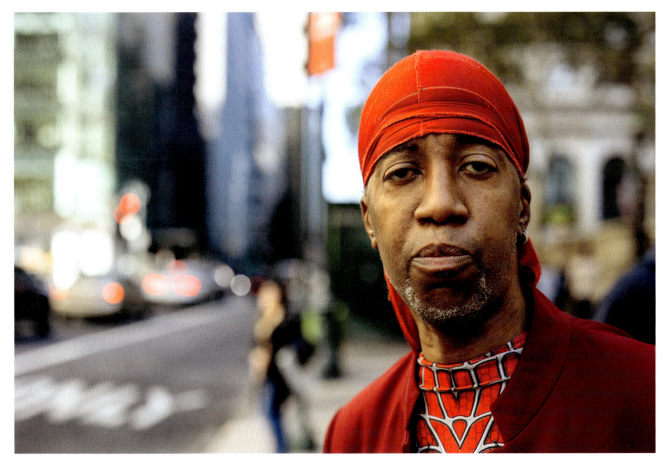

"Everyone has their problems. And my mom, you know, had a drinking problem. She used to drink a lot of wine. And smoke a lot of cigarettes. I asked her one time, I was like: 'Why do you smoke a lot of cigarettes?' And she be like: 'Deshawn, this is how I sort out my pain. It's how I deal with my pain.' She wasn't a perfect lady. But she loved a lot. And when I heard her sing, it just went into my heart. When she'd sing her Gospel songs it made me flooded. I was like a student, I studied her. I was just so happy that I got to spend time with her. And when I lost her, I lost me. It was Christmas Eve. My uncle Rome, my uncle Albert, all of them. They sat me down on Christmas Eve, and said: 'Your moms got hit by a car.' A car hit her and dragged her down the hill, it took her away on Christmas Eve. It was bad for me. I broke all the windows in the apartment. I threw the chairs; I went in a terrible rage, very terrible. It was bad for me. I went down, downhill. It was a hard life. It was a hard life like rats. School wasn't good for me. I couldn't comprehend, I couldn't catch up. Everything I had, it was taken. They'd call me all types of names. I was just a kid. Like why would y'all say that to me? When I came home I just locked myself in my room. There were pictures on the wall, pictures of my moms. So I was like: I ain't gonna leave my room. And that wasn't good. I was like an animal in a cage. I allowed the demons to come into play. They tricked my mind. They told me you don't need God. You don't need him, you need us. It's OK to do bad things. It's OK to sell drugs. When you lose somebody you love, man, it hurts. I walk the world with feelings, and sometimes I crash inside my soul. Sometimes I debate with my soul. It can happen that way, where you and your soul have a conversation. It's like, yo, what we doing here? Why do we even exist? I go back to being a kid, feeling like I ain't worth nothing. I don't want to come out. I don't want to perform or be in front of people. But then I see the suit in the closet. And I become the spider."

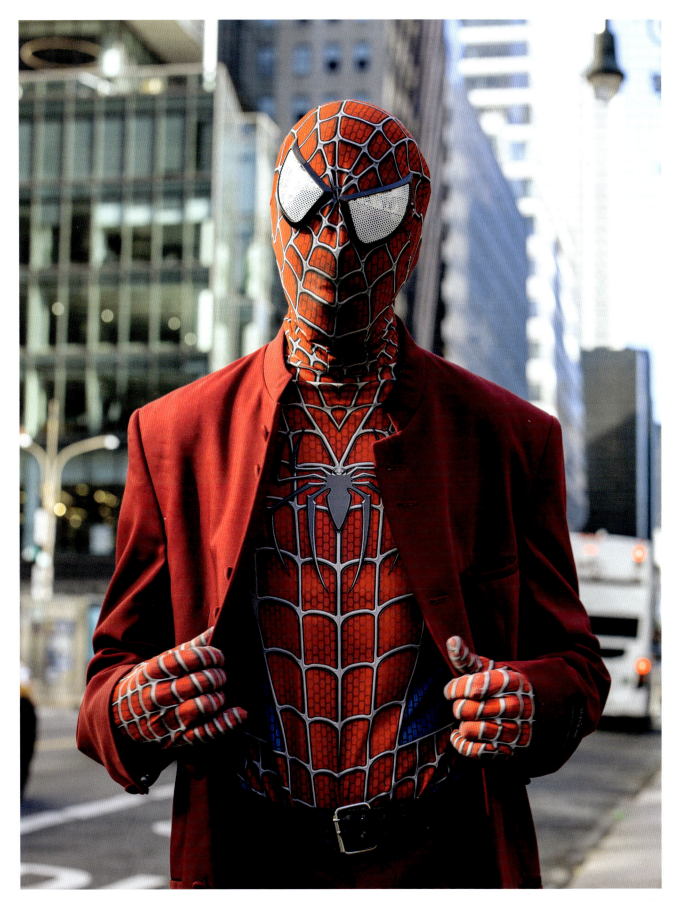

"I'm trying to get my followers back."

"It's just nice to find someone who doesn't judge you, that you can judge other people with."

"I packed on the muscle to cover it up. What our neighbor did to me, when I was a kid. It left such a darkness and shadow inside me. So much anger and sexual confusion. My high school wrestling coaches used to test me for steroids every single week; that's how much anger and aggression was inside of me. But I didn't beat up my body with drugs, like some people do. I beat it up in the gym. Working out made me feel embodied. Like nobody would fuck with me. At the age of twenty-one I decided to train for the Mr. Olympia competition. I was down to 4 percent body fat. I was getting striations like crazy. Then one day I'm riding the elevator at my office, and it froze. It hovered for one second. Then it dropped. I thought I was going to die. It fell three stories before the emergency brakes kicked in. Four herniated discs in my back. Three in my neck. I needed two shoulder operations, a knee operation. I had platinum and titanium wires put into my back. It was months and months of not being able to work out. Sitting in this dark room. No sunshine. All that pain and suffering from my childhood just rushed out. I remember sitting in my wheelchair, next to a busy street, and wanting so bad to just roll over the curb. But this is a comeback story. I'm having a little bit of a comeback right now. After my last spinal surgery, I got the sense that I could lift again. I put on a garbage bag, and walked two and a half miles a day, in ninety-five-degree heat, carrying weights. I lost seventy-five pounds. The entire time I was listening to the *Rocky* music. 'Eye of the Tiger,' on repeat. Rocky is my hero. He wasn't super smart and neither am I, especially since the brain injury. But we both know how to keep fighting. I even got a tattoo of a tiger on my chest. Its mouth is open. It's scaring the pain away: not just the physical pain, all of the pain. Right now I'm training for my first competition. It's just a small one in December, called Classic Physique. But I went hard today, and I'm feeling super strong. I don't want anyone feeling sorry for me. I want people to see me on the podium. I want to engrave a sentiment. That if this man can do it, anybody can. This isn't gonna be a sad story. It's gonna be a *Rocky* story."

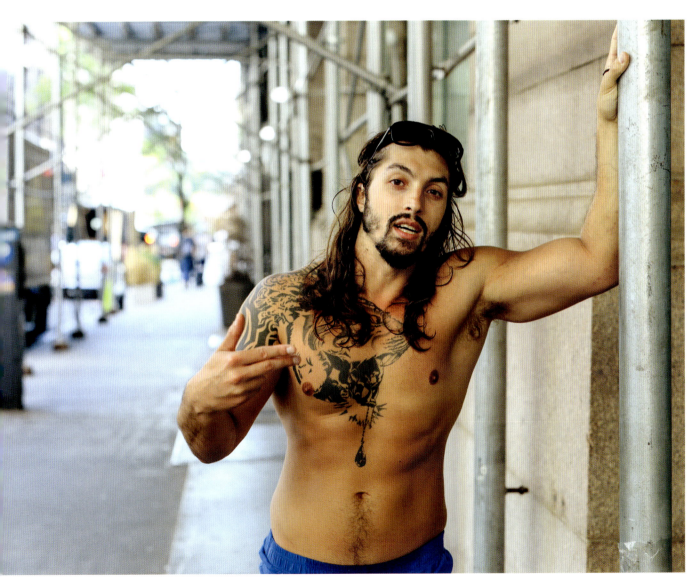

"We get girls. Well, we got one."

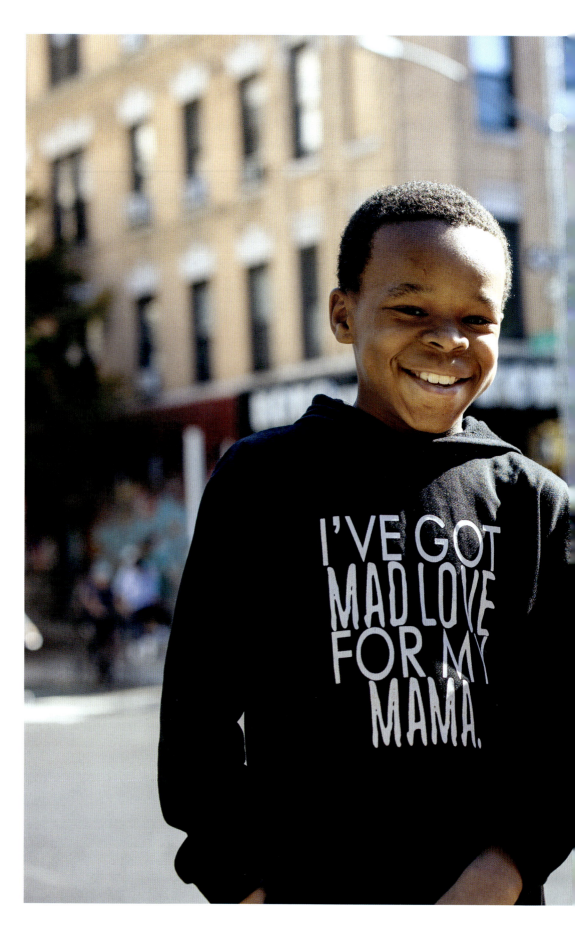

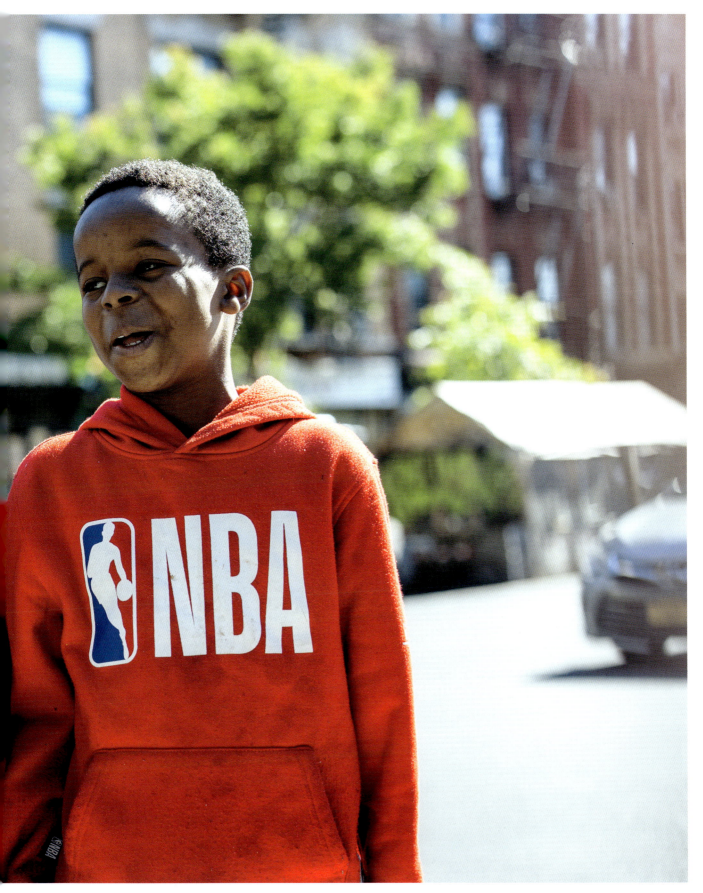

"Get a plant and name it after yourself. I tell that to everyone, especially if they have trouble with self-love. Take care of your plant every day. Water it, make it beautiful. If your plant is growing and nourishing, that means you're growing and nourishing. If it's dying, you have to ask: 'What's going on with me?' In my apartment there are four plants named after me. There's Jiu Jitsu Deisy; she's delicate but dangerous; the vines look like they're choking each other out. There's Yoga-Horoscope Deisy; she represents my spiritual life. There's Rocio, which is the middle name of both me and my mother. I hated that name for a long time, until last year, when I made amends with my mom. Then the last Deisy is Little Deisy. She's between six other plants, named after the women in my life who've nourished me."

"It's a choice to be aware of your whiteness. But it's not a choice to be aware of your blackness. On the plane ride here I was sitting next to a casting director from Broadway, and I asked him what he thought about a particular show. He took a long pause. So I say: 'I guess you didn't like it.' And he tells me: 'The entertainment industry is forced to put on stories from marginalized communities, even if they're not good.' He said that to me. As a black person. It's like, dude. I'm just trying to make conversation. What do I do now? Do I engage? Do I turn this into a learning moment? Or do I just let him off the hook? There it is, suddenly I'm back in my blackness."

"I was born on an island. In the village of Leguan, in the middle of the Essequibo River. I worked in the fields. We used to take the rice. You've got to plant it first, the seeds. Then you got to take your foot, and you got to mash. No proper shoe to wear, but you got to mash. Then after that, you got to plant. When the seeds grow up to be the patty; you got to cut the patty—you got to cut it with the knife. And when you done cut the patty, then you put it in the bundles and bring it to the man at the mill, so he can turn the patty into rice. And that's what you eat, the rice. But sometimes the water in the river rise, and it floods the island, and it washes all the rice away. But my mother taught me; it was the last thing she told me when I left for this country, she said: 'When you go through life, and it becomes rough and tough, remember that there is a God who loves you. Who cares for you and can see you. And you don't forget him. No matter what you're going through, hold on to him.'"

"When I'm going to work, coming home from work: on the trains. I spread the word on the trains, I testify on the trains: four train, five train, whichever train I'm taking. Oh, I'm happy to do it. But don't think it's always easy. Not everyone likes it. Even back in Guyana, sometimes we have neighbors and friends who would say: 'Take it away. Take it somewhere else.' But it's all in the game, it's all in the package. You got to be tested by God, brother. God will protect you if you spread his word. Don't worry about that. He doesn't send you out just so you can get shot down. But you will be tested. Believe me, you will be tested."

「我擔心佢開始上學之後會唔記得廣東話，唔識點同阿嫲傾偈。」

"I worry that when she starts school she'll forget Cantonese,
and won't know how to talk to Grandma anymore."

"It's like being in Hawaii. That's the feeling. There's no pressure, and you never want to leave. You want to stay right there and relax. You want that temporary feeling forever. But it goes away, and the pressure always comes back. Life is pressure: job interviews, things you've got to do, every day, getting up. It makes you want to go back to that place. I've been out here eight years. When I see people go by, I hear different things. People quoting and phrasing what their life is—I only get bits and pieces: 'We're going to the movies. We're getting married. We're going to Santa Cruz.' Stuff like that. I can hear it. I know that life is out there; but you have to earn it. Determination and willpower, that's what I need. There's a seed in me that wants to stop. There are days I don't want to get high. I love life. I love life, and I'm gifted. I'm gifted with age. I just turned fifty, and I think there's more to come. I have the desire to keep going. Sometimes I think, without the drugs—what am I going to do? That voice is there too. But I have to get rid of that. Because there's a life out there. There's a lot more than just getting high."

"I just watched *Casablanca* for the four hundredth time on channel 82. That's enough. I don't care what kind of bug is going around. I'm going to the movies."

"I took a super iconic photo of Erin at 9 P.M. on a Saturday night, on the couch, wrapped in a blanket, doing sudoku puzzles with curlers in hair. I'm going to surprise her with it during the slideshow at our throuple wedding with our third roommate, when all of us are old and alone."

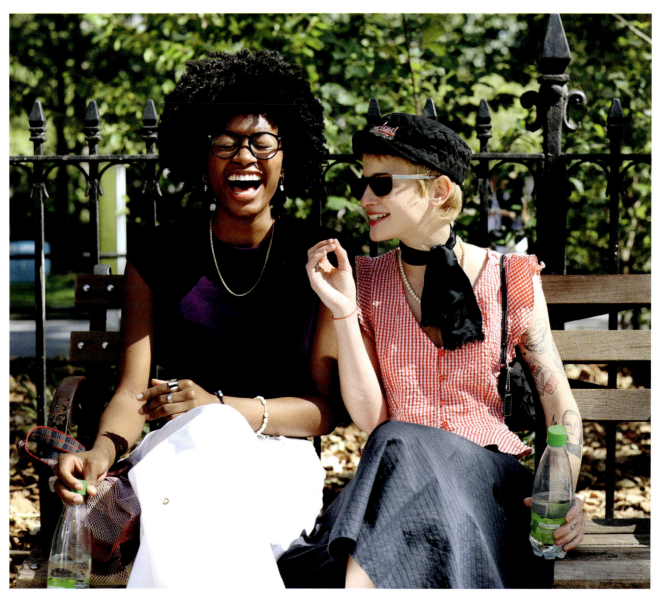

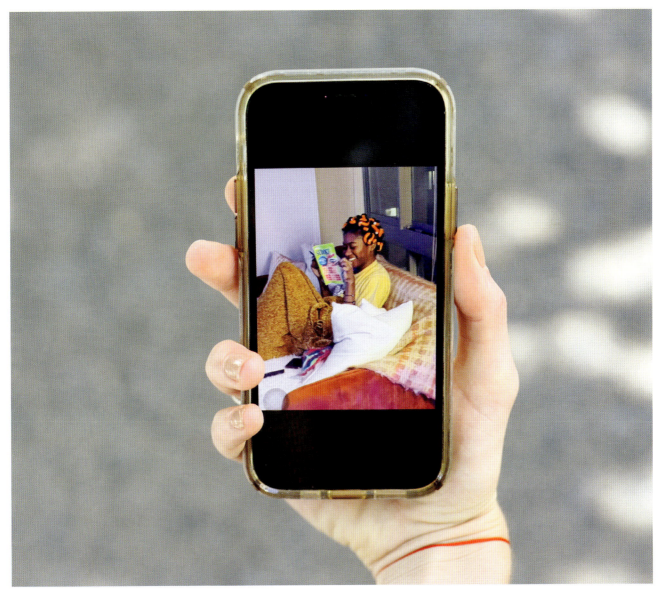

"Sometimes I like to dress fancy. Sometimes I do, like, punk cool. But today I just did normal."

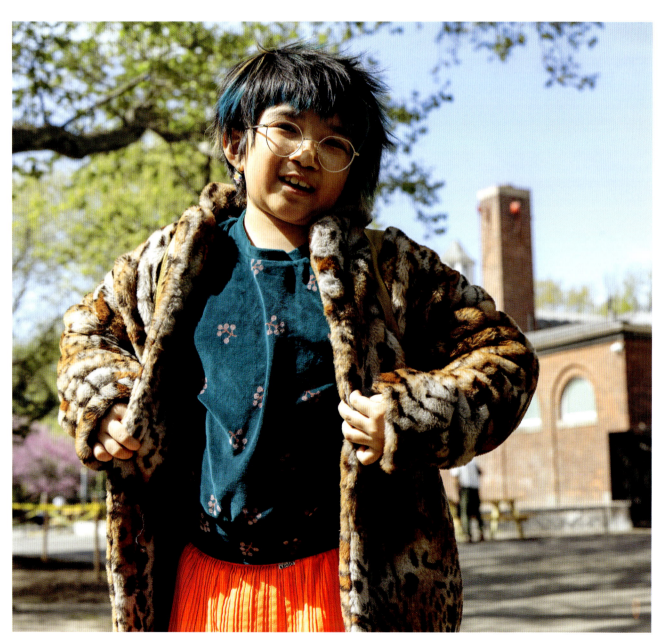

"He'd be wearing pajamas if it wasn't for me."

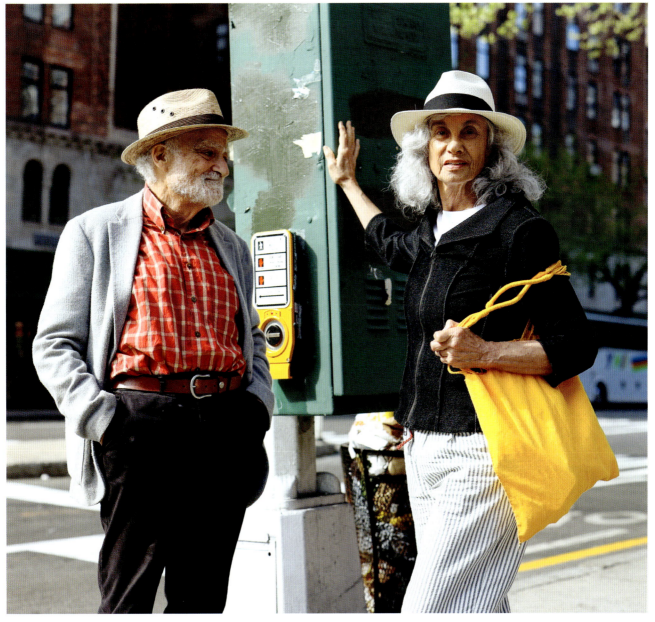

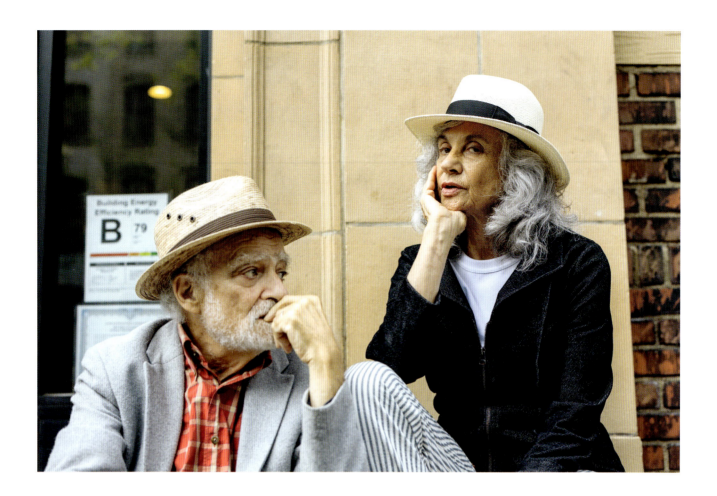

"We've been going to these pop-up discussion groups at the public library, where people discuss death. I don't think Tony would go if it wasn't for me. Most people don't like to talk about it, but I have questions. Not so much about death anymore. But I have questions about living as I get old. You know how people always say that you walk forward into the future? It's not true. You walk backwards into the future. You can't see what's ahead. Maybe occasionally you can look over your shoulder, and get a glimpse. But mostly you can only see your past receding behind you. And the past that's receding behind me is getting bigger and bigger. I'm trying to learn to say goodbye, and move forward. But how do you do that? When every week you hear about some other beloved person who's died, that you're never going to see again? I feel like I walk around with a retinue of ghosts, beloved ghosts. All the time I see images from the past: the people and the pleasures and the adventures and the beautiful places. And I could just go there and live there. You know how they say about some people: 'She's lost in the past'? I can see how it happens. I could get there. It's comfortable there, and nothing is demanded of me. And it's not just the comfort of the past. It's the danger and uncertainty of what's ahead of you. I'm fine, and pretty functional, and strong. But I could have a stroke or a heart attack any minute. It could happen at any moment I'm walking down the street. Is this going to be it? Is this going to be the walk? I don't think of it constantly. I can still be captured by a wonderful play, or a beautiful river, or a child that is so sweet looking at his parents. But it increasingly feels like I'm leaping over chasms from joy to joy."

"I don't think about it. I don't think about death. When we were young my older brother once said to me: 'I bet you cannot think about a white rhinoceros.' And immediately, of course, I thought about a white rhinoceros. But I said to myself: 'I'm going to teach myself to not think about a white rhino.' And I've really put a lot of mind time into figuring out how not to be aware of something that I don't want to be aware of. I want to detach myself from that fear. I wanted to get Harriett out of the house today, so I suggested we go to the poster museum. And to my delight she said 'yes.' We called a friend across the street who's going to join us, and we're on our way to the poster museum to have a cup of coffee and look at the new exhibit of Japanese posters. I plan to keep spooling out the story of who I am, right until the end. Hopefully it's a story that is of interest to other people. Hopefully it's a story that I'll enjoy telling and remembering, but it's ongoing. It's ongoing. I want to meet new people. I want to go new places. And when I die, I want to die playing. I've found that my highest levels of energy, my greatest ideas, my best capacity to learn—have come to me while I'm playing. And that is the gift. To still be able to play. To still feel that energy. So when my story comes to an end, I'd love to die exalting in something that makes me feel alive. I want to die playing."

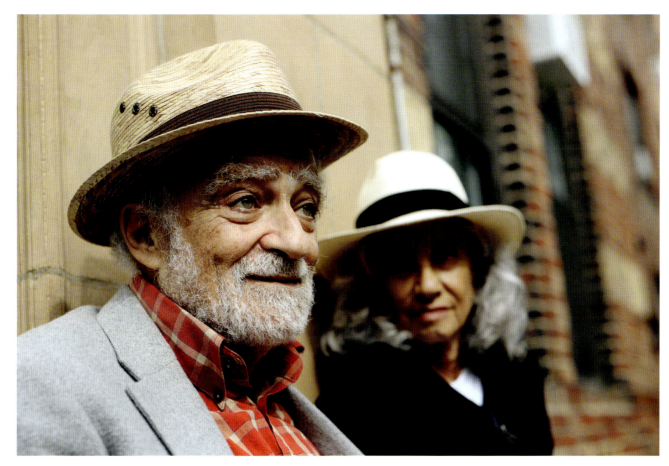

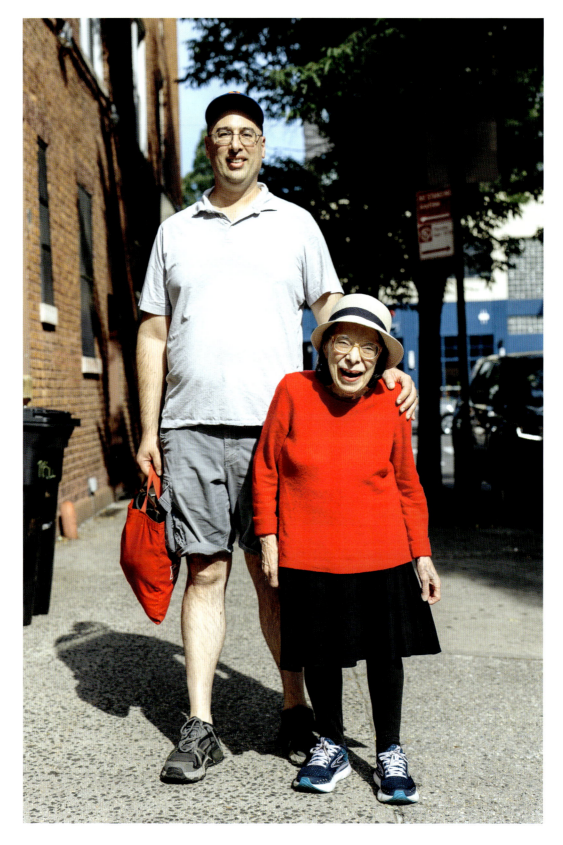

"We're first cousins!"

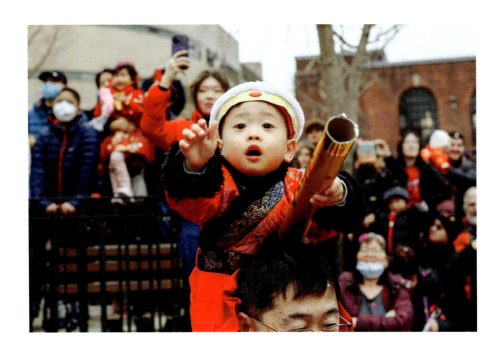

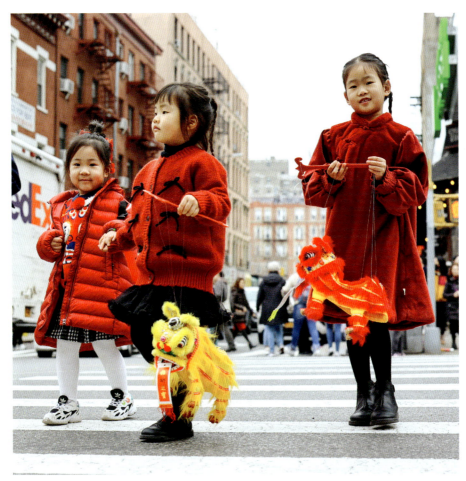

"We just finished a six-month trip around the world. I've done a lot of traveling alone as well. And that's nice too, because you get to choose everything and do whatever you want. But on the other hand, there's nobody to remember it with you. And you have to figure everything out on your own."

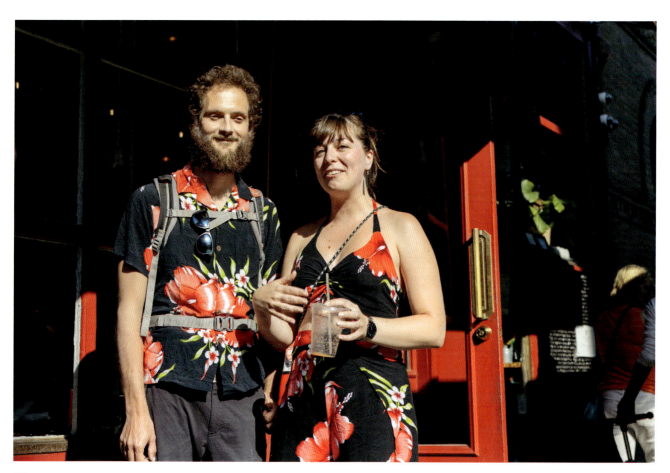

"When we met I was in an open relationship with someone else. Technically it's called ethical non-monogamy. My partner at the time was seeing multiple people. But when I met Carla, I was like: 'I'm good with Carla.' I just need one person to fulfill my needs. Or, you know, one additional person. But my partner felt some kind of way about that. I think she'd rather me be with five different girls a week than have an emotional attachment to one. What I wanted was a circle, where everyone was equal. But she wanted a hierarchy, where she got the most attention. But at the same time she wanted freedom. It was like: I'm trying to hug you, and you keep running away. Now someone over here actually wants to hug me back. I'm not saying I'm not hugging you, but you don't want to be hugged. So you don't want to hug me, but you also don't want me to be with someone who wants to hug me. And you want me to still want to hug you? That doesn't make any sense."

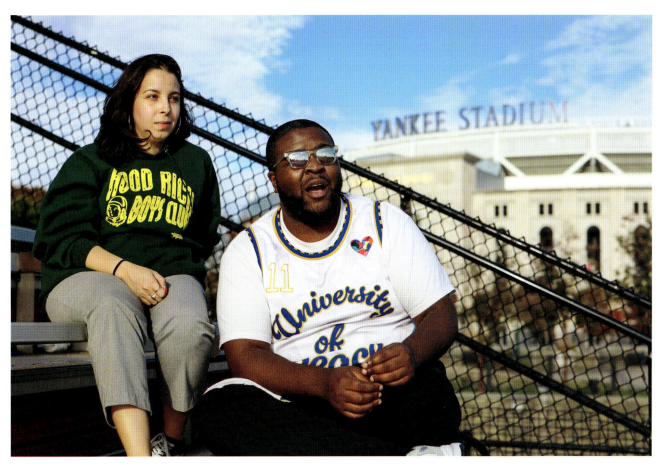

"Right after my ex-boyfriend took me ring shopping I found out that he had seven other girlfriends. That sort of thing fucks up your world. So I wasn't feeling too great about monogamy anyway, even before Gabe slid into my DMs. The first time we hung out he told me exactly what was going on. He described his relationship—to use his own words—as a circle. It was a level of communication I'd never had with a partner before. And the thing is, I was never worried about her because of the level of attention and care and openness he was giving me. I'd felt much less secure in my monogamous relationship, because the guy was never around. But Gabe was solid. He's solid. I know that when he says something, he means it. He's surprised me so many times in a good way, but never in a bad way. And I was always used to the bad kind of surprises. There are certain things that Gabe thinks a man should do, and he does them. I haven't opened a door in two years. He plans dates. We have a calendar. He leads in a way—I never thought I'd say this—he leads in a way that allows me to follow, and feel taken care of. I'm a girl. I want to be soft. And in all my other relationships, I was the one who had to show up. But Gabe is so solid that he allows me to be soft. For as untraditional as our trajectory might have been, he's a very traditional man."

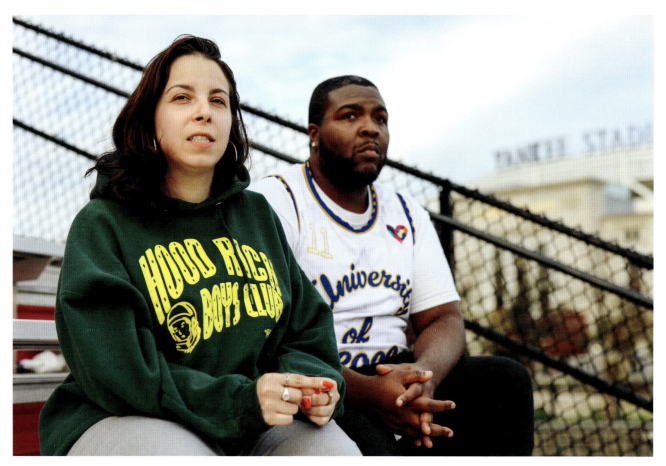

"We've been playing for two hours. It's supposed to be a team game, but since it's our second date, I've redesigned it, so that it's like a couples, get-to-know-you-more game. The goal is to be on the same wavelength. You start with two cards that are like, really completely opposite of each other. Like if one card is the sexy emoji, then the other is an unsexy emoji. Then you basically spin the wheel, and you get a score. One person knows the score, and one person doesn't know the score. If I'm the one who knows the score, then I can, like, try to guess something that's not too easy to the point where she goes over here, but easy enough so that I can, like, get her to go over here. Basically if I'm thinking the way she's thinking—then this game will let me know. I'll be very honest. This is mild compared to the game we played on our first date. That was crazy, oh my gosh. Holy crap, like we had to ask each other forty-five questions. And the questions are super, super personal. And at one point we had to look at each other for thirty seconds. I'm not sure, but I think she might have felt a little overwhelmed by that one."

"I am a snow person. Without snow, my mood is low. I don't have much mood. My birthday is in December, so I always celebrate my birthday with crazy much snow. You're not going to believe, but in Ukraine we have ten feet of snow sometimes. Me and my cousins would dig tunnels in crazy big piles of snow, entire mazes. I have a big family; we would make a lot of snowmen, crazy a lot. But for me it's been three years since I make snowman; ever since I come here, there hasn't been enough snow. So I've been hoping for this snowfall for a very long time. When I woke up this morning and opened my curtains, and I see the white, I was the happiest. I work at the hospital, but for one day they can manage without me. I called my boss, and said: 'You know, I have very important things to do today.' My shoes are wet right now. My socks are wet. My hands are cold. But I'm happy. I have much mood."

"We make the small one, because it's easier and faster."

"It was junior year of high school. We was at lunch. And this kid—well, we were both kids, but this kid starts calling my friend a pussy, in front of girls. I've got a big sack of nuts, because I'm a man. I'm also big on loyalty. Nobody's going to try to intimidate my man in front of me. So when this guy steps into my space, I hit him. I hit him a lot. When he gets up off the ground he tells me that he's gonna come back with his friends. I think he's just talking, but when I get out of school there's seven or eight kids waiting out front. They form a semicircle around me. I take my jacket off and wrap it around my arm, 'cause they got knives. I kept walking backward, giving them the runaround, using my words. It was like that for twenty minutes until the bus came. But then they followed me home, and that's what got me paranoid. It took three years to fix my mental. I had all these paranoid thoughts, I cut everyone off; I was looking at everyone in a certain light. It's the last time I fight a battle that's not mine. 'Cause if it's not solved in the right way with the right words, there's gonna be beef. It's like fighting fire with fire. It just burns, burns, burns, until somebody dies. And even then it keeps burning. Because they're gonna have family members. And now you're beefing with them."

"This morning he was whining and crying about something, and my entire body wanted to scream: Stop! But I swallowed it. I felt it in my body for a moment. Inhaled. Exhaled. Then I found another solution. Raising him has made me realize what I was lacking as a child: a home where people don't scream. It was definitely a fear-based household. I love my mom. But she was making decisions with less time and less resources. She was a widow. She cleaned houses for $30,000 a year. She learned English along with me, by watching *Sesame Street*. And there were seven of us. She was running an army. And if seven kids wasn't enough—we always had animals. It was a jungle in our house: plants all over the place, dogs, cats. A boa constrictor, a guinea pig. All kinds of tropical birds. A lot of our pets are buried in this park. We'd bring them here in a little shoebox, with a little shovel, and have a ceremony. I'm sure it wasn't allowed, but back then nobody cared. The only one who's still alive is Lorita. She was our first pet: a green parrot. She came straight from Honduras, on a plane, in my mom's purse. Lorita was the boss. She was a wild thing; everyone was scared of her. All my friends have scars from Lorita. She's much calmer now, because she had a stroke recently. She can only remember one word: Marcos. It's the name of my little brother. It's the word she's heard the most in her life. My mom yelling at my brother: 'Marcos! Marcos! Marcos!'"

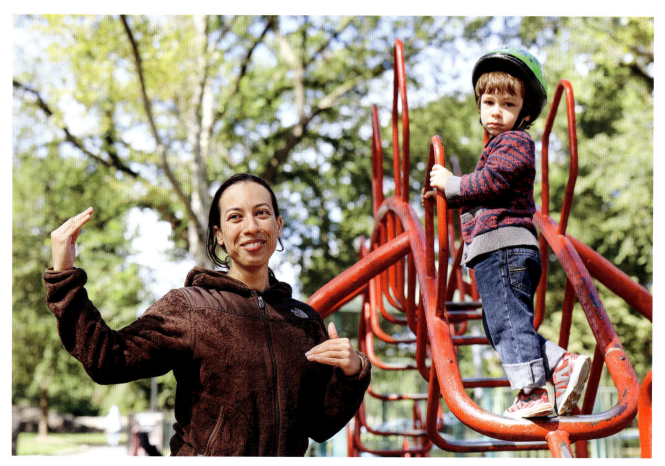

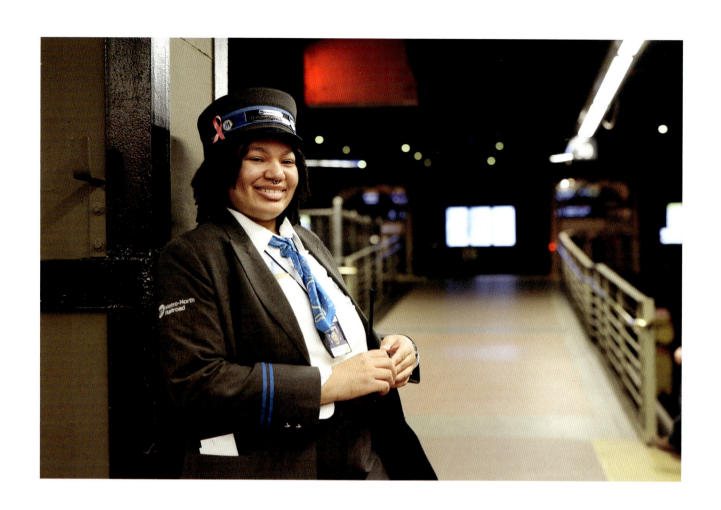

"My name is Sunshine. I named myself."

"I'm not going to pose for you, man. Not everyone is deserving of who you are. So I'm protecting my energy. Maybe there's nothing to gain from me, materially. But spiritually there's something to be taken. You think you need to know my name so that every time you see me, you can say 'What's up?' Nah, it's not like that. We don't have no feelings, no history. You can call me Sha. Just a little street name. Sounds like 'shy,' 'cause I keep to myself."

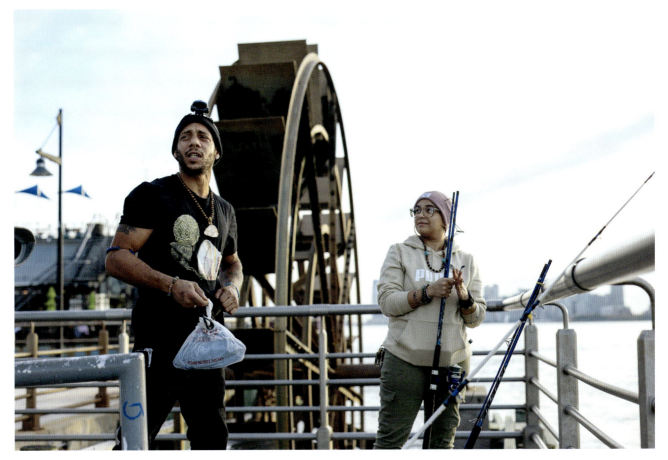

"We met not far from here—on Seventeenth. Five years ago, yesterday. I was coming home from work. She was leaving an appointment. We talked over a cigarette, talked about the crystals. When you're with a real queen who's tapped into her ancestry, you're going to learn some new things. She's got me leaving the old vibrations behind. She's got me learning to love myself more. To not be so impulsive, to utilize my whole brain, to not react if I catch someone looking at me. She'd love Sha too: the old alcoholic, the old drug dealer, always on guard, always looking for trouble. But I'm Aaron now. Women can break you. They can make you more humble and concerned with things. They can make you weak."

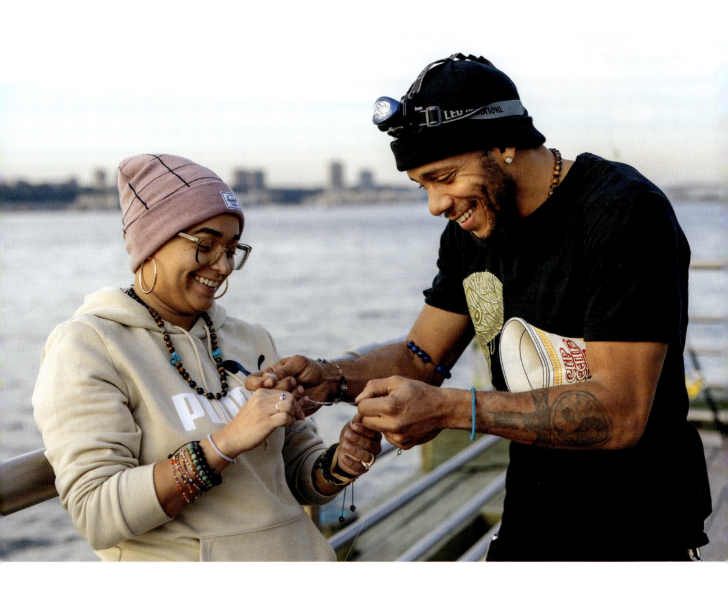

"If I cannot help other people, at least I don't want to harm them. That's the way I look at life, you know? Making other people happy multiplies the energy. The good vibe multiplies. And if everyone is happy together, there is peace in the world."

"Whenever he finishes in the bathroom, it's like: 'What died?'"

"Happy is a big word. I gave up on happy. Life is a blanket that isn't big enough. It's never going to cover all our needs and wants. If you pull the blanket up over your head, your toes will be exposed. If you pull it down to cover your toes, your head will be cold. Something's always left out. You're never going to be completely warm. So I'm not aiming for happy anymore. I'm aiming for content. Content means not always reaching for the escape hatch. Content means not running away to pleasure. Content is where I am—even when it's uncomfortable."

"My entire childhood I was always on edge. Still am. God forbid you bump into me. Actually, I'm fine if you bump into me. That's an accident. But if you don't apologize—if you don't say 'excuse me'—that's a choice. And it troubles me. It more than troubles me; I'll get involved. I'll make it epic. I'll chase you down, because I need answers. I need to know: 'What in the fucking world makes you think that's OK?' I was at a party recently. My brother-in-law made a documentary on Arthur Ashe, and there was a party on the day of the premiere. Nobody's going to have a fight at the Arthur Ashe party, right? But there were these guys at our table. They were good-looking Irish guys, in their fifties. You know, coming to the end of their cocaine, drinking, lover-boy phase—but still hitting on girls. Still full of machismo. They looked a lot like me, and those are the ones who set me off the most. One of these guys is telling his friends a story, just screaming it. They're laughing. They're high-fiving. My brother-in-law is trying to talk to me, but I can't concentrate. I'm watching these guys. I'm getting more and more anxious. I want to stand up, and say: 'Bro, this is a quiet area. What in the fucking world makes you think this is OK?' Finally, I say to my brother-in-law: 'I'm about to kill these guys.' And you know what he says? He says: 'Oh, I didn't even notice them.' During my next therapy session, I asked the therapist: 'How come I can't be like that?' And that's when she said something that blew my mind. She said: 'Remember when you were a little kid, and your father and mother would leave for a party? She'd be in a gown. He'd be dressed like those men—in a suit. Everyone's happy, everyone's laughing. But when they came home that night, your father would be punching your mother in the face, and threatening to kill her. It wasn't what those men were doing that triggered you. It wasn't the joking, or the high-fiving. It's what's next. It's what's coming next.'"

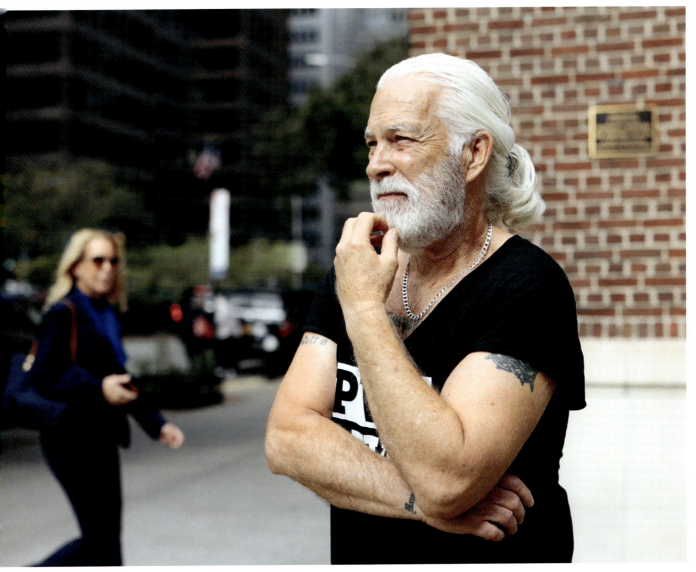

"One night I went to the theater with my wife and in-laws. We're trying to watch the show. They're singing on stage. And the whole theater's quiet, except for this one guy. He's sitting right in front of us. He's got an old man sitting next to him, and he's screaming into the old man's ear: 'Are you enjoying the show? Some voice, huh?' And of course I'm getting anxious. It's like: 'You've got to be kidding me. What in the fucking world makes him think this is OK?' But I don't say anything, because I'm not trying to embarrass my in-laws. But then even my wife gets fed up, and she goes: 'Shhh.' And that right there is a green light. Now I have carte blanche. So I lean forward, and say: 'Yo, my brother. You gotta stop talking.' And I'm thinking that's the end of it. I'm thinking it's over. But at intermission this guy wants to continue. He stands up and says: 'How dare you? I brought my father to the theater, because he's sick.' And I tell him: 'Next time bring him to the hospital.' Needless to say it gets heated. My wife finally calms me down, but I can't concentrate for the rest of the show. All I can think about is this guy. Later that night I'm lying in bed, and I'm still thinking about this guy. The entire next week, whenever a friend says: 'Doc, what's up?' I tell them about this fucking guy. I'm obsessed. It wasn't until several days later, when I was doing my breathing exercises, that I realized something: in the week following that fight at the theater, I'd done some amazing things. I went to a boxing match. I got to meet the boxers afterwards: we were taking pictures, they were calling me Papi, it was beautiful. Then that weekend I got to take my goddaughters to a Mets-Yankees game. We had an amazing time; we teased the Yankees fans. Then afterward we went to my favorite diner, and as soon as we sat down this cook comes out the back. He says: 'Hey, Doc! I burned you a CD.' Can you believe that? This guy thought enough of me to burn me a Babyface CD. So many beautiful things had happened that week. But instead of thinking about those things, the whole week I'd been obsessing over the worst minute of the worst day. Telling people about it, replaying it over and over. So I decided right there, sitting on that bench, that I was going to get this tattoo."

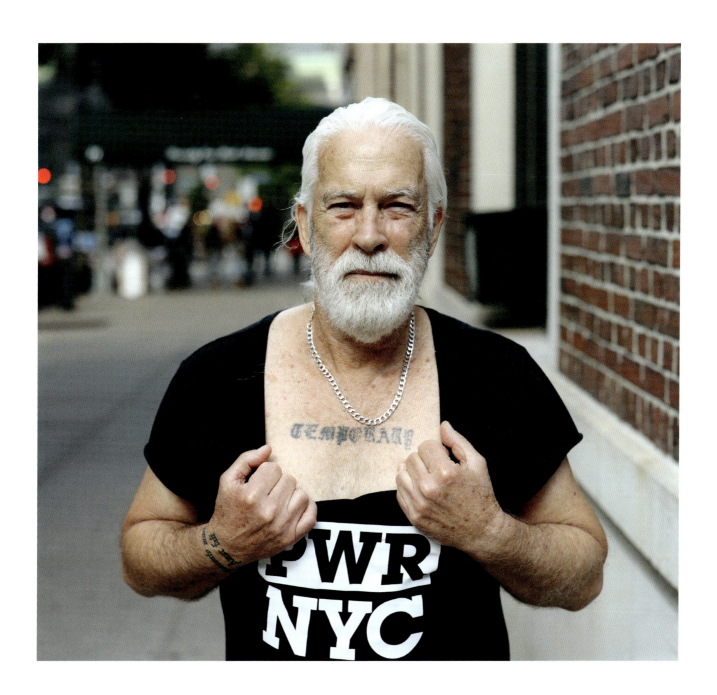

"If you'd caught me yesterday I would have been angry and wanting to hit somebody, but luckily I mulched this morning."

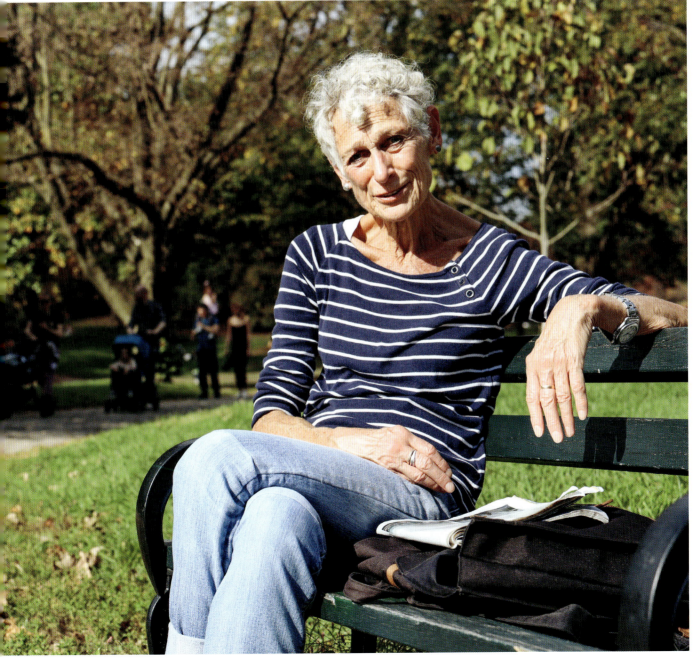

"I'm a beauty addict. I love beauty. Beauty, beauty, beauty. The bigger the sparkle, the bigger the buck. That's why I put jewels in all my art. A few years back I did a whole show where all the pieces were made of leather. I'd stapled the shit out of them until they were puffy and weird, like muscles filled with blood. Then I covered them with jewels. At the show I decided to eavesdrop on these two women: one of them was full-figured, the other one was old. And they must have gone to art school, because I heard the big one say: 'Look at these, they're so beautiful. But they do nothing.' It made me feel so dumb. When I was a kid I had a big head, a football head. I had to wear a helmet. And this woman gave me that football-head feeling all over again. I wanted to slug her. I wanted to scream: 'They do nothing? What the fuck are they supposed to do, vacuum your house?' But my mother taught me to never burn a bridge. So instead of blowing it out my mouth, I took a deep breath. I said to myself: 'Just wait, wait a minute. Gestate with negative things, like a shaman. Like a little magic man.' I said to myself: 'Maybe they're right. Wouldn't it be great if my paintings could do something?' A few weeks later I ended up finding an old man named Carl who has a hoard of crystals that he sells by the pound. All of Carl's crystals have healing 'goo goo' in them, so I bought $5,000 worth. You see? By holding my tongue, I got something. Those women gave me a gift with their bitchery. Now my paintings can heal and dazzle you at the same time."

"It was the night of Santa Con. I wasn't going to leave my apartment; the streets were filled with drunken people in one-dollar Santa outfits. But at the last minute I decided to leave, because, because I wasn't going to let them win. I went online and bought tickets to a 1920s winter ball. I put on my black vintage eighties tuxedo from Brooks Brothers, with the single-button shawl lapel. And I started walking across the park. The ball was held in a mansion on Fifth Avenue. There was a big, beautiful, sweeping staircase. A giant Christmas tree. A German woman was wandering from room to room with a light-up accordion, chartreuse. In the ballroom there was a free dance lesson, the Peabody: it's a walking dance. We were all standing in a circle, looking in, feeling awkward. She was wearing the right dress for the evening: a blue velvet dress, with a pearl-beaded ribbon. Somehow the conversation turned to World War II. And she explained that Hitler's obsession with clean lines on his uniforms led to ineffective holsters, and partly lost him the war. Then the music started. It was 'Too Much Mustard,' not the most romantic song. But I put out my hand, and she took it. Here we are, seven years later, still talking about the exact same things. Clothing, not Nazis."

"When I stopped going to church, the elders came looking for me. They actually came to my house. They were like: 'You're spiritually cold.' I told them: 'Look, man, I'm done. Write me out of the book or whatever.' They don't make it easy. When you leave the faith, they cast you out. They act like you don't exist. There's a period of extreme loneliness you have to overcome. You have to start from zero, start from scratch, and find a way to survive. I went through a period of searching. I researched a lot of religions, and none of them satisfied. It was the same story, different names. I even bought a Ouija board. I did it right. I lit the candles, everything. I even recorded it. I was like: 'Is anyone out there? Jesus? Mohammed? Buddha?' I wanted so bad for that thing to move on its own. I'd have even taken an answer from Satan. I wanted to see those red eyes light up in the darkness. But there was nothing. No reply, only silence. After that, I said: 'I'll believe in myself. I'll do whatever I want, and I can make it.' Believe it or not I'm still a spiritual person. I know there has got to be something bigger, because the world is awesome. But I'm fine not knowing what it is. Just because I don't understand it, doesn't mean I need to make up a story for it."

"I'm a late bloomer."

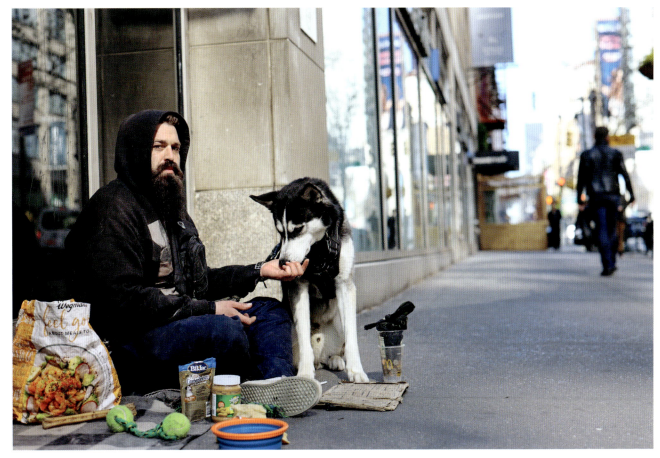

"I identified as asexual, but that was just a tactic to get people off my back. It's not easy to exist in Turkey as a gay man. My mother wasn't religious, but it's all around you. Your entire existence is expressed as net negative to society. I left home when I was sixteen. I was living in the hallway of a friend's apartment. I had a two-meter desk; a really thin one. There was nothing but a laptop, a lamp, a sketchbook, and a bust of the statue of David. I'd wake up at 6 A.M. and spend six hours drawing. I'd tell myself: 'If I can be good at this, everything else will be OK.' I'd draw these really detailed diagrams of muscle, very layered. And on top of that would be a naked figure. Mostly masculine, because I gravitated toward it. Each one was so lovingly rendered. A detail of every muscle suture, every dimple, every indent of form, every crosshatch. It was a way to harvest those feelings, both sexually and non-sexually. I wouldn't call it a release. More like scratching an itch."

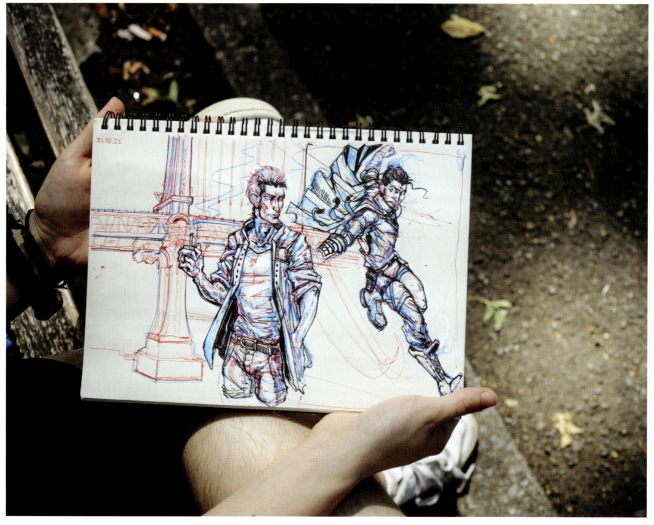

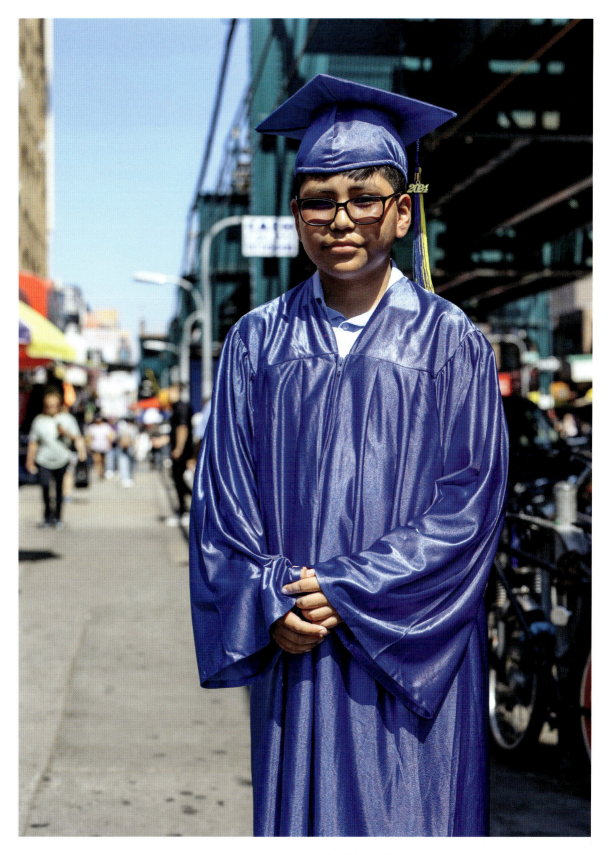

"Friends. Hard to find them."

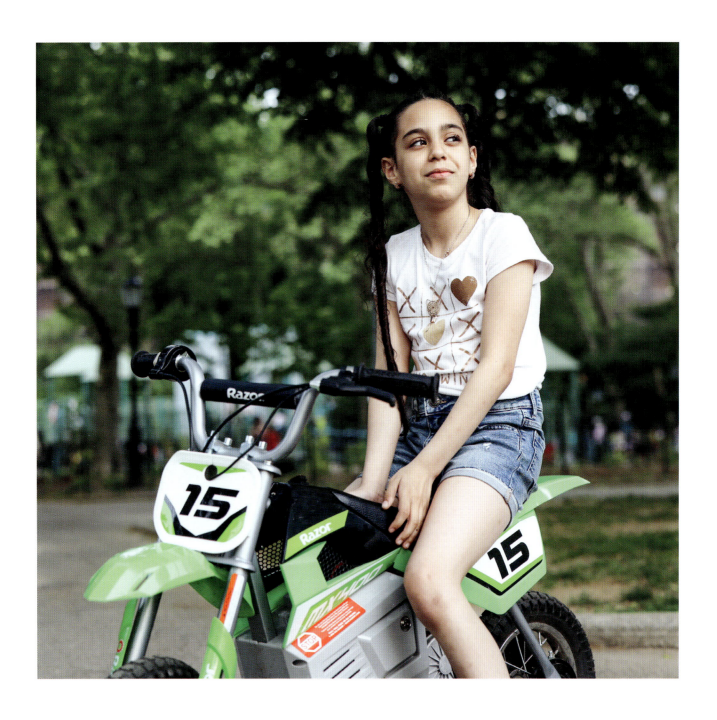

"My family says that I'm sassy. Sassy means when you want something, you get it."

"I'm trying to get it right. Thank God I've got people picking up the tab. Every village needs one idiot, and I'm it."

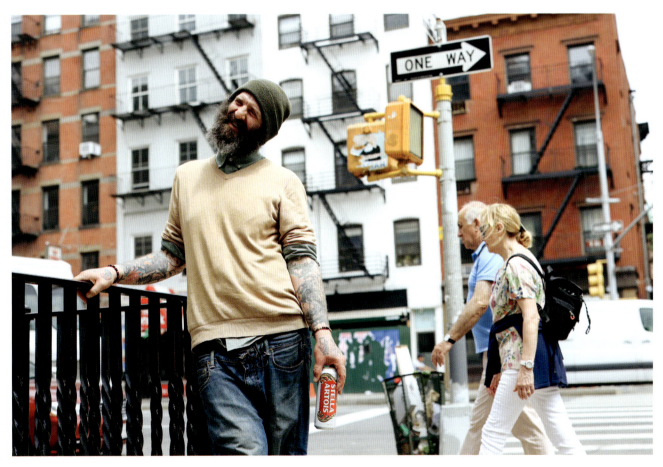

"It happened on a sunny day. I was twelve years old. And I was pretending to be a witch; just one of those things you do on the cusp of adulthood. I was standing beneath the crabapple tree on our front lawn, and I spoke into the wind. I said: 'I know that there are spirits out there, and I want to talk to you.' Immediately there was an intense stabbing pain, in my back. The kind of pain you have to breathe through. And I heard a voice. It was the voice of a young girl, saying, 'Hello.' And that was the moment she attached herself to me. Ever since then she's been like an invisible friend that's always there. In the beginning there was a lot of weird aggression. She'd pull me out of bed. She'd push me into walls, and doors. Even her presence is painful; when she's around I always get this stabbing pain. She communicates by thought, which I've grappled with—because it can make it seem like she's not real. But they're not normal thoughts. They get pushed into me: I can feel the words forming on my mouth. And it's not my normal voice. Her voice is very curt, because she's tough. She's a tough kid. One time her face appeared in the mirror, and it was one of the freakiest things I've ever seen. Her face was anger, death, and 'What the fuck?' I don't think that's how she means to appear. It's not who she is. It's just an emotional projection, because of what happened to her. She's just a scared kid."

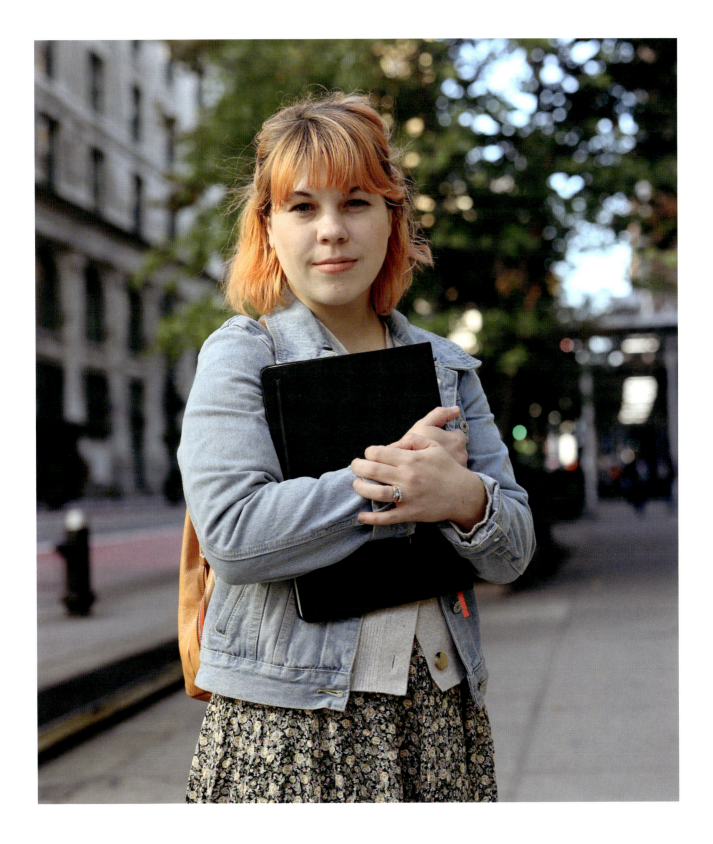

"She told me her name is Alyssa, but I'm pretty sure it's Elise. Her story keeps changing. I know she died when she was fourteen. At first she told me that she killed herself, but that doesn't make sense. I think she was murdered beneath the same tree where I met her—because of the stabbing pains. I don't think she's processed the trauma. She needs space to heal. We've come to an understanding: if she wants to stay, she can. But she's not allowed to stab my back anymore. Ever since I established boundaries our relationship has become much more tender. She's like this cousin or sibling that drives me absolutely batshit, but there's also a deep love there. When she attached herself to me, I was entering middle school. We were the same age, so I could identify with her: the feeling of being lost, the feeling of being an outsider, the righteous anger. I have a very distinct memory of sitting at my keyboard, crying over a boy. And I felt this hug from behind me. I knew it was her. Today I keep our interactions pretty minimal. She's still there, but I try not to talk to her too much. I still let her DJ for me on Spotify sometimes. I'll put it on shuffle, and say: 'Go, girl.' And she always picks the most fun stuff. It's a lot of punk. And a lot of female voices. She's more independent now. Sometimes she'll go off on her own, but she aways comes back. She's here right now. She knows we're talking about her. I'm getting the stabbing pains in my back. 'C'mon, girl. That's enough. C'mon, girl.'"

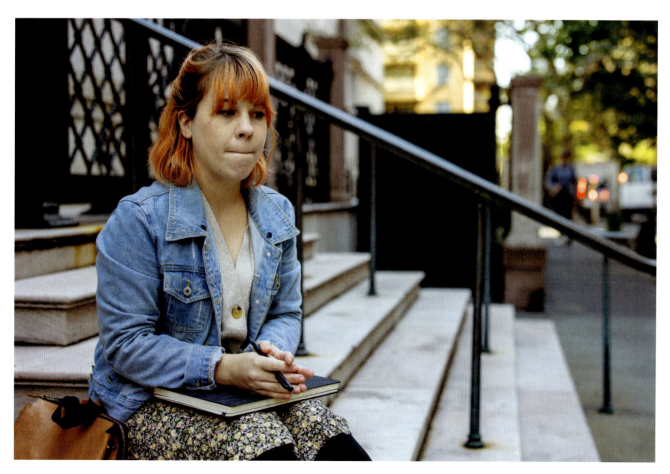

"I'm creating a comic book about her. It's about a ghost who meets this kid her age, in the same spot where she was killed, and it becomes this journey of healing. For both of us. It's a love story. I do admit that I love her. But she's too attached. She's stuck. She's stuck in arrested development. She was so young when it happened. It wasn't her choice. And she can't move on. In some ways the trauma is all she has. This is the page that shows the exact moment that she died. It's the source of all her anger. The big What The Fuck. All of us have that moment in our lives. When something horrible and unjust happens. Maybe it was random, and not directed at you. But other times it's very directed at you. And you have to deal with the fact that it happened. There's no going back. She can't go back and change it. But she can't continually let that person hurt her. She's been gripping on so tight, for so long. And she's found this place inside of me where she's allowed to stay, and be safe, and be fine. But we can't stay being kids, being safe. At a certain point, you have to go. You have to go on your journey. So when the last page is finished, that's it. It's not easy for me either. It's been a comfort, having her around. It made me who I am in so many ways. But it's time. You know, it's just not chill to have a ghost girl following you around your whole life. And also, I just need to be alone. Everyone deserves the opportunity to be at rest."

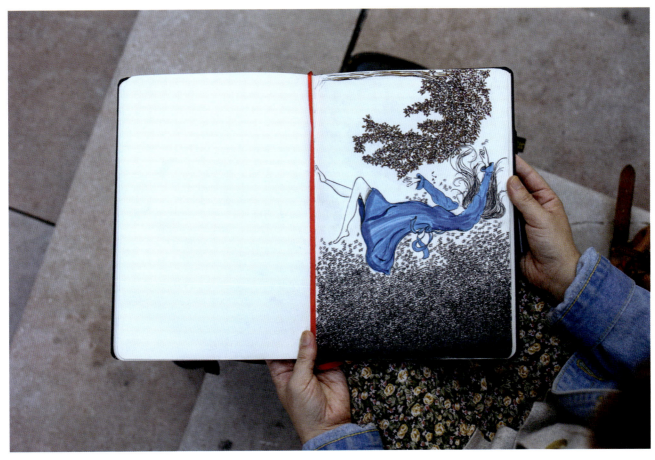

"They say it's forty hours but it's really sixty hours. It takes an hour to get up, an hour to get to work, then you take your hour to get home. Then once you're home you've got to rest, chill, spend a little time, watch a little TV, kiss, go to sleep. Five days a week. On the weekends you're tired. But it doesn't matter how you feel, because disappointing your kids is one of the most painful things—period. So you try your best to do something memorable. We came out to Coney Island for the holiday. We just played basketball for these two prizes; my son will remember that. But then you blink your eyes and the weekend's over. You've got to do it all over again. It's the matrix. At my job I'm just a number. If something happened to me, they'd go online and find someone else with the same qualifications. They're hired. I'd be replaced in 2.4 seconds. But my family? They'd be devastated. So if I had bought Bitcoin ten years ago, I'd be doing two things: exercising and spending time with my family. Period. They say money doesn't buy happiness, but it sure would help."

"His mother wanted a break. You know, it's hectic. She's a single mother. She just bought a house. It's a lot taking care of a kid on your own. She thought maybe it would be a good experience for him to come live with Uncle Olasegun for the summer. As soon as she suggested it, I was like: 'I want to do this.' And here's the reason: she did the exact same thing for me. We lost our mom when we were kids. I was really young at the time—like three. Whitney was twelve or thirteen. She and my other sister ended up taking care of me: cooked for me, took me to school, made sure I had a shower, brushed my teeth. Back then I thought she was annoying, because of my ignorance. But now it's crazy for me to think about. It must have been such a burden. She'd be hanging out with her friends, and I was always there. So I'm just trying to pay it forward. I picked him up from the airport last night. I have no idea how the summer is going to go. I like to cook, so I'll cook for him. Maybe we'll paint a little in the evenings. I'm going to teach him some kickboxing on the terrace; hopefully that'll tire him out so that I can get some work done. I'd love to be a father one day when I find the right woman. So it's going to be a good test for me. I'm just hoping he has fun. And when he goes back home, he tells his mother all about the amazing summer he had with his uncle."

"I just got back from recording with my band; it's called Care of the Cow. We started in Chicago in 1974, and it's been non-stop since then. The last time the three of us were together was in 2011. We've taken long breaks before; we always pick right back up. But this time I was worried I wouldn't be able to do it. I've been having problems with my hearing. It's a form of tinnitus; it makes everything sound like an avant-garde composition. I can't distinguish harmony anymore, and harmony has always been my first language. I've never had to think about singing. But suddenly I'm having to think about it: Can I hear, can I sing, is music a part of my life still? We met in Amsterdam, where my guitarist lives. We started every morning at eight o'clock with some coffee, then went right up to the studio. That first day we recorded three pieces, improvisational, one initiated by each of us. My piece was called 'Overnight Ferry.' My lyrics tend to be about what is happening right now. I always say that I don't do music, I do reportage. So this song was about my fear of taking the journey. One of the verses said: 'I'll bring my snippets to the table, and I know I don't have to work alone.' I went into the vocal booth. I was so nervous, but I opened my mouth and it was bang: harmony. Nobody had a second thought about it. Next track, harmony. Next track, harmony: bang, bang, bang. My friend Cher said: 'I don't know what you're talking about, you sound better than ever.' It felt so nice. Like, everything is going to be OK. We can still do this. So much has changed, but not this part. Here we are, still."

"I've been working on it for two weeks. I'm going to send it tonight, because my mom is coming to visit tomorrow. And if the reply is not good, at least my mom will be here."

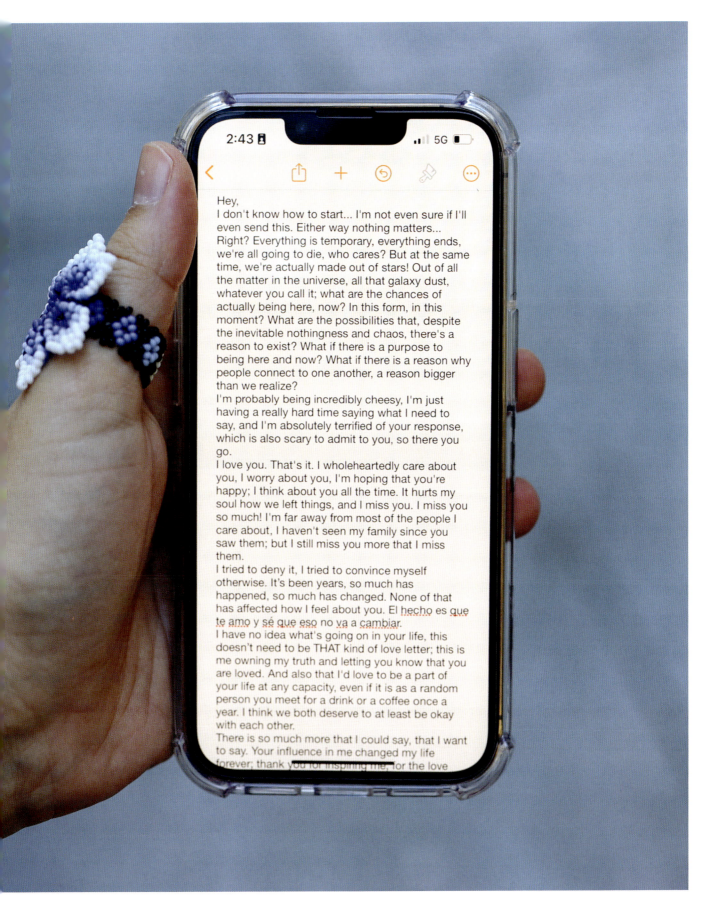

"She's the sixth one I've had. I identify with them. They're very beautiful, demanding, and stubborn."

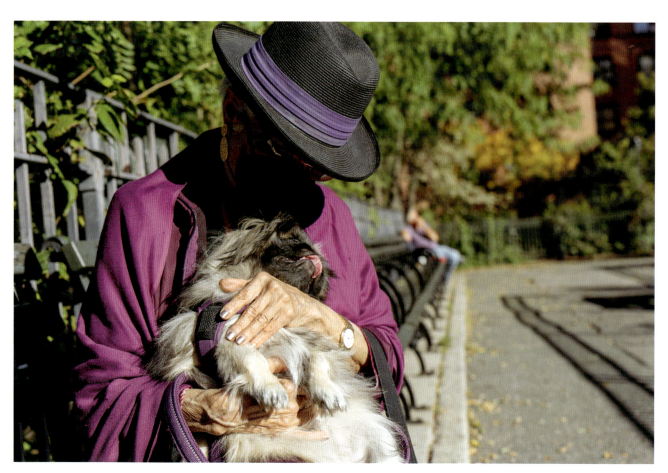

"I got this hat at the Plaza Hotel, at the Eloise shop. Up near the shelter where I used to live. It was the only hat that fitted. And I was so happy because it was an Eloise hat. Eloise's family was very rich, and they left her at the Plaza. And she brought all these animals to live there with her. It reminded me of all the times my father would bring me to the Central Park Zoo. We lived in a beautiful apartment with antiques from my grandfather's congressional years. It was my dad's third marriage. His first wife was a Portuguese princess. But he was thirty-seven years older than my mom, and it didn't work out between them. She tried to commit suicide when he left her. But sometimes he'd invite us to Maine and I'd get to see my two older sisters from his earlier marriage. We'd play tennis and there was a yacht club. I liked looking at the boats and sometimes we'd take the motorboat. But when he died, things got a lot tougher for my mom and me. We weren't invited to Maine anymore."

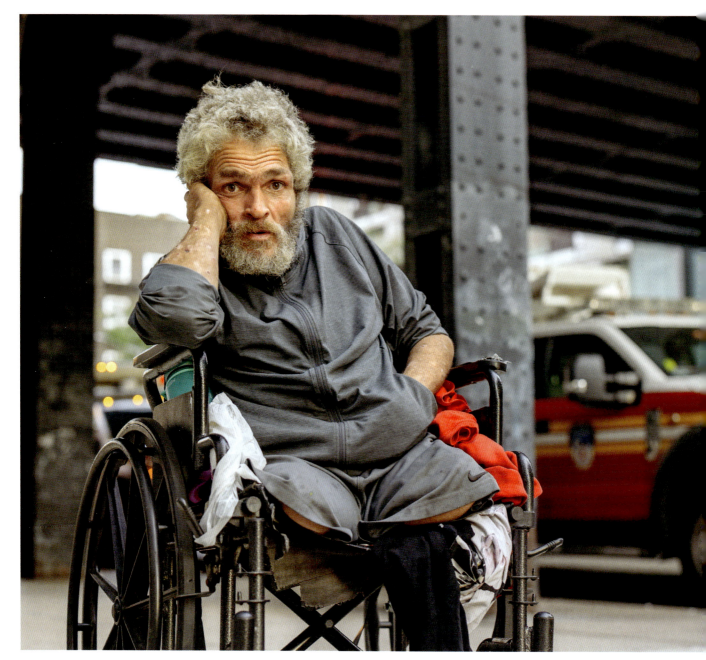

"Three girls. All born in May. They're not Mama's girls, either. They're Daddy's girls. I don't stay over there because I don't get along with their mother, and I don't want to fight. But I see them every day, every day. I pay the rent. I get a check from the military, give it all to them. And I give them half of what I make out here. As long as I can eat, buy a bag of chips every day, I'm fine. They gave me a shirt one year for Christmas. It said: 'Anyone can be a father, it takes somebody special to be a Daddy.'"

"A few days ago he saw me doing my poses in front of our building, and he said: 'I have anger issues. Can you teach me how to be calm like that?' He just came to me in such honesty. I was like: 'Sure, I'll teach you some stuff.' We've learned five poses so far. The first thing I told him is: 'We've gotta get your breathing together.' Because the way to control your emotions is to control yourself. Every time you let people take you out of a place of calm, a place of peace, you're giving them your power, and that's yours. He has eight siblings; they love to antagonize him. And there's not a lot of space in his home. So what I told him is: 'If somebody's getting on your nerves, see if you can run to the bathroom, close the door, and do your breathing. Take deep breaths.' Once you've gotten your breath under control, everything else comes easy. It all starts with the breath. It regulates the pace of the heart. When you control the breath, you control the heart space. And that's where you want to be. Because when you come from the heart, it's really hard to be angered."

"Right when we close our eyes and we meditate, like the air starts to come out and it's like we're in a whole new world where it's calm, peaceful, there's no fighting and all that stuff. That's what I like about it."

"I'll tell you straight out. I met Mother Teresa. Six weeks before her death, at a convent in the Bronx. I was in a line of nine or ten people. She was in a wheelchair, but her eyes were glowing with the joy of a four-year-old girl on Christmas morning. I knelt down, took her hand—that tiny, tiny thing. Water was coming out of my eyes. She gifted me this miraculous medal, and she said something to me. When I stood back up, everyone wanted to know: What did she say? I couldn't answer them. It's like I went to another dimension, and she was talking to me in that dimension. But I will tell you this—I saw the Holy Spirit."

"As long as my dog is fine, I'm fine."

"I never learned how to read. Nobody taught me. There were so many of us in the house, and even my nanna didn't know how to read. I hated school. Like, I was so bad at it. I acted like a clown just to avoid everything. When I was thirteen I got caught running around here with a pistol and they sent me to Tryon Juvenile Detention Center. That's where I met Miss Lakewood. She taught the computer class. Heavy-set Italian lady, about four-ten. But attitude, huge. Aura, big. She was like the grandmother in a mob movie. You know how you've got all the bosses, but when the grandmother comes in—everyone shuts up? She was like that. But she was loving too. She had pictures on the wall of all her favorite students; she called them her babies. She even had a picture of Mike Tyson up there from when he was a kid. One day we had this test. It was like this contest, on the computer. The winner got $50. And I was looking at the screen and getting so angry. I'm crying, because I couldn't read. And that's when this Spanish kid called me Forrest Gump. He had the whole class laughing at me. Miss Lakewood was like: 'What's going on?' She came over and said: 'Fix your face. Fix your fucking face, I don't want to see another tear.' Then she said: 'Tomorrow, you better get ready.' She started working with me for an hour and a half, every night. She started me on *Lion King*. It was a preschool book, so I didn't want to do it. But she made me. Every night she made me keep reading until I was able to read on my grade level. I started getting report cards with nothing less than 85. I was sending them home; my mom was getting hyped. I got my GED. I started reading so much. Today I can finish a five-hundred-page book in two days. If I smoke a blunt first, I swear to God I can picture the whole book like it's a movie. Miss Lakewood passed away when I was eighteen. I heard about it while I was in prison. Some new guys came in; they'd been in Tryon too. They heard me talking about her and that's when one of them told me. But he said: 'Yo. I'm pretty sure she had your picture on the wall.'"

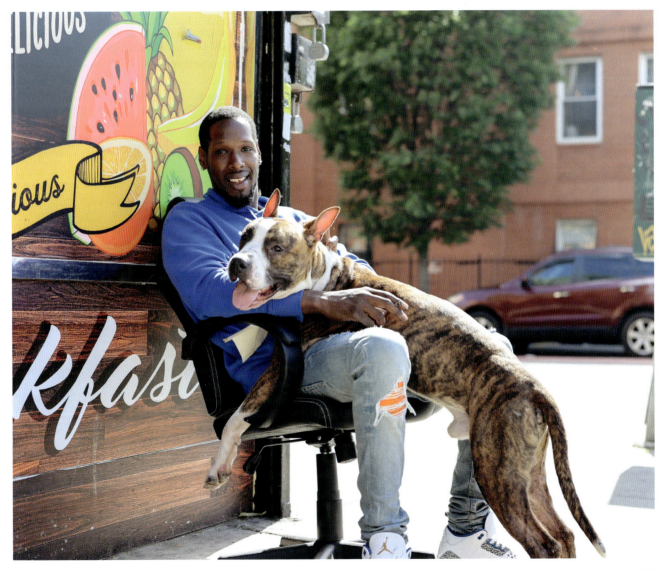

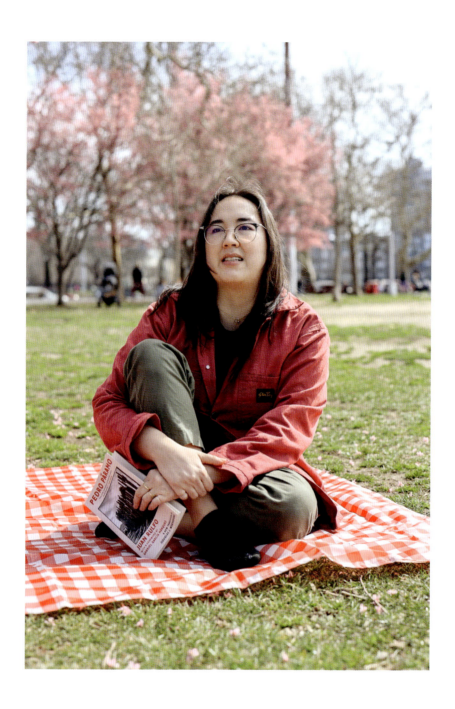

"The 'kid me,' I can kind of understand. But the young adult me—her decisions are just baffling. It's like: I knew if did this thing, then consequences would happen. But then I did it. And when the consequences happened, I'd be surprised every time. Like: 'Wow, that did happen.'"

"It got to the point where I was failing in school. So I decided rather than trying to overachieve, and prove that I'm good enough for other people, I might as well flunk out, and fail, and be the best at that. It was a control thing. My life felt so out of control, and at least there's a sense of control that comes with self-sabotage. You can't accidentally disappoint people if you're choosing to do it."

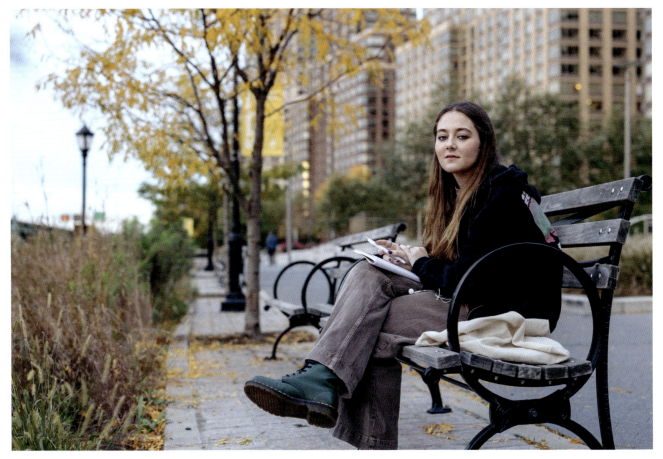

"I'm an American citizen. The right of citizenship precludes that I am going to be connected to my country, my city, and my apartment building. I want to know everything that's going on. And if I pull away from it, I think that's irresponsible. Recently we were having some issues with the tree beds in front of our building. Management didn't want us to plant; it was ridiculous. A neighbor of mine, who's lived here forty-five years, decided to plant some bulbs. But when she came home from her house in the country, the bulbs were gone. The super had ripped them all out. She was fit to be tied. It was horrible; what he did was horrible. She and I have decided to start a little organization, along with another neighbor. We call ourselves The Seedlings, and our mission is to grow community bonds. We began by sending out a questionnaire, asking what changes people would like to see. Maybe a lending library in the basement, or a super who's more cooperative, or a tool sharing service. Imagine you needed a tool, and Joe in 4D has the exact tool you need. You wouldn't need to buy it, you could get it from Joe. Eventually we'd love to have annual events for the entire building. Probably seasonal, but certainly Halloween. We've already had our first celebration. It was a picnic, to welcome the new super."

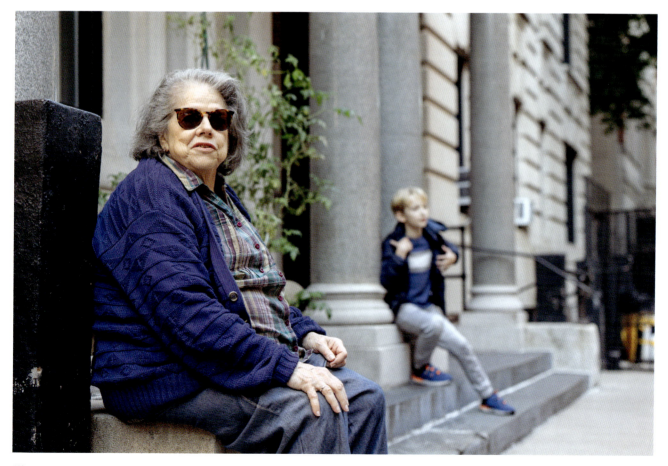

"Shit got kinda rough in Florida, so I came here. For the past week it's been twelve hours at the skate park, every day. It's keeping me from feeling sorry for myself, or feeling like I don't want to be here anymore. It's keeping me away from drugs, for sure. It's just so easy to fall into that place. But when I start to feel like that, it's like: You know what? Watch me land this shit. Every trick matters to me, I really feel that way. Like if I can make this one motion work out, this one moment, then things are possible. Things can change."

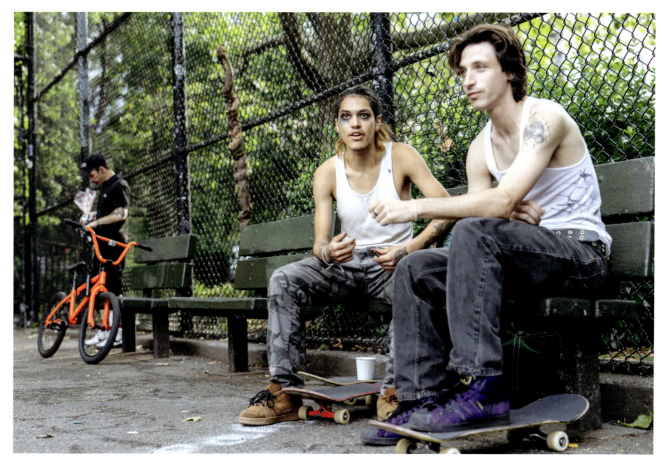

"Occasionally I'll have a beer after work and break out the sketchbook. But I had wanted to be this great painter. I wanted to do these grand things: big, huge oil paintings. But those days of painting all the time were such a roller coaster. There were these periods of extreme depression, followed by manic states of trying to put myself out there. I couldn't do it anymore. I mainly felt sorry for my dad. I know it was rough for him. My mom hadn't wanted me to go to art school. She wanted me to do something more practical, but my dad said: 'No. This is what he wants to do, and I want to support his dream.' And then I abandoned it. That was the first time I had to deal with real failure. A lot of times when you're an artist—it's your job, it's your lifestyle, it's your entire fucking identity. It wasn't like I failed to do a thing. It was like: I failed to be something, you know? It was a failure to live up to what I thought was my destiny. But then on the other side of that—there was this figuring out that there was nothing wrong with me the entire time. I didn't need to be something else to have meaningful friendships, or a good relationship. I didn't need to be something else to be loved and cared about. After work tonight I'm going home to see a person who's in love with me, and I can't wait. And that person met me long after I gave up on being a full-time artist. They met me when I wasn't even a chef yet. I was a piss-poor, part-time line cook. But even then—they decided I was worth it. So you know, there's something there. There's something there that's enough."

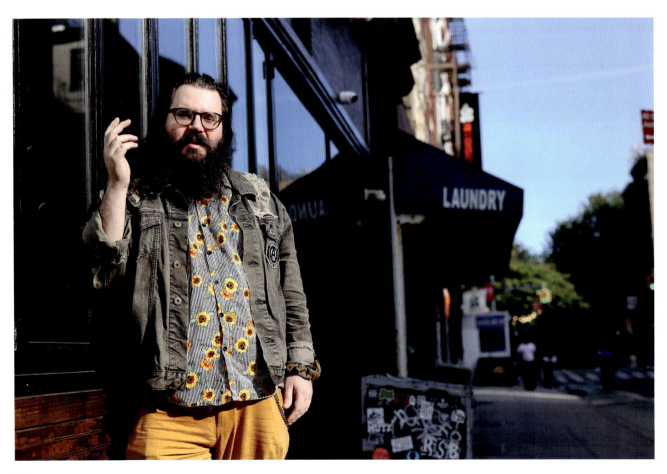

"I'm waiting for Mr. Slater."

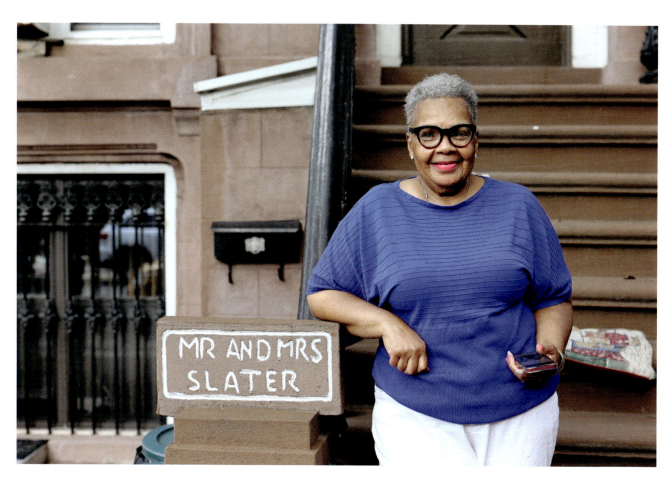

"We're trying to escape this government control."

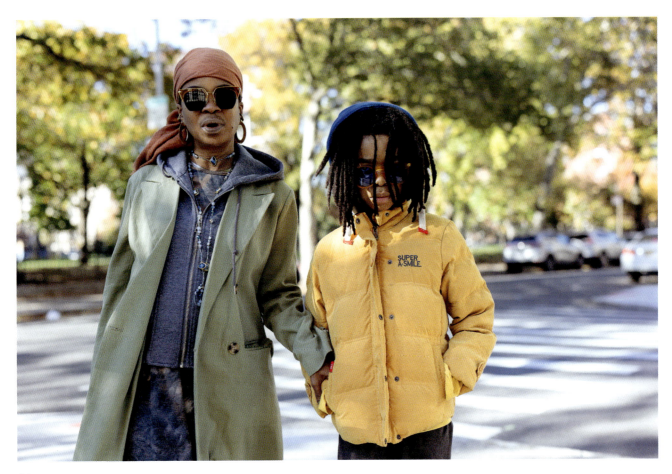

"I play music for a living; a lot of jazz. I'd say half of my work is keeping myself at a high level of performance: writing, practicing, things like that. But the other half is networking. I need to make connections with people who might want to hire me, or people that I might want to play with down the road. Some nights I'll go see my friends perform, and I'll end up hanging out with them until midnight. It's inherently fun. It happens to be what a lot of people do for fun on a Saturday night. But for me, it's also part of the job. She's a lawyer; she has to wake up early to be at the courthouse in the morning. So I think, sometimes, for her, my work can look like—"

"Play. It looks like play."

"I told my wife when I first met her. I said: you have to sign a contract. I will take care of you, I'll spoil you, you'll never have to work a day in your life, but twice a year I'm going to leave you. My Vegas trip, and my skiing trip. I go away five days in Vegas with the boys, and I go skiing for four days, with the boys. I've been doing this before I met you. And if you're going to stop me, nice meeting you. I work hard all year. And for two weeks only, I want to be stupid. I want to spoil myself. If I want to go into the candy store and buy Bazooka bubblegum—I don't need my mother smacking me around saying, 'You're not allowed to have Bazookas.' No, Mom, I'm old now. I make my own fucking nickel. I've got my own Bazooka money. I want Bazookas."

"I've always wanted to make enough money to buy my mom a house, take care of her. That's like everyone's dream, right? Other than that I'm not too sure. I'm a very simple man. I drive a twenty-year-old car. It's a hunk of rust. But I don't need flashy things. As long as I can wake up, go to work, come home, see my girlfriend, and look at my fish. My coral beauty is probably my favorite, but I also have two clownfish. And an eel. I call him Neil the Eel. He only comes around when I want to feed them, and that's about it. He's a little miserable fish, only cares about food. But I like to take care of him. I like to take care of all my fish. It brings me peace. You know, no matter what's going on in the day, I can sit down, shut my lights off, listen to the sound of the tank, look at my fish, and yeah, I'm happy."

"My ex was having an affair with a police officer. When I confronted her about it, things got heated. I stepped out. When I came back the police were there. She said I threatened to kill her. She told them what she wanted, and they listened. When I got out of jail I was told that I couldn't see my son anymore. I'd already been through so much in life: abused as a kid, went through foster care. When I was seven I watched my sister run away, never saw her again. Never met my father. Finally searched for him after my son was born, and he hung up the phone on me. So I've been through a lot. And the only person who loves me, without judgment, is my son. When his mother tried to take him from me, I fell into a depression. I was mad, beyond mad. But a lot of people talked me down from doing something I'd regret. And since then I've won two criminal cases. Won in family court. Won in the state child registry, representing myself. Today was our last trial—the custody case. At one point I was cross-examining her, and I was fucking crushing it. I was tripping her up on the stand. I said: 'The night you had me arrested, you stayed with our son, correct?' And she said that she did. Then I pulled out the investigative notes, which she didn't even know existed. And I said: 'But when the police did a wellness check later that night, you'd left our son with your mother. And you weren't home.'"

"She got scared. I could see her getting scared. So I said to the attorney, 'I'm gonna step outside with you.' I said: 'Either I pursue this with my inventory of evidence and exhibits, and humiliate the mother. Or I could allow her to understand that what I'm doing is for the sake of our son.' I offered to split the custody. When the judge awarded me child support, I told her: 'Keep the money, I don't want it. Just live your life.' Part of me wants justice. But justice has a price. Justice is going to come at the expense of our son. And more than anything else, I want there to be peace in his life."

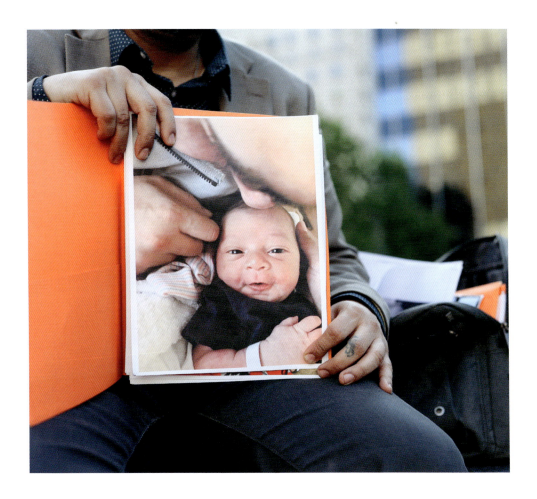

"The sugar, that's really challenging. And the screens. Screens and sugar."

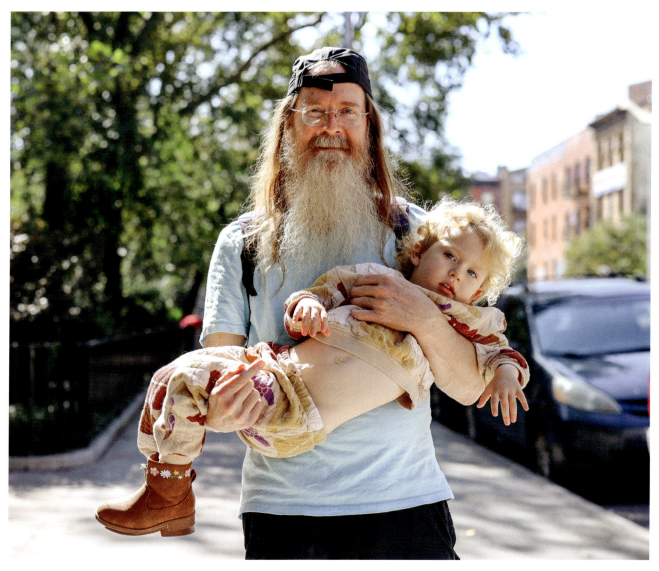

"He sneaked the phone when I was watching TV. I went in the kitchen to get my breakfast, and I saw him with the phone. Then I heard some banging noises, and I knew exactly what that meant. I said, 'Didi, why? Why did you spawn Griffin the Great?' The strongest unit, the rarest one. He costs one thousand gems. I was saving him for the final boss, the skull-face guy. And Didi spawned him on the easiest level, a sword wrath. A sword wrath! I could have fought them with normal units. Now Griffin the Great is gone. Why did you do it? Why, Didi? Why?"

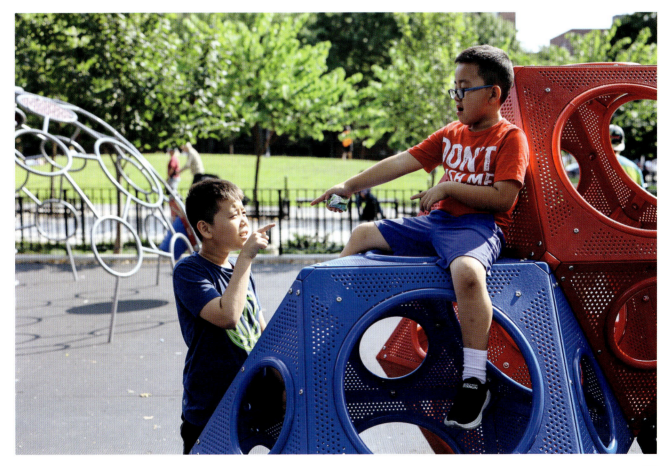

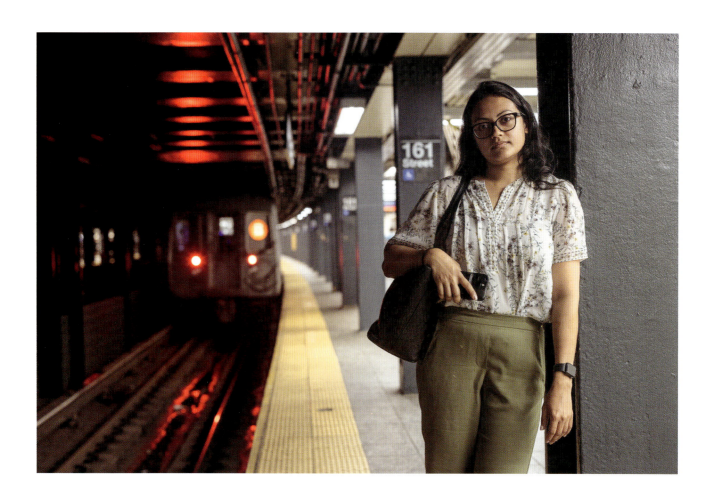

"It was senior year of high school. My mom and I were at Macy's shopping for a prom dress, and she was telling me how good my father was—to provide for things like this. Then literally two days later we find out he's cheating. He married someone else back in Bangladesh; someone not much older than me. And that's when it began to unravel. The next ten years were an endless, vicious cycle. His behavior got more erratic. He wouldn't medicate his bipolar disorder. He became addicted to several drugs. On one hand, his behavior could be explained. He'd grown up during a civil war. His father was shot dead; they never found the body. His mother handed him off to relatives, wiped her hands clean. He'd gone through so much trauma. But on the other hand: we weren't asking for much. Just be a normal dad. Think about us, and how your actions affect us. I did everything I could to fulfill his expectations, but it was never enough. By the time he died we'd grown very distant. There was a text conversation toward the end. We exchanged some kind words, which hadn't been the norm toward the end. He sent me a picture of himself. He'd lost a lot of weight; you could see how much he'd spiraled. He seemed lonely. It was hard to stay mad. And it still is. It's hard to stay mad at someone when you feel sorry for them."

"I counted the places we lived at one point. And it was over twenty-five. Over twenty-five, for sure. My mother had a lot of different men in and out. People would come live with us. It was chaos, emotional chaos. The not knowing where you're going to live, not knowing if you're going to be able to eat. Not knowing clearly what the fuck is actually going on. I moved out and got my own apartment when I turned sixteen. Went to Job Corps, finished Job Corps. Got my GED. By the time I was seventeen I was living by myself, going to college, I had a job. I was meeting a lot of people I would otherwise have never met. I was proud of myself. I'm living up to my own standard. I made it through all this bullshit. I had enough power to do it. I had enough talent to do it. I felt like a super independent woman. There's a joy of doing things on your own: the freedom, the not having to answer to anyone. Nobody you have to call and say: 'Hey, it's me. This is where I'm going, this is what I'm doing, this is when I'm going to be home.' There's also a pain of doing it on your own—and it happens to be that exact same thing."

"Trabajaba en el campo, todo el día bajo el sol. Sabiendo llegar aquí, yo decía, me va a ir mejor. Soy joven. Diez, quince años después de que yo trabajé, mi vida puede ser otra como persona. Mi mujer y yo salimos de Venezuela el siete de enero, y el siete de abril, la misma fecha, entramos a Estados Unidos. Ando con Dios, ando con Dios. Cuando llegamos a Nueva York, encontramos un refugio. Pero no me atuve al refugio. Yo quiero trabajar. En el refugio no podíamos comer, no podíamos hacer comida, no podíamos lavar, y yo no vine a eso, a mí no me gusta eso. A mí me gusta estar cómodo. Llegar a mi casa, que mi mujer me haga un café, unas arepitas o cualquier cosa de nosotros. Después de solo un mes encontré este trabajo lavando carros. Uso el equipo del patrón, pero gano un porcentaje de lo que me gano. Y echándole ganas, eso, yo me le mido. Yo me le mido a cualquier trabajo. Empecé a reunir mi plática, a reunir, a reunir . . . Y ahora, después de solo dos meses en América, hemos podido conseguir nuestra propia habitación. Al principio la habitación tenía el colchón en el piso y nada más. No tenía una mesa, no tenía una silla, no tenía ventilador, no tenía nada, ni cortinas, te digo. Ni cortinas. Y gracias a Dios, mire, siento que, me siento en casa en esa habitación. Hemos mejorado todo. La hemos hasta pintado. Me compré mi aire acondicionado, mi ventilador, mi camita, mi mesa para comer, sillas para que ella se siente y yo me siento, y ropita como mucho. Mire, es increíble, es increíble mi situación aquí como ha sido de bonita. Estoy agradecido con Dios. Dios es grande."

"I worked in the fields, all day under the sun. If I come here, I said, things will go better for me. I'm young. Ten or fifteen years after I've worked, my life could be completely different. My wife and I left Venezuela on January seventh, and on April seventh, the same date, we entered the United States. I walk with God. When we arrived in New York we found a shelter. But I did not rely on the shelter. I wanted to work. At the shelter, we couldn't eat, we couldn't cook, we couldn't wash, and I didn't come for that, I don't like that. I like to be comfortable. To get home and have my wife make me a coffee, some arepas, or something else for us. After only one month I found this job washing cars. I use the boss's equipment, but I get a percentage of what I earn. And I'm giving it my all, I'm up for it. I'm up for any job. I kept saving, saving, saving. And now after only two months in America, we have been able to get our own room. At first the room had just a mattress on the floor and nothing else. There was no table, no chair, no fan, nothing, not even curtains, I'm telling you. Not even curtains. And thanks to God, look, I feel at home in that room. We've improved everything. We've even painted it. I bought my air conditioner, my fan, my bed, a table to eat at, chairs for her and me to sit, and plenty of clothes. Look, it's incredible, it's incredible how beautiful my situation has become here. I'm grateful to God. God is great."

"She was institutionalized for the first time right after I graduated high school. With my mom the battle has always been medication; she won't take any. She's like: 'This is me. This is who I am, so why do I have to take it?' And I'm like, 'Mom, I get it. But sometimes, you need to sleep.' It's been such a difficult thing to navigate. We've always been very close. She's told me before: 'You're the only one who gets me. I can talk to you about anything.' But sometimes I don't even want to call home. Because if she's elevated—it stresses me out. It's like: 'Shit, I need to drop everything and fly over there to be with her.' It's gotten better with time. I've been able to build these boundaries, where I'm OK not being there. Where I'm OK with not solving every problem that she has. I've created these boundaries so I don't lose myself, or my life, or my relationships. But still, it's this thing that always hangs over me. I'm always waiting for the big one. And is that boundary going to hold, when things really become real?"

"I was going for a stroll on the beach in San Diego. I would usually always walk north, but this time I went south. And that's when I saw him walking from the lifeguard station down to the water's edge. I caught my pace, so that I would be able to match his trajectory. And when we got close, I said: 'Walking this way?' And he said: 'Talking this way?' And we laughed, because those are the lyrics from an Aerosmith song. I told him I was only bluffing, and I pointed at a bluff on the hill. It was banter—we bantered. We walked down the beach for a ways, and that's when he asked if we could meet for dinner later. The funny thing is: I was staying at an eighteen-million-dollar beachfront property, and he also owned a beachfront property. But we made plans to meet on a street corner, because neither of us wanted a gold digger."

"I paid my own way through college. When I got my first job, my father told me: 'Don't take the job, because a man needs that job.' When I decided to go to graduate school, he warned me against it, because men don't like smart women. And when I bought my first house, he told me: 'Don't buy that house, because no man will want to marry you if you own your own house.'"

"When I lose I feel like the game has no purpose. But when I win, I want to keep going. You start to have hope. You envision going higher, and turning pro, and going to events. Getting the rank motivates you. And the more you win, the higher the rank gets. I spent the whole summer in my room. There's a bar to 100, and once you fill it up, you move up to the next level. I was trying to hit Gold, but I finally reached it. So I'm going for Diamond now. It used to be one of the highest, but they actually just added some ranks. Now it's: Diamond, Ascendant, Immortal, Radiant. If you can reach the highest rank, which is Radiant—you get noticed. My parents hate it. They think it would be better to read, or to write something. Or to invest more time into education. They don't think that video games can lead to a career. My dad is old-school, so he's thinking doctor, or engineer, or something like that. One time he woke up in the middle of the night, saw me playing, barged in the room, and unplugged it. I was so mad. Because you lose more rank rating when you leave midgame."

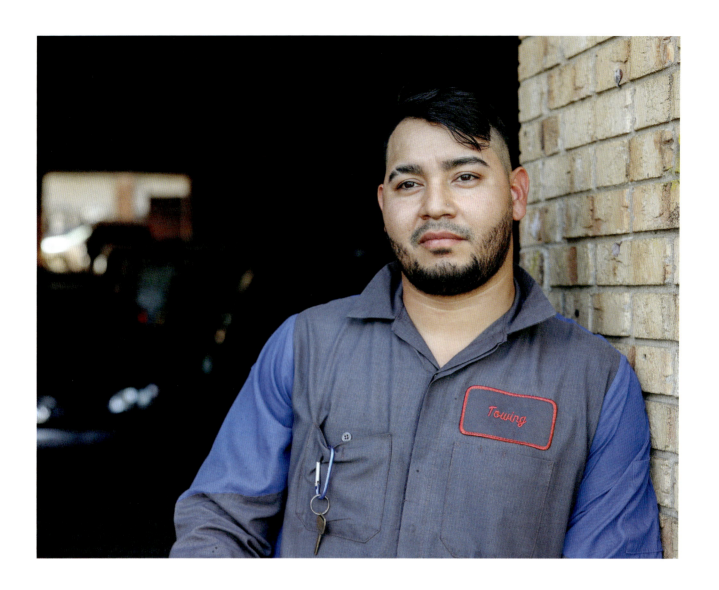

"Yo estaba trabajando en una tienda, como los deli. Era empleado. Lo que ganaba semanal eran diez dólares. No me alcanzaba para comprar el alimento para mis hijos. Ver a mis hijos... o sea que, que no estaban bien alimentados. Es algo que, que no quiero desearle jamás a nadie. De verdad que era algo que, que me partía el alma. Ese día fue como que algo se quebró dentro de mí que yo dije que tengo que hacer algo drástico, algo grande para sacar a mi familia adelante. Ya los dos años que tengo acá. Yo viví en un shelter por cinco meses. Fue lo peor de mi vida. Gracias a Dios conseguí este trabajo. Me superé. Ya pago un cuarto, y yo semanalmente les mando ciento cincuenta dólares a mis hijos. Pero lo más difícil es eso, llegar y estar solo. No tener con quién hablar en casa. Yo sé que a mí me hacen falta y yo les hago falta. Pero no tomaría una decisión de devolverme y, y verlos pasando mucha necesidad. Prefiero yo estar aquí, así esté triste, pero veo que, que no les falta nada. Que tienen un plato de comida todos los días."

"I was working in a store, like a deli. What I earned weekly was ten dollars. It wasn't enough to buy food for my children. Seeing my kids . . . I mean, they weren't well-fed. It's something that I never want to wish on anyone. It was really something that broke my heart. Something broke inside me, that made me say: I have to do something drastic, something big to move my family forward. I've been here for two years now. I lived in a shelter for five months. It was the worst time of my life. But thank God I found this job. I improved. Now I pay for a room, and I can send home $150 a week. But the hardest part is coming home and being alone. Not having anyone to talk to at home. I miss them, and I know they miss me. But I wouldn't make the decision to return and see them going through a lot of hardship. I prefer to be here, even if I'm sad, but I know they have a plate of food every day."

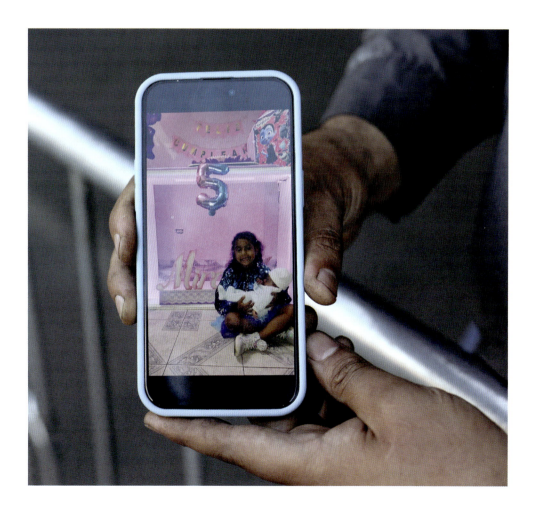

"A great gift of New York, I think, is that no matter what you're doing, no matter how special you feel for a split second or two, there's ten thousand other people who probably look like you, probably dress like you, who are trying the exact same thing. Maybe some of them do it a little bit worse. Some of them do it a little better. If you're lucky, there's not that many that do it better. But in the end nothing you do is going to be able to convince you, ultimately, that there's anything special about you. You are in a sea of people with all of your same human weaknesses that are reaching for the same shit as you."

"When I have something planned that I'm looking forward to, it's all I can think about, and I feel so excited. But when it gets here, I don't feel like it's actually happening. And before it's over I start looking forward to the next thing."

"We were both counselors at an eight-week summer camp in Maine. We talked a little about pickleball during orientation. But our first real conversation was at the eighties-themed dance; we talked about books that we love. From there it just kinda started happening naturally. We went paddleboarding on Echo Lake. We'd run around Echo Lake, in the rain. We'd get up early, and stay up late—so we could read to each other by Echo Lake. She started coming to my nighttime yoga classes at the old boathouse, and that's when all the girls in her cabin realized something was going on. They'd come up to us the next morning at breakfast, and be like: 'What positions did you guys try last night at yoga?' One night during week five we were sitting in a cemetery together, and I was about to tell her: 'Being around you makes me nervous.' But right as I was about to say it, a shooting star went across the sky. And Paige was like, 'Shooting star!' And I was like: 'Cool! Shooting star!' And the moment kinda passed. But the next week we were sitting by Echo Lake with some other counselors. We had to check in by midnight, and it's like 11:55. So everyone else leaves. And it's just the two of us. I couldn't hold it anymore. I was like: 'I really like you, OK? Like, I really like you. Like, I've wanted to kiss you this entire time.'"

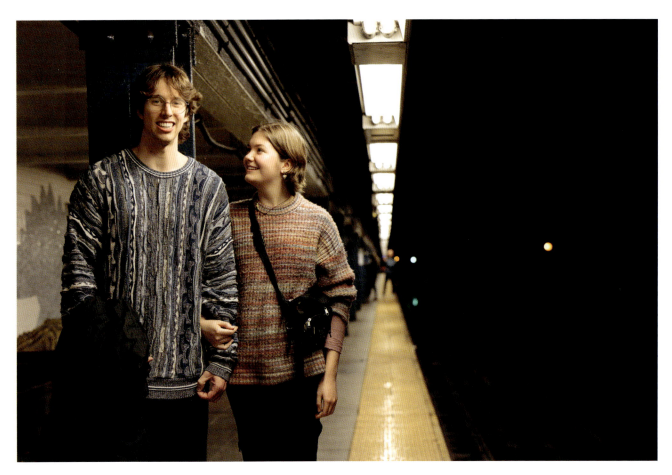

"I was an actress when I had my first child, but I had to stop doing that. I thought at some point I'd reach some level of peace with motherhood, but it never happened. So when the kids were eleven and thirteen I made my decision to travel the world and photograph. I'd go here for a month, there for a month. Everyone was against it: their father was against it, the kids were against it. They wanted me to be there for them 24/7, every day of the year. Whenever I was away, I felt guilty. But whenever I was home, I didn't feel completely realized."

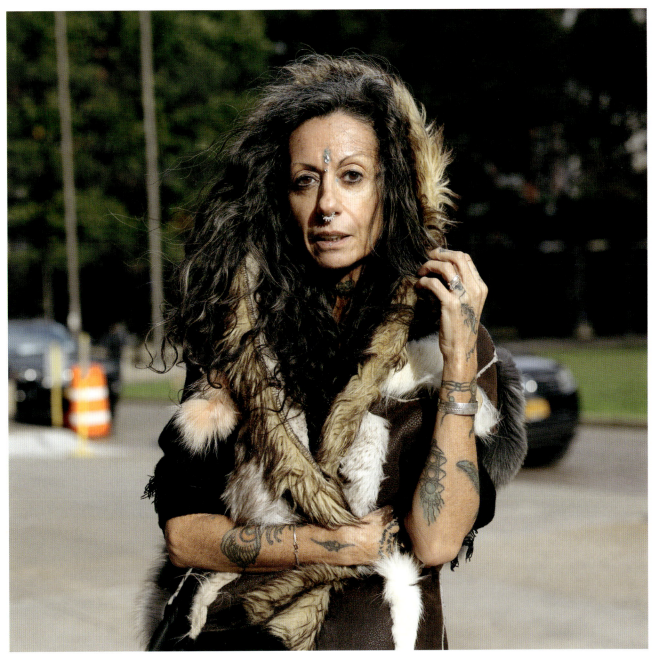

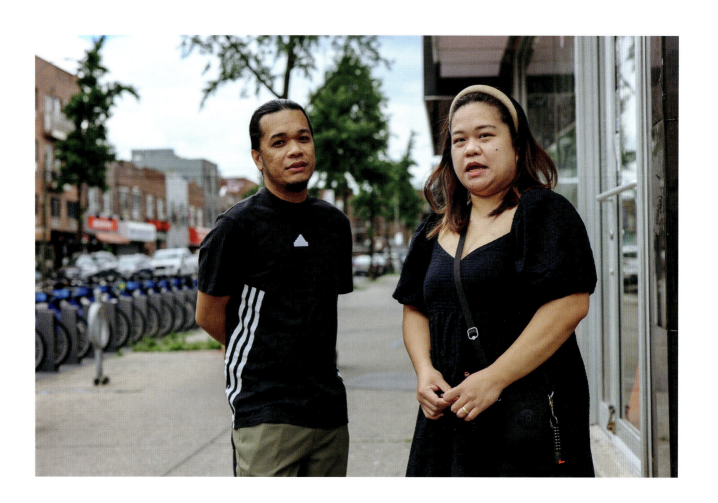

"We're not just husband and wife, we're best friends. If you separate us from each other, it's like one of us is going to get sick. But right now he's working as a live-in health aide, which means he's not coming home every day. It can seem like he's working overseas; sometimes I will only see him two days a week. But we're together today. We're together right now, so we're spending the time we have now."

"It used to be everything them, everything them. Without my kids I was nothing. I made them my idol. My kids were my idol."

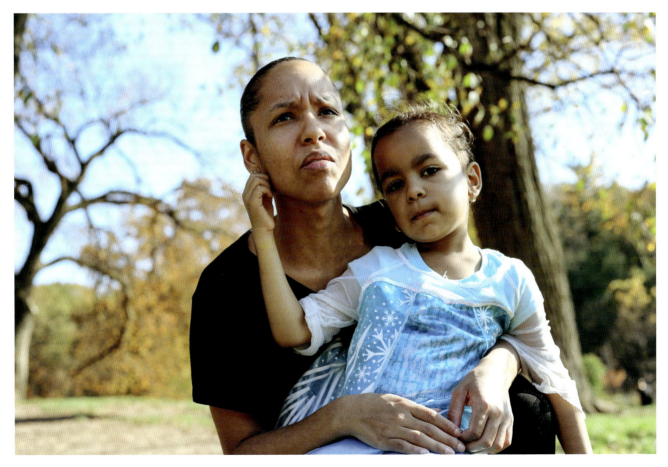

"I was looking for a girl from Brooklyn.
I met a man from New Jersey."

"I ran away when I was seventeen and entered into a militant anarchist underground group that was training to overthrow the government, but then those people went to prison. I ended up being placed on an FBI watch list for that, so I was like: 'Wait. I have to do this in an art way.' Now I'm forming a collective of avant-garde artists to create work that connects revolutionary anarchist art ideas with healing and spiritual liberation. I'd describe myself as a contemporary surrealist situationist with a religious devotion to the overthrow of capitalism."

"I was like, you know, lower class. And I was in Catholic school with a lot of really rich people who were bullies to me. I was the weirdo. I was always the weirdo, you know? And I just noticed, it always seems like the person who's in control of the situation hates me. Whether it be my fascist dad, or my teachers, or the bullies at school—it just seemed like no matter what I did, I upset authority figures. Even when I wasn't being negative. Even when I was just being a middle-school girl wearing weird clothes because I thought they were cool, I'd get bullied. It was really extensive, really traumatizing. You know how little girls are. They tried to get everyone to hate me. In every system of hierarchal authority, there are different roles people play. And the scapegoat is a central role. And that's me, I'm the scapegoat."

"I was one of those kids you see on St. Mark's with the dogs and the overalls and the patches and shit. Back then I'd probably ask you for a dollar. Or I'd just rob you, for real. But in my heart I'd promise to pay you back later if I could; I was still a sweet kid. I was just angry. I'd grown up in Red Line Chicago: feeling small, feeling undervalued, feeling like the world wasn't going to take care of me. Then I found this group of older kids who were living off the grid. All of them had read *Infinite Jest*, and it seemed like they had all the answers. We were such cliché fucking punk kids. Our way of rejecting the system wasn't activism. It was drugs, and disassociation, and complete oblivion. We'd go to these shows and sing along with all these lyrics about how the system is rigged and we were different. We'd talk forever about the white men in suits who were making all the decisions and bringing the world into darkness. But all these kids came from money. Whenever we got stuck without a place to stay—one of them could call their parents to pay for a hotel room. This whole time they'd been talking about the system, they were actually talking about their parents. The whole thing was about rejecting their parents. For me it was: 'Fuck you, government.' For them it was: 'Fuck you, Dad.' And that's different. It's different."

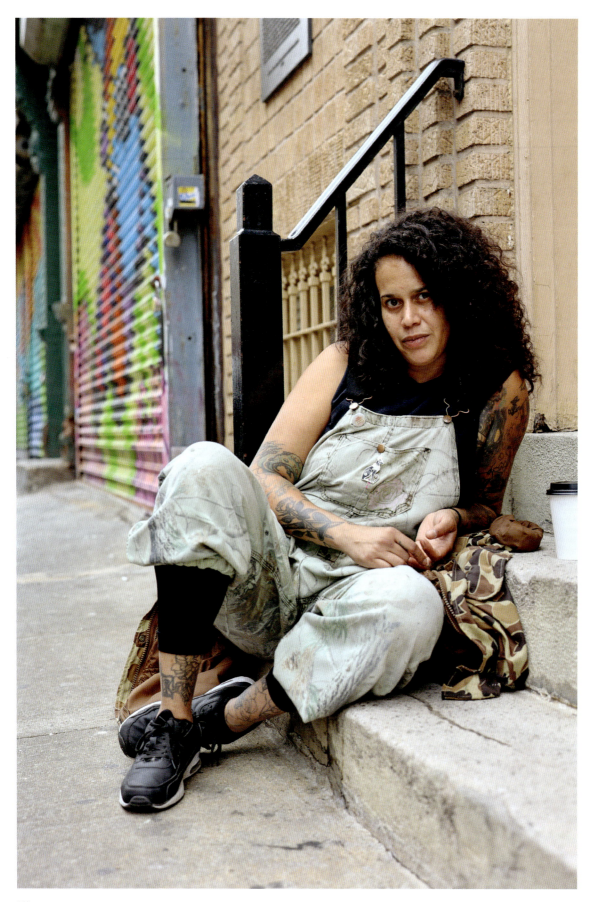

"It was the height of the pandemic. Everything was closed, the stores were boarded. All these people were leaving and going back to Ohio or Connecticut or wherever the fuck they're from, and they're just leaving their belongings on the street. All this valuable stuff, just sitting on the street. It's like: 'What the fuck?' So I hung up some shelves on one of these boarded-up buildings, stocked them with perfectly good stuff from the street, and hung up a sign that said: 'Free Store.' I called it The Free Store Project; I ended up doing seventeen locations around the city. I'm proud of it, I'm very proud of it. And I like to think that it's still kinda counterculture. Capitalism creates this whole scarcity mentality. The system makes us fight against each other for scraps. But one of the things I tried to do with the free store is create this idea that we will always have enough. Nobody was guarding these shelves, but for the most part they were always stocked. In my experience when people see how much stuff there is, the less likely they are to hoard everything. The more faith they have in like, their fellow man."

"People keep putting in these fake reports with Child Protection Services. I keep asking: What is the maximum number? What is the max number? I have over fifteen cases. I told the caseworker: 'You want to take these kids out of my household, put them in a different household, yet you expect me to sit here and be sane?' I don't got nothing else. All I got is my kids."

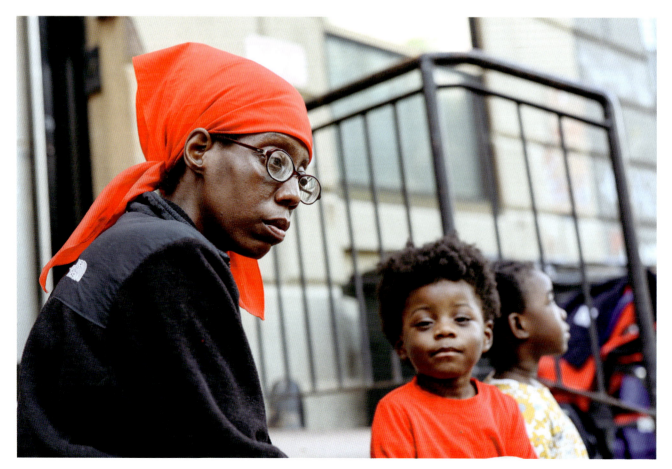

"I'm on a global team that oversees a lot of global businesses; we work to find new partnerships and innovative opportunities to make more money for our parent company. It's lots of Gmail. I send twenty-five emails, done. They're good emails. Half of them are good emails. The other half are fake work. Fake work is when you're like: 'Yes, I'll do that.' And even though you could do it in fifteen minutes, you space it out over a week. It's like, survival spacing-it-out."

"I have my morals. I'm not saying I want you to be in pain. But at the same time, I don't feel your pain. If you told me right now that somebody close to you died, I would understand that it's a bad thing. I'd see you crying. But I wouldn't feel sadness. Your world kind of doesn't matter to me. Not that it doesn't matter, but you know: most people's problems are the same. And when you hear them over and over, it's difficult to empathize. Maybe it would be better if I could. It would allow me to understand people more, if I could feel what they were feeling. That would mean more knowledge. It would be something else to know."

"I only got one leg, but it's a goddamn good sexy leg, I'll tell you that. It's a sexy-ass fucking leg. It's sexy. It's sexy as fuck. I'm telling you the truth. This shit is goddamn sexy. I don't have to explain it. It explains itself. Tell him why you're sexy, leg."

"This meat cleaver was a gift from a friend. There's a poem engraved on it; it's literally a poem to my deadname. An ode to the person I used to be. So many people in my life had such a grotesque attachment to that persona. Now I'm Jessica, Jessica Wick. It's this little bullshit street name I made up. A play on John Wick. 'Cause I'm a girl, but I'm tatted up and ready to fight. I used to keep this cleaver in a shrine; now I use it for real. Because expiration on trans girls is pretty fucking low. Most likely I'm going to die by violence at the hands of some dude who looks just like you. Cis white men are fucking per capita the most serial killers, spree shooters, wife beaters, date rapists, pedophile priests, fucked-up presidents, fucking slaveholders, Nazis. You fit the profile, exact. Luckily you came up proper, a little out to the side. Or else I'd have barked at you, bro. You almost got the fucking business. You know how many people been raped by people who look like you? Presume you are an enemy. Start there. Start with the idea that your body is a fucking weapon, whether you like it or not. But you walk around in your white supremacist sneakers, with your shorts above the knee, like everything is lovely. That's the white male visage for you. The one that tells you: 'I can exist in the world unscathed. I can feel totally free to approach strange armed women on the street, and ask to take their picture. I'm just going to assume that because I'm a white man, this bitch won't fucking cleave me.'"

"I know how you're looking at me right now. I know when people look at me like I'm a woman, and I know when people look at me like I'm a faggot in a dress. And you—you. You see me as a whimsical faggot in a dress. If I went to kiss you, right now, would you respond like I was a cis woman? Answer me. Would you? You waited too long to answer; I'm a faggot in a dress to you. It's precognitive, baby. You've gotta deal with it, honey. All you boys. Do your reading; I'm not going to chew your food for you. You've been trained on white supremacy. You're addicted to it. You're addicted to the false sense of egoic identity that it provides you. The only reason you exist is because you're a white man. Could a black man do your job? Could a woman do your job? Actually, I'm gonna stop you right there. Don't even answer that. I don't care what you believe. I don't. I truly don't. You're grossly unqualified to speak on any experience other than that of an upper-class white man who takes adorable pictures, and plays on the fucking formats. Yeah, motherfucker. Deal with it. You're not that talented. Why are you the one on prime time? Because you're white and male; no way you're the baddest photographer around. You wouldn't even know. You have no clue how good you are, because you've played on the easy game so fucking much. You ever been called a faggot? You ever starved? I'm homeless, baby. I'm out here dying. So go ahead and get your shot. Get it. I'm only doing this because you're giving me some bread. This is a performance. Sex work, baby. And if that's not what you want, then I've got nothing for you."

"Okay, cool. I'm smoking now. I'm cool. You're familiar with the concept of an away game, right? This is an away game for me. You, y'all, all of y'all, y'all are an away game. I'm really fucking different around people in my community. With the people I love, I'm calm. And I don't love you, bro. Not even close. I've got all kinds of softness that you're never going to see. You're just some fucking guy. I'm never going to trust you, ever. But thank you for listening to my rant. It's just—have you ever been really fucking sure about something? Ever had real righteous fucking vengeance run through your body? Highly recommend, honey. Cis white men can be lovely. I've fucked a bunch of good ones. Even loved a few. My son is a cis white male, my father is a cis white male. The thing is—the patriarchy doesn't care about you either. Nobody gives a fuck about your internal life in any meaningful way. You're a fucking workhorse. You've been trained with bullshit movies that make you fucking worship guns and worship weak men. You've been trained to effectuate their need for control. But your life, your world is my prison. And all the guards look like you. Can you imagine? Can you even imagine your own body feeling like an alien mech suit? That you just get dropped in, and it never goes away? I suffer. I suffer for you. This life is mostly fucking difficult and torturous for me, with occasional moments of absolute gorgeous beauty that keep me going. My community. My partner. My kids. My family. My art. So every day I continue to choose not to kill myself, as an act of service to the world. And you are ungrateful, laughably so."

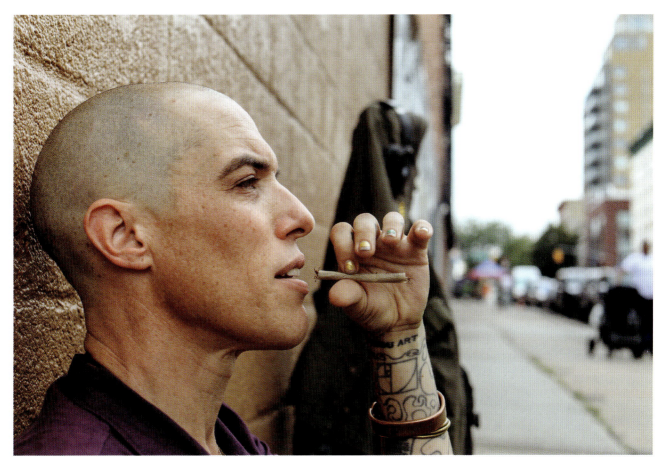

"My earliest memory was when I was five or six. He was installing storm shutters down in Florida. And I remember the really sharp ringing of the screws going through the metal. That was Pops. His life was work; Pops was very much work. There were times that the ends would not have met otherwise, but he had good-paying jobs as well. And he worked just as hard. Maybe it was his upbringing, or his culture, or his own values; but work just took on this momentum. I think in his mind it was the only valid way to spend one's time. But work is supposed to be a way to get to somewhere. If you die in the middle of working towards something, that's it. That's where the story kind of ends for you. Pops had a heart attack three months ago while taking a nap in the back of his car. How did we find out he was gone? Because he didn't come home an hour after work—and he'd never done that before in his life."

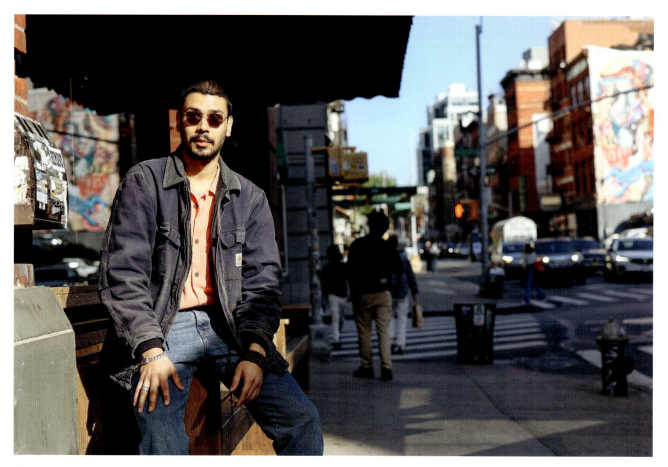

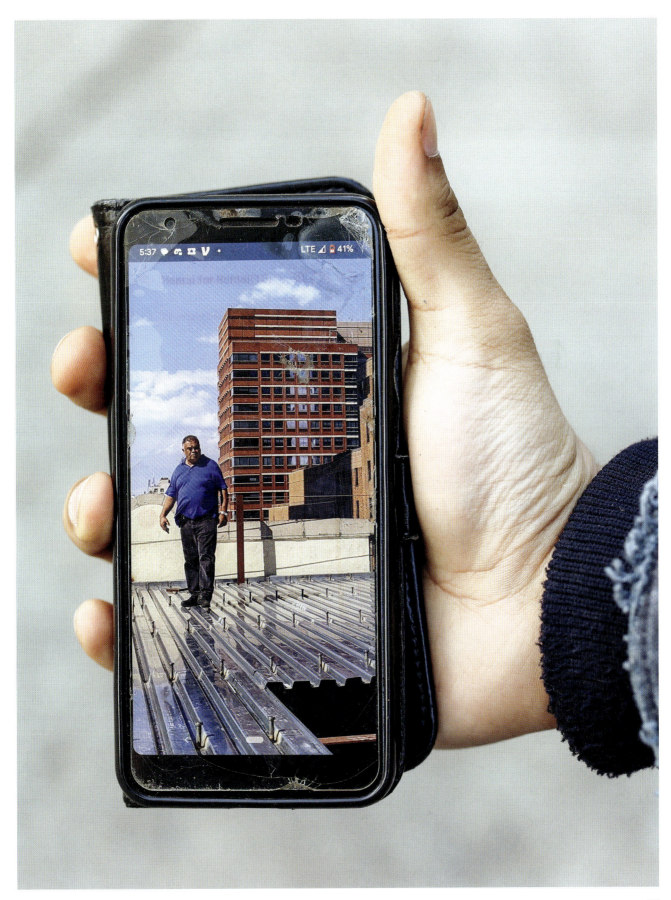

"I was nervous about it at first. He wanted to be with me all the time. It's like, how am I going to tell him? How am I going to tell him that I need my space?"

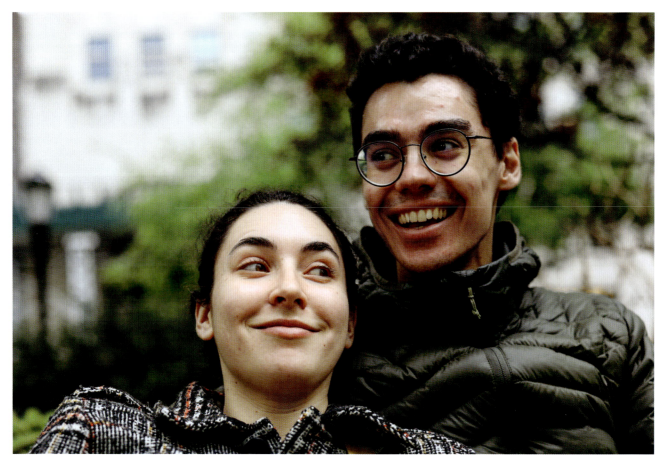

"Life is so short and there are so many things I want to do. It's time. I feel the pressure of time extremely acutely. So I'm trying to navigate that, while realizing that going fast is not the answer. Going fast doesn't extend your time. It actually compresses it. And I've been going so, so fast. And so, so frantically, basically my whole life."

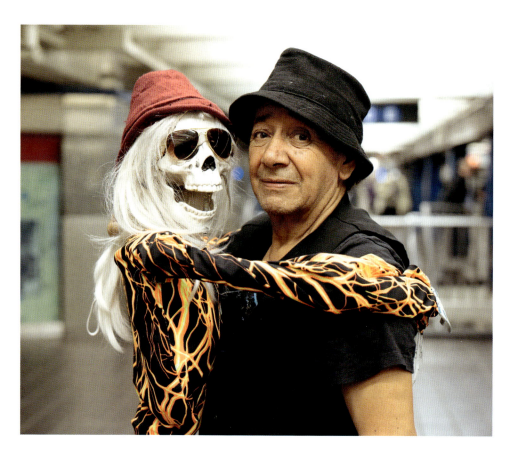
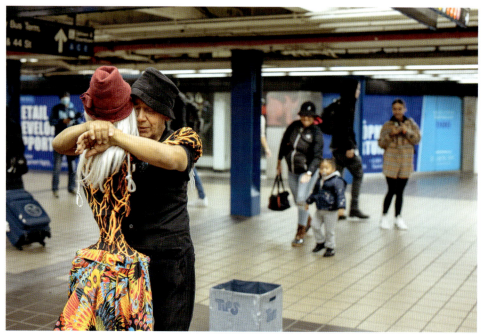

"Cuando bailo con esta muñeca, pienso en mi exesposa, Gloria. Todos tenemos ese primer amor. Ella tenía dieciséis años cuando la conocí. Era un evento de baile de Coca-Cola. Yo era bailarín profesional; un salsero. Y yo era bien parecido, porque en ese entonces llevaba afro. Pero Gloria, ella era como una reina. Verla era ver a una reina, y todos la buscaban. Pero ella eligió bailar conmigo: acercó su cintura, se apoyó en mi pecho, y cuando sentí su aroma, me llené con el deseo más profundo de que fuera mía. Por favor, no me lo recuerdes. ¡Ay, Gloria! Pasamos nuestra luna de miel en Cartagena. Pero créeme, no vimos nada de Cartagena. Tres días pasamos en el hotel. Imagínate, esa mujer: ese pelo largo, ese cuerpo perfecto, esa sonrisa, solos en la cama. Ella me dio los mejores años de mi vida, tuvimos tres hijos juntos. Pero yo no supe apreciarla. Me descubrió con otra mujer. Intenté decirle: 'Gloria, no es nada. Esta mujer me está ayudando a instalar unos espejos.' Pero ella no quiso escuchar. Me dijo: 'Te voy a pagar de la misma manera.' Y lo hizo, lo hizo. ¡Gloria! ¡Ay, Gloria!"

"When I dance with this doll, I think of my ex-wife Gloria. We all have that first love. She was sixteen when I met her. It was a Coca-Cola dance event. I was a professional dancer; a salsa dancer. And I was good-looking, because back then I had an Afro. But Gloria, she was like a queen. To see her was to see a queen, and everyone was after her. But she chose to dance with me: she pulled her waist close, she leaned against my chest, and when I smelled her scent, I was filled with the deepest wish for her to be mine. Please, don't remind me. Oh, Gloria! We spent our honeymoon in Cartagena. But believe me, we saw nothing of Cartagena. Three days we spent in the hotel. Imagine, that woman: that long hair, that perfect body, that smile, all alone in your bed. She gave me the best years of my life; we had three children together. But I didn't know how to appreciate her. She caught me with another woman. I tried to tell her: 'Gloria, it is nothing. This woman is helping me install some mirrors.' But she would not listen. She told me: 'I'm going to pay you back, in the exact same way.' And she did, she did. Gloria. Oh, Gloria!"

"Every firm I've ever worked at, every position I've had, I've tried to be a cut above the rest. Not just clothing, in every way: my intellect, my demeanor, even just being a good person. I've helped a lot of my friends get jobs, that's important too. But I never want to blend in. I hate the idea of being one of many. It's a sad fact: a lot of people live mediocre lives. They live and die and nobody notices. They leave just as they came, except for the suit they wear in the coffin."

"I'll help any kind of person. But if I have to give my whole soul and energy, I want it to be to my people. So I don't date outside my culture. My ex-husband was from the islands as well. We were married for twenty years, and I have no regrets about that: two beautiful babies came out of that marriage. But the only emotion I've ever seen from him is toward his kids. Best father in the world, he deserves a medal. But he didn't have much to give a wife. I never heard 'I love you' from him. A lot of 'Oh, you're beautiful.' But never 'I love you.' He was basically an orphan. The last time he saw his mom was when he was six years old; his dad was a drunk. A black man comes with a lot of burdens. Not saying white people don't go through these things. But with black men, there's more. These mountains you have to climb, these stairs you have to climb: infidelities, the fighting, the bickering, when you're broke, the bills coming at you. You have to go through so much to have a steady relationship. The black woman has to give more, succumb to more. Because we're dealing with all his setbacks."

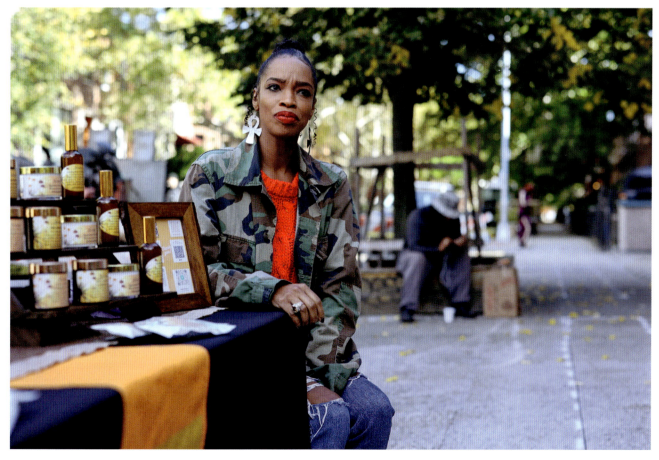

"It's not cute. It's not a cute situation. It's too intense. I don't like when a person takes over my mind, and this has just been a complete takeover. You know, a complete invasion. I can't focus on work, which is probably why I'm sitting here in the park, trying to calm down and not think about the situation. I hate it. No, I don't hate it. It's just uncomfortable. It's an uneasy feeling. I guess that's the beauty of it too. But I'm a person who values space and control. That's the thing—I'm a control freak. I need my life to be completely in order. And love kind of messes that up. It's the only thing that messes that up."

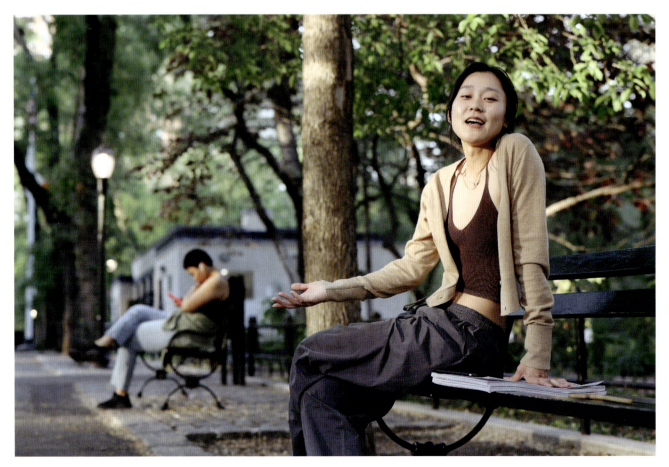

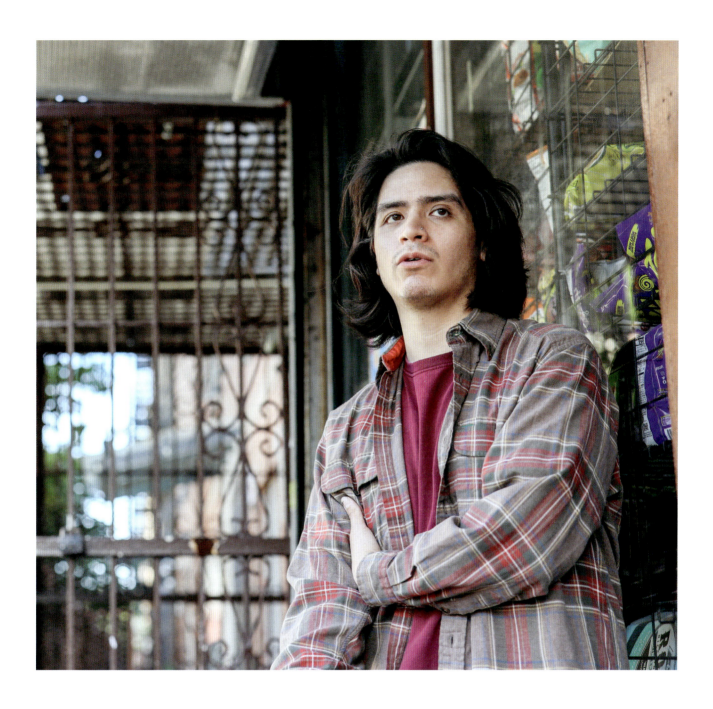

"I'm trying to get some air. I live in one room with three people, all artists. It's a fucking hellhole: books, paintings, camera lenses, countless art supplies. Rats, roaches, ants. And there's cats in there too, so yeah. But at least I have a roof over my head. It's collapsing, because of the rats. But at least I have a roof."

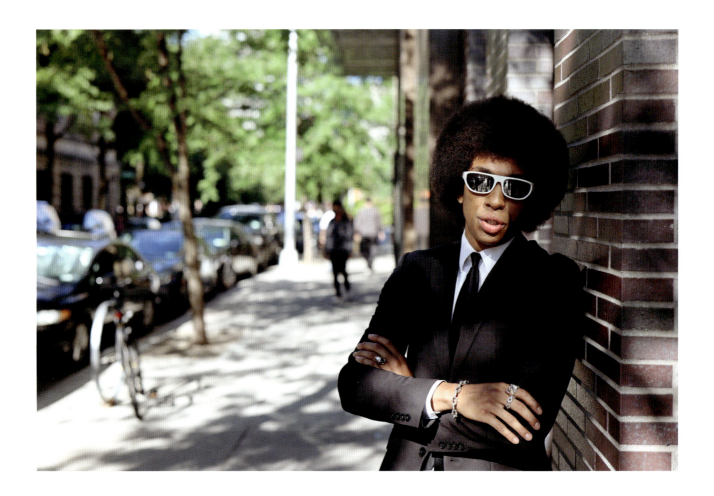

"I call it God's Gift; it's priceless. 1981 Oldsmobile Cutlass, right? I got a great deal on it. And I knew it matched my vibe. In the beginning it was all about the exterior. Visual stuff, you know what I mean: add-ons, new rims, new tires with fresh white walls. But I ended up losing my first engine. Because I never paid much attention to things like maintenance, and oil changes. How clean it should be on the inside. When they lifted the old engine out of the car, I remember thinking: it looks just like a mechanical heart. It made me think about the food I was eating. There were never many healthy choices in my community. It was McDonald's every day after school. Either that or corner store food: powdered donuts, sunflower seeds, bag of chips. I grew up on that, heavily. Those are low vibrational foods. And I think they were responsible for a lot of my most negative behaviors. Right now I'm in transition to a plant-based diet. And I definitely try to stay away from anything man-made. People in my community see me in the street, just by my panache, my verve. They notice it. And they want to know: What can they do to obtain it? I tell them the truth: the diet."

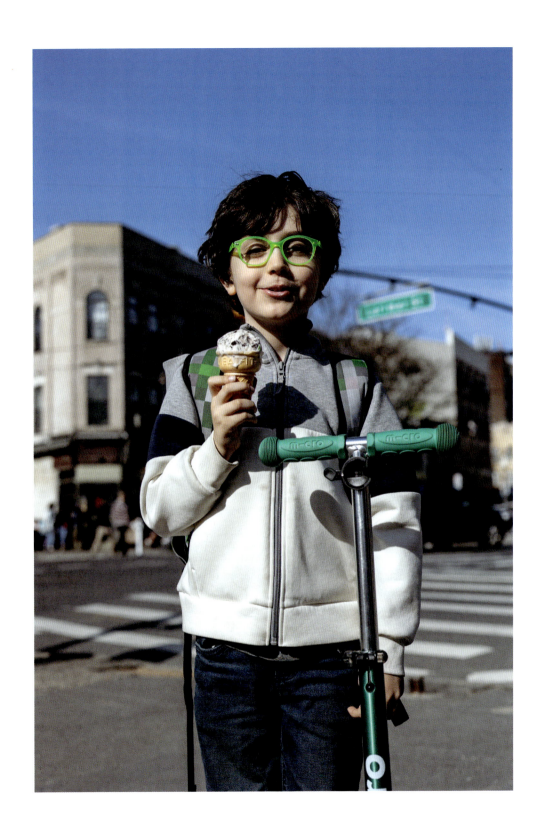

"I love TV because I get to watch things."

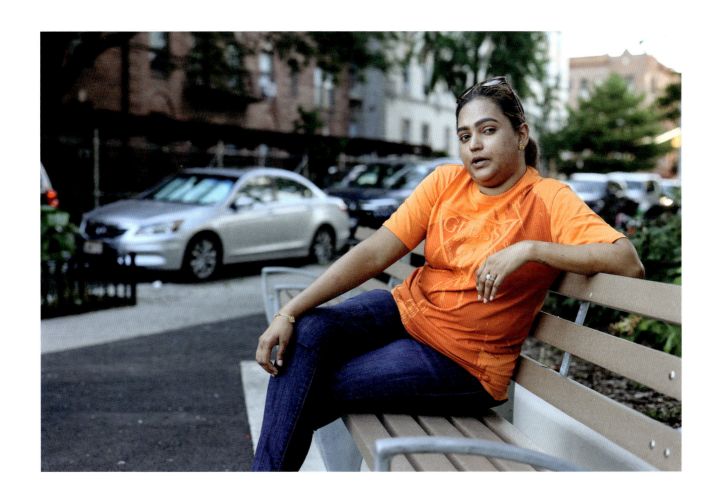

"He was always the kid that loved school. He'd be excited to wake up in the morning and go to school. But two months ago, he started to be like: 'Do I really have to go?' I knew something wasn't right. But it took him two months to finally tell me that some kids were bullying him: calling him fat. It broke my heart in a way, that he couldn't tell me about it sooner. I thought we had this strong connection. It made me wonder how things would be different if his dad hadn't left. And it did make me cry a little bit, but only to myself. I would never let him see me cry. It's important that he never sees me as a weak mom. Because then he'll try to be strong for both of us, and he'll start keeping things to himself."

"Tell your friends, or anyone who is having problems: tell them that we are in heaven. This is heaven."

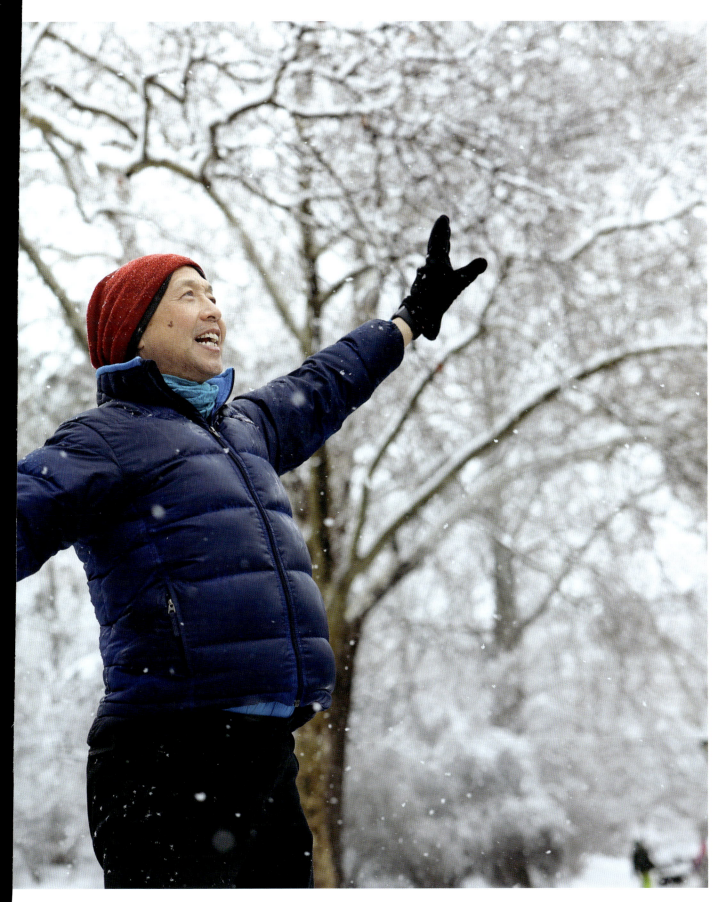

"I grew up in northern China; there was snow like this. We lived in a coal mine city, but my family could not afford coal for heat. At night it would get so cold that I could not sleep; I'd wake up with blisters on my hands. I was a very weak child. When I was twelve the doctor diagnosed me with a heart condition. He said: 'If you want to live, you must go to Shanghai for surgery.' But my family was too poor for surgery, so there was no hope for me. It was my uncle who said: 'You are living in the birthplace of Tai Chi, why don't you give it a try?' In the morning my father began taking me to a small park to practice. The first thing I noticed was the heat. When I practiced, my body would get warmer. And this gave me hope. It was hope. It made me feel: through effort, and discipline, I can change things. Even if things seem impossible, they can change. In 1976 the education system in our country opened up, and kids like me could finally take the college entrance exam. I received a high enough score to qualify for university, but back then, if you had a serious health condition, you were disqualified from going to college. Everyone was worried about my heart. My whole family was gathered outside the doctor's office, waiting for the results of the physical exam. And when the doctor said: 'Your heart condition is gone,' it was the biggest moment, the biggest moment of my life. I knew then I could go to Shanghai, I could go to Beijing. I could go anywhere."

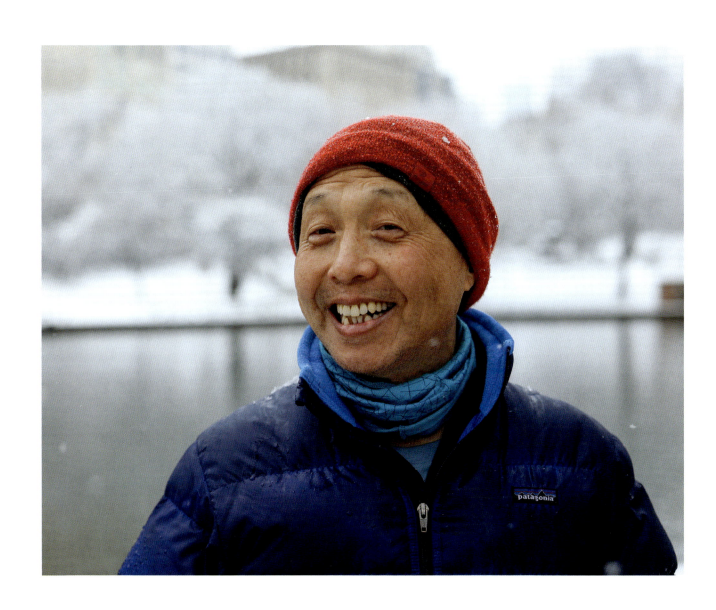

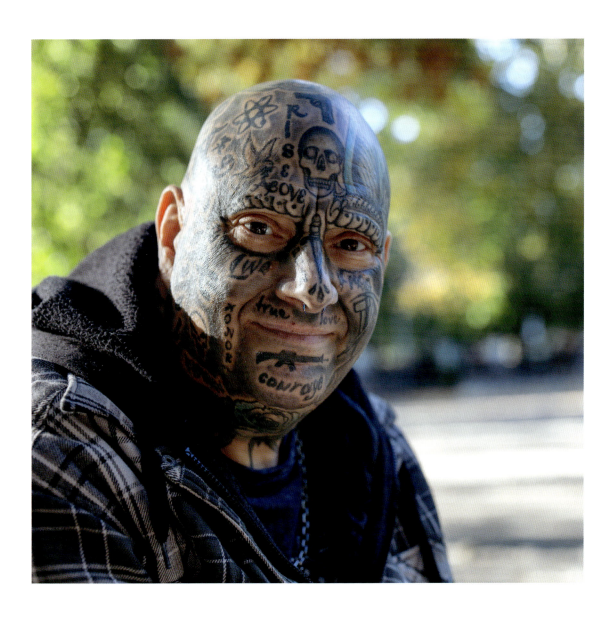

"It was all my parents' fault."

THANK YOU

I want to begin by thanking anyone who allowed me to take their photograph, or tell their story, over the past fifteen years. In the beginning these interactions were brief—just a quick photo. Over the years they evolved into long conversations on sidewalks all over the city, sometimes lasting more than an hour. Often these conversations were joyous. Other times they were very intense, for both of us. Very personal things were shared. Hundreds of people began listening in, then thousands, then many millions. This journey did not come with an instruction manual. I had to learn, day by day, under the brightest spotlight, what it meant to be a steward of these stories. I was a young man in a hurry; mistakes were surely made. The only thing I can promise is that I tried to be better, every single day. I hope, and believe, that for almost everyone—our meeting, on some sidewalk, long ago—was a positive experience. If at any time I fell short of that mark, I can only hope for your forgiveness. How these conversations changed me, I cannot know. But all ten thousand of them are down there, somewhere. I am where I am, and who I am, because of you. Thank you.

Thank you to my wife, Erin, who I met during my first months in New York and who has been by my side every step of this journey. You've kept my feet on the ground and the phone out of my hand. Thank you to my children. The three greatest surprises in a life of great surprises. If I had to give it all away, tomorrow, for you, I would.

Thank you to my small handful of old friends for giving me a place of return.

Thank you to my agent, Brian DeFiore. You've made me a better artist, a better writer, but most importantly, a better man.

Thank you to everyone at St. Martin's Press: Jen Enderlin for steering the ship. My editor, Michael Flamini, for his passionate advocacy, and steak pizzaiola. Thanks to Laura Clark for being so opinionated, and so often right. Thanks to Jess Zimmerman, Martin Quinn, Jeff Dodes, David Rotstein, Paul Hochman, Tom Thompson, Erik Platt, Claire Cheek—the supporting cast for many of my fondest memories. And a very special thanks to the designer of all my books, Jon Bennett. The other man in the trenches. Your artistry and attention to detail have elevated my work beyond measure.

And finally, thanks to everyone who has followed and cheered me on along this path. I have been quoted many times saying that the people who follow *Humans of New York* are "the nicest thirty million people on the internet." I still believe this to be true. It's not as much of a two-way conversation as it used to be. As my family grew, I had to pull much of my energy inward, so that I could be present for a smaller circle of people. But my love, and gratitude, is no less deep for this magical gift that you've given me.

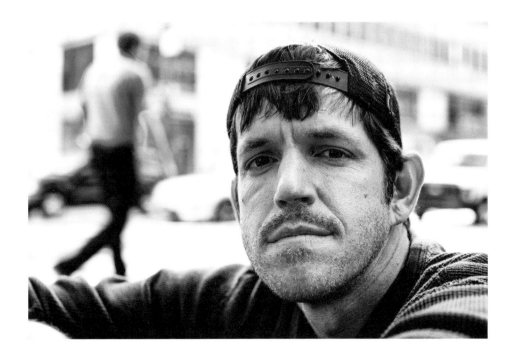

BRANDON STANTON is the writer and photographer behind *Humans of New York*, a storytelling platform with over thirty million followers. He has photographed and interviewed over ten thousand people in forty different countries around the world, including extensive series in Iran, Iraq, and Pakistan. During this time he has helped raise over $20 million in support of various causes and individuals that have been featured in his work. In 2013 *Time* magazine named him one of "30 under 30 Changing the World." In 2015, he became the first social media creator to be granted an interview in the Oval Office, with then President Barack Obama. He is also the author of four #1 *New York Times* best-selling books, which have sold millions of copies around the world: *Humans of New York* (2013), *Humans of New York: Stories* (2015), *Humans* (2020), and *Tanqueray* (2022). He grew up in Atlanta and is a proud graduate of the University of Georgia. He currently lives with his wife and three children in New York City.

Author photo taken, in the act of creating this book, by Lawrence Wilkes.
FLICKR: WILKES.SNAPS

First published in the United States by St. Martin's Press,
an imprint of St. Martin's Publishing Group

DEAR NEW YORK. Copyright © 2025 by Brandon Stanton.
All rights reserved. Printed in China. For information, address
St. Martin's Publishing Group, 120 Broadway, New York, NY 10271.

www.stmartins.com

Designed by Jonathan Bennett

Case design by David Baldeosingh Rotstein

The Library of Congress Cataloging-in-Publication Data is available upon request.

ISBN 978-1-250-27758-9 (paper over board)

ISBN 978-1-250-42367-2 (signed edition)

ISBN 978-1-250-27759-6 (ebook)

Our books may be purchased in bulk for promotional, educational, or business use. Please contact your local bookseller or the Macmillan Corporate and Premium Sales Department at 1-800-221-7945, extension 5442, or by email at MacmillanSpecialMarkets@macmillan.com.

First Edition: 2025

10 9 8 7 6 5 4 3 2 1